NAM JUNE PAIK
eine DATA base

n der Mittelachse durch eine Apsis ab geschlossen. Wäh

alität den äußeren Eindruck bestimm wurde das In

undriß von 1938

GRAPHIK

SAAL 4

GRA

SAAL 2

SAAL 1

SA

ndriß.

nd Monumen-
re durch eine

K

3

M. 1:400.

Venice is the most advanced city in the world,

since it has already abolished the automobiles.

John Cage, 1958

La Biennale di Venezia XLV Esposizione Internazionale D'Arte 13. 6.–10. 10. 1993

NAM JUNE PAIK

Padiglione tedesco German Pavilion Deutscher Pavillon

eine DATA base

herausgegeben von Klaus Bußmann und Florian Matzner

edition cantz

INHALT

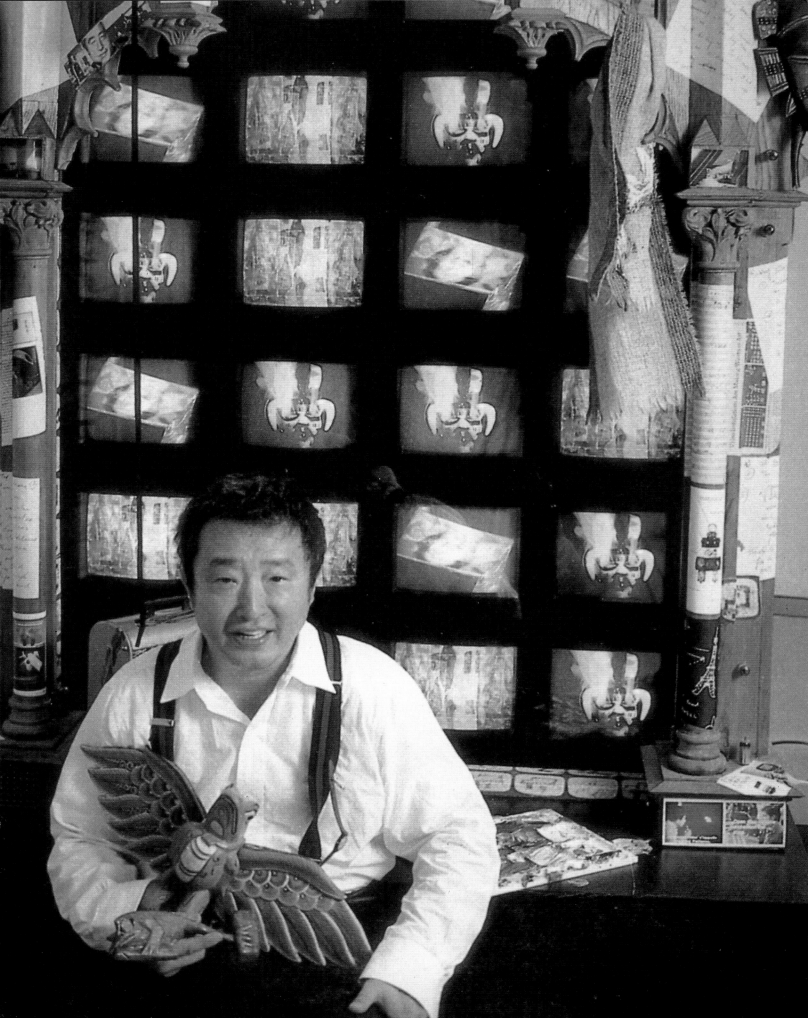

NAM JUNE PAIK

KLAUS BUßMANN

Nam June Paik im Deutschen Pavillon der Biennale Venedig zu zeigen, ist keine Selbstverständlichkeit. Als ich ihn vor mehr als zwei Jahren einlud, gemeinsam mit Hans Haacke die Bundesrepublik Deutschland zu vertreten, schrieb er spontan zurück: "It is a great honor for me to be in the German Pavilion" (in Englisch, obwohl wir sonst meist Deutsch miteinander reden, was er auf ähnlich unvergleichliche und originelle Weise spricht wie Englisch).

Ich denke, es ist eine Ehre für die Bundesrepublik Deutschland, und es ist ein gutes Zeichen für den geistigen Zustand Nachkriegsdeutschlands, daß der Weltbürger und Prophet der internationalen elektronischen Kommunikation, Nam June Paik, sich im Deutschen Pavillon zuhause fühlen kann.

Er ist Koreaner, lebt überwiegend in New York (mit Zweitwohnsitz in Bad Kreuznach), ist Professor an der Kunstakademie in Düsseldorf, "Vater der Videokunst" – mit prägendem Einfluß auf mehrere Generationen junger deutscher Videokünstler –, einer nicht mehr ganz neuen Kunstgattung, der die Biennale in Venedig bisher wenig Aufmerksamkeit geschenkt hat.

Nam June Paik ist gewissermaßen "Ehren-Gast-Arbeiter" der Bundesrepublik. Er steht für die große Zahl von Ausländern, die nach dem Zweiten Weltkrieg zum Aufbau des Landes beigetragen haben, als Arbeiter in den Fabriken, als Händler und Gewerbetreibende, als Künstler und Intellektuelle.

Paiks Entscheidung – und ihre Konsequenzen –, als junger Mann statt nach Paris in die Bundesrepublik Deutschland zu gehen, werden im Beitrag von Pierre Restany einleuchtend kommentiert. Seine Rolle in der deutschen und internationalen Fluxusbewegung, seine Freundschaft mit Joseph Beuys und vielen anderen deutschen Künstlern und Studenten, seine Kenntnis und Liebe zur deutschen Kultur sollen nicht darüber hinwegtäuschen, daß er sich nicht für ein einzelnes Land reklamieren läßt. Er ist Nomade und Kosmopolit, der sich seiner kulturellen und bürgerlichen Wurzeln in Korea immer bewußt geblieben ist, aber schon früh, vielleicht aufgrund der historischen Situation des geteilten Landes, in dem er aufwuchs, das Problem der globalen Interdependenz erkannt hat. Auch wenn er vorgibt, in technischen Dingen Laie zu sein, hat er ein untrügliches Gespür bewiesen für die Möglichkeiten der neuen elektronischen Medien und ihre Bedeutung sowohl für den Weltmarkt wie auch für die davon bestimmte Weltzivilisation. Gegenüber dieser Medienwelt behauptet er sich als Individuum – auch in seinem persönlichen alltäglichen Verhalten –, das sich nicht von den Apparaten und Medien vereinnahmen läßt.

Der vorliegende Katalog mit einem "Blumenstrauß" persönlicher Widmungen ist Ausdruck der Faszination, die die Persönlichkeit des Künstlers auslöst. Er ist zugleich, von vornherein, auf Wunsch des Künstlers mehrsprachig angelegt, Ausdruck des Bewußtseins einer internationalen Kultur, von der das neue Deutschland weiterhin integraler Bestandteil sein wird.

Die Zustimmung des Künstlers und seine intensive Teilnahme an der Vorbereitung des Projektes wie auch des Kataloges war die Voraussetzung für das erhoffte Gelingen. Ihm gilt mein Dank in erster Linie. Die Realisierung des Projektes wurde ermöglicht durch Paiks bewährten Produzenten und Galeristen Carl Solway in Cincinnati und seine Mannschaft, durch Paiks langjährigen Galeristen Hans Meyer in Düsseldorf und durch die finanzielle Unterstützung, die Peter Hoenisch mit persönlichem Engagement bei RTL Deutschland erwirkt hat. Sehr hilfreich war die Vorschau, die Holly Solomon in ihrer New Yorker Galerie eingerichtet hat – gewissermaßen als Vorlauf für die Installation in Venedig. Ihr möchte ich

ebenso danken sowie Helge Achenbach in Düsseldorf für die spontane Bereitschaft, das Projekt zu unterstützen. Ohne den restlosen Einsatz meines Mitarbeiters Florian Matzner wären die Realisierung und der Katalog nicht möglich gewesen. Ihm gilt mein ausdrücklicher Dank ebenso wie Frau Petra Haufschild im Westfälischen Landesmuseum in Münster für die zusätzliche, außerordentlich belastende Schreibarbeit. Herrn Bernd Barde und der Druckerei Cantz in Stuttgart verdanken wir den vorliegenden Katalog, der aus den Mitteln der öffentlichen Gelder des Auswärtigen Amtes nicht hätte finanziert werden können. Danken möchte ich schließlich den vielen Freunden Nam June Paiks, die spontan unserer Einladung zur Mitarbeit gefolgt sind und damit die Sympathie bezeugen, die dem Künstler weltweit entgegengebracht wird.

To show Nam Jun Paik in the German pavilion of the Venice Biennial is not a matter of course. When I invited him, more than two years ago, to represent the Federal Republic of Germany together with Hans Haacke, he spontaneously answered: "It is a great honor for me to be in the German Pavilion" (he wrote this in English, though we mostly speak German together, a language which he speaks in a similarly unique and highly original way as he speaks English).

I think, it is an honor for the Federal Republic of Germany, and it is a good sign of the intellectual state of postwar Germany that the cosmopolitan and prophet of international electronic communication, Nam June Paik, can feel at home in the German pavilion.

He is Korean, mainly lives in New York (with a second home in Bad Kreuznach), he is a professor at the Düsseldorf art academy, and he is the "father of video art" – with a forming influence on several generations of young German video artists – an art form which, although it is not so new any more, has not been paid much attention to by the Venice Biennial.

Nam June Paik is, so to speak, an "honorary foreign worker" for the Federal Republic of Germany. He stands for the great number of foreigners, who after World War II as workers in the factories, as shopkeepers and traders, as artists and intellectuals contributed to the reconstruction of this country.

Paik's decision as a young man to go to Germany instead of Paris, and the consequences of this decision, are plausibly commented in Pierre Restany's contribution to this catalogue. Paik's role within the German and international Fluxus movement, his friendship with Joseph Beuys and many other German artists and students, and his knowledge and love of German culture should not hide the fact that he does not allow a single country to lay claim to him. He is a nomad and a cosmopolitan who always remains conscious of his cultural and social roots in Korea, but very early – maybe because of the historical situation of the divided country in which he grew up – he realized the problem of global interdependences. Though he pretends to be a layman in technical things, in fact he has proven an infallible instinct for the various possibilities of the new market as well as for the media-determined world civilization. Against this media world he holds his ground as an individual – also in his daily life – who does not allow machines and the media to possess him.

The catalogue at hand with a "bouquet" of personal dedications expresses the fascination that the artist's personality arouses. Printed in several languages – at the artist's request – it is at the same time an expression of the awareness of an international culture, of which Germany will continue to be an integral part.

The artist's consent and his intensive participation in the preparation of both the exhibition and the catalogue were the basic requirements for the hopefully successful outcome. In the first place, I am especially grateful to him. Paik's capable producer and galerist in Cincinnati, Carl Solway, and his staff, Paik's galerist for many years in Düsseldorf, Hans Meyer, and the financial support which Peter Hoenisch, due to his personal commitment, obtained from RTL Germany, made it possible to realize this project. Very helpful was the show which Holly Solomon organized in her gallery in New York – so to speak a preview of the installation in Venice. I would like to thank her, as well as Helge Achenbach in Düsseldorf for his spontaneous agreement to support the project. Without the total commitment of my assistant, Florian Matzner, the project as well as the catalogue could not have been realized.

Last 16th Century Painting, 1988
Courtesy Carl Solway Gallery, Cincinnati

First 21st Century Painting, 1988
Courtesy Carl Solway Gallery, Cincinnati

I am indebted to him, as well as to Ms Petra Haufschild in the Westfälisches Landesmuseum in Münster for additional, extremely laborious clerical work. To Mr. Bernd Barde and the Dr. Cantz'sche Druckerei in Stuttgart we owe the catalogue at hand, which could not have been financed with the public means of the State Department. Finally I want to extend my thanks to the many friends of Nam June Paik, who spontaneously accepted our invitation to contribute to this catalogue and thus testify to the high esteem in which the artist is held world-wide.

Esporre Nam June Paik nel padiglione tedesco della Biennale di Venezia non è un'ovvietà. Quando più di due anni fa l'invitai insieme ad Hans Haacke a rappresentare la Germania, Paik mi scrisse spontaneamente "it is a great honor for me to be in the German Pavillion" (in inglese, anche se ci parliamo principalmente in tedesco, lingua che lui parla allo stesso modo inconfondibile ed originale dell'inglese).

Che il cittadino del mondo e profeta della comunicazione elettronica internazionale Nam June Paik si possa sentire a casa propria nel padiglione tedesco, lo ritengo un onore per la Repubblica Federale, ed un buon segno per lo stato della Germania del secondo dopoguerra.

Nam June Paik è coreano, vive principalmente a New York (il suo secondo domicilio è a Bad Kreuznach) è professore all'Accademia d'Arte di Düsseldorf; "padre dell'arte video", ha esercitato una grande influenza su più generazioni di giovani artisti video tedeschi - un genere artistico non più tanto nuovo a cui però la Biennale fino ad ora aveva rivolto poca attenzione.

Nam June Paik è in un certo senso un "lavoratore - ospite - d'onore" della Germania Federale. Egli rappresenta quel gran numero di stranieri che dopo la seconda guerra mondiale hanno contribuito, come lavoratori nelle fabbriche, come commercianti e artigiani, come artisti ed intellettuali, a ricostruire il paese.

La decisione - e le conseguenze derivatene - del giovane Paik di venire nella Germania Federale invece che andare a Parigi, è commentata in modo chiarificatore nel contributo di Pierre Restany. Il suo ruolo nel movimento Fluxus tedesco ed internazionale, la sua amicizia con Josef Beuys e con tanti altri artisti e studenti tedeschi, la sua conoscenza ed il suo amore per la cultura tedesca non devono lasciar credere che egli si faccia identificare con un solo paese. Nam June Paik è un nomade ed un cosmopolita che è peró sempre rimasto cosciente delle sue radici culturali e civiche coreane, e che già molto presto, forse a causa della situazione storica del suo paese diviso in cui egli è cresciuto, ha riconosciuto il problema dell'interdipendenza globale. Anche se dice di non essere un esperto nel campo della tecnica, ha dato prova di grande intuito nel riconoscere le possibilità dei nuovi media elettronici e del loro significato sia per il mercato mondiale, che per la cultura che da questi viene influenzata. Nei confronti di questo mondo mediale Nam June Paik rimane - anche nel suo atteggiamento personale quotidiano - un individuo che non si lascia irretire dagli apparecchi e dai media.

Il presente catalogo con un bouquet di dediche personali è testimonianza del fascino che esercita la personalità di quest'artista. Questo catalogo, seguendo il desiderio dell'artista stesso, è stato fin dall'inizio pensato in più lingue, espressione della consapevolezza di una cultura internazionale di cui la nuova Germania continuerà ad essere parte integrante.

Il consenso dell'artista e la sua intensa partecipazione alla preparazione del progetto e del catalogo è stata la premessa per la loro riuscita. A lui va in prima linea il mio ringraziamento. La realizzazione del progetto è stata resa possibile dalla collaborazione del gallerista di Paik Carl Solway di Cincinnati e del suo gruppo di collaboratori, di Hans Meyer da anni gallerista di Paik a Düsseldorf, dall'appoggio finanziario che è stato reso possibile grazie all'impegno personale di Peter Hoenisch presso RTL Germania. Di grande aiute è stata l'"anteprima" offerta da Holly Solomon nella sua galleria di New York - in un certo senso un'anticipazione dell'istallazione di Venezia. A lei va il mio ringraziamento come anche ad

Helge Achenbach di Düsseldorf per la spontanea disponibilità a sostenere il progetto. Senza l'impegno totale del mio collaboratore Florian Matzner non ne sarebbe stata possibile la realizzazione nè il catalogo. A lui va il mio espresso ringraziamento come anche alla signora Petra Haufschild del Landesmuseum di Münster nella Westfalia per il lavoro di dattilografia estremamente pesante. Al signor Barde ed alla sua tipografia dobbiamo il presente catalogo che non sarebbe stato possibile realizzare con i mezzi pubblici del Ministero degli Esteri. Desidero infine ringraziare i tanti amici di Nam June Paik che hanno accettato spontaneamente il nostro invito a collaborare. La cerchia di coloro a cui si devono dei ringraziamenti è grande e testimonia la simpatia che in tutto il mondo viene sentita per quest'artista.

NAM JUNE PAIK
DE-COMPOSITION IN THE MEDIA ART

When we compare the film industry of the U.S. and Europe, one main difference is the power of the director. In Europe a distinguished director of the calibre of Godard or Herzog is a virtual dictator of his house. He decides the script, role casting and main scenes. However, in the U.S. even a well-known director is just a link in the chain, which starts with the share-holder, company president, vice president of production, producer and continues on to the casting-director and the union representative. A very critical character like Donald Duck was invented through a committee decision rather than by Mr. Disney himself. For better or worse, this is the prevalent reality and also a reason why Hollywood overwhelmed the European art movies.

Also in the world of science, the collaboration, often beyond the national border, is now a standard procedure rather than the exception. There are three classical examples which have intrigued me for years. Paul Erdös is an eminent mathematician born in Hungary in 1911, one year before John Cage. When John Cage's mother (a writer for the L.A. Times) bought a piano for John at the age of three, John climbed up on the keyboard while the piano movers were still bringing the piano into the living room, and he never quit playing or, unplaying until August 12, 1992. Likewise, Paul Erdös started spitting out mathematical numbers when he turned three and his parents (both mathematics teachers) noticed that they were mathematically important new numbers ... and unlike some wunderkind, who stops growing at some point of his life, this guy continued to spit out these original numbers well into his advanced age (I bet he is still alive in Budapest). And his ideas were so many and so new that he chooses collaborators around the world and he travels the whole year and his whole life around the world discussing the results he had and enjoying the privilege of free travel. His prestige in the mathematics field is such that there is the jargon of G1, G2 and G3. G1 are the mathematicians who worked directly with Paul Erdös himself; G2 are the mathematicians who worked with a guy who worked with Erdös; and G3 are the men who worked with G2. Einstein is reputed to be only G2.

Erdös suffers from some mysterious skin disease & he can tolerate only silk underwear. His mother traveled with him his whole life, and now his aunt does. He washes his silk underwear every night before he goes to bed. (Source: "The Atlantic Monthly", Nov. 1987.)

There is another mysterious Hungarian who was rather obscure until recently. Leo Szilard was a physicist living in Berlin in 1931. One day he was at the cross-section waiting for the traffic light to turn from red to green. Well, millions of people have this kind of experience millions of times in their lives. Suddenly (it seems) the red light turned green and Mr. Szilard put out a foot forward ... in this second the idea of a nuclear chain reaction came into his head. Sensing the dangers in pre-fascistic Germany, he crossed the Channel and from London he wrote his idea to Einstein, his old teacher in Berlin, and together they composed the famous letter to Roosevelt about the Atomic bomb. But when Szilard saw the first test-detonation in the desert of Nevada, he was horrified by his co-invention and became the ring leader of the "stop the bomb" movement before Hiroshima. He was fired from Los Alamos and his name was obscured until recently. Even after he left nuclear physics, he again invented a Nobel-class new theory about genetic biology, whose meaning hasn't become clear until just now ... 35 years after his death. Needless to say, for better or

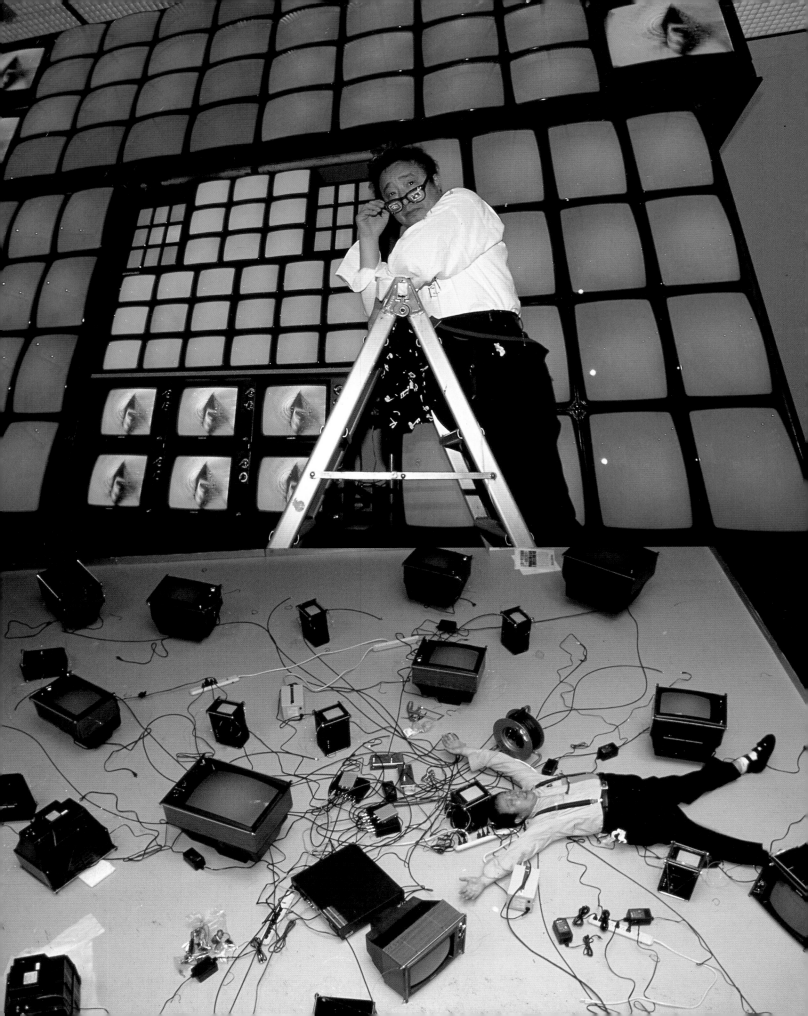

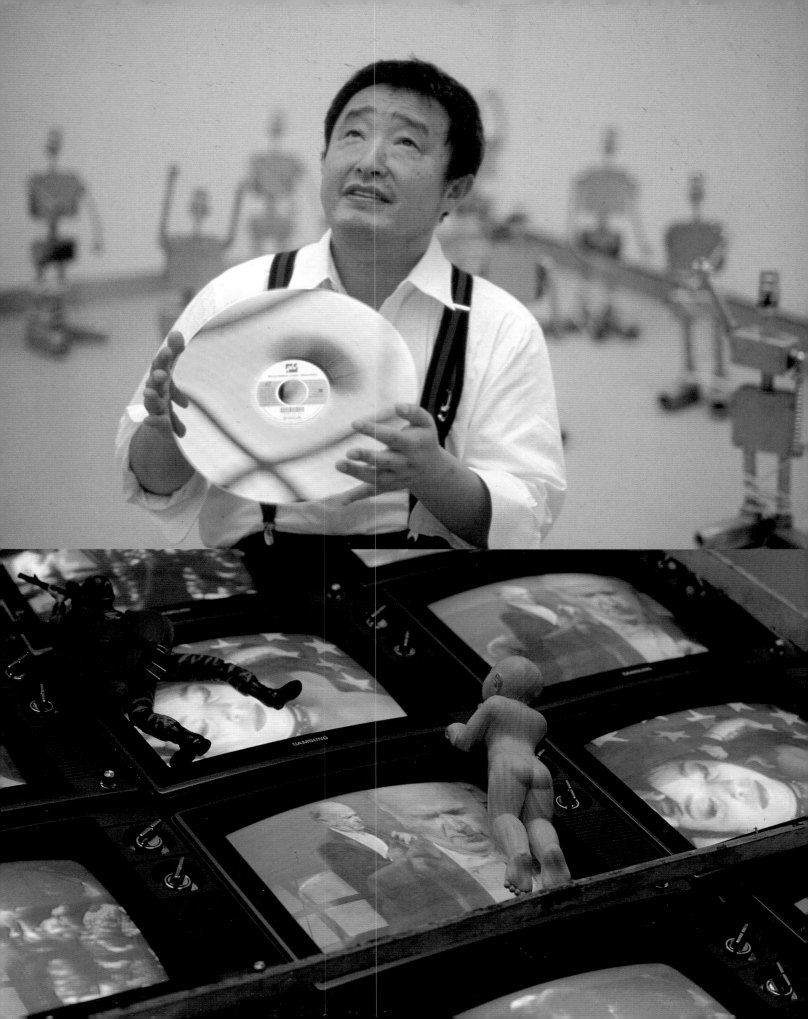

worse, Los Alamos has become the largest-scale example of scientific collaboration (with NASA). (Sources: "Discovery Magazine" published by TIME-LIFE a few years ago, and a new biography co-written by his brother ... details differ in the two versions.)

I don't share the genius with Szilard, but at least I share a bad habit with this man. We both take a long bath, which on some days can last two hours. It is the time for free association, or Twilight-Zone, where hidden drawers can be opened and closed.

The third guy is Norbert Wiener, a popular name. He not only co-invented the age of cybernetics but also was the first guy to warn of its consequences, like Leo Szilard. I'll bet that through it, like Wernher von Braun, regardless of the consequences and only later, he finds himself to be a small boy who burned down the whole house while playing with matches. Norbert Wiener, who first took a science degree at MIT, went to London to study Philosophy with Bertrand Russell; then, he analyzed the difference between Newtonian Time (repeatable) and Bergsonian Time (unrepeatable) and he developed the concept of time series by hurting & killing frogs in order to see how the animal's nerves would react to the continuing stimulus (largely negative) and applied this knowledge to the invention of radar. When he got shot at, a fighter pilot would react similarly to a frog who was punched and needled by a scientist. In any case, his research into radar was quite advanced at MIT before World War II when a fellow professor (a German mathematician) accepted the call from Hitler to return and take up an important position in pre-war Germany. Somebody high up at the Roosevelt White House was worried and asked Norbert Wiener: What if this mathematician leaks your experiment to the German armament industry? Wiener answered: "Don't worry, Sir. My system's thinking method is so very different from a German's ... My radar principle is based on such ambivalent, empirical, inductive, a-linear methods that Hitler, who thinks in straight logical terms would never put money in it." In any case, the Anglo-American radar system for which Wiener supplied the mathematical groundrules, became the key in turning the tide in both the European and Pacifics battlefields. (The London Blitz & Midway)

His contribution continues even to the Patriot missile. What a result a few dozen frogs who died in the torture chamber of this MIT professor brought in. George Maciunas, the chairman of Fluxus, confided to his Lithuanian poet friend Vyt Bakaitis that he would like to become a frog in his reincarnation. I hope he got caught by a French restaurant owner to be boiled and eaten quickly rather than be sold to MIT.

Norbert Wiener pioneered the idea of Mixed Media and interdisciplinary collaboration of many different sciences. Many of his academic papers are written with one or more co- authors ... This guy simply had the output of too many ideas to digest them all alone. When he died suddenly at Stockholm from a heart attack, he was well-immersed in the study of Chinese. I'll bet the Gestalt-like, wholeness concept of the Chinese idiogram interested Wiener, who grew up in the linear alphabetic culture. The consequences could have been interesting if he had lived another ten or twenty years.

The first collaborator I had was a teenager named Guenther Schmitz, whom I recruited at a Werkschule (equivalent to technical middle school) at Ubierring Cologne in 1962. He guided me through the discovery of horizontal and vertical deflection modulation and other techniques which became the scan-part of the video synthesizer later on. He told me to intercede with a picco con-

densor before I feed new sinewaves into the grid of a deflection tube. He also taught me how to survive an electro shock. Also, for the 1963 Wuppertal show (galerie Parnass Electronic Television and Exposition of Music) I credited the following names in the invitation flier:

P.S. Außerdem lernte ich von Mary Bauermeister den intensiven Gebrauch technischer Elemente, von Alison Knowls "cooking party", von J. Cage "prepared piano" etc. etc. etc. ... ∞, von Kiender die Verwendung von Spiegelfolien, von Klein "Monochromity", von Kopke "shutting event", von Maciunas "Parachute", von Patterson "Terminschaltung und Ansatz zur Elektronik", von Vostell die Verwendung von Stacheldraht und von Tomas Schmitt und Frank Trowbridge viele verschiedene Sachen bei unserer Zusammenarbeit.

In 1963 I met Shuya Abe and in 1964 Charlotte Moorman in New York (ref: Abe, "My Best Doctor" in the On the Wing publication, Yokohama 1991, 1992 reprint at Edith Decker in Dumont book 1992.)

It was in February 1977 when I paid a fortune to rent Carnegie Hall to do the 10th anniversary concert of the 1967 topless opera arrest. I prepared an evening-filling new opera. Then, one day before the concert Charlotte appeared at my Canal Street loft and told me she would start with the Third Aria of the original Topless Opera which was not played because we were both by then in the police wagon. However, in ten years times changed and in this new era of permissiveness the original version would neither shock nor soothe in any artistic way. I insisted on playing the new work but to no avail. I protested that even Mozart cannot write a new opera in one day ... in any case I complied ... and the result?

In any case Charlotte re-awakened my interest in the performing arts which I thought I terminated in 1962. I cannot thank her enough for this beautiful persuasion. My collaborating career turned a fateful point in 1967 at WGBH TV Boston. Until then in any collaborative case, I kept the upper hand. However, facing the enormous bureaucratic and equipment wall of broadcast television, I became powerless. With the given budget, I had half a day shooting schedule, which includes a union coffee break every 45 minutes, and another half day in the editing which meant in the 1967's antiquated stage only 16 cuts. I was supposed to create a master work, which had never been seen in the entire billion $ history of film and TV.

In the making of "The Medium", devotedly produced by two rich socialite ladies, Ann Gresser and Pat Marx (the latter soon after married Daniel Ellsberg of the Pentagon Papers), I was in a complete panic. So I told Fred Barzyk and David Atwood: "I am not here, do whatever you want. In any case I don't know anything about it"... and 10 and behold Fred and David made a 5 minute masterpiece, from which I was able to get two years of Rockefeller residency and invite Shuya Abe to design and manufacture the Video Synthesizer in Boston. I still wonder, since Barzyk and Atwood were such good artists, why didn't they produce something equally good before I came to WGBH Boston. Certainly my input was less than 40%.

In 1972 I moved to WNET and by then I was supposed to be a techno-art genius, but I could not even serve the simple two banks keyer-mixer and I never even played the so-called Paik Abe Video Synthesizer which I was supposed to have invented. When the Big Day for the Gloval Groove arrived, I had to bribe John Godfrey, the super engineer: "Please, do whatever you want, I am here

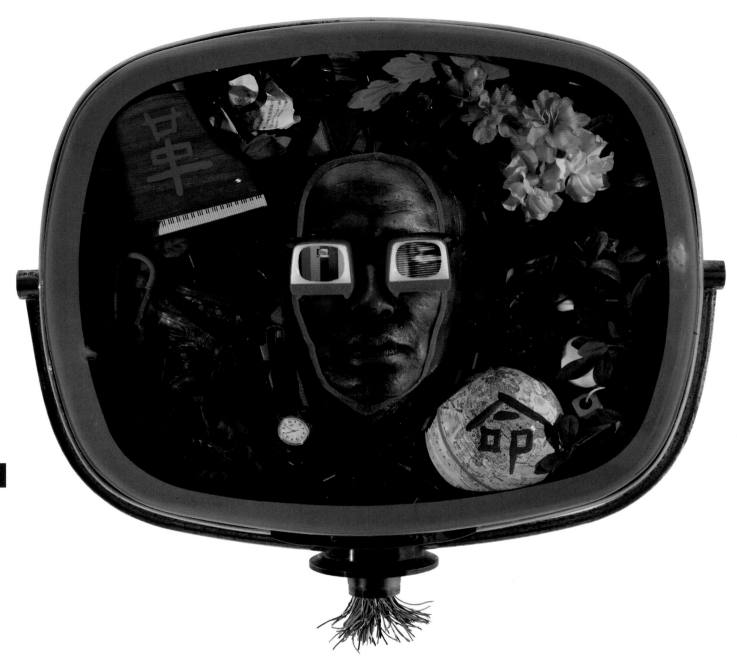

Self-Portrait, 1989

but I am not here. It is your ball game. You will be the 50-50 co-author and you will get 50% revenue from all income." He switched back and forth both my Paik Abe videosynthesizer and newly invented grassvalley switcher with downstream keyers. Often 1 plus 1 is 1.2 or even 0.8 but in this case one plus one became 100 ... like the case of Cage-Cunningham's collaboration. In any case I got through the pinch, and there are some sections in the Global Groove, which after 20 years I still cannot figure out how John Godfrey made it. I still have not paid 50% royalty to him. I will do it this autumn by making five large paintings. I promise.

Needless to say, in the three large scale satellite live shows, "Good Morning, Mr. Orwell", 1984, "Bye Bye Kipling", 1986 & "Wrap Around The World", 1988, my share was for better or worse maybe 30% of the whole piece. I did get the full share of credit or blame. The tragi-comedy was Squeeze zoom. The whole New York/Paris show was conceived on the 2 channel squeeze zoom.

There was a French specialist in the transmission booth. But he thought I was an expert. He did not know I was a techno-idiot. He left the mixing booth out of reverence to me just before the transmission went live before 40 million viewers in Europe, the U.S., Canada and Korea. My French was too limited to get him back and the live show started. I was still only 52 years old, which alone spared me a heart attack. In all three shows the control room was more interesting than the show itself. Who was in charge ??? Whose show was it ??? I don't know. I will do my last live TV show in the year 1999, December 31. Id' better stay healthy.

Luckily Paul Garrin came to me in 1982 after I finished the preparation for the Whitney show. Otherwise he would have claimed my Whitney show, too. At least I did that show on my own. Shigeko found him at Anthology Film Archives for one dollar & twenty-five cents per hour. I gave him the job of repairing my shoes. He did that rather well. Then I discovered that this 25 year old Cooper Union student has a strange talent. He would buy a junked car for 75 dollars and repair it and run it for three years and sell it for $ 300. WNET's super engineer John Godfrey has the same trait. He would buy an old Rolls Royce Silverghost for $ 7,000 and recondition it and rent it out to the movie industry. Once Ruth Bonomo-Godfrey drove Woody Allan in it. He later sold it for $ 50,000. In this way Godfrey collected 6 Rolls Royces and bought a big mansion with the 6 unused horse stables in Connecticut and became the first millionaire from Experimental TV.

"Adio"

Anyway my collaboration with Paul Garrin is like an improvisation of a 4 man Jazz ensemble. The first tenor is a digital effect generator ... "Adio" – "Mirage" – "Kaleidoscope" – "Harry" etc. ... Those high speed analogue image catchers are spin offs from the missile tracking industry and they often come from manufacturers who also service the large missile bases in England and Canada. Without the dual use of military and civilian, nobody would foot the enormous development cost which becomes outdated every four years.

If the first tenor is a new machine, the first soprano is Paul Garrin, a guy who is at least 200 times faster than me in those machines. That means in the first $ 1,000 dollars-a-hour machine time expense he can produce 200 times more than me. The first alto is the house engineer at Broadway Video or Post perfect, who knows machines very well, yet he did not have the chance to use his fantasy and has been compelled to produce the standard commercial usage. These guys are frustrated pilots who are forced to fly an F16 with the good old zero fighter speed. They collaborate well and produce stunning effects. Jonathan Howard and Mr. Applebaum produced something which we cannot reproduce even after 6 years. Those star editors are the test pilots of Wright brothers days. They lead the industry. What is my role?? This old man is nothing but a cheerleader who brings in fat cheesecakes at midnight and diet soda with double espresso at 3 AM.

From 1987, we turned to the digital video. The first one was the 3F technik of Freiburg im Breisgau. The rental fee was 1,000 DM for one day and for the 100 days of Documenta, Dr. Schneckenburger and I had to cough up 100,000 DM.

From the 1989 Whitney Museum's "Image World" on, we were able to work with Sinsung Electronics in Seoul who provided us with not only inexpensive hardware but also imaginative programmings. Oh Seh Hun, Lee Jung Sung, and Cho Sung Ku initiated further digital switching devices.

In the digital imagemaking, my thanks first go to Rebecca Allen (U.C.L.A.), who supplied me with the Kraftwerke Computer graphics, which is the result of one and a half years of full time manual and intellectual slave work. This tape gave me the decisive edge at the Imageworld show at the Whitney. Even though I would sometimes receive the full credit instead of her, she suffered gracefully. However, of more enduring importance is that three leading computer graphic artists of our age: Hans Donner, Judson Rosebusch, and Dean Winkler also gave me permission to use their software for no money. This is equal to about a $ 5 million dollar bonanza. This happens only because I live in New York.

My laser works are actually not my laser works. This is 50% Horst Bauman, 30% Paul Earl (MIT's center for advanced visual study). My input is that I chose the cartoon-like figures of Cunningham. Maybe next time we will simply use Donald Duck. I wonder what my new laser collaborator, Norman Ballard, brings to me.

In Cincinnati we have a Hollywood kind of structure. Our Cecil De Mille is Carl Solway. I am Hitchcock, Marc Patsfall is the casting director (unsung hero in Hollywood or Cincinnati) ... and our stars include Lizzi (Rita Haywarth), Marcello (a cross between Audrey & Katharine Hepburn, Bryant (Brando), Bill (Clark Gable), Chris (H. Bogard ?), Curt (James Mason), and Steve (de Niro). Media art is too complex to be controlled by one man, and in New York and the Düsseldorf side Jochen Saueracker, John McEvers, John Huffman, Glen Downing, Blair Thurman and Thomas Countey played equally important roles both in craft test and even in generating new ideas.

Last but not least important ... Shigeko Kubota. During long and frequent conversations, it is hard to distinguish who said which idea first. Therefore we made a demarcation line in a priori ... she owns Marcel Duchamp, John Cage in Bremen, Glass, plastic mirror, water and the concept of death. I try not to transgress this line. The world is big enough for two video artists.

P.S. Recently Ulrike Oettinger gave me permission to use her three hour epic "Joan of Arc of Mongolia" and I thank 100 famous performing artists with whom I worked for the last 15 TV shows. They are recycled in many museum installations. I have to pay them some day.

Edited by Alan Marlis.

YONGWOO LEE
NAM JUNE PAIK'S TEENAGE YEARS

Nam June Paik's extensive body of work has come under scrutiny from a variety of points of view, but little consideration has been given to how his artistic sensibility was formed and to how he spent his teenage years, a critically important period for artists. A great deal has been written about the fruit of Nam June Paik's art, but the development of his artistic sensibility has been woefully neglected. Nam June Paik's résumé begins with his birth in Korea, his graduation from Tokyo University, and his voyage to Germany for further musical training. The artistic sensibilities he developed in his teenage years in Korea before he entered Tokyo University are the roots of his art today; these formative years, amazingly, have continued to flow through his art to this day. Nam June Paik is not a chauvinist or nationalist, and he is considered to be an artist who, in the jargon of art, has the power to attract the interest

of the general public. His public appeal comes from the unique talent that he developed in his teenage years, and it is the result of channeling his original vision and ideas into his art.

The landmark event of Nam June Paik's teenage years was his discovery of the music of Arnold Schönberg. In 1947, Schönberg's music opened Nam June Paik's eyes to new possibilities when Paik was a sixteen-year-old student at Kyunggi High School, one of the most elite high schools in Korea at the time. Nam June Paik found out about Schönberg through Japanese recordings, and he became fascinated by atonal music and the 12 note tone scale, both of which were virtually unknown in Asia at that time. Paik's discovery of Schönberg is astounding for the times because Korea had just come out from under 36 years of harsh Japanese colonial rule with the end of the second world war. For Nam June Paik, however, Schönberg's music was the key to opening a new world in music and art. When Schönberg converted to Judaism, Nam June Paik was baptized in new music and was preparing to make his jump into that new world.

Two Korean music teachers were behind Nam June Paik's discovery of Schönberg: pianist Jae-duk Shin and composer Keun-woo Lee. As Nam June Paik's music teachers, Shin and Lee found artistic disposition and, indeed, genius in their young student, and they encouraged Paik to develop a vivid imagination and technical ability. Nam June Paik met Jae-duk Shin when he became a student at Kyunggi High School, and he acquired a strong base in music composition from piano to vocal music. In addition, Keun-woo Lee, a composer who was fascinated by contemporary music at that time, challenged Paik in this new territory of musical composition. Nam June Paik's first composition appeared in 1946, two years after he had become acquainted with these two mentors. This composition has been lost, but Paik remembers the title as "My Elegy", and he remembers only two syllables. Written between 1947 and 1948, the second composition puts the poem "A Song – Nostalgia" by a left wing poet of the time, Pyeok-am Cho, to music in four syllables. "A Song – Nostalgia" is a lyric poem that creates a strong image of the poet's hometown.

> If only darkness fell, this lonely journey would go by as
> Water flows through the gills of fish. Today, reflected in
> The window of the train my loneliness and melancholy.
> Like a fallen down new calf, searching, ever nervous,
> I keep longing for home, a foggy village, a dark cozy
> village.
> A warm bird's nest, let me fly in and root myself.

This composition was lost in the Korean war, but Nam June Paik has been able to reconstruct the score from memory. In addition, Paik set poems by a close friend and classmate of his at Kyunggi High School, Young-hun Jin, to music, but they too have been lost. Young-hun Jin believes that Paik put three of his poems to music, and he remembers that, although they were written in a popular style, they retained distinctly avant-garde characteristics.

In the 1940s, Korea emerged from 36 years of Japanese colonial rule, and with the liberation, the ideological conflict between the Left and the Right intensified amidst increasing social chaos. Nam June Paik was influenced by leftist ideas that were circulating in intellectual circles at the time. In his teenage years, Paik's mind was absorbed in his respect for Sun-nam Kim, a left wing composer, and for Jae-duk Shin and Keun-woo Lee; in the stimulation of discovering new music that had begun with Schönberg; and in reading books about Marxism that he found in antiquarian book

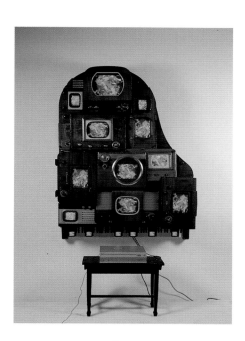

My Life has been on Trip, 1990

Courtesy Carl Solway Gallery, Cincinnati

stores in Insa-dong, the antique and art center of Seoul. Karl Marx and Schönberg were Nam June Paik's idols, but his contact with his two mentors, Jae-duk Shin and Keun-woo Lee, was his reality. It is not important how much Paik was able to understand and appreciate Schönberg's music, but it is clear that Paik was stongly attracted to atonal music that had developed from late-Romanticism to the string quartet form. The 12 note scale was coming to the fore at that time, and the almost total lack of repetition in atonal music must have been curious and exciting for Nam June Paik. Even now, Paik understands Schönberg's music only partially, and he feels great success in being able to play Schönberg. More than being in awe of Schönberg, Paik is referring to his own "nostalgia for home" by using Schönberg as a metaphor for the variation on a theme found in contemporary music and Fluxus and video art and the reflected image. In his first show at the Parnasse Gallery in Wuppertal, Germany, Random Access reflected Schönberg's Structural Functions of Harmony. Among the various forms of musical composition, the 12 note scale reminds one most of the free flow of the human consciousness. If Nam June Paik had not gone to Hong Kong in 1949, he probably would have had a deeper understanding of Schönberg. Nam June Paik's teenage years in Korea came to an end, in fact, when he left for the Loyden School in Hong Kong, and when he returned to Korea in 1950, he was not able to make progress in his artistic career because of the outbreak of the Korean war.

Nam June Paik comes from a very wealthy family, the owners of a large textile company, Taechang Textile Co., founded during the Japanese colonial period. Paik is the youngest of five children, and he received the best education available at the time by attending elite schools from kindergarten through high school. He received Japanese-style aducation during his childhood and until his early teenage years, but at the age of fourteen, he began to show his interest and talent in art in the feverish atmosphere of post-liberation Korea. The five years from the ages of fourteen to eighteen have weighed heavily on Nam June Paik, and they have nurtured much of his art since. Many things in his art recall those years: Asian sensibilities that appear as wit and jest in the eyes of people in the West, the allusions to the Asian philosophy of mindful living away from the woes of daily-life, and the native Korean items and symbols.

In Nam June Paik's 1991 work, Two Teachers, explanations of Jae-duk Shin and John Cage are included in the work. Paik recalls Jae-duk Shin jumorously, "When Mrs. Shin played the zither (yanggeum), I would drool ...". "Cage means 'bird cage' in English, but he didn't lock me up; he liberated me", Paik says of John Cage. In this work, Paik returns to the sensibilities of his teenage years and creates an image in a video sculpture of the relationship between language and karma.

Nam June Paik's discovery of Schönberg overlaps with his receiving tuition from Jae-duk Shin (1946–1950) and Keun-wo Lee (1947–1949) – this means that the beginnings of Paik's art are concentrated mainly in music. The importance of the two Korean mentors is clear in Paik's discovery of and exposure to the chaotic works of Schönberg one year earlier than Milton Babbit. Jae-duk Shin and Keun-woo Lee were both musicians at the beginning of the 1930s. Shin became the first professional pianist in Korea, and she later served as dean of the College of Music at Ewha Women's University in Seoul. She died in 1989. Keun-woo Lee, along with Sun-nam Kim, imported avant-garde music from over-

TV Chair, 1968
Whitney Museum of American Art, New York

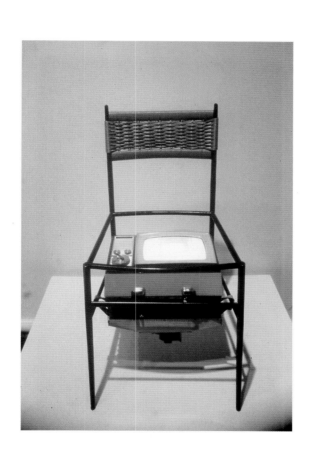

seas before anyone else, and they were very protective of contemporary music. Paik was very fortunate to have had these two mentors. Shin and Lee received their education during the Japanese colonial period, but they went on to become leaders in the field of "national music" education. Sun-nam Kim, whom Nam June Paik had never met, was an outstanding composer, equal to any composer in Japan at the time, and he influenced Yisang Yun, an active Korean-born composer in Berlin.

Paik's discovery of Schönberg one year earlier than Milton Babbit, a leading authority on Schönberg at Princeton University, shows that artistic awareness and artistic freedom existed in Korea in the turmoil of 1947.

Nam June Paik went to Japan and learned composition from Nomura Yoshio, Moroi Saburo, and Shikaishi Aki-O. His real interest, however, was in Schönberg as an "extension of Korea", and he graduated from Tokyo University with a graduation thesis entitled Research on Arnold Schönberg.

(Translated by Robert J. Fouser)

Anti-Gravity Study, 1976
Walker Art Center, Minneapolis

PIERRE RESTANY
NAM JUNE PAIK ET LE RENOUVEAU CULTUREL ALLEMAND DES ANNEES 50

Nam June Paik est arrivé en Allemagne en 1956. Il avait 24 ans. Il avait quitté Seoul avec sa famille en 1950 au moment de la guerre de Corée et après un bref séjour à Hong-Kong, il avait fait des études d'esthétique et d'histoire de la musique à l'université de Tokyo, couronnées par une thèse de B.A. sur Arnold Schönberg.

Le jeune musicologue débarque en Europe en passant par Calcutta et Le Caire pour trouver une Allemagne de l'Ouest en plein élan de reconstruction et de fermentation créative. La première chose qui le frappe après avoir vécu à Tokyo, c'est l'absence de centre et l'extrême dissémination de la vie culturelle. "J'étudiais à Munich", dira-t-il à Gottfried Michael Konig en 1959, et à bien d'autres encore par la suite – "et, passionné de "Neue Musik", j'entendais dire qu'il se passait des tas de choses aux "Ferienkurse" de Darmstadt, à l'école de musique de Fribourg, au studio de musique de Fribourg, au studio de musique électronique de Cologne, dans les galeries de Düsseldorf ..."

Cette large décentralisation culturelle, liée à une osmose entre la "Neue Musik" et l'art d'avant-garde, créa un climat extrêmement propice à l'épanouissement de la personnalité de Nam June Paik. Ses continus déplacements dans les centres d'art du bassin de la Ruhr firent de lui une fois pour toutes un perpétuel errant, un homme de partout et de nulle part, mais qui sait être là quand il faut. Et aujourd'hui, bien qu'il vive à New York, qu'il ait repris des contacts suivis avec le Japon et la Corée, et qu'il sillonne le monde dans tous les sens, il demeure attaché à son poste de professeur à l'académie des Beaux-Arts de Düsseldorf, où l'avait appelé le sculpteur Kricke lorsqu'il était directeur de l'établissement. Les méthodes d'enseignement de Nam June Paik ne sont certes pas orthodoxes, mais les élèves raffolent de leur professeur errant, et le lien scolaire, outre qu'il atteste son attachement au terroir rhénan, le rassure socialement: "J'aime bien retourner régulièrement dans un pays où les gens trouvent normal de m'appeler "professeur Paik", a-t-il répondu récemment à Otto Piene qui lui demandait où il en était de son enseignement à la Kunstakademie.

L'événement déterminant pour Nam June Paik a été sa rencontre

avec K.H. Stockhausen aux "Internationale Ferienkurse für Neue Musik" à Darmstadt en 1957. Avec Stockhausen, c'est la perspective d'un espace neuf, à la fois créatif et existentiel, qui s'ouvre devant lui: expérimentation électronique, rapport "objectif" avec l'instrument, contacts avec l'art d'avant-garde ... Ce monde deviendra naturellement le sien. Il s'installera en 1958 à Cologne, Aachenerstrasse, à proximité de Stockhausen, mais aussi de l'artiste Mary Bauermeister, la femme de Stockhausen à l'époque, et dont le studio abritera plusieurs performances de Nam June Paik. Et puis Cologne c'est le studio de musique électronique du WDR, où il pourra aller travailler, c'est aussi la galerie Lauhus, où Christo exposera ses monuments temporaires de bidons en 1961, et où lui-même s'associera aux "performances spontanées" de Wolf Vostell et de Stefan Wewerka.

Nam June Paik développe ainsi, au contact de ce microcosme expérimental allemand une sorte de personnalité Pré-Fluxus basée sur une propension innée aux dépassements de l'orthodoxie des genres d'expression, sur une vision naturellement "expansive" des arts et quand il rencontrera en 1961 George Maciunas, son adhésion à l'esprit de Fluxus-New York sera la sanction d'une pure évidence.

Entre temps il a fait la connaissance, toujours aux "Ferienkurse" de Darmstadt en 1958 de John Cage et de David Tudor. Le jeune gourou a trouvé son maître. Il exprime sa jubilation dans des articles enflammés qu'il envoie de Cologne à des revues japonaises et coréennes. Les titres parlent d'eux-mêmes: "The Bauhaus of Music", "The Music of 20,5 century". La Rhénanie est devenue son

Charlotte Moorman and Nam June Paik with Robot K 456, 1964
Photo Peter Moore

28

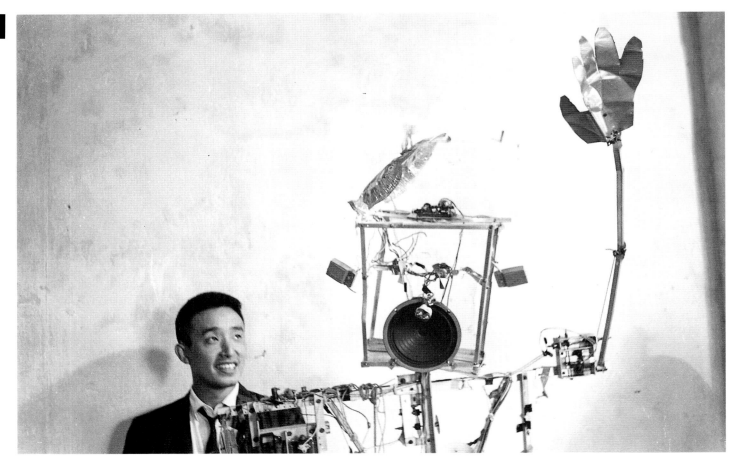

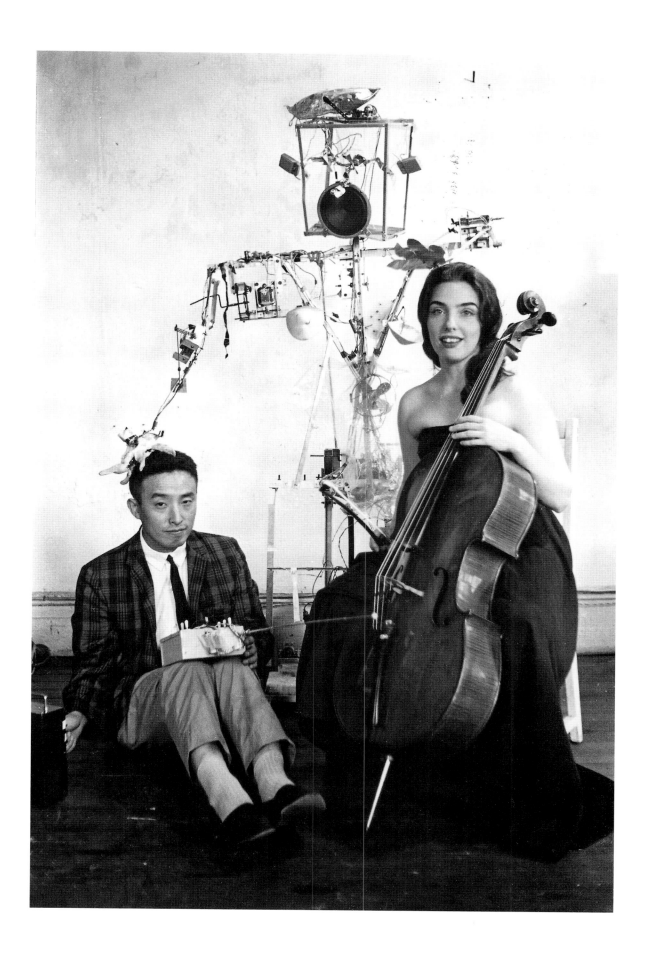

Bauhaus de création musicale. La Galerie 22 (Kaiserstraße 22) à Düsseldorf est dirigée par Jean-Pierre Wilhelm qui en a fait un véritable pont culturel entre Paris, Düsseldorf et Milan. Comme beaucoup d'intellectuels de l'époque, à commencer par son ami et associé Manfred de la Motte, il partage sa passion entre l'informel et la "Neue Musik". A l'occasion du vernissage d'Horst-Egon Kalinowski, J.P. Wilhelm ouvre ses portes à Nam June Paik qui exécutera son premier hommage à John Cage, "Musik für Tonbänder und Klavier". Cet hommage est à vrai dire un manifeste stylistique, le modèle des performances à venir: un montage d'actions et d'objets, un collage de gestes et de sons dont la musique est le catalyseur physique ou le discriminant algébrique. Tous les gens qui comme moi ont connu Nam June Paik à cette occasion ont été frappés par la tension fervente qui émanait de l'artiste durant l'action. Nam June Paik avait trouvé son propre langage, il s'exprimait à travers un total engagement dans le vécu. L'hommage à John Cage sera répété, avec quelques variantes à Cologne en 1960,

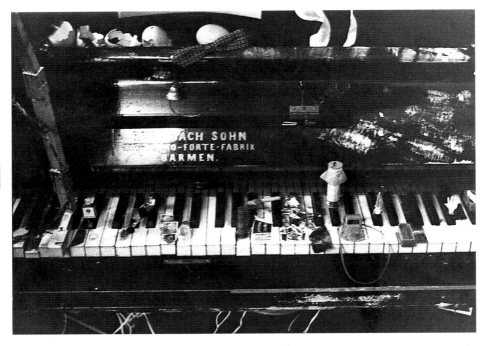

Galerie Parnass, Wuppertal 1963

dans l'atelier de Mary Baumeister, intégré dans un programme itinérant "d'aktion music" en Scandinavie en 1961, et dans le festival Fluxus de Wiesbaden en 1962. De 1961 à 1963 Nam June Paik participe aux côtés de Maciunas et avec la bénédiction de Cage à l'osmose germanique de la mouvance Fluxus new-korkaise. Stockhausen lui offrira un espace autonome, "Zen for Head", dans sa manifestation "Originale" au Domtheater de Cologne (26.10.– 6. 11. 1991). Il intégrera la musique de La Monte Young dans sa participation à "Néo-Dada in der Musik" à Düsseldorf en 1962. 1962 est aussi pour Nam June Paik l'année Alisaon Knowles! Il lui dédie une sérénade, jouée à Amsterdam, et un article dithyrambique dans la revue "Dé-coll/age" de Vostell dont il est un collaborateur permanent jusqu'en 1964.

Le point d'aboutissement, l'apothéose de la période allemande est l'exposition de 1963 à la galerie Parnass de Wuppertal, au mois de mars: "Exposition of Music-electronic television", véritable panorama-collage de l'expressivité de cet "action-musicist" qu'est Nam June Paik. Rolf Jährling, un architecte, était le directeur de la gale-

rie qui, dès 1951, avait entrepris un programme d'échanges internationaux basés sur l'Ecole de Paris. En 1963 il fait figure de tsar des pionniers: la 1ère Documenta a eu lieu à Kassel en 1955, la galerie Schmela a ouvert en 1960 à Düsseldorf avec le bleu d'Yves Klein, Jährling est le président moral du club des galeries activistes dont les deux membres les plus influents sont la Galerie 22 de Düsseldorf et la galerie Vertiko de Bonn. Le fait de donner carte blanche à Nam June Paik équivaut à une consécration pure et simple sur la scène créative allemande. Thomas Schmit, qui fut à fois témoin et acteur de l'opération en fut très conscient à l'époque. Maciunas aussi: il avait déjà participé, avec Paik et Patterson à une "Kleines Sommerfest" à la galerie Parnass en 1962. Relayée par tous les circuits Fluxus internationaux, la résonance de l' "Exposition of Music" se propagea au sein de toute l'avant-garde mondiale.

Nam June Paik pouvait désormais retourner au Japon, puis aller s'installer à New York dès 1964. Le microcosme culturel ouest-allemand des années 50 l'avait lancé: il était arrivé en 1956, au juste moment, en plein ferment d'expérimentation artistico-musicale dans une Rhénanie en total renouveau, qui vivait avec la fin de l'informel et l'émergence du Nouveau Réalisme, l'apparition de Fluxus bien avant le Pop Art. Son destin, dès lors, est tracé: le robot avec Shuya Abe au Japon, la rencontre avec Charlotte Moorman à New York, l'emploi de la première camera vidéo port-a-pack en 1965 ... et nous ne sommes qu'en 1965!

Old Robot, 1963

JOHN CANADAY
ART: THE ELECTRONICS-KINETICS TREND. PAIK'S TV SETS ON VIEW AT GALERIA BONINO

Once we get Christmas behind us, we must get around to thinking about what is going to be new next season, since people keep asking. The current season has pretty definitely identified itself with electronic and kinetic art. This is a relief, really, since at the end of last season, it was looking as if this was to be the Year of the Dirty Picture. Obstreperously sexed nudes of both genders were popping up in so many galleries that for a while you could hardly tell whether you were in one of Madison Avenue's cultural temples or in a hideaway given over to the performance of some pagan cult's initiation rites.

Two current gallery shows exemplify the season's electronic-kinetic trend. At the Albert Loeb Gallery, 12 East 57th Street (until Dec. 20), the German artist Harry Kramer is having his first one-man exhibition in the United States. He calls his wire constructions "automobile sculptures", meaning self-powered rather than referring to the Detroit chariots. And at the Galeria Bonino, 7 West 57th Street, there is an exhibition by a young Korean, Nam June Paik, who seems to be the John Cage of the ordinary domestic TV set. Perhaps he had better be taken up first.

Mr. Paik is exhibiting a dozen or so TV sets, each one violated by its own electronic attachment to deform the image beyond anything you can imagine, no matter how bad your reception is. Mr. Paik is in constant attendance at his show, to demonstrate the operation of these attachments. The images he produces are occasionally recognizable as weird distortions of whatever program is (so to speak) coming through. But in most cases the screen becomes a field of operation for totally abstract images, in motion,

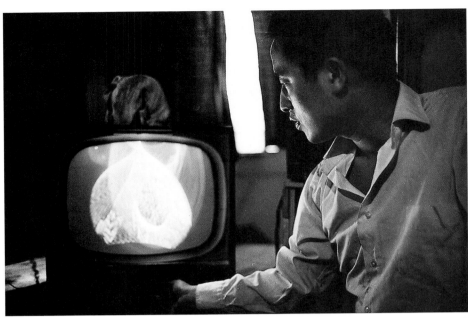

Electro-Magnet TV, 1965
Photo Peter Moore

composed sometimes of wonderfully organized lines of light, and sometimes of curious hazy, flowing shapes. They are accompanied by titles with "in" references, such as the pseudo-equations illustrated here. (Mr. Paik does manage, however, to misspell the name of Marshall McLuhan, philosopher of things modern.)

The TV sets can be "played" as one would play a musical instrument if music were light – although possibly Mr. Paik has not yet quite brought his electronic art to a level comparable to any music except John Cage's. Mr. Cage has written an introduction to the catalogue, in which he performs a stunt or two with the English language as well.

As an experiment in a new medium, the exhibition has unquestioned fascination and a probable potential for expansion. Mr. Paik is also exhibiting a life-size robot that walks, waves its arms and excretes dried beans; but the TV sets are the real show.

(published in: The New York Times, December 4, 1965)

TV Garden, 1974–78
Whitney Museum of American Art,
New York 1982

Participation TV, 1965
Photo Peter Moore

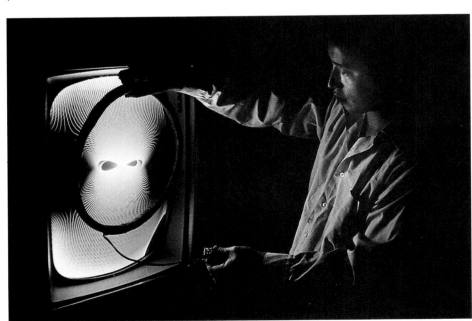

The only time anyone has ever seen Paik seriously depressed was in February of 1967, when the police stopped the performance of his new "Opera Sextronique". Paik had been a little nervous about doing this piece in New York. He and Miss Moorman had performed it without incident in Aachen the preceding July, and then in January at the Philadelphia College of Art, but New York was at that time in the grip of one of its rare public morality seizures, and the police were abnormally alert to vice. "Opera Sextronique" has four "arias", or acts. In the first, Miss Moorman, wearing a bikini consisting of small electric light bulbs, plays the cello on a darkest stage; in the second, she wears a topless evening gown, plays the cello, and puts on and takes off a succession of grotesque masks; the third aria has her nude from the waist down and clothed in a football uniform and helmed above; in the fourth, she is totally nude, playing, in lieu of her cello a large, upright aerial bomb. The New York performance, at the Film-Maker's Cinémathèque, on West Fortyfirst Street, was interrupted by a police squadron at the end of the second (topless) aria, and Miss Moorman and Paik were carted off to jail. Miss Moorman retains a vivid memory of Paik sitting for his police photography with a number hung around his neck and saying mournfully, "Oh, Charlotte, I never think it come to this".

Later that night, in jail, Paik remembers, he felt very calm – "like the last scene in Stendhal's 'Rouge et Noir', when Julien Sorel is so much at peace", he says. "I thought that when I got kicked out of United States I would be hero in Germany. I was happy things were ending here – all the complicated life. Well, we were released on parole next day, and a guy called from San Francisco offering us five thousand dollars to do our 'act' in a night club. We had many offers like that." They accepted none of the offers, and Paik was hard pressed to raise money for their defense. His lawyer was Ernst Rosenberger, who had represented Lenny Bruce and other prominent performers. When the case came to court, in April of 1967, Rosenberger had no difficulty persuading the court that under no law could a composer of music be arrested for obscenity, but Miss Moorman was less fortunate. Although the flower of New York's avant-garde came to testify on her behalf – and in spite of the fact that nudity was rapidly becoming the obligatory scene in the New York theatre – she was convicted on a charge of indecent exposure and given a suspended sentence.

The conviction, according to Miss Moorman, caused her grandmother in Little Rock to suffer a heart attack, and ended her own career with the American Symphony and as a musician for TV commercials, which had until then been her main means of support. Lucrative offers to repeat the "act" in Las Vegas and elsewhere only made her feel worse about it all. Paik, too, was at a low ebb. He had been receiving small amounts of money from his family in Tokyo, but now they ceased to arrive; the family, he says, "had just lost another fortune". He owed a rather large bill to Consolidated Edison, which he couldn't pay, and he was having visa problems. It was with some relief, then, that he accepted a post as artist-in-residence at the State University of New York at Stony Brook, Long Island. Allan Kaprow, who was trying to establish a sort of avant-garde institute at Stony Brook with funds from the Rockefeller Foundation, had been instrumental in getting the assistent director of the Foundation's arts program, Howard Klein, to visit Paik's studio, and Klein and his boss, Norman Lloyd, had subsequently arranged a one-year appointment to Stony Brook for Paik. Nobody bothered him there, so he spent his time doing video

Charlotte Moorman performing
Nam June Paik's "Concerto for TV Cello and
Videotapes", Galeria Bonino, New York
December 1971
Photo Peter Moore

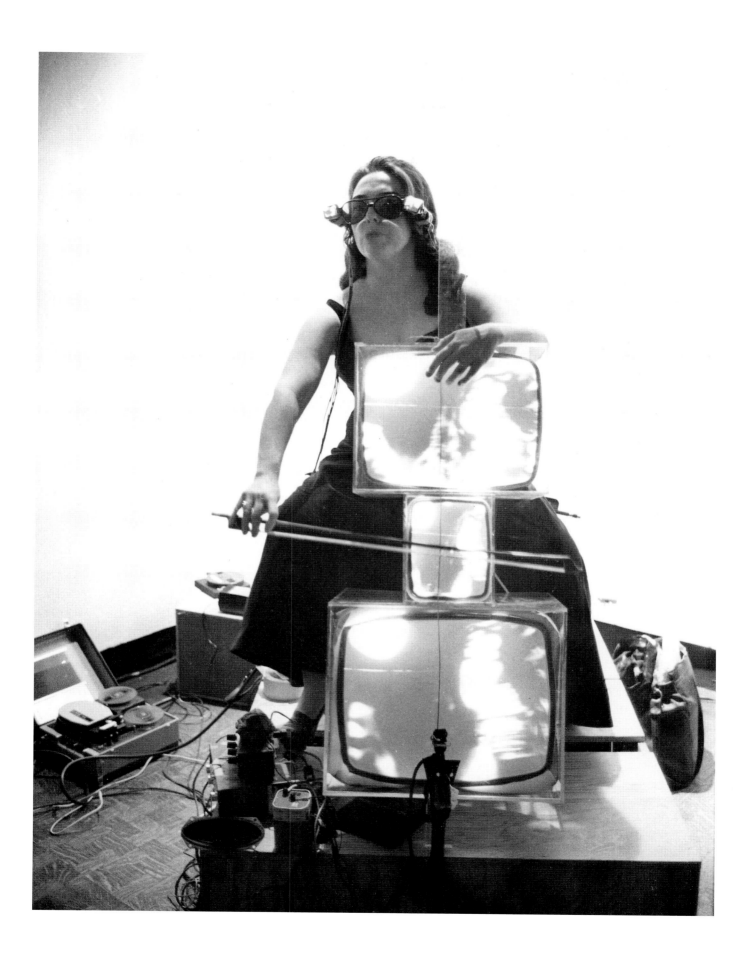

experiments and writing a long report on the uses of television in the "instant global university" of the future. One of his recommendations was that television stop being exclusively nationalistic. "You simply cannot escape Camus or Sartre in a bookstore", he wrote. "But do you remember seeing a production of French TV recently?"

(. . .)

Paik, of course, has had his problems in dealing with the establishment. "Only reason I survived this long at WNET is I had underground outlet", he conceded last month. "I have a lot of frustration to work within system. A lot of frustration. So when I get mad at them I don't fight – I yield to them, and then go and do some stupid thing in small place which satisfies me so that I can work with them again. Underground outlet is my safety valve. I like being world's most famous bad pianist. But I also like to do NET because it is important, is where I can maybe influence society."

After a moment's reflection, Paik went on, "We are now at stage of ancient Egypt with hieroglyphics. Until recently, TV equipment is so expensive that only the priests can use it. And there is constant effort made by networks and by TV unions to keep production costs high. That is classical way of monopoly capital – you know? I want to find ways to cut costs so it can be opened up to others – many others. Now we have color portapak – costs three thousand dollar in Tokyo, sig thousand here, but will come down. And with use of computers cost of editing videotape will become much chaeper. Problem is not really Socialism or Capitalism but technology, you know – now we manage that. For instance, technological forecasting, future-research – I am very interested in that. They need us artists, to make that sort of information available to public. Even New York Times will not print Rand Corporation Report, because it is so boring. Like McLuhan say, we are antenna for changing society. But not only antenna – we also have output capacity, capacity to humanize technology. My job is to see how establishment is working and to look for little holes where I can get my fingers in and tear away walls. And also try not to get too corrupt."

(published in: The New Yorker magazine, May 5, 1975)

GRACE GLUECK
THE WORLD IS SO BORING

Some people think Nam June Paik is the best thing that ever happened to TV. With such helpful devices as electromagnets and signal interceptors he busts up images on the screen, melting performers into iridescent puddles, swirling deodorant ads into instant Op, converting panel shows into Impressionist landscapes.

"I've always wanted to integrate electonics into the visual arts", Paik said the other day, passing a clumsy electromagnet over a color set whose innards he had already "adjusted". A twitching, crescent-shaped seed on the screen exploded into a geometric flower. "The images I'm creating here are as 'esthetically' valid as painting.Electronics is essentially Oriental – light, weight and flexible. Incidentally, don't confuse 'electronic" with "electric", as McLuhan often does. Electricity deals with mass and weight. Electronics deals with information, which has no gravity. One's muscle, the other's nerve."

Paik, a multi-input type born in Korea 36 years ago, has processed plenty of data himself. He studied esthetics, art history, music and philosophy at Japanese and German universities, absorbing five languages (besides his own) along the way. Later, with the German electronic musician Karlheinz Stockhausen, he worked experimentally at Radio Cologne's Studio for Electronic Music. (He's one of the few technology-oriented artists who can do his own tinkering.) Right now, with the aid of a Rockefeller Foundation grant at the Stony Brook campus of New York State University, he's studying ways to apply electronic media to education.

The TV Terror, who has Happened, mixed media and concertized all over the country with far-out cellist Charlotte Moorman, began his public career in Germany, demolishing pianos at "action music" concerts, "suffocated by the European music establishment", he explains. Always a man for his era, he later dropped Steinway for Sony and zapped into the electronic age.

Paik says his current exhibition at the Bonino Gallery may be his last art show. He plans to devote the next few years to research for a kind of electronic – Esperanto, – a world language developed with the aid of computers. "Better communication among peoples is so much more important than putting men on the moon. The space effort is self-deceptive, like heroin. It changes nothing for us."

Paik has a peck of other electronic notions. Among them: (a) an "Instant Global University", whose computer-stored, mailable video tapes would give instruction on anything from advanced astronomy to koto playing; (b) film-recording for posterity the words and presences of great contemporaries (Duchamp, Sartre, Bertrand Russell); (c) the employment of artists to help develop "personality" for computers that teach, to keep students awake while taking instruction.

"The world is so boring", he sighs. "I have to think of things continually to keep myself tense."

(published in: The New York Times, Art Notes, May 5, 1968)

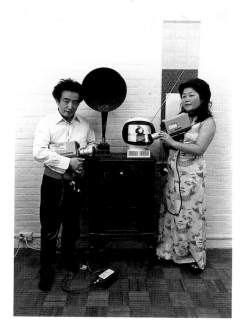

Shigeko Kubota and Nam June Paik,
New York 1974

Photo T. Haar

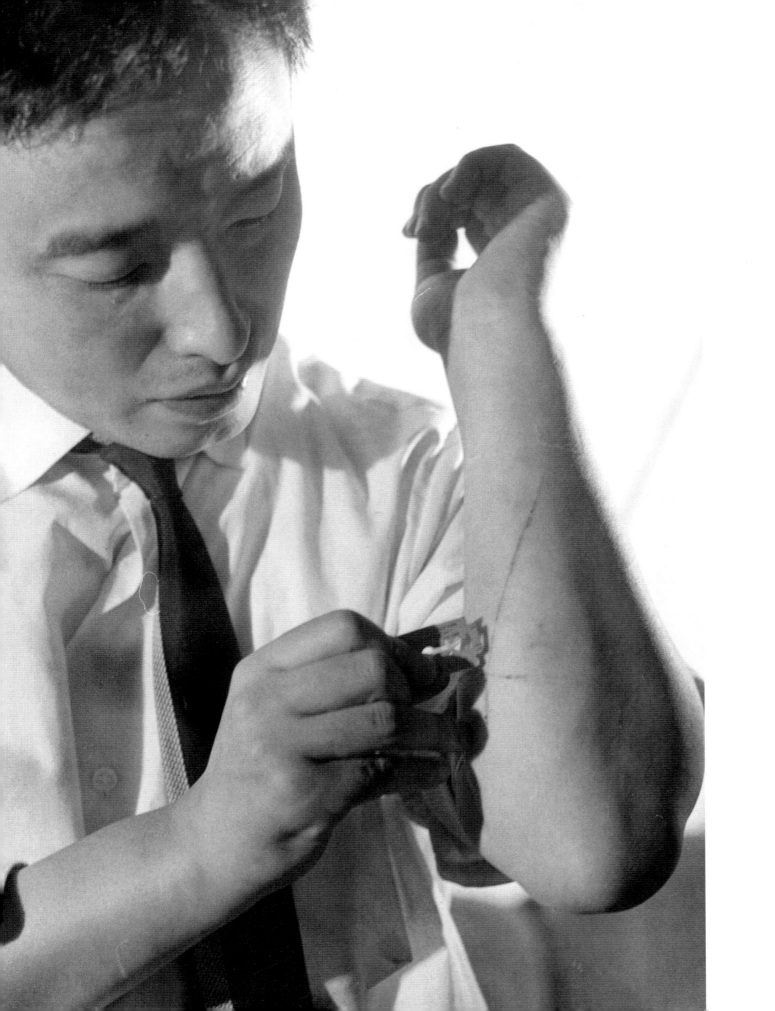

Nam June Paik, 1967

Photos Peter Moore

DAVID BOURDON
CHANNELING WITH CHARLOTTE – AN AIRWAVES ODYSSEY

"Have you heard about the explosion at the World Trade Center?" neighbors ask as I hurry out of my midtown-Manhattan apartment building to keep a luncheon date. It is Friday, February 26th, and the blast is serious: several people have been injured and subway trains are out of service. Later, returning home, I turn on the TV to get the evening news and discover that Channel 2 is the only station on the air. A virtual television blackout exists in the city because the other stations transmit from the top of the World Trade Center. Channel 2 remains on the air because it transmits from the top of the Empire State Building. I can't believe this is happening, so I click relentlessly from one cannel to the next, but, instead of getting different programs on channels 4, 5, 7, 9, 11 and 13, all I get is one black screen after another, each pulsating with demonic white lint and accompanied by droning static.

In my frustration, I notice a videocassette that Nam June Paik recently sent me. I insert it in the VCR and am soon watching Paik's documentation of myself, speaking at a memorial gathering for art critic Gregory Battcock, a sparkling bon vivant who contributed oceans of merriment to our lives. The memorial, organized by Paik, took place in Soho more than 10 years ago and concluded with our gallant friend Charlotte Moorman mournfully playing her cello as she rode on the hood of a car that drove slowly around the neighborhood. Gregory cruised out of this world on Christmas Day, 1980 (his murderer never apprehended) and Charlotte made her ultimate glissando toward the stratosphere on November 8, 1991. Life's redeeming frivolity hasn't been the same since their exits. I would much prefer to watch Charlotte and Gregory in any medium than to observe this videotape of myself, unfavorably photographed in a low-angled close-up. But, having witnessed Paik's live performances in which he mutilated pianos and whacked violins to smithereens, why would I expect him to flatter my face?

I switch back to the blacked-out broadcasts, aimlessly roaming from one channel to the next. The oscillating patterns and basso profundo droning begin to hypnotize me. I feel faint, disoriented, imagining disembodied voices and wispy ghosts whirling about in the penumbral recesses of the monitor. Suddenly, my eyelids flickers uncontrollably and I momentarily lose consciousness.

I am roused from my swoon by the clatter of tossed coins, accompanied by a grating singsong voice that sounds like a rusty hinge in need of oiling. I look up to see a peculiar configuration on the television screen that gradually spheres into the thin, bearded face of a man. "I was consulting the I Ching", he says, "and, by chance, one of my coins hit the antenna on the World Trade Center." His laughter suggests this was a witty and serendipitous move on his part. I realize it is John Cage. "What an unexpected pleasure", I say to him, trying to look nonchalant while thinking darkly to myself, "Didn't he die last August?"

"Are you in heaven?" I ask.

"I don't think so", he says, "because I'm still studying counterpoint with Arnold Schönberg. That's how I started out nearly 60 years ago in Los Angeles. Then, I followed Schönberg's rules in writing counterpoint, he would say, 'Why don't you take a little liberty?' And when I took liberties, he would say, 'Don't you know the rules?' By happenstance, I became a go-between for Nam June Paik, who stalked me with scissors while doing his thesis on Schönberg. Paik was involved in his own 12-step program to alleviate dependency upon musical tradition and neckties."

"Did Paik understand what you were doing?" I ask.

"The truth is we don't know what we're doing and that is how we manage to do it when it's lively. My advice to Paik fans: always wear a tie in Düsseldorf."

"Düsseldorf? Did I hear someone say Düsseldorf?" another voice calls out. A striking, gaunt face comes into murky close-up. Is it Lon Chaney in The Phantom of the Opera? No, it's Joseph Beuys! Has he, I wonder, been piloting above the globe since January, 1986? "I like Paik and Paik likes me", he proclaims loudly. I want to ask Beuys why he attacked one of Paik's prepared Pianos with an axe during a 1963 show in Wuppertal, but I'm too timid (and, after all, he may still have the axe).

"Professor Beuys, any advice for Paik today?"

"Paik should polish the story of his life during the Korean War. The public does not want to hear about his family flight to Hong Kong and his father's adventures in the ginseng-root business. Instead, Paik should tell how he flew a fighter plane over North Korea and was shot down and crashed behind enemy lines. He should tell how he was rescued by a peasant family who helped him retain his body temperature by wrapping him in cabbage leaves and submerging him up in a large crock of kimch'i. It doesn't matter if it's rotkohl (red cabbage) or weisskohl (white cabbage): human kindness is beyond politics."

Turning away, Beuys walks to a blackboard, picks up a stick of white chalk and writes in an excessively loopy calligraphy, "I will stay after school and practice my penmanship." He writes this sentence over and over again, covering dozens of blackboards, which he throws to the floor when he has finished with them. The

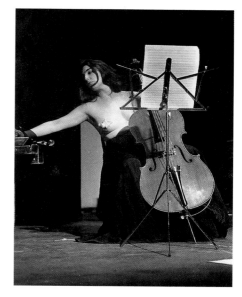

Charlotte Moorman performing Nam June Paik's "Opera Sextronique", 1967
Photo Peter Moore

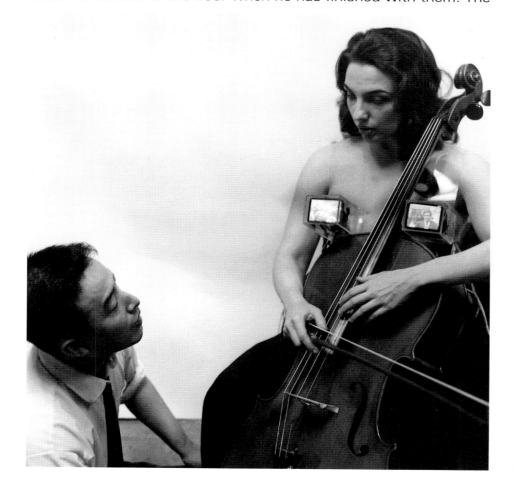

Charlotte Moorman and Nam June Paik performing "TV Bra For Living Sculpture", Howard Wise Gallery, New York 1969
Photo Peter Moore

screeches of chalk on blackboard feel like knife-thrusts in my ears. The shrill piercing sound evolves into the squealing seesaw of a bow being dragged across a stringed instrument and Charlotte Moorman materializes on the screen, playing her cello. She is wearing Paiks's TV Bra for Living Sculpture, which includes a pair of three- inch television sets. "Hello, David", she says, greeting me with a radiant smile. "Tell Paik that an electromagnetic disturbance is causing his TV Bra to malfunction. I'm unable to scramble the television images." Poor Charlotte. Her absurdist performances once made her the most notorious musician from Little Rock, Arkansas, but now she has been eclipsed by saxophonist Bill Clinton.

I first saw Charlotte and Nam June perform in a 1964 production of Originale by Karlheinz Stockhausen at New York's Judson Hall. She hung from a balcony railing while playing the cello and he dunked himself in a tub of water. Their antic personalities complemented each other superbly.

"Is it true that Stockhausen insisted that you cast Paik, whom you didn't know, in Originale?"

"Yes. My first reaction was 'What's a Nam June Paik?' I didn't know him from the king of Korea."

An explosive sound emanates from the TV set and a blindingly white light spreads across the screen. "Who calls the king of Korea?" demands an imperial voice.The screen separates into two horizontal sections at the 38th parallel line and the face of an Asian man appears in the lower portion. He glares at me, then squints disapprovingly at Charlotte, who remains on the upper portion of the screen. "I am Sejong", he announces proudly. "Why do you disturb me?" Although I do not recognize his face, I certainly know who he is: the Yi Dynasty king who devised the Hangul writing system in the fifteenth-century. He points in Charlotte's direction and asks, "Han-gung-mal-lo meo-ra- go hae-yo? (What's this called in Korean?)" I introduce Charlotte to him and explain that she is a close friend and colleague of Paik's. He looks at her bra and frowns, saying, "T'e-re-bi-jyeon an na-wa-yo (The television doesn't work)."

Sejong focuses his next scowl on me. "Tell Paik Nam-June that he is naughty boy who brings shame to his countrymen. Why goes he around the world calling imself 'George Washington of video art?' Is much better he live with Japanese woman? Is a disgrace, no? Brings shame to his countrywomen. And why he always wear woolen scarf around his stomach? Looks like obi, no? Perhaps he thinks he is Japanese woman, too? He is bad boy." The king snaps his fingers toward someone offscreen. Yeo-bo-se-yo (hello)", he says. "Kimch'i chom teo chu-se-yo (Please give me more kimch'i)."

Sejong dissolves from view and Charlotte regains the entire screen – much to her relief. "What a disagreeable man", she says. "No wonder Paik left Korea." I notice that she has changed her costume, switching from the TV Bra to a pair of small whirling propellers that she has somehow affixed to her bare breast. "Do you remember in which piece I wore these?" she asks.

"Opera Sextronique, of course. They made a terrific clatter as they accidentally struck the cello when you leaned forward to bow. For me, it was one of the highlights of the piece."

How could I forget a detail like that on such a momentous evening – February 9, 1967 – when Paik staged the premiere of his "opera" at the Film-makers' Cinémathèque on West 41st Street. Halfway through the performance, a couple of dozen policemen, many of

them plainclothesmen, rushed from the rear of the auditorium, stormed the stage and closed the curtain. The audience, stunned, listened to the muffled sound of onstage scuffling. Paik's worried face emerged between the curtains. He scanned the audience, spotted me in a front row and asked me to come on stage to negotiate with the policemen. He must have imagined that I, being an editor of Life magazine, could resolve the crisis. I hurried up the side steps to the stage, saw the police tussling with Charlotte, who was tearfully pleading for her coat and cello and was swept immediately into the vortex of the fray. The police arrested Charlotte and Nam June for indecent exposure and drove them away in

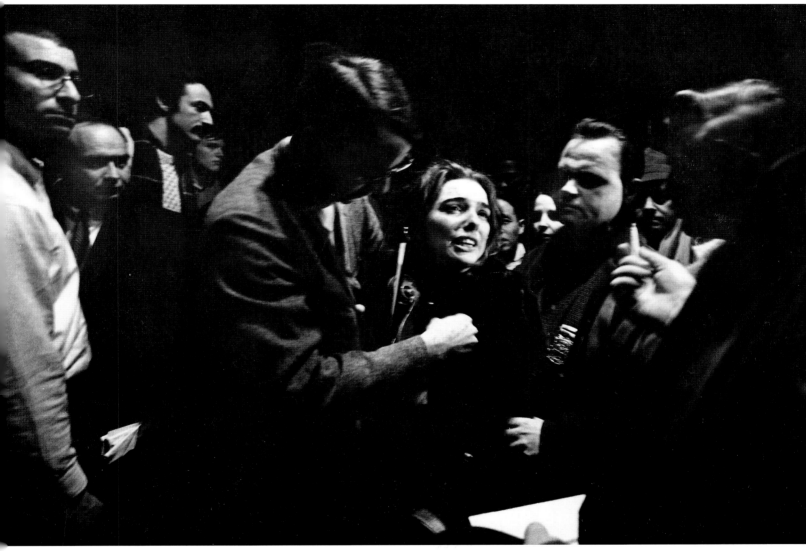

a fleet of at least 16 police cars. Obviously, the police had anticipated a much larger cast of nude performers. By the next day, Charlotte was notorious in the tabloids as "the topless cellist".
"It was so sweet of you, David, to testify on my behalf in Criminal Court, even though the judge twisted your words around to convict me of lewdness. At least he didn't send me to jail. I wish Gregory had been there, too."
Loudly clearing his throat to command our attention, Gregory Battcock slides into the right side of the screen, facing Charlotte. "My dear Charlotte", he says, "your case was a lost cause the mo-

Charlotte Moorman arrested by Police after the Happening "Opera Sextronique" in 1967
Photo Peter Moore

ment David was called to the witness stand. His wardrobe, as usual, was too humiliating for words. What trial judge would believe an art critic wearing a polyester jacket, bell-bottom trousers and Thom McAn shoes? It's a wonder you weren't sent up for life! David has many character flaws, but the most serious is his failure to keep up with Italian men's fashions. Have you ever seen him in an Armani suit?"

"They're too expensive", I protest.

"What did I tell you!" Gregory snorts. "Now if we had testified, we would have worn our vestito da festa, probably a three-piece worsted wool suit with a custom-made English shirt and an Italian silk tie, and our testimony would have been preceded by a press conference at Delmonico's, where we would have served a noteworthy champagne. After our testimony, we would have hosted a modest colazione with prosciutto cotto di Parma, scampi alla Veneziana and risotto con funghi, accompanied by an insalata mista di stagione and followed by an assortimento di formaggi. And we would have invited a few press photographers, of course."

"I have a list of them right here", Charlotte says, cheerfully waving a few sheets of paper.

Her gesture triggers the offscreen clicking of several cameras. One familiar-sounding click is followed by the hissing sound of a Polaroid print being regurgitated from its plastic chassis. By now it's hardly a surprise when Andy Warhol appears onscreen."Oh, hi, David, I'm up here in heaven and it's so-o-o-o beautiful. Everyone you've ever wanted to know is here and the parties are just great. Next week we're having a reception for Lillian Gish and Ruby Keeler."

"Are you sure you're in heaven?" I ask. "Your voice sounds awfully close to Earth. Maybe you and Charlotte and Gregory and Beuys and Cage are all trapped in some peculiar wavelength at the low end of the electromagnetic spectrum. Or maybe all of you are confined in some kind of air inversion, like a smog belt. It's odd how you're all connected to Paik whose only use for a halo would be to interfere with television reception."

"Why don't you ask him about it?" Andy says. "He's so smart. I just love that big pyramid of television sets in Seoul."

"You mean the ziggurat of 1,003 television sets that he designed for the National Museum of Contemporary Art?"

"Yeah. What a great idea to repeat the same image a thousand times in row after row. Where did he get the idea to do a grid of identical pictures? Why don't you ask him that, David?"

"But, Andy, you're not the only artist who's used grids."

"Ask him anyway. See what he says." He silently fades away.

When I come to, the black television screen is still fizzing with spectral lint. My memory is numb, but I recall that I have messages to relay to Nam June Paik. I slowly come to the realization that I've been channeling! At last, the New Age has found me.

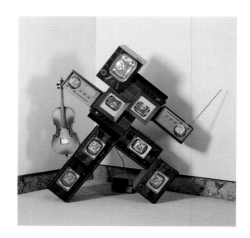

Charlotte Moorman, 1990
Courtesy Carl Solway Gallery, Cincinnati

OTTO PIENE
"CHARLOTTE", FOR WHITNEY MUSEUM, 15.2.92, N.Y.C.

This should be written
with a golden pen
on paper from the most
 exquisite mill
on paper saved for centuries
on film resulting from
 the most concerted effort
of technology
in Kodak and related labs
released in air
which no foul breath
 has spoiled:
The purest sky
which has not heard
 of war
or of St. John's revelation:
The blue which holds its own
the oxygen which never
 entered
 human lungs
the oxygen attaining
 purity
before it peters out
into the unadulterated
 space
where stars take on their
 unadministered dimension
 Charlotte is dead
The JVCs, the Sonys, the
 Super Eights,
 the High Eights and the
 Canons,
the Leicas, the friends,
 the poets & musicians,
the media men & women,
 the systems, bandwidths,
frequencies,
the channels, stage sets
 and assistants,
the cats, dogs, insects
 and the dinosaurs

of unabashed media
 attention,
the critics and purporters,
the advocates and the prac-
 titioners of avantgarde,
the analog & digital,
the versatile and stubborn,
the open-minded, sex-
 crazed
tv hounds and still photo-
 graphers,
the book-compilers and the
 merely fascinated,
loving colleagues, loving
 friends,
loving flesh
aspiring to be spared:

 Charlotte is dead
She has been the living
 proof:
Agony is to come out of,
morphine is to persevere,
the grail which life is
belies Sloan-Kettering.
She is with us,
we can continue.
Scarlet is the color of her
 dress:
The cello is a double heart
quadrupled when we
 see it turning,
the bow a wand,
the color earth
appearing polished
 by the sunset
and quite aesthetic
 from a distance
when progress cancels
night and day & seasons
and maybe, reality:

Charlotte Moorman and Nam June Paik
performing "Music Is A Mass Transit Too –
So Is The Bra", 10th Annual Avant Garde
Festival of New York, December 9, 1973

Photos Peter Moore

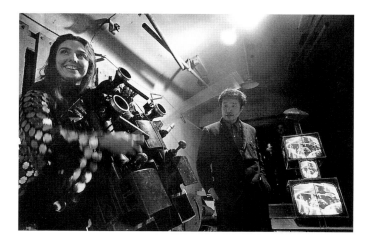

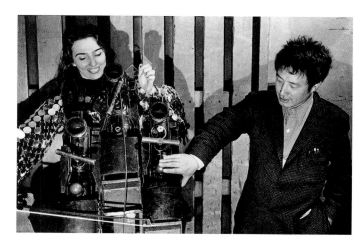

Charlotte is dead.
Apologies to Frank
and Vin and Shawn
and to Paul Earls,
Elizabeth and Paik,
to the egregious late Howard,
to Jim MacWilliams & Kosugi,
to Yoko Ono, Peter, Barbara,
to Ay-O, New York City
& to some who went
 before her:
Bart Johnson & Stand VanDerBeek,
to Beuys and Schmela -
for saying it plainly:

 Charlotte is dead
Charlotte and I loved
to drink beer
 with Frank & Elizabeth
– I say Beuys & Paik once only,
I can't say beer two times -

Once I woke her to play
the cello to the stillness
of Lone Pine & the Ala-
 bama Hills
composed of Rocks
that look like resting
 brides
 of volcanic age
Once – right after sunrise –
we drove to the edge
 of Death Valley
where we beheld a sign
to Charlotte's wide
 amazement:
Swansea, California,
 population three
Then we drove on
to arrive in due time
 at the airport
of the City of the Angels

Given as pre-performance
 presents
and tschatchkis in the mail
came hearts of glass,
of shells, of paper and
 of chocolate
We had a cardiac altar
 on Valentine's Day
her favorite
 for sentiments of written
 statements
and basic human kitsch
since humanness is dialectic
 and purity sublime
A woman cut from the rib
 of Georges de la Tour
her glance is elsewhere:

Why Charlotte was Charlotte
 forceful, truthful
 beautiful,
 funny
 and
 dead-earnest
 expressive
 and
an image like no other –
 we may learn
 – if ever –
when we are dead.
[E.'s poem]
Elizabeth Goldring

Not for Heretics

For Charlotte

An ancient shopkeeper
in Karlsruhe
climbed up the ladder
until
far out of reach
at the back of a dusty shelf
he fund an angel
playing the cello

you said you liked it
and you set it out
with your what-nots
 Irresistable
 to be remembered
 and be lived
 forever
 her battle cry
 to draw us to her
 & into her art:
 I love you!

 Yes, we love you, Charlotte,
 yes.

Charlotte Moorman and Nam June Paik
performing "Human Cello", Part of their
version of John Cage's "26. 1. 1499",
Café au Go Go, New York 1965

Photo Peter Moore

46

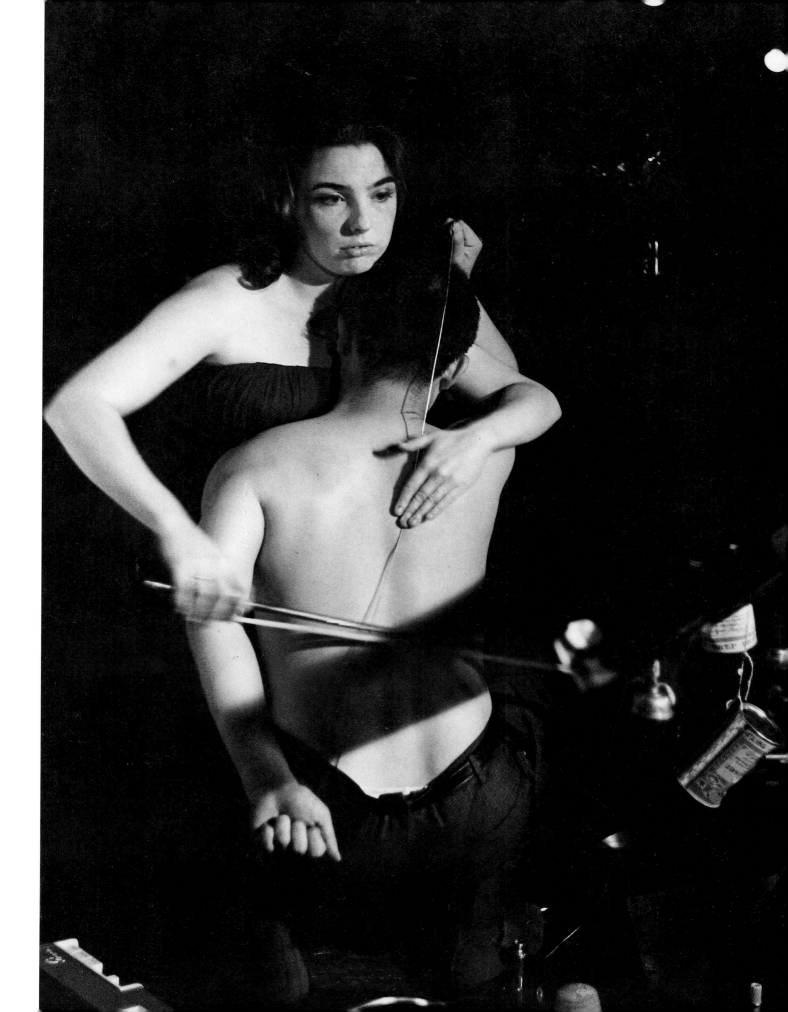

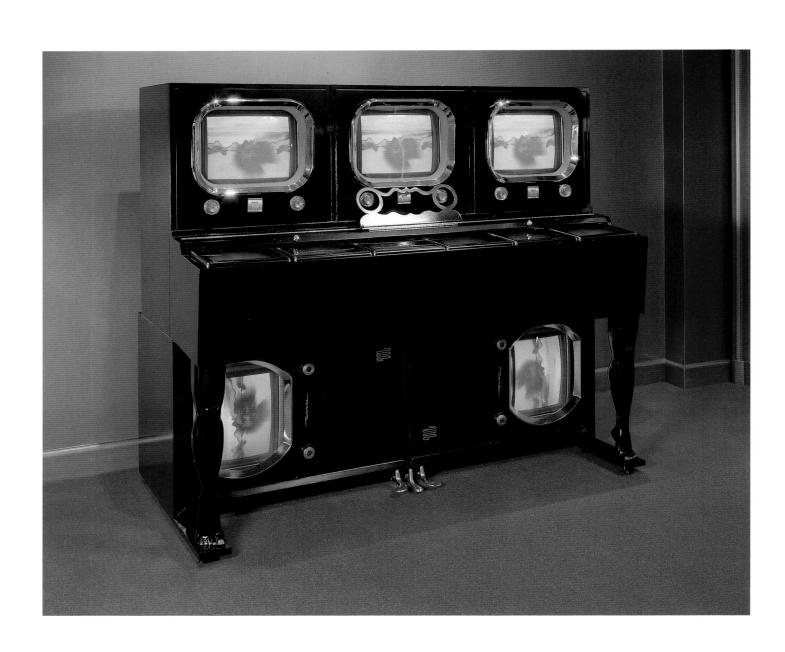

"We didn't sell a single work during the whole time he was with us, but the publicity was worth it!" says Fernanda Bonino, Nam June Paik's first dealer in America. Already owning galleries in Rio and Buenos Aires, "Nanda" Bonino and her husband, Alfredo (who died in 1981), opened their elegant and very uptown New York space, Galeria Bonino, Ltd., at 7 West 57th Street in 1963. It represented Paik for more than a decade, starting in 1964. (During that period, Paik also participated in group shows at the Howard Wise Gallery).

Actually, the meeting of Paik and the Boninos was one of those wonderful accidents that seem prearranged. Each needed the other: Paik, like all artists, wanted a sympathetic place to show his work; the Boninos were after a lively young talent who would generate some publicity for their new venture. The Korean-born Paik had been living and studying in Germany, and had already staged an experimental TV show at the Galerie Parnass in Wuppertal in 1963. "At the time, color TV was coming, and I wanted to work with it," he said in a recent interview. "I came to New York through Tokyo because materials and engineering were cheap there. I bought old TV sets and brought them here."

In Germany, Paik had spent time in the late 1950's at the universities of Munich and Cologne and the Freiburg Conservatory, then worked experimentally from 1958 to 1961 with the electronic musician Karlheinz Stockhausen at Radio Cologne's Studio for Electronic Music. He also did performances, ripping neckties, plunging his soap-lathered head into a washtub, and demolishing pianos. His presentations were very much in tune with the philosophy of Fluxus, the loosely-knit international group of writers, artists, composers, filmmakers and performers to which he belonged, who created works that ran counter to traditional notions of art. In his "Zen for Head," performed in 1962 at the Fluxus Festival in Wiesbaden, for instance, Paik used his body as a vehicle for paint.

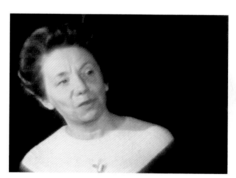

He had planned to show his adjusted TV sets at the Fluxus Festival in Tokyo in 1964, but George Maciunas, the guiding light of the group, asked Paik to exhibit instead in his loft on New York's grungy Canal Street. "When I got here I saw that Canal Street was already so full of junk that the TV sets wouldn't stand out," Paik recalls. "I needed an uptown setting. And it was hard to get uptown space for such an unsalable commodity." He tried the Green Gallery, the short-lived avant garde outpost run by Richard Bellamy, but it was about to close.

Meanwhile, the Boninos had met Mary Bauermeister, a young German artist who knew Paik through their mutual association with Stockhausen. Bauermeister, who created beautiful collages and sculptures of lenses and polished stones, had been invited to the States by Fairleigh Dickinson University in New Jersey. "Mary knew everybody," Nanda Bonino recalls, "Johns, Rauschenberg, the whole art community. We represented mostly Latin American artists, and we wanted to have an American in the gallery." Paik turned out to be their "American"; he was introduced to the Boninos by Bauermeister, who also joined the Bonino stable.

Nanda Bonino

Paik's first one-man show, at Bonino in the fall of 1965, had as its stellar attraction "K456," a robot with 20-channel radio control and 10-channel data recorder, that walked, waved its arms and excreted dried beans. With its speaker mouth, paper hat and tiny fan for a navel, it was not an unattractive monster. Its companions were the dozen or so ancient TV sets Paik had brought from Tokyo, wired up to change ordinary images into weird electronic abstractions, and the Korean "cultural terrorist," as Allan Kaprow

I am the World's Most Famous Bad Pianist
1986
Courtesy Carl Solway Gallery, Cincinnati

dubbed him, stayed in the gallery, sleeping there overnight, to minister to his creations. "When a critic came to see the show, I had to wake Paik up to plug something in," Nanda recalls. "Alfredo was mad because Paik's helpers ate and drank all over the gallery, and the floor was covered with TV wiring and tubes."

Nevertheless, Paik did bring the gallery the attention it sought. For one, his and Bauermeister's friends from the downtown avant garde became regular visitors – among them Paik's mentor, John Cage; Merce Cunningham, Allan Ginsberg, and Allan Kaprow. Cage even produced the catalogue introduction for Paik's first show. "Art and TV are no longer two different things," he wrote, in a text as free-wheeling as his music. "They're equally tedious. The geometry of the one's devitalized the other (find out what bad habits you have); TV's vibrating field's shaken our arts to pieces. No use to pick them up. Get with it: Someday artists will work with capacitors, resistors and semi-conductors as they work today with brushes, violins and junk."

Critics came, too. "As an experiment in a new medium, the exhibition has unquestioned fascination and a probable potential for expansion," wrote The New York Time's John Canaday. And many visitors came to the gallery just to see what was going on. Still, to an art audience attuned to Johns and Rauschenberg and just latching on to Pop, Paik's cryptic technical tinkerings were a little bit off the track. But he was always amusing and scandalous, and his performances with the cellist Charlotte Moorman – who played topless – got lots of attention in the press. Ms. Bonino remembers it as "all pretty fascinating. It was a particular moment in New York, a relationship of artists, dealers, critics and museum people that no longer exists. There was a completely different feeling about art – people bought what they liked and didn't think of how much it would sell for the next year. Dealers didn't even think all that much about money. In the '70's it all changed."

Paik had five solo shows at the Galeria Bonino. For his second appearance, in 1968, he got his artist friends Ayo (a Japanese sculptor who made mysterious boxes), Christo, Ray Johnson, Mary Bauermeister, Robert Breer (Breer, a kinetic artist, was also represented by Bonino), Otto Piene and others to participate with him. Christo wrapped a TV set, Piene covered one with plastic beads; Bauermeister made a lens box with a TV set producing images reflected by the lenses, Ray Johnson a relief collage combined with a TV set, and so forth. In another room, Charlotte Moorman – a wonderful free spirit whose interest in new music and the avant garde was unshakeable – played the cello on a pedestal for two hours in the morning and two in the afternoon.

In between shows, Paik was by no means idle. With the aid of a Rockefeller Foundation grant, he worked at the Stony Brook campus of the State University of New York, hatching ideas on how to apply electronic media to education – for example, an "Instant Global University," whose computer-stored videotapes would give instruction on anything from advanced astronomy to koto playing; film-recording for posterity the works and presences of great contemporaries, like Duchamp and Sartre, and the employment of artists to help develop "personality" for computers that teach, to keep students awake while taking instruction. In 1969, under the Rockefeller sponsorship, Paik and Shuya Abe, the Japanese engineer with whom he often worked, developed the Paik-Abe video synthesizer, which synthesized video images in a brilliant color range.

Nam June Paik and Charlotte Moorman performing "Infiltration Homogen" of Joseph Beuys, Airplane Wreck, Solomon Island 1976

Charlotte Moorman performing "Bloody Ridge", Airplane Wreck, Solomon Island 1976
Photo F. C. Pileggi

MARY – MARY = 2075.003
Electronic Moon
Courtesy Galeria Bonino, New York

At about this point, another supportive dealer came into Paik's life. Howard Wise was a wealthy ex-businessman from Cleveland, whose interest in art finally prompted him to sell his family's paint factory and open a gallery in his home town. For a while he showed the work of contemporary painters and sculptors, opening a second gallery in New York, at 50 West 57th Street in 1960. But by 1961, he had begun to develop an interest in artists involved with kinetic and light sculpture, a movement enhanced by the increasing availability of sophisticated hardware. Wise, unmotivated by the need to make profits, could afford to support artists involved with new technologies, and the Howard Wise Gallery soon became a center for artists who worked in light, motion and sound.

Paik appeared there in several group shows, "Light in Orbit" and "Festival of Light," in 1967 (for the latter he created "Electronic Zen Tri-Color Moon"), and "TV as a Creative Medium" in 1969. For the '69 show, he developed the famous "TV Bra for Living Sculpture," worn by Charlotte Moorman, a pair of tiny TV monitors strapped to her bare breasts, the imagery on the monitors changing as she wielded her bow. (When Paik and Moorman were arrested in 1967 at the Filmmakers Cinematheque during a performance of Paik's "Opera Sextronique," Moorman gave a press conference at the Howard Wise Gallery explaining her case.) Actually, it was through the Wise gallery that Paik made his first sale – and the only one for a long time thereafter – "Participation TV," an interactive work which generated images of viewers in different colors on different monitors, bought in 1969 by the collector David Bermant.

In 1970, Wise closed his gallery, in the realization that many of the artists he supported had begun to lose interest in creating light and kinetic machines – difficult to maintain, at best – and were now involved with large-scale environmental works whose scope was beyond the gallery's space limitations. Besides, Wise's own interests were focusing on the electronic medium of video art, which he initially saw as an unparalleled means of conveying ideas and information, particularly in the political sphere.

In 1971, he set up a non-profit organization, Electronic Arts Intermix, whose original purpose was to channel funds to artists. It became a support organization for a number of groups and individuals working in the field, including Charlotte Moorman and her annual New York Avant Garde Festival. E.A.I. also developed a video-editing facility for the use of artists, and generally served to promote the idea of video as an art medium. In 1973, responding to the pleas of video artists who had difficulty getting their work out and around, E.A.I. started a videotape distribution service, very much in business today. Its circulating collection, with hundreds

of tapes, is the most comprehensive in the United States. Wise died in 1989, having made a significant and lasting contribution to the field of experimental art.

Meanwhile, Paik continued his solo presentations at the Bonino gallery. His 1971 show, in collaboration with Shuya Abe, featured the video synthesizer, demonstrated along with Charlotte Moorman's performances. For his 1974 exhibition, the last at the gallery, he showed his most ambitious work to date, the forerunner of his big environmental pieces, "Global Groove," a half-hour video collage which used 20 screens and multiple tapes to produce a breathtaking rush of split and synthesized images. To experience it, the viewer stood on a raised platform looking down on what Paik described as a "sea," or "garden" of televised images.

Unexpectedly devoting his entire Sunday column in The New York Times to "Global Groove," the conservative critic Hilton Kramer said that the images didn't matter: it was "the sequence of forms changing color and shape that absorbs all attention." He compared the work's abstraction to a Kurt Schwitters collage. He went on to say of Paik's piece, however, "The art one actually experiences is rather modest, its delights are flickering, small-scale and fragmentary, and quickly dissipated."

Despite such attention in the press, Paik's work continued not to sell. Although the Bonino gallery had no difficulty placing the work of some other artists in its stable – particularly the Latin Americans Alicia Penalba, Marcelo Bonevardi and the sculptor Edgar Negret, along with Mary Bauermeister (once the collector Joseph Hirshhorn bought three Bauermeisters over the telephone) – Nanda Bonino found the market for Paik's work nearly non-existent. Once, to be sure, she almost sold his "TV Buddha," a TV set with a Buddha sitting in front of it. It was wanted by a collector who intended to donate it to the Museum of Modern Art. But, Ms. Bonino recalls with a shrug, the Modern refused it. (The piece is now owned by the Stedelijk in Amsterdam.)

Nude in Blue
Courtesy Galeria Bonino, New York

Global Groove, 1973
Photo Peter Moore
Courtesy Galeria Bonino, New York

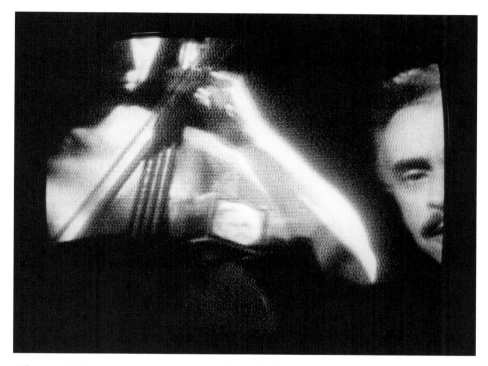

Global Groove, 1973
presented by Russel Connor
during one month on Channel 13, N.Y.C.

"Once Paik gave me a bunch of line drawings to sell, and I couldn't even get rid of those," she says, "because the tape on the back showed. I gave one as a gift, and it was returned. There were so few collectors, anyway, in those days. Everyone knew who was buying: Joseph Hirshhorn, Jean and Howard Lipman, and a few others. Still, we really didn't care if we sold Paik's work or not since he, along with Robert Breer and Mary Bauermeister, made the gallery a popular place to come."

And Paik remains grateful for Nanda Bonino's "far-sighted vision and non-commercial attitude. "She was very, very positive," he says. "In a way, she needed public attention and didn't dream of making money for a long time. She gave me several solo shows, and that was a lot of financial commitment. Without an uptown gallery I never would have made it."

"Of course," he adds, "Mary Bauermeister and I did put the gallery on the map of New York."

►
TV Clock, 1963-81

►►
Moonlight Sonata, 1989
Courtesy Dorothy Goldeen Gallery, Santa Monica

12 Piano Compositions for Nam June Paik
1962/1989
Courtesy Carl Solway Gallery, Cincinnati

Symphony for 20 Rooms, 1961/1989
Courtesy Carl Solway Gallery, Cincinnati

Streich Quartett, 1957/1989
Courtesy Carl Solway Gallery, Cincinnati

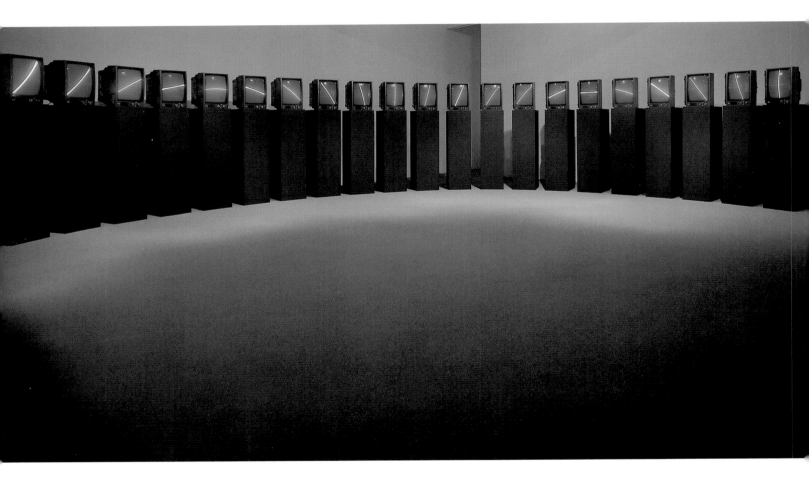

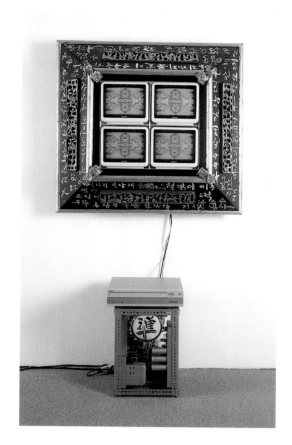

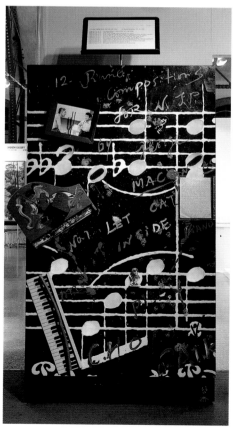

KARL RUHRBERG
UNRUHIGER SCHLÄFER

Die Welt ist ein Dorf, und Nam June Paik hat tatkräftig mitgeholfen, sie dazu zu machen. Für sich selbst durch eine nomadenhafte schöpferische Existenz ohne archimedischen Punkt, für uns andere durch die – Zeit und Raum verbindende – Elektronik, durch die simulierte Totale der Realitätserfahrung von Seoul bis New York, von Sibirien bis Feuerland, von Alaska bis zum Äquator in seinen Video-Türmen. Musikalische und bildnerische Strukturen, U-Kunst und E-Kunst, Scherz, Satire, Ironie und tiefere Bedeutung – bei Paik wird das alles zur klassenlosen Gesellschaft. Mir geht es mit ihm ähnlich wie meinem Freund Wieland Schmied: Obwohl (oder weil) ich 1971 von Hans Strelow und Konrad Fischer mit "Prospect-Projection" in der Düsseldorfer Kunsthalle die damals brandneuen Medien en bloc vorstellen ließ, hätte es mir angesichts des lange Zeit scheinbar unzertrennlichen tutti frutti von Erhabenem und Lächerlichem leicht passieren können, daß ich Video "mein Leben lang gehaßt" hätte, wenn ich nicht beizeiten Nam June Paiks Werken begegnet wäre, deren preisgekrönte Hochschätzung ein anderer verehrter Kollege, Werner Schmalenbach, noch immer für einen gigantischen Irrtum des Zeitgeistes hält.

Ich will mich aber gar nicht aufs hohe Roß setzen. Denn vor knapp einem Vierteljahrhundert lag ich genauso daneben, als Paik in seiner damaligen Doppelrolle als Komponist und Interpret im Wechselspiel von Ekstase und Lethargie in der "Galerie 22" des unvergessenen Jean-Pierre Wilhelm seine laute Huldigung an den leisen John Cage vorführte, wobei die Verwechslung eines rohen mit einem gekochten Ei die neo- dadaistische Partitur erheblich durcheinanderbrachte. Wenn ich meine damalige Besprechung heute nachlese, kriege ich immer noch rote Ohren, zumal ich wenig Gelegenheit hatte, schriftliche Wiedergutmachung zu praktizieren; es sei denn der Hinweis auf das melancholische deutsch-koreanische Farewell von Joseph Beuys und Nam June Paik an zwei Klavieren zu Ehren von George Maciunas 1978 in der Düsseldorfer Kunstakademie.

Immerhin gab mir ein freundliches Schicksal die späte Chance zu beweisen, daß ich in der Zwischenzeit ein bißchen gelernt habe. Denn vor anderthalb Jahren konnte ich im Verein mit meinen Jurykollegen Nam June Paik als Pionier eines neuen Mediums, als Unruhestifter ersten Ranges in unserer allzu saturierten Kunstlandschaft zum Kaiserringträger der Stadt Goslar machen: eine "extraordinäre Erscheinung", wie sein zeitweiliger Kompositionslehrer Wolfgang Fortner ihn titulierte, den Wanderer zwischen den Welten, den ewigen Nomaden, der so oft, so gern, so intensiv und so lange schläft, wenn er nicht gerade hellwach einen neuen kreativen Wirbel entfesselt.

Paik gehört zu den Künstlern, die den hohen Anspruch Marcel Duchamps nicht zu fürchten brauchen, daß Kunst vor allem intelligent zu sein habe: eine Forderung, der in unseren Tagen eine besonders brisante Aktualität zukommt.

Nam June Paik, Drawing: "Tribute to Poter A. MacCray, who saved many hungry composers including my self (1975-92)"

NAM JUNE PAIK **ON BEUYS**

when i visit BEUYS at the studio (of course, i did it as rarely as possible and as short as possible in each visit, because the best present i could give him was not to take his valuable time away) ... our conversation were very frequently interrupted by many phone calls from old and new friends, which were not that important ... he picked up every telephone and answered carefully ... quite a few with genuine affection. I asked why you don't hire a secretary, who could sit in his basement and screen the incoming phone call?

he said no ... he wants to answer all phone calls ... actually john cage was same in this point ... I asked the same question or suggestion and got the same answer ... certainly these limitless goodwills shortened their lives.

The german wirtschaft wunder had left out many wonderful minds in the cold ... these drifters und underdogs did need an uncle of their psychoanalysts to talk and to be consolaced.

beuys filled this task with his all conversations and free university activities ... in one of meetings at the Kassel documenta 77 one physician in the crowd talked: everybody wants to be equal and wants to see the democracy realized ... yet let us see how our body works ... ally parts are equal ... you cannot live without heart, yet without lever you cannot live either ... even hands and foots are basically equally important ... but our hands don't want to become our foot. our foot wants to stay as our foot and they don't want to become our brain ... all parts are equal but they do different functions ... and they don't complain. our lever don't envy our heart ... our heart don't envy our kidney ... it is an organism ... it is an ecology.

this quiet advice cooled down quite a few hotheads, who were pressing beuys for the more immediate action.

in the wirtschaft wunder everybody wants to become the chairman of boards ... or terrorist ... beuys was one of the very few who could communicate with the super-rich and super-poor ... he did have the trust of both ... now in the postunification agony, i wonder what beuys's action would have been. would he be still living in duesseldorf?"

he may have moved to Halle or dresden to soothe the sensitive minds, who feel they lost in the competition, although they are glad that they lost ... he maybe the honest broker ...

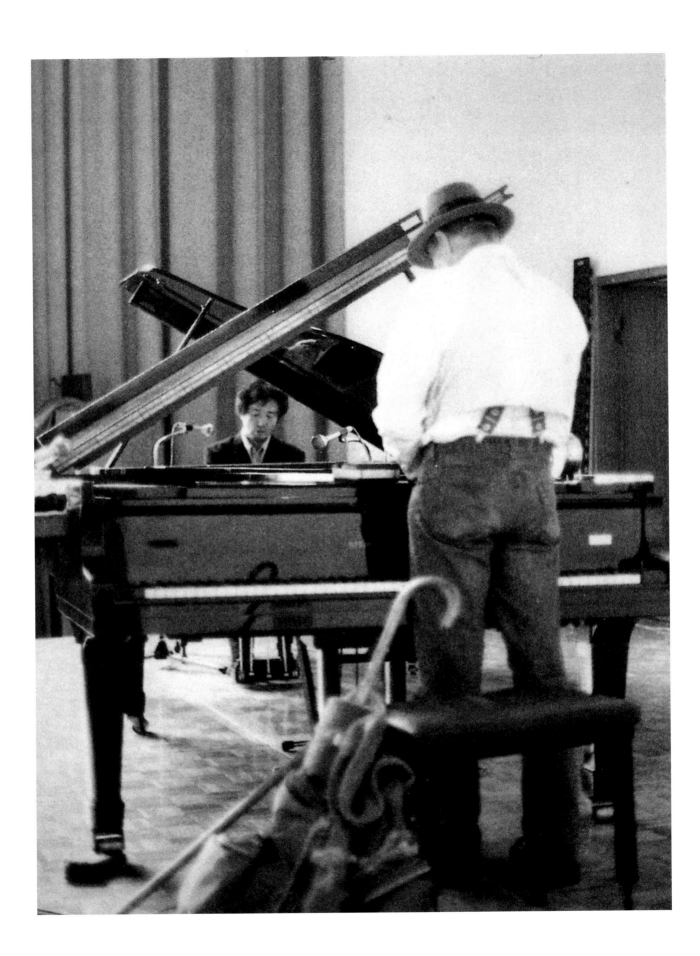

although he was very sick and almost in the terminal stage of his heart problem ... he still wants to come to hamburg for the peace biennale concert to play with henning christiansen and me ... it was eva beuys's strenous persuasion, which i seconded, which saved him from one more trip.

instead we asked him to talk through telephone, which would be amplified and fed into the public. there were technical malfunctions, which made it sound as if he was calling from paradise or hell ...

if he had a choice, certainly he would have chosen hell because in this way he could have soothed the all mal-contentees and all the broken hearts, all the underdogs and terrorists and drifters. he would have enjoyed the nice accompaniments.

Beuys gave charlotte a felt bag in which she played his 'infiltration' piece ... a collector was sending some money every month, who would possess this felt piece after some time ... this time came and of course charlotte sent him the cello ...

one day charlotte and frank PILLEGI, her husband, visited Beuys. he simply grabbed a scissor and went to the felt room and cut out another cello ... it was another fortune to give away.

one day I visited him in the free university.

he put in my hand a bundle of 500 DM bills ... and just said
 "this is for charlotte."

TV Boys/Beuys, 1988
Courtesy Carl Solway Gallery, Cincinnati

"In Memoriam George Maciunas", Concert
with Joseph Beuys and Nam June Paik
Düsseldorf 1978
Photo René Block

Beuys Vox
Won Gallery, Seoul

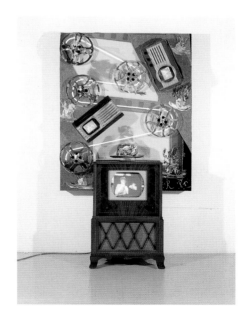

Beuys' Only Film, 1991
Hyundai Gallery, Seoul

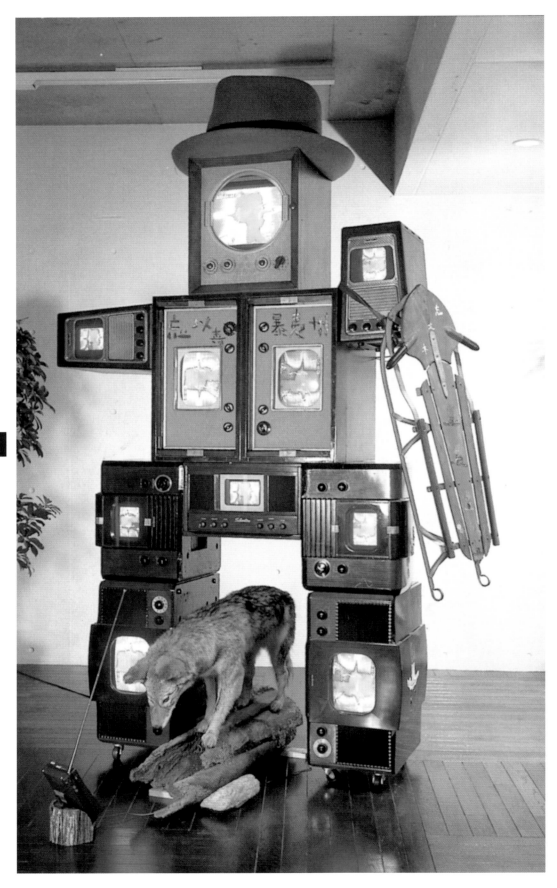

Beuys, 1988
Shizuko Watari Collection, Tokyo

IRVING SANDLER
NAM JUNE PAIK'S BOOBTUBE BUDDHA

Can't get Nam June Paik's TV Buddha, 1974, out of my mind. This sculpture of the sitting Buddha viewing His own image on a closed-curcuit television screen is hilarious. An inanimate sculpture looking at its inanimate mirror images. The Buddha as a media star and couch potato in a Buddha Sitcom. But it's not a one-line joke. What else can it mean?

Does it demean an Established religious icon in the spirit of Fluxus iconoclasm? Or, is it spiritual: the Divine looking at the Divine – without interference? Instantaneous holy feedback. God using electronic media to contemplate Himself. Why not? The luminous TV image is the perfect medium for contemplating pure contemplation.

The Buddha is a traditional sculpture. So is the TV set in the modernist vein – a Duchampian Readymade that still possesses an iconoclastic Dada charge. But the image on the screen is not sculpture, at least not traditional sculpture. At least, not yet. An old established medium contemplates a new, still problematic medium.

The Buddha sculpture from a bygone age contemplates the TV Buddha of the modern age. The image does not change; it is transcendent.

Television fuels our consumer society. It aims to deliver consumers to suppliers. The primary images on television are the commercials. What is Paik selling? Spirituality in a materialistic world.

That was the message of the Counterculture in the 1960s.

Beatitude. The Buddha was its icon. Television was spurned because it was a commodity-crazed spectacle. If commercial television was an opiate, Paik subverted its mind-drugging programming, turning it against itself. At the same time, he created an alternative television whose aim was to truly "humanize electron-

TV-Buddha, Installation Kölnischer
Kunstverein, Cologne 1977

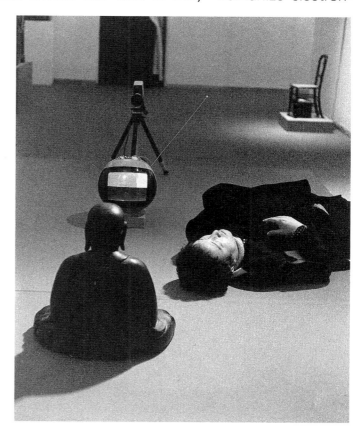

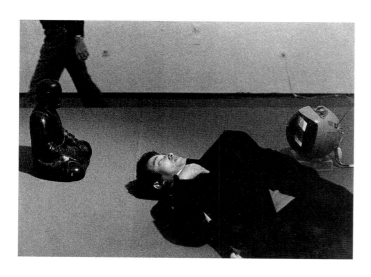

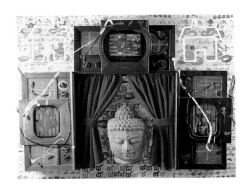

Homeless Buddha, 1992
Courtesy Carl Solway Gallery, Cincinnati

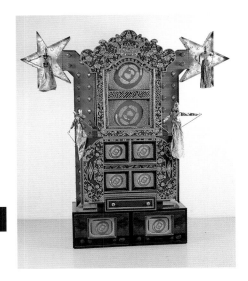

Buddhamorphosis, 1992
Courtesy Carl Solway Gallery, Cincinnati

ics". Paik was, then, the consummate Counterculture artist.

John Cage, the prophet of "joy and revolution", was Paik's Buddha – and a guru of the Counterculture. The Cagean Buddha annihilates the self. Paik also believes that in the future, society will be "egoless. ... Many people are giving up acquisitiveness in terms of money and material comfort; next stage is to give up acquisitiveness in fame. Of course, Fluxus people, including myself, are vain and do have ego. I know that. Is very, very hard."

The Buddha is all serenity. But as you are drawn into its calm, the other – absent – aggressive side of Paik's work flashes into mind. Etude for Pianoforte, 1960, in which Paik jumped off the stage and with a large scissors attacked Cage, cutting off his necktie, among other violent gestures. Killing the Buddha you love. No wonder Allen Kaprow called Paik a "cultural terrorist". (But then Zen isn't all passive. When Paik spent three days in a monastery in Japan, the head monk struck him repeatedly with a long stick.)

The Buddha's otherworldly being calls into mind the absent corporeal body – and sexuality. Cello Sonata No. 1 for Adults Only, 1965, in which Charlotte Moorman appeared playing phrases of a Bach cello sonata. On finishing a phrase, she removed a piece of her clothes. She ended up on the floor, completely naked, playing her cello, which was on top of her.

The last line in Paik's Electronic Opera No. 1, 1969, was Paik's voice announcing: "Please follow instructions. Turn off your television set."

Postscript

In Zen for TV, 1963-75, another work that keeps coming to mind, a single, centered, vertical line – the beatific vision of Barnett Newman – replaces the Buddha on the television screen. Barny Buddha, friend of Cage Buddha, meets Paik Buddha.

The quotes in this essay come from Calvin Tomkins, The Bride and The Bachelors (New York: Viking, 1965), p. 137, and The Scene: Reports on Post-Modern Art (New York: Viking, 1976), p. 205, 216, 219.

VITTORIO FAGONE
NAM JUNE PAIK E IL MOVIMENTO FLUXUS. TRA EUROPA E AMERICA, ORIGINI E SVILUPPI DELLA VIDEOARTE

Wuppertal, nel 1963, e New York, nel 1965, sono il luoghi ai quali ormai si assegna l'avvio "storico" della ricerca video attraverso l'opera di due artisti del movimento Fluxus: Nam June Paik e Wolf Vostell. Paik e Vostell nella Galerie Parnass di Wuppertal destrutturano il nuovo "utensile" televisivo, di cui avvertono l'enorme potenzialità massificatrice, scomponendo i supporti meccanici ed elettronici dentro una diversa evidenza. Paik, due anni dopo a New York, avvalendosi della possibilità di accesso al nuovo mezzo di ripresa, consentita dalla prima telecamera portatile amatoriale, il port- pack della Sony, sperimenta una sintesi di ripresa, consentita dalla prima telecamera redefinitoria dell'immagine elettronica.

I due momenti devono essere incrociati per una reale comprensione della ricerca video di questi anni in quanto destrutturazione critica degli elementi stabili della comunicazione televisiva e costituzione di una nuova immagine, dialettica rispetto a quella della convenzione figurativa, risultano due costanti sempre riconoscibili. Una strategia di tale tipo si accorda con la poetica di Fluxus che ha

due obiettivi fondamentali: stabilire un nuovo ambiente culturale-sociale, utile per la circolazione veloce a ogni livello di una nuova comunicazione estetica in grado di ridurre la distanza tra artisti e pubblico sollecitandone il reciproco impegno dentro un unico campo di creative relazioni linguistiche, e opporre ai canoni e alle convenzioni dell'arte istituzionale nuovi aperti modelli in grado di stabilire una totalità inedita, ridefinitoria di comportamenti estetici e di permutazioni attive dei linguaggi.

Se Vostell e Paik hanno avviato una linea di ricerca che ha sollecitato gli artisti visuali a misurarsi, senza soggezione, con il nuovo utensile elettronico come strumento utile di una espansione della dimensione delle immagini visuali capace di coinvolgere in una spazialità virtuale, tempo storico e tempo interno dell'operatività artistica nella dimensione, inedita, del tempo reale, che non può certo considerarsi esaurita dallo scenaria artistico attuale profondamente mutato, bisogna ricordare l'influenza decisiva che sulle pratiche della ricerca video hanno avuto le teorizzazioni e le sperimentazioni, fondamentali del resto per tutto il movimento Fluxus, di John Cage.

Paik ha più di una volta dichiarato che senza Cage, la ricerca video non avrebbe potuto realizzarsi. E' lecito chiedersi cosa Cage ha potuto fornire alla nuova area sperimentale entro la quale Paik ha poi lavorato con l'assiduità e felicità di risultati che tutti conoscono. Cage ha sicuramente dimostrato la possibilità di un diverso atteggiamento nei confronti di elementi disomogenei che possono tuttavia essere orientati verso una particolare congruenza e organizzazione linguistica; ha poi praticato una riflessiva ironia spinta fino alla utilizzazione di un negativo strutturante (suono/silenzio) come in Paik immagine unita/immagine dispersa e frammentata, in un rovesciamento di posizioni. Certa è anche l'influenza delle sonorità concrete, e alla lettera "attive" di Cage, che poi la ricerca video ha utilizzato in un crossing altamente ridefinitorio tra immagini e azioni performative. Il valore della sezione sonora dell'audiovisuale elettronico è il risultato esaltato da questa precisa consapevolezza.

Anche Vostell ha sostenuto che se Fluxus espande alcune tipiche tensioni dell'happening degli anni Cinquanta, in un coinvolgimento totale del rapporto arte-vita secondo un parametro che risulta fondamentale di tutte le avanguardie del secolo, è la scelta della musica, come campo di tensioni e di azioni, di persone in movimento e di immagini stabili ma anche di riflessioni nello stesso tempo aperte e riformulanti, che costituisce il carattere distintivo della nuova area sperimentale.

Se non sono da trascurare, come più volte ho cercato di sottolineare, i rapporti tra le prime forme di video e le esperienze già mature del cinema sperimentale europeo e americano, al quale un contributo determinante è venuto dagli artisti visuali, la relazione particolare tra area sonora, campo privilegiato dell'esperienza Fluxus e le tensioni innovative performative, contribuisce a dare specificità linguistica al nuovo modello di comunicazione artistica.

Strategie della ricerca video: destrutturare-strutturare

Quando Nam June Paik e Wolf Vostell dichiarano che le chiavi per comprendere ragioni e sviluppi della ricerca video vanno ricercate nella complessa e libera poetica – ma sarebbe più esatto parlare di strategia – del movimento Fluxus, danno un'indicazione che difficilmente può essere messa in discussione solo che si consideri l'indiscutibile e fondamentale contributo dato da questi due autori alla nascita della videoarte o il valore ridefinitorio del contagio tra

► Paik watching Fish Flies on Sky
Photo Timm Rautert

►► Video Fish (Detail), 1975–77

Fish Tales, 1986
Private Collection

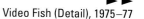

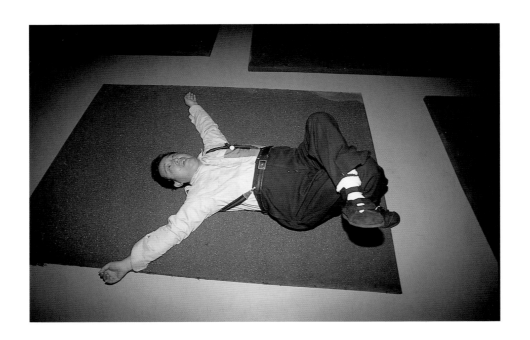

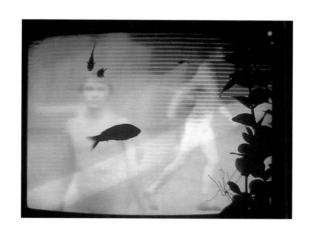

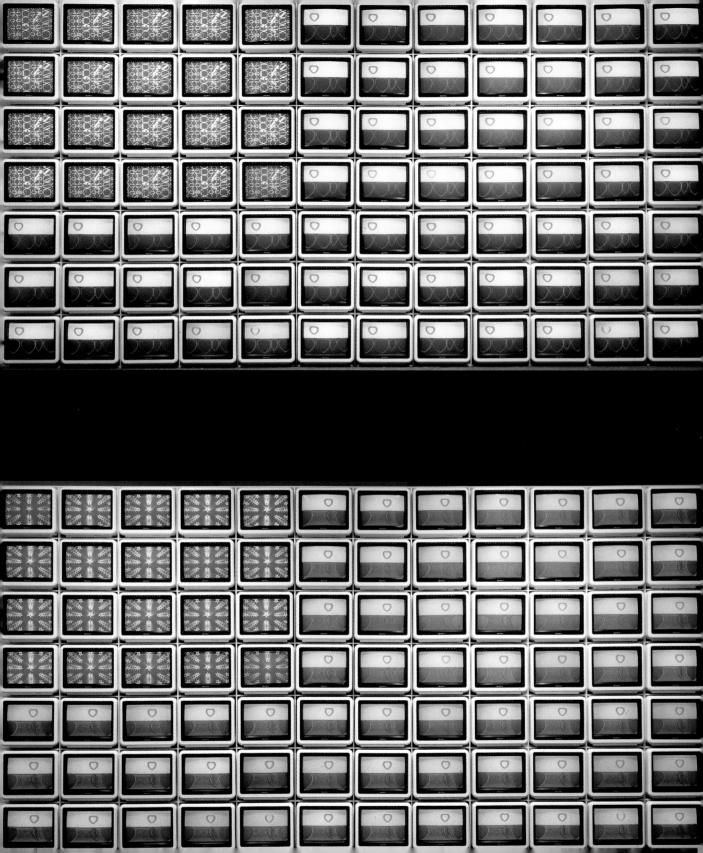

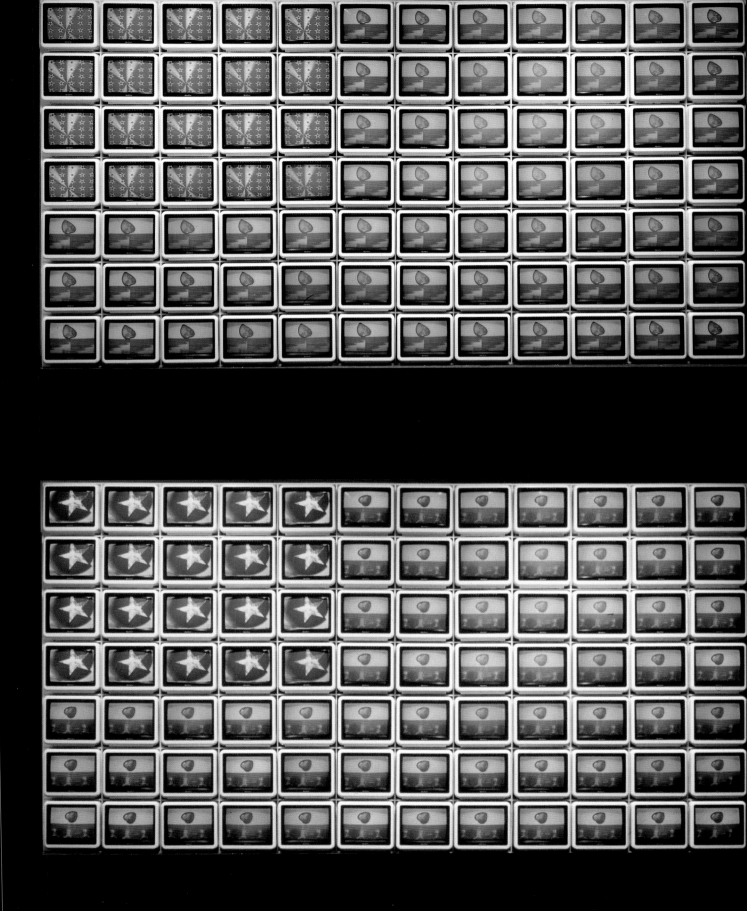

diversi linguaggi artistici e modelli della nuova comunicazione, sostenuto e praticato, almeno nei primi anni di attività, da tutti gli artisti del nuovo movimento, Paik e Vostell compresi.

Nell'assumere questo dato come non contestabile, bisogna però, a mio giudizio, tener conto di tre elementi non meno rilevanti: 1) Fluxus nasce, alla fine degli anni Cinquanta negli Stati Uniti dove viene considerato una intellettualistica manifestazione tardodadaista, incline a "pericolose" utopie anarco-comuniste e per questo osteggiato o emarginato. In Europa invece, e particolarmente in Germania, la reale attitudine dialettica e innovativa del movimento trova aperti spazi di intervento e, per quanto non generalizzati, positivi riconoscimenti da parte della critica; 2) La reale vita, e inerenza storica, del movimento Fluxus, come sostenuto da Shigeko Kubota (Video d'Autore, Taormina Arte, 1990) deve considerarsi conclusa al 1974 quando scompare George Maciunas e con lui anche il movimento. Oltre quella data, restano certo le singole individualità operanti degli "artisti Fluxus", ma non possono essere presi in seria considerazione né gli accomodamenti di autori epigonisti o replicanti, né il "pentitismo" tardivo di collezionisti, mercanti e critici a riconversione paradossa; 3) Negli anni Sessanta e almeno fino alla metà degli anni Settanta, il campo maggiormente disponibile, se non d'elezione, delle diverse sperimentazioni d'avanguardia risulta quello delle arti visuali che accettano, e in molti casi promuovono, un attivo scambio tra espressioni mediali dei nuovi linguaggi della comunicazione, arti visuali convenzionali e arti performative.

Se si tiene conto dell'insieme di questi dati, la ricerca video assume le connotazioni di una dialettica e veloce progressione piuttosto che l'amèbica indefinitezza di un ingenuo e astorico spazio periferico, sospeso, in una sorta di limbo, tra linguaggi artistici ad alta densità espressiva e modelli della nuova comunicazione tiepidamente inerti se non freddi come ipotizzava McLuhan.

Detto in termini più espliciti, i quasi trent'anni che separano lo scenario attuale dalle prime presentazioni di opere video di Nam June Paik e Wolf Vostell alla Galerie Parnass di Wuppertal non sviluppano una prospettiva unilineare. La vivace dinamica del nuovo movimento di ricerca, caratterizzata da una reale e costante internazionalità, presenta momenti, attitudini e strategie diverse che oggi risulta importante isolare per una corretta compresione del fenomeno nella sua storia e attualità.

Riconsideriamo gli avvii. Cosa presenta Paik a Wuppertal per tentare di spiazzare e ridefinire l'immagine elettronica, monopolizzata dalla televisione e sotto ogni forma preclusa agli artisti nonostante l'evidenza del dato visuale costitutivo? Paik deforma su tredici monitor in altrettante differenti maniere un'immagine televisiva in bianco e nero intervenendo sulla modulazione luminosa di questa immagine tanto in senso orizzontale che verticale. L'obiettivo destrutturante dell'operazione à chiaro. L'immagine elettronica è esaltata nella sua qualità luminosa primaria ma, alla lettera, contrastata nella sua apparenza televisiva di immagine assolutamente veridica e quindi unica.

Quando Paik nel 1965 può finalmente intervenire non solo sul dispositivo di trasmissione, il monitor, dell'apparato audiovisuale elettronico, ma anche su quello di ripresa, la telecamera, utilizzando il portpack, dimostra – nel video girato a New York e intitolato, con una significativa indicazione del luogo di ripresa, Café Gogo, 152 Bleeker Street, October 4 and 11, 1965 – di quale ridefinitoria soggettività può caricarsi la ripresa di uno spazio di vita dall'apparenza banale. Paik nella sua formazione passa dalla Co-

◄
Video Flag X, 1985
Los Angeles County Museum

rea, in cui è nato, a Tokyo, e quindi, nel 1957 in Germania (prima a Monaco poi a Colonia) seguendo un itinerario strettamente legato alla ricerca musicale d'avanguardia. E' in Germania che avviene il suo incontro decisivo con Fluxus, e in particolare con John Cage, da cui prende avvio una creativa deriva tra i diversi linguaggi artistici, praticata attraverso e nello spazio del video.

L'attitudine destrutturante è forse ancora più netta nell'opera di Wolf Vostell, anch'egli tra gli artisti dell'esposizione alla Galerie Parnass e già dalla fine degli anni Cinquanta riconosciuto come una delle figure di maggiore spicco di Fluxus, che nei TV decollage interviene violentemente nella decomposizione-ricomposizione di immagini estrapolate da programmi televisivi di larga diffusione.

Nel rapido giro di pochi anni la ricerca video sposta comunque il suo baricentro dall'Europa negli Stati Uniti da cui, come si è accennato, la matrice catalizzatrice, Fluxus, era stata espulsa. Mentre il radicamento della ricerca video in Europa è infatti affidata al pionierismo generoso di galleristi-promotori come Gerry Schum, che prima a Berlino poi a Düsseldorf e quindi all'interno del Museo di Essen, propone un originale modello di VideoGalerie in grado di produrre, presentare e archiviare video d'artisti, negli Stati Uniti si aprono, anche se solo per un breve periodo, prospettive di ben altra portata.

Video versus televisione, ieri e oggi

Ho di recente potuto intervistare a lungo Wolf Vostell sulle ragioni che ispiravano, già in quel primo periodo, la dichiarata avversione degli artisti del video contro la televisione. Accanto alla motivazione, comunemente accertata, della necessità di un'opposizione all'uso massificato del nuovo medium, Vostell ne aggiungeva una più direttamente esplicativa. Alla fine degli anni Cinquanta e nei primi anni Sessanta, attraverso gli studi di Radio Colonia, era stato possibile avviare un'operazione di innovazione musicale radicale, con il contributo del giovane Stockhausen e di Nono (e al quale collabora lo stesso Paik), di portata fondamentale per la nuova musica elettronica. Struttura radiofonica e struttura televisiva nella Germania Occidentale di quegli anni coincidono.

Perché si rivela subito impossibile realizzare sul medium elettronico la stessa riflessione creativa e critica che viene fatta utilizzando risorse e canali del medium acustico?

Al di là del feticismo dell'audience, coltivato precocemente da tutte le televisioni, commerciali e pubbliche, al di là della necessità di mantenere un regime di massima stabilità conservativa, non solo formale ma sociale, della televisione, la domanda resta ancora senza risposte. Così non è azzardato oggi affermare che la reale cultura espressiva del nuovo medium si è sviluppata nell'area del video come un'ipostasi, esterna al mondo della televisione.

Negli Stati Uniti, almeno agli avvii, la situazione è diversa. Nel 1965, anno in cui Paik già opera a New York, la Rockefeller Foundation assegna alla catena televisiva di Boston WGBH 275 mila dollari per la promozione di programmi televisivi sperimentali affidati ad artisti e ricercatori (si badi, non su artisti, ma di artisti).

I programmi realizzati vengono regolarmente trasmessi. Presto verso queste forme di avanguardia si rivolge l'attenzione, non l'entusiasmo di un Gerry Schum, di galleristi accorti e influenti come Leo Castelli. La questione del rapporto tra video e televisione, in Europa come anche in America, resta oggi spinosamente aperta.

A parte la dimostrata disponibilità di Channel Four in Gran Bretagna, di Canal Plus in Fancia, del programma Videographie in Belgio, è difficile ricavare indicazioni che inducano a qualche ottimismo. Per quanto riguarda la televisione pubblica del nostro paese – di quella privata non è possibile neppure accennare – sarà bene ricordare che la Rainon ha mai avuto il coraggio di mandare in onda le rare produzioni sperimentali che pure ha realizzato, e che gli artisti ha sempre preferito piazzarli davanti anziché dietro le telecamere a sperimentare le risorse di una nuova visualità, con il risultato, ogni giorno sotto gli occhi di tutti, di un generale appiattimento.

Esiste tuttavia un dato certo: i quasi trent'anni di innovative e significative ricerche del video dimostrano che questo può, anche se appare irragionevole, fare a meno della televisione senza perdere di velocità comunicativa né di efficacia. Fino a quando, è lecito domandarsi, la televisione potrà rinunciare a esplorare una cultura creativa anziché riproduttiva del medium che utilizza, senza definitivamente rassegnarsi ad essere un generico, e spesso improprio, contenitore?

Se la relazione video-televisione resta ancora, nel panorama europeo, bloccata o obliquamente attiva solo in alcune zone marginali (sigle, spot, clip), mutata risulta oggi la relazione video/arti visuali che pure agli avvii, come si è accennato, ha avuto un ruolo fondamentale per le referenze e le inerenze a specifici modelli linguistici e metalinguistici (dall'arte concettuale alla body art) e per lo spazio di attenzione che ha saputo offrire.

Il ritorno alla materialità delle immagini dipinte che si ha alla fine degli anni Sessanta e la perdita di velocità delle ricerche immateriali e comportamentali nell'area visuale (si pensi al declino della performance) coincidono con l'abbandono del video da parte di alcuni artisti e con una larga disaffezione da parte degli spazi avanzati di promozione artistica. Questa situazione, che stabilisce anche un naturale processo di selezione rispetto a molte curiosità esterne e disinvolti opportunismi, libera la ricerca video da una dipendenza troppo stretta verso l'area visuale.

Il legame con le arti visuali, anzi la specifica inerenza, resta produttivo nelle videosculpture e videoinstallazioni, area in cui oltre al lavoro coerente di maestri come Paik, ben rappresentato in questa esposizione romana, si afferma anche una generazione nuova, capace di una declinazione ed espansione ambientale del video, lucida e soft. Agli inizi degli anni Novanta, più che a una dura e dialettica contrapposizione alla televisione, la ricerca video dei maestri riconosciuti e dei giovani autori, pare proporsi come una diversione sofisticata e creativa.

L'immagine elettronica risulta, nel video, in grado di stabilire un attivo regime di scambi con le espressioni degli altri linguaggi artistici e della comunicazione mediale, senza sudditanze o imposizioni, entro i mobili tracciati di una nuova forma di rappresentazione mediale, senza sudditanze o imposizioni, entro i mobili tracciati di una nuova forma di rappresentazione immateriale, intelligente, complessa oltre che seducente.

Fluxus

Il primo evento Fluxus della storia si può far risalire forse alla fine del secolo scorso. Attorno al 1880 quando vennero stesi i primi cavi di telecomunicazione atlantici.

Come sapete per comunicare tra Washington e Londra ci volevano almeno sei mesi. Andata e ritorno! In seguito, quindi, si dovette procedere a collegare con i cavi Londra all'America. Cavi sotto il mare. Le navi americane dovevano incontrarsi nell'Oceano e "darsi

la mano" per attaccare i rispettivi cavi. Naturalemente per far questo ci vollero ingenti risorse economiche. Si misero in vendita pacchetti azionari a Londra e New York e in tutto il mondo così da poter finanziare questo progetto. Ci vollero anni per trovare tutto il materiale necessario a studiare i cavi che avrebbero collegato i due Paesi. Questi si incontrarono, finalmente, in mezzo all'Oceano Atlantico per unire i cavi. Ma quando stavano per congiungersi, una delle due parti, credo quella americana, perse i propri cavi e il tanto atteso evento sfumò. Andarono così perduti 4.000 km di lavoro.
Questo episodio lo considero veramente un "evento" Fluxus: un momento importante nell'idea Fluxus. La perfezione che diventa errore, che si trasforma in errore. Arrivare alla fine e dover ricominciare dall'inizio.

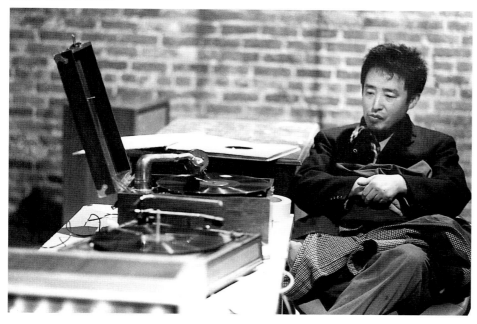

Nam June Paik performing "Flux Sonata 4"
New York 1975
Photo Peter Moore

Video, Comunicazione, Tecnologia

E' importante lavorare su due livelli di comunicazione, reciproci e interattivi perché la comunicazione unilaterale, "one way", è molto comune.
Oggi credo a esempio che i meccanismi della teleconferenza aprano prospettive interessanti. Anche perché rispetto al satellite è molte più economica. I problemi che incontrammo col satellite potevano forse essere superati dalla teleconferenza, ma allora, nel 1984, questa tecnologia non era ancora molto sviluppata.
La prima idea "satellitante" che ebbi riguardava la possibilità di far danzare Merce Cunningham con Baron. Fui abbastanza naif. Contattai Baron chiedendogli se volesse improvvisare con Merce Cunningham ... I grandi nomi ... Ma lui disse che doveva andare a una festa di Campodanno. La verità è che l'evento non garantiva sufficientemente la loro professionalità a reputazione. Nel loro caso, infatti, si trattava di improvvisare senza prove e il pubblico avrebbe potuto scambiare la performance per una specie di competizione tra due illustri personaggi.
La stessa cosa avvenne tra Beuys e Cage, ai quali chiedemmo di suonare insieme un duetto al pianoforte. Immaginate? Beuys e Cage ... L'evento del secolo! Ma Beuys esitò. Da una parte c'era Cage che aveva sviluppato, nel corso di tanti anni, uno stile personalissimo; dall'altra Beuys che aveva un suo programma artistico preciso. Era impensabile che essi cambiassero improvvisa-

mente il loro stile. E fu lo stesso con Beuys e Allen Ginsberg ... Per loro la televisione non era molto importante. Sono stato io a trascinarli. Erano molto occupati. Così quando chiesi loro di venire dissero di sì. Ma non presero mai il progetto sul serio. Al contrario Laurie Anderson prese molto sul serio Good Morning Mr. Orwell perché lei è un'artista multimediale.

Per un giovane artista usare oggi gli strumenti della teleconferenza potrebbe significare sperimentare una nuova forma d'arte. Del resto ho scoperto che la comunicazione "two way" è molto più importante della stessa comunicazione "dal vivo". Sono arrivato a questa conclusione dopo aver speso un milione di dollari e otto anni di ricerche sul satellite. La diretta tra un uomo e un altro avviene sempre dal vivo (uno di fronte all'altro). La macchina cela sempre qualcosa, come i vestiti celano gran parte dell'informazione che da tutto il corpo potrebbe scaturire. Lo studio dei costumi è molto interessante per chi si occupa dei media perché, in qualche modo, ci si deve occupare del trucco, di ciò che è nascosto.

Nel 1984 ho preso una posizione. George Orwell affermava che la televisione era comunque negativa. Io al contrario affermai che la televisione non era sempre nagativa, che non era il "Male". In Good Morning Mr. Orwell dicevo proprio questo: sono stato il solo al mondo ad affermarlo, e ne sono orgoglioso.

Ho sempre aspettato che le apparecchiature divenissero più accessibili economicamente. Nel 1964 tentai di lavorare con la tecnologia digitale, ma a quei tempi, il computer costava milioni di dollari e solo l'industria militare aveva quel tipo di computer. Dovetti aspettare che la tecnologia diventasse più economica per poterla usare e questo avvenne nel 1967. Questo è il mio rapporto con l'hardware e le industrie produttrici: aspettare che i prodotti diventino più economici. Posso aspettare anche vent'anni.

Insomma, se si parla di tecnologia e arte occorre parlare di soldi. In questo campo è un po' come nell'industria cinematografica. Si deve iniziare con i soldi. Del resto noi utilizziamo degli studi di post-produzione che costano migliaia di dollari al giorno e non possiamo permetterceli. Occorre trovare dei sostenitori che ci consentano di utilizzare tecnologie, che ci affidino gli strupenti per portare avanti il nostro lavoro.

Del resto è anche vero che le grandi aziende hanno bisogno di noi. Ci affidano le nuove tecnologie per sperimentarle, per verificarne i limiti. Questo anche perché non si possono permettere di farlo fare agli scienziati. Quindi spesso siamo noi, gli artisti, a sperimentare nuove tecnologie.

Il velocissimo computer che usiamo, originariamente fu sviluppato e prodotto per il sistema di guida dei missili. Se un computer soddisfa le esigenze militari è ovvio che può trovare delle applicazioni per gli spot televisivi: le macchine sono neutrali. L'industria militare può sviluppare la tecnologia perché possiede le risorse economiche necessarie.Del resto lo stesso Marconi venne sostenuto dalla Marina Britannica.

L'industria militare sviluppa le tecnologie. Io non amo i militari, ma abbiamo bisogno di fondi per sperimentare nel nostro settore: non dico che sia un bene o un male, è il nostro destino. D'altra parte, tutto il XX secolo è stato segnato da una grande competizione: quella tra la tecnologia dei media e l'arte. E gli artisti sono stati insieme i sacerdoti, le vittime e le antenne della sfida.

Nam June Paik performing "Violin with String" ("Violin to be dragged on the street") 1961-75, Twelth Annual New York Avant-Garde Festival, September 27, 1975

Photo Peter Moore

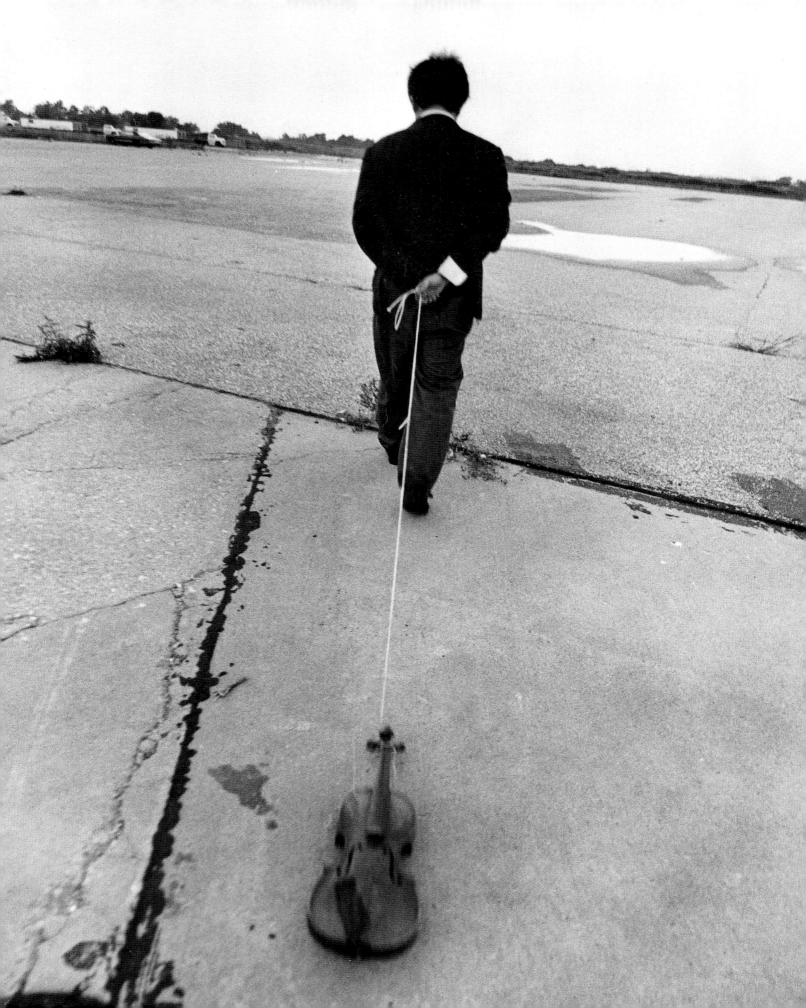

Storia, Memoria

Gli artisti conoscono più del futuro che del passato. Non sempre è così, è vero, ma generalmente credo di sì. Gli artisti sono stati l'avanguardia dei grandi cambiamenti; non sempre siamo nel giusto ma lo siamo sicuramente più di altri.

Io conosco il mio ruolo: qualcosa che sia tra lo sviluppo dell'hardware e quello del software. E quello che so è che mi riesce bene fare da interfaccia.

Noi tutti desideriamo una certa sicurezza e una vita migliore. Abbiamo bisogno di conoscere qualcosa del futuro e più conosciamo del passato, più possiamo dirci sicuri. Conoscere il passato, cioè la memoria, significa capire e vedere il futuro.

La memoria è una serie di curve, un radar qualcuno dice, tra il passato e il futuro. Noi siamo qui nel presente, conosciamo il passato, possiamo provare a capire il futuro. Ma non possiamo conoscere il presente. La memoria quindi è molto importante per conoscere il futuro. Ecco perché dedico almeno due ore al giorno alla lettura dei giornali.

Io guardo all'influenza esercitata dalla cultura sciamanica nordcoreana con grande interesse. Una volta ero a tavola con uno studioso canadese che si occupava di indiani americani. Gli chiesi a quale tribù di indiani sarei appartenuto se fossi nato in America. Mi disse senza alcuna esitazione agli Eschimesi. Così ora so che appartengo alla tradizione sciamanica siberiana. Per me, comunque, questo è anche un legame con l'infanzia. Gli sciamani infatti sono quello che io ricordo della mia infanzia.

Ma sulla carta stampata va diversamente ... Tutta la storia scritta retrocede fino all'individuazione di una "prova". Ciò significa all'invenzione dell'agricoltura, all'età dei metalli. Ma questo è soltanto un brevissimo periodo nella storia dell'umanità. Prima di allora abbiamo vissuto milioni di anni. Prima delle "prove" scritte e archeologiche è tutto memoria audio-visiva. Più lavoro con il video più conosco questa parte della Storia. L'Età della Pietra, il Neolitico. Questo periodo della nostra storia è il più importante perché è il più lungo. Milioni di anni.

E' il motivo per cui tutta l'esperienza videoartistica e audiovisiva di questi anni mi aiuta a entrare nella storia delle cose umane. Gli artisti sono molto bravi nell'esercizio della memoria. Tutta l'esperienza accumulata dell'audiovisivo, della musica e dei video dall'inizio a oggi mi permettono di entrare nella memoria della storia. Del resto il nostro cervello è fatto così, come un nastro magnetico.

Sono stato un pessimo compositore prima di incontrare Cage. La più grande influenza su di me l'ha avuta John Cage. Lui mi disse che si considerava una combinazione di Dada e di filosofia Zen della "vacuità". Per lui il Dadaismo fu importante; così per me lo furono il Dadaismo e Duchamp.

Io sono una sorta di espressionista. I miei primi pezzi sono abbastanza espressionisti. Il Futurismo l'ho conosciuto nel 1958, non prima. E' interessante perché fu il primo movimento artistico che esprimeva la componente "Tempo", e il video è Immagine più Tempo. Così il Futurismo è stato importante anche teoricamente. Il tempo influenza l'arte; così nella storia del video occorre ricordare il contributo del Futurismo.

Penso che i momenti più importanti nella cultura di questo secolo siano rappresentati dallo sviluppo del cinema e della musica Pop. Grazie a queste due forme d'espressione, che non esistevano nel XIX secolo, genti diverse hanno potuto comunicare fra loro. E questo processo non è ancora giunto a conclusione ...

(published in: catalogue Il Novecento Di Nam June Paik, Rome 1992, p. 23-29)

MACLUHAN CONTRE DUCHAMP

JEAN-PAUL FARGIER

Rose Art Memory, 1987–88
Courtesy Carl Solway Gallery, Cincinnati

Fountainebleu, 1988
Courtesy Carl Solway Gallery, Cincinnati

Mieux que Godard – Mieux qu'Einstein – Mieux que Verlaine – Mieux qu'Hitchcock, etc., c'est une série de tableaux électroniques de Nam June Paik, qui comprend également un Mieux que Paik (une téléviseur). Un des premiers gestes publics de Paik équivalait à faire avec John Cage un Mieux que Cage (l'épisode de la cravate coupée) et, peu de temps après, avec Marshall MacLuhan, un Mieux que MacLuhan (l'histoire du "massage électronique" opéré avec un aimant sur la gueule de celui qui avait déclaré: le message c'est le medium). Vingt-cinq ans plus tard, on peut voir dans ce "massage" ironique le message de tous les travaux de Nam June Paik: vive l'audio-tactile. L'audio-tactile, qu'est-ce que c'est? Il faut le demander au maître de Toronto. Dans "La Galaxie Gutenberg", Marshall MacLuhan oppose le livre imprimé à la télévision. Le livre est le moyen de communication par lequel le visuel établit son règne au détriment de tous les autres sens. Le cinéma accroît encore cet impérialisme de la vision. Avec la télévision, au contraire, on assiste au développement d'un moyen de communication qui ne fait plus exclusivement appel à la visualité. La télévision est audio-tactile. Radio à images, elle accorde au son un rôle prédondérant. Objet plastique, elle se laisse manipuler constamment (par les techniciens d'abord qui, en régie, "touchent" aux images, les mélangent, les chargent de titres, les divisent, les multiplient, les inscrivent, les transfèrent, etc. et en bout de chaîne, par les téléspectateurs qui les convoquent, les renvoient, les bousculent, dérangent leurs couleurs, bref les tiennent à la merci de cette télécommande qu'ils ne cessent de tapoter). Dès le départ, Nam June Paik crée des sons qu'on écoute avec la bouche, en suçant un drôle d'écouteur. Puis il invente une machine à tripatouiller les signaux: le synthétiseur Paik-Abe. On tourne des boutons, on pousse des manettes, et les images virent de couleur, dansent, s'agi-

Nam June Paik, 1977
Photo Peter Moore

tent, se désintègrent. Le premier qui en fera les frais sera justement le théoricien de l'audio-tactile. Hommage ou animosité? Autant que le coup de ciseau à la cravate de Cage était un hommage plus que cagien (et tactile, très tactile) aux théories de John Cage sur l'indétermination en musique, autant le massage électronique qui déforme le visage de MacLuhan peut être considéré objectivement comme une vérification plus que touchante des théories ma

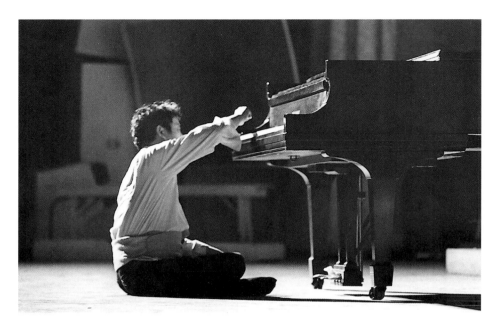

Nam June Paik, 1977
Photo Peter Moore

cluhaniennes, même si Paik prétend verbalement qu'elles ne l'intéressent pas plus que ça. Inversement, Paik ne cesse de louer Duchamp alors que chacune des œuvres qu'il invente (de ses peintures qu'on écoute à ses sculptures bourrées d'images) oppose un démenti au roi du ready made. Mac Luhan contre Duchamp? C'est la carte que joue Paik à tous les coups sans pouvoir s'en vanter (il y a une "terreur" duchampienne). L'audio-tactile brise la clôture duchampienne, qui soumet l'art au visuel. Un ready-made n'est pas audio-tactile parce qu'il n'est pas une représentation, mais le refus de toute nouvelle possibilité de représentation. Le ready made enferme la représentation dans le visuel. Duchamp, en voyant une hélice d'avion, avait dit à ses copains: "nous sommes foutus, nous ne ferons jamais mieux que ça." Paik en jouant l'audio-tactile contre le visuel, la sculpture contre la peinture et la télé contre tout le monde (Godard comme Hitchcock, Einstein comme Verlaine), prouve depuis trente ans le contraire à qui mieux mieux.

WULF HERZOGENRATH
DER PARADIGMENWECHSEL BEI NAM JUNE PAIK.
VON MATERIALITÄT ZUR IMMATERIALITÄT ZUR SCHEIN-
MATERIALITÄT

I Materialisation

Um 1960 erleben wir in der Arte Povera und bei den Fluxus-Künstlern die direkte Visualisierung der Materie. Das Feuer brennt real (Kounellis), der Wind bläst (Haacke), Der Stein formt sich zur Skulptur (Long) und das Wasser fließt (Rinke).
Bei Paik wird der Leerfilm mit seinen physischen "Fehlern", Kratzern, Spuren zum Inhalt des Film ("Zen for Film", 1964), aber auch das Gesamt-Klavier, das mit vielen tönenden Objekten besetzte "Klavier Integral" zum vielstimmigen Orchester.
Das Fernsehgerät ist als Objekt selbst Skulptur: "Rembrandt Automatik", 1963/76 (das mit der Mattscheibe nach unten liegende, scheinbar kaputte Gerät. Aber auch in seinen frühen Manipulationsmöglichkeiten, von Paik "Participation TV" genannt: mit dem

Fußschalter das laufende Programm gestört, mit dem Magneten abstrakte Bilder geformt ("Magnet TV", 1965) oder mit dem Mikrophon den Ton in Bilder umgesetzt. "Zen for Wind – objets sonores", 1963 ist eine Skulptur mit an einer Leine hängender Objekte, die bei leichten Windbewegungen Klänge von sich geben. "-Zähle die Wellen des Rheins – falls es den Rhein noch gibt", eine wunderbare konkrete Anweisung auf der viertletzten Seite der "Symphony No 5", 1965.

Für Charlotte Moorman denkt sich Paik nicht nur Objekte mit Video aus, sondern er hofft, endlich die Aufführungs-Praxis der Musik zu verändern. 1960 konzipierte er eine Aufführung der "Mondschein-Sonate" durch eine nackte Spielerin (nie von ihm realisiert). Charlotte Moorman realisierte dagegen oft ein wichtiges Wasser-Stück: sie unterbrach ihr Cello-Stück aus "Schwanensee" und stieg in eine mit Wasser gefüllte Riesentonne, um dann den zweiten Teil pitschnaß weiterzuspielen: ein elementares Seh- und Hörereignis: das Stück klingt nicht nur anders danach, man empfindet den realen Wassereinbruch physisch auch als Beobachter.

Die Plastikhülle der ersten von Paik verwendeten Video-Spule wird von ihm zum Objekt erklärt "A painting which exists two times a second", 1965, und ein altes Backform- Holzgerät wird zu einem "First transportable TV", 1975, umgemalt, oder aber die Kerze in ein völlig entleertes TV-Gehäuse gestellt und entzündet: "Candle TV", seit 1975: die reale Kerze erleuchtet die Realität des Fernsehers.

Paik vollzieht hier wie andere in anderen Bereichen der Kunst eine klare Position der Materialisierung der Objekte, die pur und direkt sich entfalten.

II Entmaterialisierung

1969 hat Paik mit Shuya Abe den ersten Video-Synthesizer entwickelt: künstliche Bilder entstehen ohne Kamera, rein synthetisch, und alle vorhandenen Bilder können in jeder Form manipuliert, verändert werden: der Sprung in das Immaterielle ist getan: die künstlichen Bilder werden noch ungreifbarer. Die Geräte lassen nicht die Bilder ahnen, der Computer trennt sich von seiner Botschaft.

Bei den großen Skulpturen und Environments wird nicht mehr die äußere Skulpturform des TV-Gerätes wichtig, sondern der elektronische Bildschirm wird Träger der Bildinformation, das Gerät verschwindet hinter Urwaldblättern ("TV-Garden", 1924), hinter Aquarien mit Guppie-Fischen ("Fish-Art", 1975), im Dunkel des weiten, hohen Himmels ("Fish flies on Sky", 1975), oder als Feuer-Licht-Projektionen (Raum "Eine Kerze", 1989). Die TV-Bildschirme sind auf dem Boden liegend, nach oben strahlend und versteckt – oder sie hängen schwebend an der dunklen Decke, oder sie sind streng gereiht, um nur als Bildschirm-Reihe zu wirken. Das Dreidimensionale des Geräts, die Hülle, wird unwichtig, das Plastische des Gerätes wird verdrängt, überspielt, selbst immateriell, oder es wird sogar die Projektion bevorzugt, die sich immateriell von jedem Objektträger abzulösen scheint und im Raum sich auch vielfach übereinander kombinieren läßt.

Paik wird fasziniert von der Idee der "Satelliten"-Übertragung, seine erste Arbeit ist auch ein wichtiger Teil der ersten Satelliten-Übertragung von Kunst überhaupt: die Eröffnungsaktionen von Beuys, Paik und Davis zur Eröffnung der documenta 6, 1977, in Kassel, als Paik eine Art Miniretrospektive seiner Arbeiten durchspielt: dabei aber auch ein wichtiges neues Stück für dieses neue immaterielle Eröffnungsereignis entwickelt: das Klavierspiel mit der

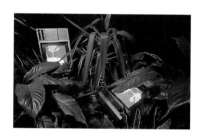

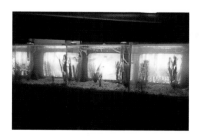

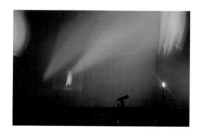

schwarz-weiß-Handkamera: Bild und Ton sind identisch und doch ist es für den Betrachter kaum vorstellbar, wie sich materiell Bild und Ton zueinander verhalten. Danach wird es von Paik noch drei weitere Satelliten-Ereignisse geben: "Good morning Mr. Orwell", 1984; "Bye, Bye Kipling", 1986, und "Wrap around the world", 1988. Die Gleichzeitigkeit der Ereignisse, das Zusammenspiel durch Luft und Zeit von Musikalischem und Szenischem, Paik fasziniert es.

III Schein-Materialität

Seit 1986 entsteht die "Family of Robots" mit vielen Generationen und Familienmitgliedern: Großeltern und Tanten, viele Babys und dann die Helden der Französischen Revolution sowie Freunde und Künstlerkollegen, Reiter und Autos werden geformt und immer aus entsprechenden TV-Kästen zusammengesetzt und mit jeweils passendem Bildmaterial visualisiert. Hier materialisiert sich eine dreidimensionale Gegenstandsform, und zugleich bleibt eine immaterielle Ebene nicht nur im Bild auf den vielzähligen Bildschirmen erhalten: eine eigentümliche neue Schein-Materialität.

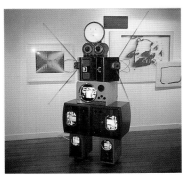

Diese Schein-Materialität klärt sich auf: es ist die Als-ob-Welt der Medien, die sich eben nur scheinbar hier materialisiert als "Fountain", in dem eben doch kein Wasser, sondern "nur" blaue Neon-Linien herunterplätschern, der Baum sieht ebenso aus und formt sich als Tannenbaumzeichen, aber eben nicht als wirklicher Rund-um-Baum, und vielleicht zunächst erst gar nicht bemerkt: das "Feuer" der Zerstörung der TV-Geräte hat nicht die Geräte versengt, sondern nur als Schein gewütet: die Geräte sind nicht verbrannt (wie das Objekt "Burnt TV – für Bob Durham", 1976), sondern "nur" zerstört und am Boden verteilt: das Feuer wütet "nur" auf den Bildschirmen, das Reale wird nur dargestellt, simuliert.

Dieses ironische Spiel mit der Form des "als ob" ist Paiks kleiner Beitrag zur postmodernen Diskussion. Indem er die Nähe und die Personifizierung so weit treibt, daß viele dies als zu nah empfinden, baut er kleine Distanz-Schwellen ein, die so subtil sind, daß sie kaum wahrgenommen werden.

Hermann Pollig gewidmet zu seinem Abschied vom IfA, Stuttgart am 30.4.93. für den Biennale-Katalog der Bundesrepublik Deutschland in Venedig 1993 geschrieben.

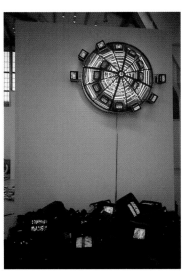

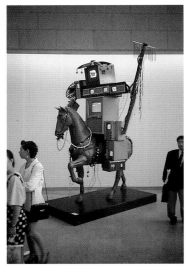

Zen for TV, 1963

Klavier integral, Performance by Nam June Paik, Kölnischer Kunstverein, Cologne 1976

Earth: TV-Garden , documenta 6, Kassel 1977

Air: Fish flies in Sky, 1976, Whitney Museum of American Art, New York 1982

Water: Fish TV, 1976, Kölnischer Kunstverein Cologne 1976

Fire: One Candle, Museum für Moderne Kunst, Frankfurt 1988

Dematerialisation: Laser projection (with Horst H. Baumann) and Videotape "Merce", Kölnischer Kunstverein, Cologne 1976

Aunt from: Family of Robots, 1988
Holly Solomon Gallery, New York

Don Quichotte, 1992
Museum of Modern Art, Seoul

The planet Mercury and the fire, detail of the installation for the exhibition "Feuer, Erde, Wasser, Luft", Mediale, Hamburg 1993

Photos W. Herzogenrath

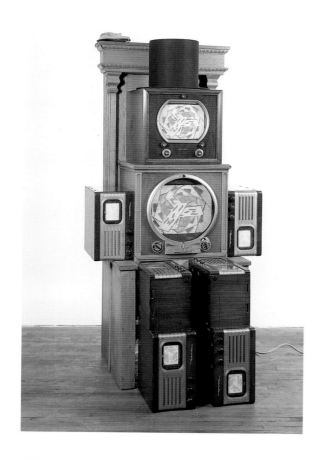
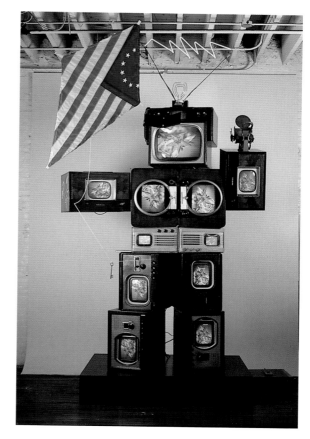
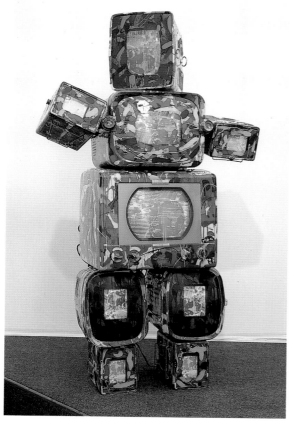
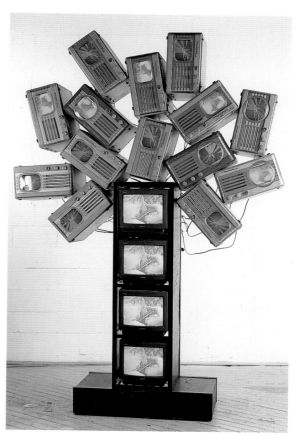

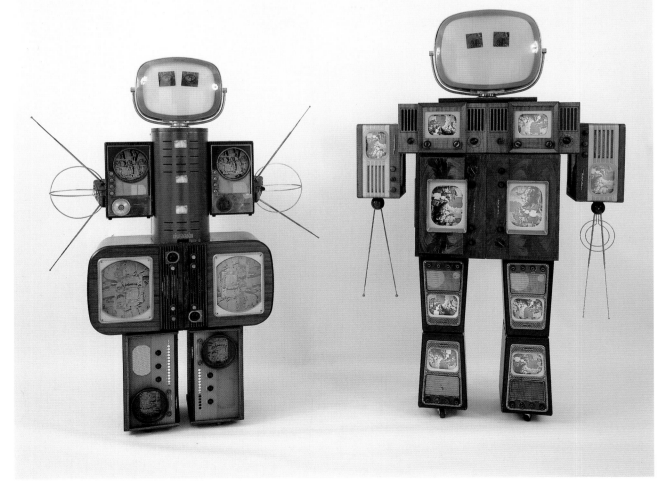

ACHILLE BONITO OLIVA
IL DORMIVEGLIA DELL'ARTE IN NAM JUNE PAIK

La video-installazione rappresenta la fondazione da parte dell'arte di un crocevia di spazio e tempo insieme.

L'artista contemporaneo, in questo caso alla fine del XX secolo, riassume dentro la propria opera gli stimoli, gli sconfinamenti linguistici verso una dimensione di arte totale.

La totalità è l'approdo di un lungo viaggio realizzato dal lavoro creativo a partire dal Barocco, passando attraverso il teatro wagneriano per giungere fino a noi dove l'artista diventa artefice di uno spazio scandito dal tempo reale e caratterizzato da una pluralità di materiali.

La video-installazione è la fondazione di un campo di architetture miniaturizzata, giocata sulla contaminazione, l'assemblaggio, il cortocircuito di diverse materie intorno al progetto di un percorso.

Tale percorso costituisce la struttura disseminata di un'opera risolta con la stabilità di alcuni materiali e con la mobilità elettronica di altri.

La dialettica tra la stabilità e dinamismo costituisce l'elemento di rinvio all'architettura, ad uno spazio abitato dalla complessità, dalla differenza e dallo spostamento. Lo spettatore si trova di fronte ad una unità urbana, intesa come presentazione di un artificio trificio tridimensionale ed in qualche modo abitabile.

L'abitabilità della video-installazione può essere frontale e puramente contemplativa, osservabile dall'esterno, oppure percorribile ed esperenziale, frutto di un movimento polisensoriale del corpo che si inoltra nel labirinto dell'opera.

Se nell'installazione normale è il corpo dello spettatore a costituirsi come termometro e clessidra vivente, che scandisce temperatura e temporalità dell'opera nella videoinstallazione à il flusso cinetico dell'immagine a documentare un tempo duplice. La duplicità è data da une doppia possibilità di misura. Una dettata dalla cadenza interna della tecnologia e l'altra dall'incontro con essa dei materiali fermi su sé stessi e del pubblico fermo o in movimento.

In qualche modo ci troviamo di fronte ad un'opera che inizialmente sembra farsi compagnia da sola, in quanto funzionante anche fuori dalla presenza dello spettatore. L'immagine televisiva, astratta o figurativa, è posseduta dal tempo spietato ed inarrestabile della sua trasmissione elettronica. Mostra così un carattere, involontariamente ironico di autosufficienza, quasi ad indicare l'ipotesi apocalittica di una scomparsa dell'uomo.

Contemporaneamente la video-installazione possiede la capacità oggettiva, nella sua attiva produzione di temporalità, di controllare l'eventuale presenza del pubblico. Nel senso che realizza una iconografia cinetica e sincronica al movimento dello spettatore.

Abbiamo così l'effetto di un doppio dinamismo temporale all'interno di un recinto spaziale definito dal campo della video-installazione. Tale campo si presenta volutamente con l'assemblaggio scoperto e provvisorio dell'accampamento, o luogo cioè dove materiali, oggetti e strumenti tecnologici convivono in uno spazio circoscritto e nello stesso tempo percorribile.

La percorribilità dell'opera produce un percorso contemplativo, un'esperienza polisensoriale sollecitata dal rimbalzo e dalla relazione tra le varie parti del campo estetico dell'opera.

Arte urbana è la video-installazione, la scelta da parte di un artefice che manipola linguaggi, come l'urbanista con segmenti di città.

Quest'ultimo infatti muove non soltanto spazi urbani astratti, ma piuttosto condensati di vita vissuta e pieni di esistenza concreta degli abitanti. La video-installazione possiede la stessa interna densità, conserva una sorta di memoria collettiva che la diversifica dal silenzio impersonale della pittura e della scultura.

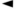

Percussion Kid, 1991
Courtesy Carl Solway Gallery, Cincinnati

Space Kid, 1991
Courtesy Carl Solway Gallery, Cincinnati

Family of Robot: Mother and Father, 1986
Courtesy Carl Solway Gallery, Cincinnati

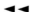

Lincoln, 1990
Courtesy Carl Solway Gallery, Cincinnati

Benjamin Franklin II, 1990
Courtesy Carl Solway Gallery, Cincinnati

Family of Robot: Painted Metal Child, 1986
Courtesy Carl Solway Gallery, Cincinnati

Family Tree (Derrida Tree), 1992
Courtesy Carl Solway Gallery, Cincinnati

L'artista elabora un percorso rilevabile non soltanto dalla plastica collocazione degli elementi, ma piuttosto definibile dalle dinamiche stabilite dentro il recinto dell'opera.

In questo senso ci troviamo non di fronte ma dentro, immersi, cioè in una realtà totale di arte giocata sul continuo sconfinamento dei materiali tra loro e dello spettatore dallo spazio della vita nel tempo dell'arte.

Lo spettatore diventa Alice nel Paese delle Meraviglie, protagonista di una inversione della spazialità in una pura temporalità. Il passaggio attraverso lo specchio è evidente e concreto. Lo spettatore passa realmente la soglia di divisione tra arte e vita. Qui egli si trova a percorrere un tempo attrezzato visibilmente da oggetti e forme intrecciate tra di loro. Non ha bisogno di sognare: è la video-installazione a produrre il sogno dell'opera mediante la proiezione di un tempo estetico in uno spazio abitabile tridimensionale.

Del sogno la video-installazione riprende il procedimento dello spostamento e della condensazione. Spostamento dei materiali dal loro luogo di origine, collegati in una inedita relazione che ne fonda un uso originale e puramente fantastico. Condensazione come accumulo intenso di situazioni spaziali e temporali assolutamente arbitrari, con le stesse modalità dell'esperienza onirica.

Rispetto al surrealismo questa realtà estetica possiede l'ulteriore capacità non soltanto di riprodurre mentalmente le associazioni libere del sogno, ma anche di produrre un'esperienza dinamica legata alla totalità polisensoriale del corpo.

Non riproduzione dunque, ma produzione in diretta è la video-installazione che supera l'imposizione alienante dell'evento televisivo, basato sull'immobilità del telespettatore, perfidamente garantito nella sua contemplazione del fatto che il dramma, il tempo reale dell'azione, si svolge altrove.

Nell'esperienza estetica non esiste spazio o tempo garantito. Lo spettatore è calato, vivo, nel vivo del percorso formalizzato dall'opera. Se nella domestica spettacolarità televisiva la realtà viene assottigliata e resa pura immagine bidimensionale, circoscritta e costretta dalla cornice del televisore, qui invece tutto esplode e sconfina nel campo mobile delle relazioni dell'opera con il pubblico.

La video-installazione ribatte colpo su colpo, con gli stessi mezzi, paesaggio di strumenti, disseminazione di eventi all'esperienza urbana dell'uomo moderno. Ribatte e ribalta la passività sociale in un movimento esperenziale giocato sulla responsabilità individuale.

Questo è possibile, perché tale costruzione estetica non punta più, come le forme dell'arte concettuale e video, sull'informazione ma sulla comunicazione, sulla relazione cioè intersoggettiva che intercorre tra l'opera ed i suoi destinatari, il corpo sociale.

L'arte come informazione, come tutti i segnali altamente codificati della città, produce inevitabilmente una finale paralisi di entropia, una diminuizione di energia informativa inevitabile. La video-installazione cerca di combattere il carattere entropico dell'arte sperimentale, puramente basata sulla scoperta di nuove tecniche e materiali, utilizzando la qualità dinamica della contemplazione, facendone un campo di esperienza e di confronto diretto con l'opera.

L'inevitabile ed interna entropia della forma viene dall'artista affrontata chiamando apertamente il pubblico in soccorso dell'arte in modo da creare una sorta di agorà, un luogo di confluenza sociale in cui è l'intero corpo comunitario ad agire e trasformare un cimitero di oggetti ed apparecchiature tecnologiche in un sistema di scambio e comunicazione intersoggettiva.

Nella video-installazione sembra non esistere più gerarchia tra sog-

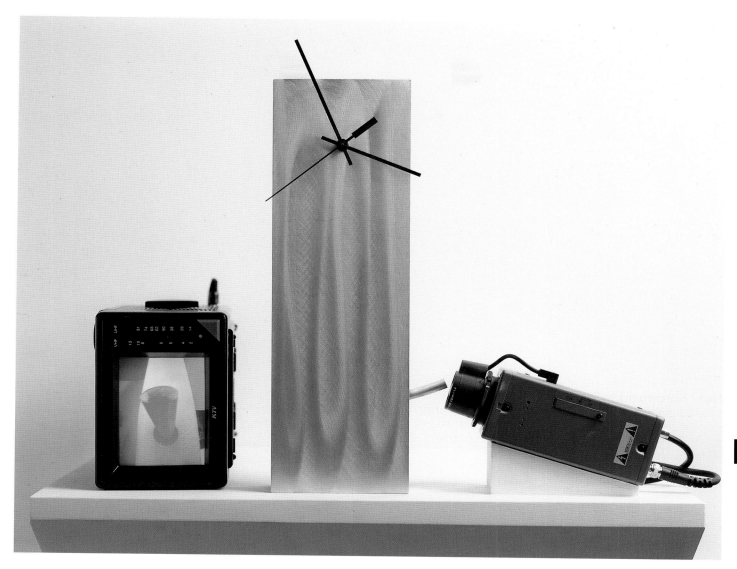

Fucking Clock, Edition 1989
Courtesy Carl Solway Gallery, Cincinnati

getto ed oggetto, possibile strumentalizzazione del primo sul se-
condo. Qui invece entrambi concorrono alla buona riuscita dell'es-
perienza. L'animazione di uno spazio garantito da una temporalità
interna ed esterna. Interna in quanto commentata dal flusso delle
macchine ed esterna, in quanto frutto dell'irruzione viva e reale
dello spettatore nel recinto dell'opera.
In tal modo si realizza uno sorta di doppio sogno.
L'esperienza estetica riguarda, nella sua produzione di trasforma-
zioni, l'opera stessa ed il pubblico. Avviene così la creazione di un
corto circuito sensoriale che si realizza dentro il perimetro artificia-
le della video-installazione, impossibile d'altronde nell'artificio ur-
bano entro cui l'uomo si muove.
Concreta è la differenza che intercorre tra le due dimensioni, visibi-
le è anche il diverso modo di agire e reagire del soggetto, anche
l'oggetto sembra esibire una inedita dimensione che lo sottrae alla
sua inerte e supina utilità per spostarlo in un'altra, inedita e dina-
mica, imprevidibile ed involontaria.
Volontario invece è il percorso strutturato dall'artista, artefice di un
campo magnetico di forme che suggeriscono esperienza senza im-
porla, risposte senza domande.

Infatti la video-installazione volutamente rinuncia alla identità metafisica dell'arte, quella tradizionale, normalmente caratterizzata da un'identità investigativa e sterilmente analitica, più adatta alla concentrazione della mente che all'espansione polisensoriale del corpo.

Qui ci troviamo di fronte ad un accampamento complesso e disseminato di oggetti familiari e quotidiani, non inquietanti e misteriosi, piuttosto invitanti all'attraversamento ed alla percorribilità senza patemi di animo o sospetti verso un universo enigmatico e simbolico.

La video-installazione non è abitata dalla poesia di una forma unica e reticante, ma piuttosto dalla prosa affollata di oggetti appartenenti al vissuto quotidiano.

Tale vissuto produce, nella forma dello spostamento e condensazione, un ulteriore spostamento del doppio sogno nello stato del dormiveglia, la sensazione di un passaggio giocato non sul salto ma sulla continuità del movimento.

L'opera infatti è costruita nei caratteri della riconoscibilità e familiarità dei materiali.

Da tale riconoscimento parte la peripezia del publico che si inoltra nel percorso, slittando tra le varie forme senza traumi. Senza traumi è sempre, per carattere, la videoinstallazione che vuole conservare l'identità laica dell'arte contemporanea, tesa ad incalzare la vita senza fantasticare su un romantico altrove. Senza traumi lo spettatore entra nell'opera riconoscendo nel perimetro di essa, i tratti di un universo cosificato di immagini e di materiali appartenenti al passaggio urbano ed a quello onirico che ne consegue.

La differenza rispetto a questo sta nel fatto che ora il pubblico può circolare in uno spazio doppiamente animato dall'attività del soggetto e dell'oggetto, spurgato della passività quotidiana. Ora non c'è bisogno più di sognare un altrove sostitutivo e sublimato.

La video-installazione fonda il tempo del dormiveglia, garantito proprio dall'esistenza di uno spazio concreto entro cui è possibile girovagare, conservando la memoria personale dell'esperienza quotidiana ed assumendone un'altra più articolata, mediante un'esperienza mobile ed iconograficamente ariosa.

(published in: catalogue Il Novecento Di Nam June Paik, Rome 1992, p. 19–21)

Connection (With Wings), 1986–88
Courtesy Carl Solway Gallery, Cincinnati

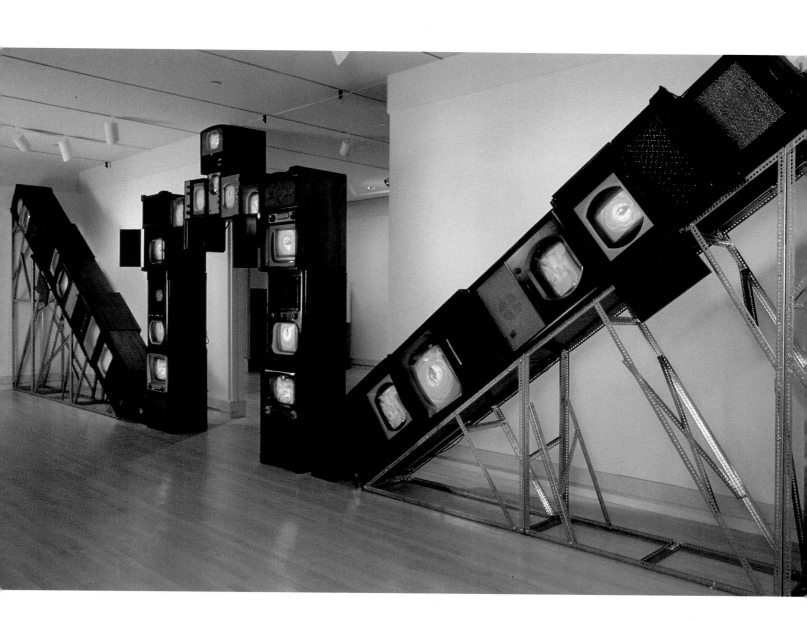

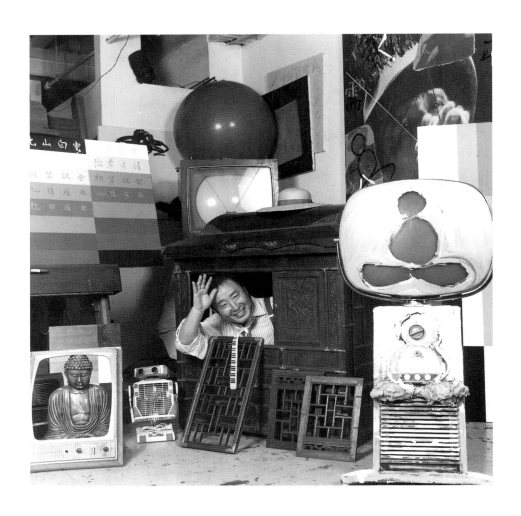

EDITH DECKER
GROßE FISCHE FRESSEN KLEINE FISCHE

Meine erste persönliche Begegnung mit Nam June Paik fand 1982 im Whitney Museum in New York statt. Es war am Tag der Pressevorbesichtigung seiner umfangreichen Retrospektive. Ich hatte mit meiner Doktorarbeit über seine Videoarbeiten begonnen und war voll akademischen Eifers zu diesem Ereignis angereist. Bei meinem Rundgang durch die Ausstellung traf ich Paik irgendwann auch im dunklen Raum der Installation "Fish Flies on Sky" an. Er lag auf einer der Matten am Boden und sah zu den Monitoren hinauf, Shuya Abe, sein langjähriger Chefingenieur und Freund, war bei ihm. Da ich irgendwie ein Gespräch beginnen wollte, war ich so töricht, ihn zu fragen, was für eine Bedeutung die Fische für ihn hätten. Paik und Abe feixten und ich verstand soviel wie, daß große Fische die kleinen fressen würden. Ich fühlte mich schrecklich auf den Arm genommen und unterließ fortan derartiges Inquirieren. Bei allem Verständnis für wissenschaftliches Arbeiten war Paik jedenfalls nicht gewillt, Interpretationen seiner eigenen Arbeit zu liefern, soviel war mir klar geworden. Für Sachfragen im Sinne von was, wann und wo war er dagegen offen und zeigte sich sehr hilfsbereit. Was die Fische angeht, habe ich damals kurz erwogen, sie doch nicht inhaltsdeutend zu verwenden, ikonographische Beispiele aus der Kunstgeschichte boten sich dafür an. Mir wurde aber klar, daß es wenig Sinn macht, traditionelle Ikonographie zur Deutung des Paikschen Werkes heranzuziehen.

Paik gehört der europäischen und amerikanischen Avantgarde an, die sich ganz bewußt und vorsätzlich Traditionen entgegengestellt und neue Parameter geschaffen hat. Er ist ein westlicher Künstler mit Exotenbonus, seine asiatische Herkunft ist nur bedingt relevant für das Verständnis seiner Arbeit. Sein Werk ist ebenso international, wie die Avantgarde der letzten Dekaden. Die buddhistischen Motive, wie etwa der "TV Buddha", kommen nicht aus einer persönlichen Überzeugung, sondern sind Versatzstücke aus dem fernöstlichen Materialfundus, über das er ebenso verfügt wie über westliches Kulturgut.

Dieses Verständnis der Arbeiten Paiks hatte ich mir erarbeitet und stand damit auch nicht alleine dar. Seit den späten achtziger Jahren ist jedoch eine Wandlung zu beobachten: Paik scheint immer asiatischer zu werden, ob durch den kommerziellen Erfolg bedingt oder durch das Alter. Er kehrt zum ersten Mal wieder in seine Heimat Korea zurück, und fortan kommen auch seine koreanischen Wurzeln verstärkt zum Vorschein. Was vorher an Koreanischem mitschwang, etwa der Schamanismus durch die Zusammenarbeit mit seinem engen Freund Joseph Beuys, zeigt sich jetzt mehr und deutlicher. Seit sich Paik mit der koreanischen Kultur in seinen Arbeiten auseinandersetzt, scheinen auch die koreanischen Strukturen in der Person des Künstlers offensichtlicher zu werden. Nicht daß er sich wirklich verändert hätte. Es ist mehr ein Phänomen der Rezeption, der Wahrnehmung einer Person, die durch eine leichte Drehung andere Facetten aufscheinen läßt. Plötzlich erkennen wir ihn als das, was er wohl immer war, als koreanischen Künstler, der bei aller Verwestlichung die vom Konfuzianismus geprägten Umgangsformen und Wertnormen nicht verloren hat.

Um zum Anfang zurückzukommen: Das mit den Fischen war doch nicht so abwegig. Heute weiß ich, mit welcher Selbstverständlichkeit er die Grundgesetze des Lebens akzeptiert und respektiert und mit Gelassenheit das Gute im Schlechten und das Schlechte im Guten erkennt.

Nam June in his atelier, New York 1989
Photo E.Kroll

►
Chicken Box, Chicken Farm, 1986
Courtesy Carl Solway Gallery, Cincinnati

►►
The Late, Late Show, 1987
Courtesy Carl Solway Gallery, Cincinnati

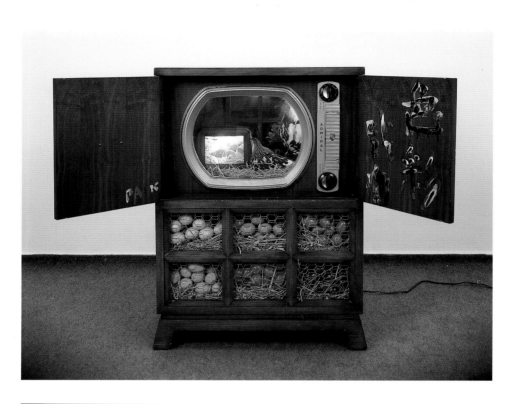

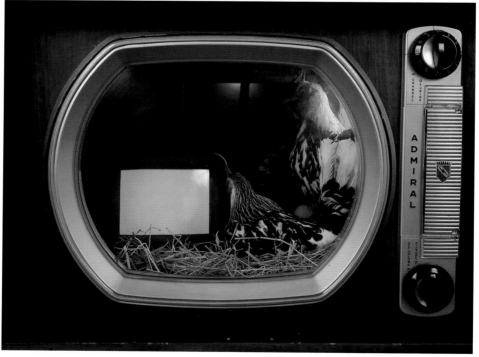

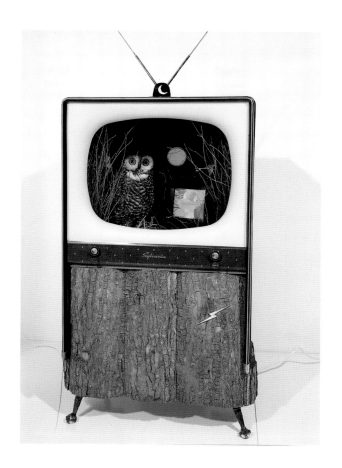

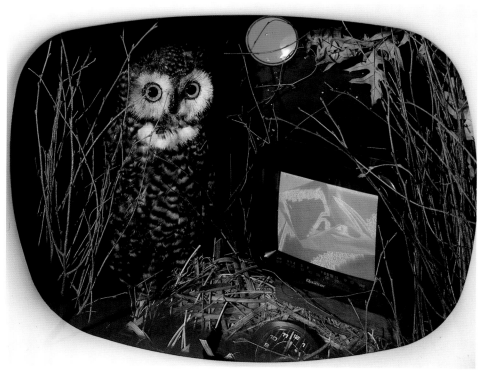

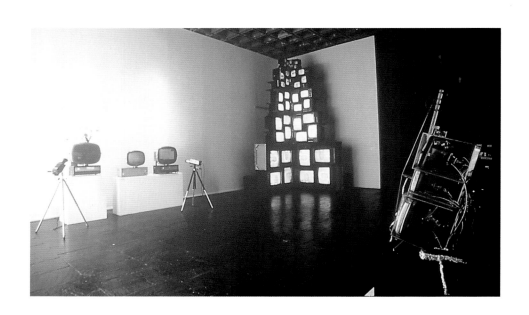

LARRY LITT
EXCERPT FROM VIDEO-MUDANG – SHAMANISM/SHAMANISN'T

In Korean shamanism, "Shin" are beneficial deities living in mountains, the sea, and the home. "Kwishin" are spiteful spirits of the restless dead that cause humans no end of physical, psychological and spiritual trouble. "Kut" or rituals are performed by "Mudangs" or trance shamas who ask various "Shin" for their support and help in the struggle between humans, nature, and the after life. This "Kut" is dedicated to all the Koreans who led me to understand the concept of Universal Shamanism.

CHANTRA: O Viddy, O Viddy, O Viddy, O Viddy, O Viddy, O Viddy, O Viddy, O Viddy, O Viddy, O Viddy, O Viddy, O Viddy, O Viddy ...

"SHINBYONG"
(Spiritual Sickness)

Turn me on, turn me on,
Remote control is easy, easier, easiest,
Convenience, never get up, you might walk away.
Who controls who?
Sit comfortably in your armchair, arms are for chairs,
Watch me, Watch me, Watch me change yet stay the same.
I am greater than you, man who wonders who is greater than him.
I am Watch, Spirit in the tube, Tele-kwishin of the airwaves
Invisible until you turn me on,
You call me, You want me, now Watch me.
Remote, far away, alien, distant, no one near you,
Yet never alone when I am on, I am with you,
Coming to you from the invisible world, all around you
Invisible until you turn me on, Watch,
I am there for you, in your chair, Watch,
with stories, myths, miracles.
I am the flesh without soul. Watch.
I am the separation of the flesh from the soul. Watch.
Transistors, wires, circuits, looking glass.
I am Tele-kwishin, Golem, Frankenstein. Watch.
Before my creation you told stories to each other,
Now I am the soulless circuitry you Watch.
I have news, wars, sports, horrors, riots,
entertainment, enterbrainment, dementertainement!
And now a message from our adver-tithers:
"Pardon us, we just want to let you know, Buy
This thing we're selling is really good for you, Buy.
Let us help make your life better, Buy.
Or else, no one will like you, Buy.
There's no money honey, if you don't Buy something!"
And now back to stories about people just like you, Watch.
People with a soul, just like you, Watch.
Just like you want to be, Watch.
Just like you will be, Watch.
Do you still think I'm invisible?
Turn me on, sit in front of me, together,
People just like you, just like I want you to be.
Stories just like yours, all stories the same,
What does it matter?
Just sit and Watch me, you don't have to do anything,
Sit back, rest, relax, sleep the sleep of stories, news,
progress for people just like you.
Now go to bed my sheep. Make more people just like you

◀
V-yramid, 1982
Whitney Museum of American Art, New York

To Watch me, while my public eye Watches you.
Remote control Dream: You can be on me, in me, under me,
Eternally, a part of me.

VIDEO-MUTAL
(Initiation and education by a master)

Michin nom nom, michin michin, nom nom, michin nom nom, michin nom, nom michin, nom michin, michin nom, michin nom!

Korean parents tell their artistic children they are "michin-nom": mad, self-enslaving, egoistic. Only a crazy person wants to be an artist." "Michin nom" ist the "shinbyong" or spiritual sickness of the young artist.

"Musyong": becoming a shaman or mudang needs a "Mutal": an initiation and education by a master.

Without a master the process takes much longer and is very much more painful and dangerous, frequently leading the young artist to an premature, tortured, spiritual death.

That's why it is important for "mutal" artists to look for young artists suffering "shinbyong" to guide and direct them to their "musyong" or becoming, out of their "shinbyong".

NAM JUNE PAIK
(Pansu-mutal)

Pack, Pike, Park, Peck, Poke,
Pig in a Poke,
Pock, Pick, Pickpocket, Parking Ticket,
Poke with a Stick in the Eye,
Names like water that slip through the hand
Pick out the channels,
Park your self in front of the television,
Pack a Lunch,
Peck like a chicken at all the stations,
Slow poke don't you see they're all the same,
Pick one and stay with it, stay with the one you choose,
There's something there, no difference, I'm sure there is,
If not something to learn
Then something to spurn,
Pack, Pike, Park, Peck,
Mocking my parallel parking,
Can I do anything to change, to change,
To change the channel to
Please, pansu-mudang, he-shaman,
The invisible gods of this remote control?

CHARLOTTE MOORMAN
(American-Mudang)

Mudang hiding behind that wooden Buddha of a cello,
Wearing the "TV Bra" knowing the world of the classics
Would throw you out.
Did you really want to be in?
Or was being out,
As in as you could get?
Crawling on your soft belly with your Buddha cello burden
On your back, over Guadalcanal beaches searching for
Souls of dead soldiers
Finding them in time to put them to rest for us.
Playing, all the ways that can be played,
silence and noise without your conductor on his podium
guided by your own calling.

Are you mudang or mansubaghi, shaman or musician,
permanently pattering on videotape your adlibs
that make the world know your own trance
and love for performing video kut, the ritual.
Sweet player,
Your flesh is gone but your soul still visible,
still playing the beautiful fulsome dream of video mudang sleep.

MUDANG
(Trance)

The quiet ones are meditating, painting, writing poetic koans,
tending gardens to please their deities.
The noisy ones are singing, dancing, playing music, walking on
Earth, Air, Fire, and Water like Merce Cunningham.
The noisy ones are chanting and singing about meditation like
Howling Allen Ginsberg.
The noisy ones are screaming like a coyote into the microphone,
Leading Beuys scouts into the woods to plant trees in Germany
Paid for in Japan.
The noisy ones are bathing in mud becoming earth, naked and
Beautiful brown clay, sexual and desirable like Amy Greenfield.
The noisy ones are on stage taking off their clothes, hugging and
Loving each other, inviting the audience to join their "mugam",
The dance that leads to ecstasy, like The Living Theater.
The noisy ones are throwing the I-Ching looking for the right
place to listen to the "Music of The Peers" like John Cage.
The noisy ones are dancing and drumming until they fly out of
their bodies, sweating, gasping for breath, ecstatic souls.
The noisy ones are inside the looking glass tube, turning dials
on a synthesizer making the invisible visible, video-mudang with
props and costumes.
The noisy ones are burning pianos while orchestras play the music
of the dead.
The noisy ones go on cruises, eat, come home, eat, have a party,
eat, gossip, and eat some more like Gregory Battcock.
The noisy ones are trying create international peace on the
"Media Shuttle: Moscow/New York" and everywhere else they
can.
The noisy ones are Selling New York like Russell Connor, even if
The only advantage to living in New York is that all New Yorkers
Go directly to Heaven.
Having served their time in hell on Manhattan Island.
The noisy ones bring you beautiful, social, invisible stars of
The arts who become visible if you turn them on.
The noisy ones are looking for more of the same.

SHINMYONG
(Ecstasy)

Yang, yang, bang, bang, drumming, action, hot, dancing, music,
Singing, spirits, trances, exstasy, dancing, kimchi, spice, hot,
Sweat, sweet, spinning, wet, action, alive, flesh, spirit rising
From heat rising, from dancing, from hot food, hot soju,
Hot bodies, heat, beat,
Yang yang, bang bang, universal shamans in South America, East
Europe, Central Asia, Siberia, Native Americans dancing, hot,
Action, spice, food, bodies, sex, combining the flesh and the
Spirit, hot sauce, salsa, hot music, sha sha sha man, dance, call
The deities and spirits through your hot flesh.
Tell them you want more of the same man, more of the same man,

more of the shame man, more of the shaman, Now!
Garlic, pepper, ginger, vinegar, paprika are cures for body
sickness.
Sweetness appeases the gods after the hotness possesses you.
Bring the gods into your body. Pomegranate, chocolate, orange,
sweet after hot, like dessert, sweat after hot, like love and
dancing, both necessary for ecstasy.

MANSHIN
(Possession)
Buddha is my meditating monitor, Adonai is my all knowing editor,
Allah is in my gas tank, Christ is my cable, Krishna is my cassette,
and Confucius pays all the bills.
My imperfect, artist soul is mudang, shaman.
I dance for all of you, to bring you together in me.
I sing for all of you, to bring you together in me.
I bang the drum for all of you.
I eat hot and sweet for all of you.
I make love for all of you.
I write poems and stories for all of you.
I am the herbs and spices, vegetables and fruit
That grow in the earth.
I talk to you, make you laugh at me, laugh at you,
While I weep for those who don't know all of you as one
In their dance with the Earth, dance with trees, dance with
Mountains, dance with fire, dance with rain, dance until I can
Talk to all of you, because I am all of you.
No separation, no identity.
I am as simple now as my birth,
I sing to you in the language of my purified heart.
Question: "What happens to my soul after death?"
Answer: "Who sees your videos knows your soul after death. Rest
now, you are immortal."

MULLIM
(Repelling the Demons)
Let the advertising pass back into the invisible world,
Make fun of it. Ridicule it. Know it for what it is.
"You have my money in your pocket and I want it,
Buy this, get some of it, try this,
It's good for you, fills you up not out, makes you desirable,
Makes you hireable, you won't smell,
You'll be cleaner than you ever thought possible,
Your house will be rid of spirits, rid of kwishin,
Wash with this, your body will be rid of kwishin,
Spray this, the air will be rid of kwishin,
Drink this you'll have power,
Smoke this you'll be a man,
Eat this you'll be stronger faster,
Drive this you'll get there before I do,
Live here, there are no kwishin in the kitchen!
Laugh Now! Laugh when you see me worshipping, sitting, in front
Of my tele-kwishin, laugh when you see the Buddha watching
Himself,
Laugh when you see the fire on the piano, laugh when you see
Dancers dropping down on the floor from ecstasy and exhaustion
like sex, laugh after you burst out of yourself in Orgasm, laugh
when you know all things are temporary.
Video is the most temporary of all.

Tug the plug. Off the wall. Out of the wall.
You're on your own again. No more tele-kwishin network,
Bloomin' human comedies, dramas, and the news, news, news.
Out of your chair, into your body, runaway from the tele-shrine,
You bought it, you used it with your eyes, your ears, your body
sitting in front of the tele-kwishin.
Watch wants you to see all, know all, hear all, the latest, the
greatest, the newest, the fashionable, the trends, the thing to
do, the people to know, the thing to be, to be, to be.
You can end it all, not by jumping, hanging, shooting, stabbing,
swallowing, but by tugging the plug, tugging the plug, on little
tug of the plug out of the wall.
It's all over. Silence. The sound of yourself. Are you afraid?
Just you. The ultimate possession. It's your world now.
Not filtered by the tele-kwishin looking glass.
Look out! Don't sit down! Keep dancing, singing, laughing.
If you sit, Watch will bring you a tele-kwishin.
Be your own video-mudang.
Breathe your own breath, use your own eyes, touch without a
remote, close, very close, close enough to hurt, smell, feel,
without glass.

Be your own video-mudang. Laugh now!
Be your own video-shin.

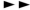
Music is Not Sound, 1988
Literature is Not Book, 1988
Dance is Not Jumping, 1988
Painting is Not Art, 1988
Drama is Not Theatre, 1988
Star is Not Actor, 1988

► ►
The More the Better (Maquette),
Installation with 1003 Monitors for the
Olympic Games in Seoul 1988
Courtesy Won Gallery/Hyundai Gallery, Seoul
Photo Young Kuyn Lim

Time Flies Diagonally, 1992–93
Courtesy Carl Solway Gallery, Cincinnati

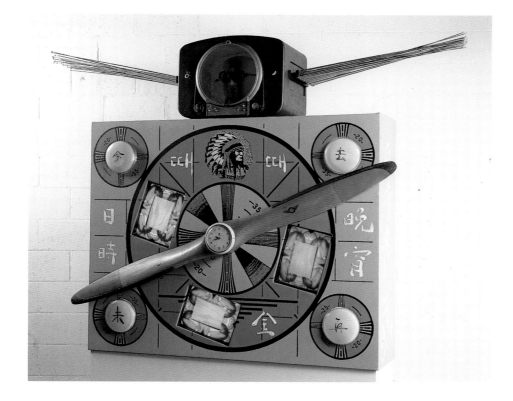

O Viddy, O Viddy, O Viddy, O Viddy, O Viddy, O Viddy, O Viddy,
O Viddy, O Viddy, O Viddy, O Viddy, O Viddy ...

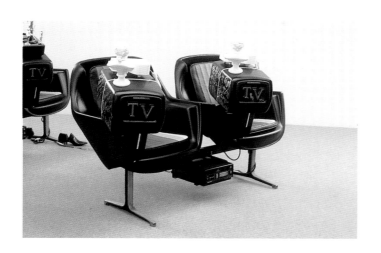

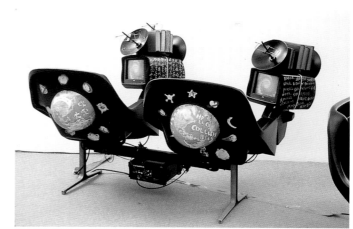

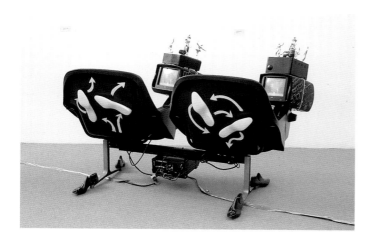

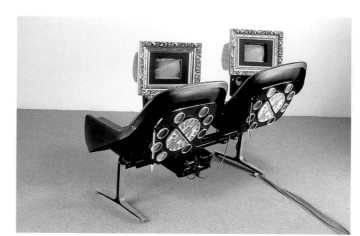

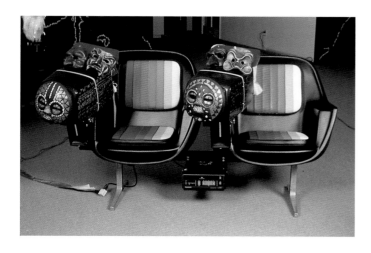

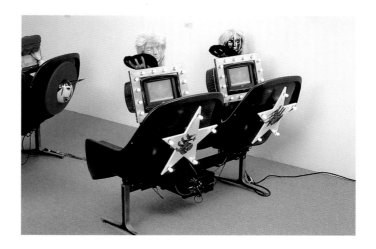

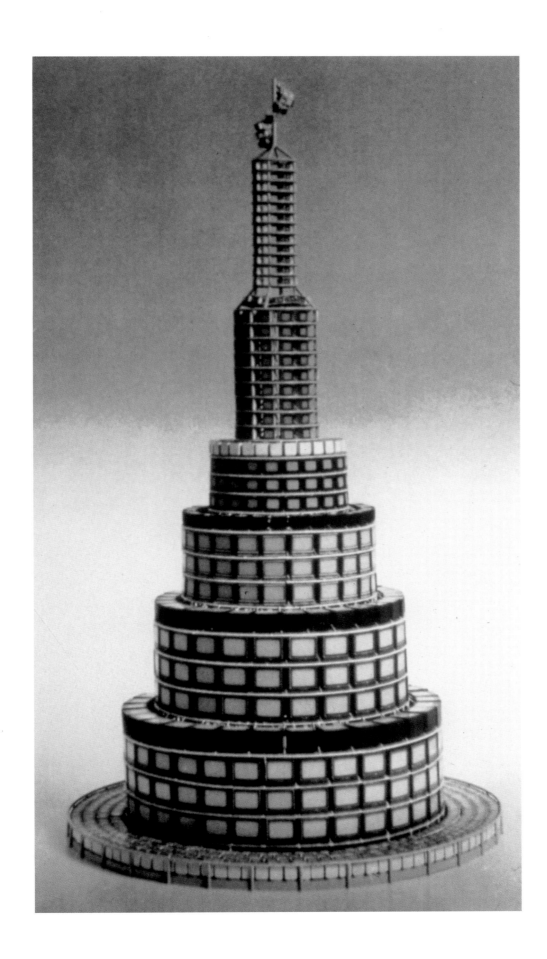

HANS-WERNER SCHMIDT
MEINE LIEBLINGSGESCHICHTE VON NAM JUNE PAIK

Lenin lebte von 1914 bis 1917 im Schweizer Exil. Er hatte seinen Wohnsitz in Zürich in der Spiegelgasse 1. 1916 gründeten Tristan Tzara, Hugo Ball, Richard Hülsenbeck und Hans Arp in Zürich das "Cabaret Voltaire". Sie trafen sich dazu im Haus Spiegelgasse 16. Das Programm hieß "Dada".

Lenin hatte in jenen Tagen die Möglichkeit, sich zu entscheiden: Kommunismus oder Dadaismus. Er entschied sich für die Diktatur des Proletariats. Es dauerte sieben Jahrzehnte, bis Dada diese Fehlentscheidung und die Folgen überwinden konnte – in der Person von Vitautas Landsbergis. Landsbergis war Freund des Exillitauers und Fluxus-Begründers George Maciunas. Landsbergis wurde von den Fluxus-Künstlern als einer der ihren gesehen. In seiner Präsidentschaft siegte 1990 Dada/Fluxus über den Kommunismus. Litauen ist keine Fluxus-Republik geworden. Ein Ex-Kommunist hat in demokratischer Wahl Landsbergis abgelöst.

Paik sieht das Video-Tape als modifizierbaren Informationsträger und damit verwandt der Kunde, der Sage und dem Volksmärchen. Als Erzählung und in Vorstellungsbildern lebend, wird die Kunde über große geographische Entfernungen und auch durch die Zeiten getragen. Die Kunde nomadisiert wie ihre Träger. Als Trägerin von Nachricht bleibt sie im Fluß, nimmt neue Quellen auf, während andere versiegen.

Ich freue mich darauf, die Geschichte wieder zu hören, die von der Spiegelgasse, von Kommunismus und Dadaismus, von Herakles am Scheideweg – und den Folgen.

Nam June Paik, Milan 1988

Photos F. Garghetti

OTTO HAHN
LE NOMADE, LA GIRAFE, LE ROSSIGNOL ET LES OURS

Le temps est comme un puzzle avec des pièces qui s'emboîtent. Tout le monde n'a pas la chance de finir sa planche. Certains croient prendre un raccourci et se perdent. D'autres s'égarent avant de trouver leur chemin.

J'ai connu Nam June Paik au mois de mai 1964. C'était déjà un zombi planétaire mais je le voyais comme un inconditionnel du happening.

J'ai traversé de noirs marécages, de vastes étangs brumeux, j'ai connu la stérilité glacée du Grand Nord et taillé mon chemin à la hache dans les fourrés de cèdres impénétrables.

A l'époque, c'est le pop-art et le happening qui m'intéressaient. Je voyais Nam June Paik dans cette optique. Voici ce qu'écrivait Jean-Jacques Lebel, en 1964 dans un tract intitulé "Riposte": "Le happening et le pop art, dans le sens où nous les entendons, n'ont en effet qu'une chose de commun: leur critique radicale des valeurs morales, esthétiques et politiques de la Société Industrielle (...). Dans cette mesure, ces deux moyens d'expression assument profondément la fonction d'un art vivant et libre. Mais ce n'est pas tant la forme de ces manifestations qui est contestée par la presse de gauche comme par celle de droite. C'est implicitement leur contenu réel, aussi bien social que culturel; c'est la volonté de libérer les publics pour une autogestion de la culture et de la vie. Face à l'inertie d'un public dépersonnalisé par les formes traditionnelles de l'activité culturelle il faut provoquer la participation de tous, directe et spontanée, à l'expérience créatrice".

La conclusion qu'en tirait Jean-Jacques Lebel, organisateur du workshop de la libre expression, tenait dans un éclat: "La colère des chiens de garde n' y changera rien".

Mon intérêt pour Nam June Paik s'articulait autour du happening qui me semblait un moyen d'expression tout à fait nouveau. Oldenburg, Jim Dine, Allan Kaprow s'adonnaient à cette théâtralisation de l'activité plastique. Rauschenberg et Jasper Johns s'intéressaient au ballet, façon plus esthétique de faire mouvoir le corps dans l'espace.

Vagabond insouciant, Nam June Paik parcourait les rivières inconnues des géographes. Il travaillait déjà avec l'image électronique et jouait des mélopées technologiques sur un tambourin de peau de loup. Les reptations rituelles qui accompagnent cette musique se faisaient au travers du tube cathodique.

Dans cette histoire, j'étais le piroguier émmerveillé. Je découvrais Kudo, Malaval, La Monte Young, George Brecht, Ben, Jodorovski, Allen Ginzberg, Gregory Corso: des îles encore inexplorées.

Les civilisations sont jugées d'après les monuments qui leur survivent. Nos monuments s'appellent peut-être Sotheby's, Christie ou Hôtel Drouot: les générations futures visiteront les ruines de ces institutions qui jugeaient l'art selon son poids financier. Et l'on évoquera la crise de 1990 qui ébranla les colonnes du temple, faisant tomber le fronton qui ensevelit ceux qui exécutaient la danse du ventre devant l'entrée de l'église.

"Je ne suis pas bouddhiste", m'a dit Nam June Paik, "je suis artiste."

Nam June Paik est un des seuls à avoir réussi à faire la synthèse entre deux civilisations. L'exploit passe par la bande vidéo. En effet, l'Orient et l'Occident ne se mélangent pas sur la toile. Les audaces s'estompent dans des demi-mesures. Le collage de séquences visuelles permet de superposer tout en gardant la spécificité de l'Espagne et de la Corée, de New York et de Tokyo, du rossignol et de la girafe.

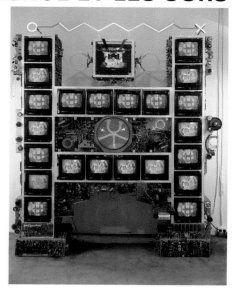

Homo Sapiens, 1992
Photo M. Tropea, Courtesy Carl Solway Gallery, Cincinnati

Picasso a dit: "Je ne cherche pas à faire de l'art espagnol. Je suis espagnol." Nam June Paik pourrait dire: "Je ne cherche pas à faire de l'art oriental. Je suis oriental."

Les ours de V. se rassemblent par groupe pour fouiller dans les épluchures que les cuisiniers jettent dehors à leur intention. Les animaux se comportent entre eux avec une courtoisie des plus édifiantes et ignorent poliment les spectateurs en quête de sensations fortes qui les photographient sous toutes les coutures. Les vétérans qui reviennent régulièrement doivent commencer à se sentir terriblement blasés devant l'objectif. Les jeunes réagissent avec plus de spontanéité. Peu avant la sortie de la forêt se tient en permanence une équipe d'oursons escortée d'une femelle sur le compte de laquelle courent des histoires terrifiantes. Le groupe est posté là pour attendre les automobiles et si l'une d'elles s'arrête, tous les oursons se précipitent pour mendier des friandises avec une effronterie sans pareille. Assurément, leur conduite jette un certain discrédit sur bon nombre de vénérables traditions. Mais le public se réjouit: après une aventure de cette nature, il peut sans mentir se déclarer capable de regarder un artiste de face.

Nam June Paik et moi sommes cousins. Nos ancêtres jouaient ensemble dans les steppes mongoles. Nous avons été séparés lorsque sa tribu choisit d'aller vers le soleil levant alors que la mienne se dirigea vers le couchant. Nous sommes arrivés, sous la conduite d'Attila jusqu'aux portes de Paris mais nous avons été repoussés jusqu'aux plaines hongroises dont l'herbe tendre convenait à nos chevaux. Nous sommes restés là-bas durant des générations jusqu'à ce que mon père réussisse ce qu'Attila avait manqué: s'installer à Paris. Nam June Paik fit le trajet dans l'autre sens ce qui nous permit de nous rencontrer boulevard Raspail, près de Montparnasse par un joli jour du mois de mai.

Utilisant la technologie la plus sophistiquée, Nam June Paik ne sait même pas brancher un fer à repasser.

L'humour de Nam June Paik: né en Corée, il fait ses études au Japon, vit à New York et représente l'Allemagne à Venise.

Nam June Paik, 1982
Photo Peter Moore

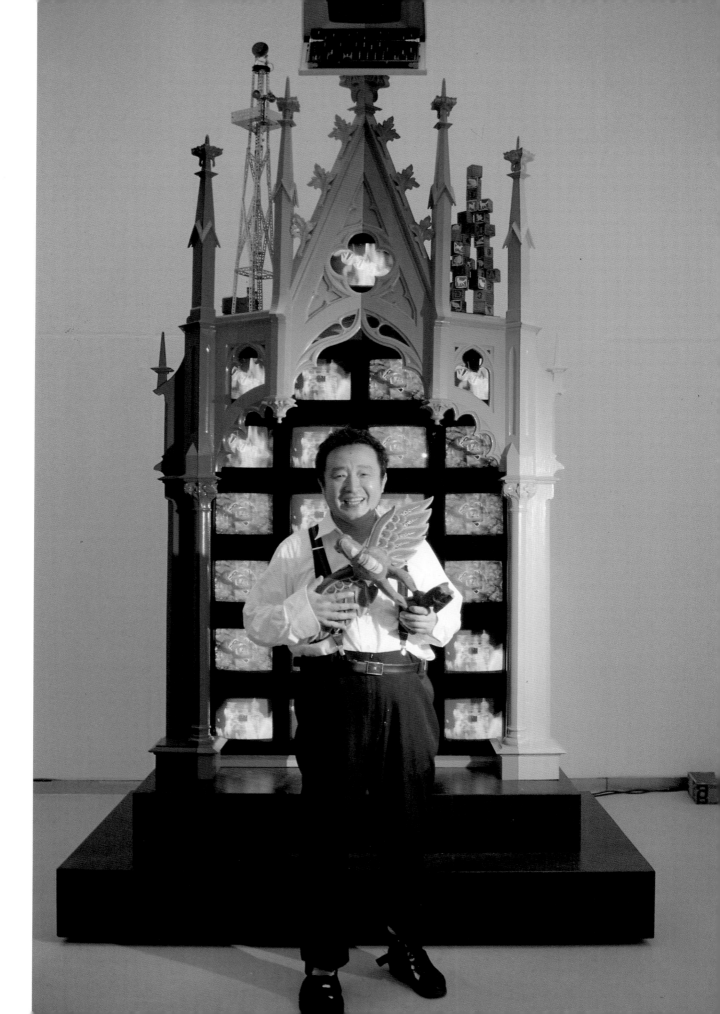

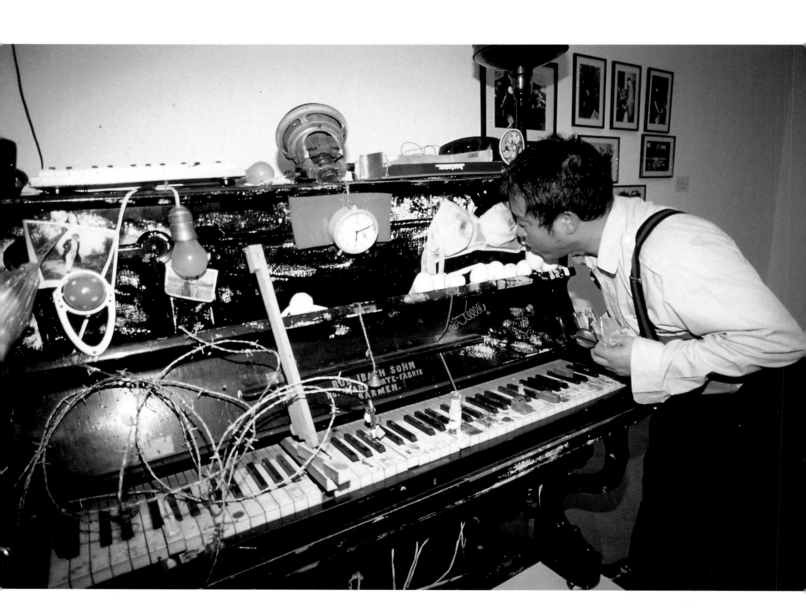

NAM JUNE PAIK
VENICE I – 1960, JOHN CAGE IN VENICE

In 1960 I went down to Venice to attend Cage-Cunningham Tudor-Caroline Brown performance at the old barock theatre. The Time magazine of October 10th 1960 covered this performance:

Yesterday's Revolution

In its 23 seasons, Venice's International Festival of Contemporary Music has more than once moved its audiences to near violence; in his 48 years, self-styled Non-Expressionist Composer John Cage, the "prepared piano" man has reduced more than one audience to near lunacy. Last week U.S. Composer Cage and the Contemporary Music Festival linked forces in a concert at Venice's famed old La Fenice Theater. The explosion could be heard across the Grand Canal.

Mad Mélange. For his Venice performance Cage prepared a typically mad mélange of musical low jinks. The evening started mildly enough with Round 1. in which Cage and Pianist David Tudor sat at different pianos alternately plunking notes at up to 10-second intervals. Presently Dancer Merce Cunningham started undulating in symbolic suggestion of an embryo wriggling toward manhood. By Round 3. when Cage was thumping his piano stool with a rock, the restive audience began to jeer. The jeers grew in Round 4. as Cage and Tudor launched into a piano duet playing chords with their elbows while assaulting the pianos innards with knives and pieces of tin. After Round 6. in which Cage slammed the piano top with an iron pipe and dropped bottles on the floor, an elderly music lover strode to the stage, walloped cage's piano with his walking stick and stalked out shouting "Now I'm a musician, too."

Soon Cage and Tudor were darting about between three record players shifting from Mozart to blues to a recorded speech by Pope John XXIII calling for world peace. By the finale fights had broken out all over the theater. "Get out of here", screamed the traditionalists. Replied an un-Caged modernist: "Go somewhere else if you want melody! Long live music." Cage barked at the audience: the audience barked back at Cage. One notable dissenter Igor Stravinsky, who found the whole business so tedious that he slipped out in mid-concert. Asked if the tumult was equal to what went on at the Paris premiere of his own Sacre du Printemps in 1913, the old man replied proudly: "There has never been a scandal like mine."

Deft Exercise. Later in the week Stravinsky touched off some mild demonstrations of his own. Occasion: the world premiere in Venice of his seven-minute Monumentum Pro Gesualdo di Venosa Ad CD Annum inspired by the music of late-16th-century Madrigalist Don Carlo Gesualdo, who has long fascinated Stravinsky (Gesualdo had his wife and her lover murdered and is said to have suffocated one of his own children before relieving his tensions in song. In 1956 Stravinsky set himself the task of "recomposing" three Gesualdo madrigals for orchestra.The results added up to little more than deft exercises in Stravinskian orchestration, but the audience warmly applauded the ailing. 78-year-old composer (he was carried up and down stairs in a sedan chair).

Perhaps the most significant thing about the festival was the attitude of young Italian composers, who were amused by Cage, tended to find Stravinsky somewhat decadent but accepted both of them with respect. (Time Magazine, October 10, 1960, p. 59)

It was a great concert and also a great scandal, as Stravinsky remarked. Cage appeared in formal dress (swallow-tailed frock coat), and during this performance I decided to cut off his tail in the upcoming concert which was planned at the Mary Bauermeis-

ter Atelier in Cologne in the ensuing month. (Actually I did cut off his necktie instead of coat tail.)

After the performance there was a party at Peggy Guggenheim's chateau and I almost killed her dog.

I was first introduced to her by Earle Brown and again by John Cage later. Peggy G. said that a good friend has to be introduced twice.

Then I saw two absolutely identical dogs on a sofa, and they did not move at all for long time. Getting tired I was going to sit on one of this immobile, therefore (it must be) a stuffed dog. But I continued the conversation with other guests ... then lo and behold ... this stuffed dog suddenly awoke and walked away ...

Parallel to this official performance there was a counter festival at a smallish classroom at the art academia in Venice. Merce, Cage, Tudor, Bussoti, and an American oil execitive, who also composed, were the main composers and performers. It was an intimate atmosphere and I had a chance to ride the vaporetto with Cage. It was a day time.

It was foggy next night time Heinz Klaus Metzger also rode on the vaporetto with Cage. There was a very heavy fog. In order to avoid the collision, one boat blew a steam-whistle ... and the next one responded and the third one echoed and from the distant end another vaporetto answered ... and all on the background of beautiful Venice ... and there was John Cage with him. Metzger said it was the best Cage concert he ever attended.

Before this happening (in its truest sense), George Brecht sold a ticket as a concert ticket to enter the trainstation.

NAM JUNE PAIK
VENICE II – 1966, GONDOLA HAPPENING

In 1966 charlotte moorman and I went to venice biennale uninvited and staged a commando-style happening.

the leafet saying just

GONDOLA HAPPENING

"venice is the most advanced city in the world,
since it has already abolished the automobiles."

John Cage, 1958

there were many hundreds of the audience waiting for our gondola, which was delayed as always by one hour. Finally we appeared and everybody cheered. charlotte played first john Cage piece. A movie was projected across the canal to the century old wall. luckily we could rent out the only 16 mm projector (for the rental) existing in the whole city of venice ... and it did not break down. In the next piece (my saint saens variation), miss moorman bravely jumped into canal and came out to play the piece as instructed drench wet with the 10 centuries polluted water. after the show, she had to go to a doctor for the typhus shot. and after the show, we had only 5 dollars left. we were thrown out of a free pension, because charlotte played cello around 2 a.m. ... luckily we had had the first class eurail pass and could stay overnight at the first class waiting room at the station.

in this whole tragi-comedy after 27 years I could find only one witness, who saw the performance and could testify that indeed it happened ...

his name is wim beeren (Amsterdam).

Charlotte Moormann and Nam June Paik
Performing the "Venice Gondola Happening"
at the Biennale in 1966

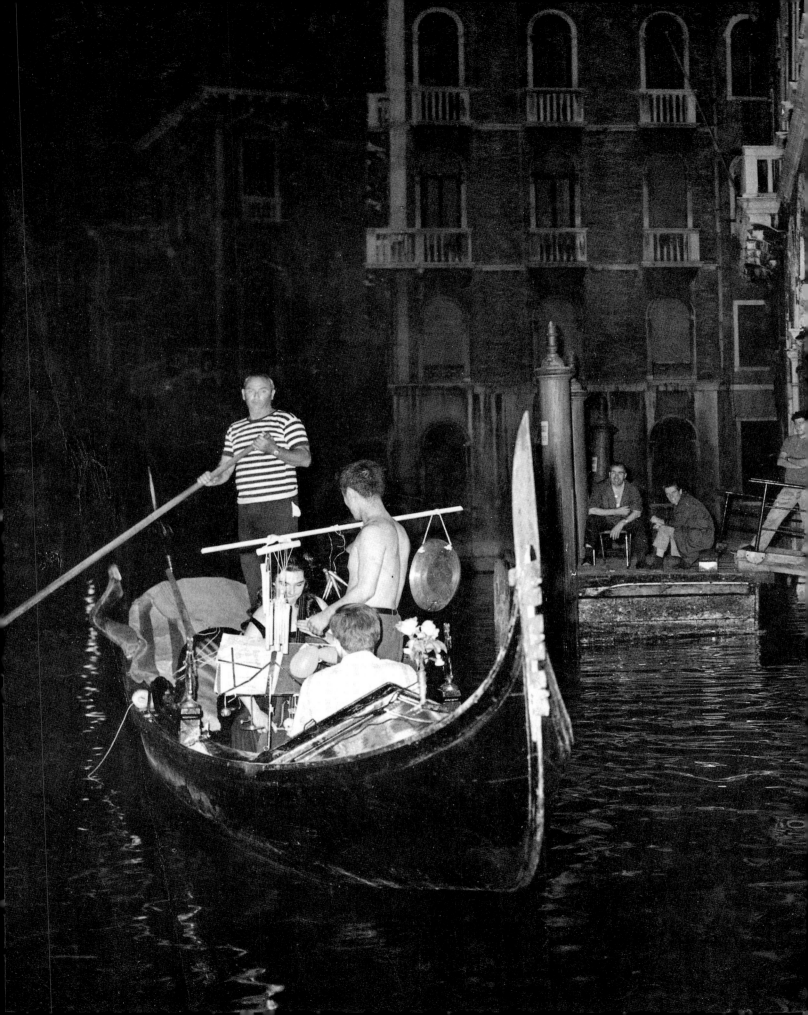

NAM JUNE PAIK
VENICE III – 1975, THE CITY OF COLOGNE STOLE MY IDEA

In 1975 there was not a regular biennial of venice due to the after-math of the student revolution of 1968. Instead, the organisation of the biennial invited a dozen artists to submit a plan to develop the mulino stucky building at the Giudecca island, which has been sleeping for many decades over the centuries. I proposed to open an international freeport for the information exchange and a center for the international student for the same purpose.

This proposal was printed and distributed widely as the official publication of the venice biennial.

Lo and behold!!!

In just ten years, the city of cologne declared their cargo railway station in Cologne (Gereon Gueter Bahnhof) to be the Media Free park and opened a well-funded media university.

Did the city of Cologne steal My idea??, as Bill Clinton did later?

Idee für Giudecca

Der langsame Übergang unserer Gesellschaft vom Industriezeit-alter zum postindustriellen Zeitalter korrespondiert mit dem lang-samen Übergang unserer Lebensform von "Hardware" zu "Soft-ware" und ebenso mit dem schrittweisen Übergang unserer auf Energie basierenden Wirtschaft (Benzin, Öl) zu einer neuen Ökonomie, die auf Information (Ideen) basiert.

Der Wohlstand Venedigs im 12. bis 13. Jahrhundert war zu jener Zeit auf dem Austausch von Hardware gegründet. Diese Blütezeit kann jedoch durch den Austausch von Software auf der Insel Giu-decca leicht wieder ins Leben gerufen werden. Die Videotechnolo-gie ist dazu bestimmt, die führende Industrie im 21. Jahrhundert zu werden, weil hier das Verhältnis der gewonnenen Informa-tion/Unterhaltung zum Energieverbrauch sehr günstig ist.

Dennoch wird der internationale Austausch von Video-Software durch viele Probleme erschwert:

1) das komplizierte internationale Urheberrecht
2) Videosysteme (NTSC, PAL, SECAM etc.)
3) Sprachen/Übersetzungen
4) kulturell-gesellschaftlich-religiöse Bräuche, die Nacktheit etc. betreffen
5) das politische System und der Grad der Freiheit im Ausdruck etc.

Deshalb kann die Notwendigkeit eines internationalen Freihafens für Informationen, wo sich Käufer und Verkäufer und Studenten aus der ganzen Welt ungeachtet ihrer Herkunft treffen, diskutie-ren, sich in der Software aus aller Welt umsehen und einen Handel abschließen können, nicht überschätzt werden.

Die Insel Giudecca ist für diese Funktion geographisch wegen ihrer Nähe zur westlichen, sozialistischen und arabischen Welt gut ge-eignet.

Dieser Freihafen für Informationen entspricht auch ihrer kulturellen Tradition als Händlerin zwischen Ost und West, und er wird das wirtschaftliche Überleben der Giudecca-Insel für lange Zeit garan-tieren.

(published in: Magazzini del Sale alle Zattere, Venice 1975, pp. 86, 88)

One Candle, 1988
Photos Timm Rautert

NAM JUNE PAIK : "Bill Clinton

1974 Media Planning for the Postindustrial Society

In 1974 I proposed the "Electronic Super Highway" to the Rockefeller Foundation and made 12.000 $. The idea was published in German (3.000 copies) in 1976. Maybe Bill Clinton read it in the Oxford Library. He used exactly the same terminology.

Conclusion:

The Depression of the 30's was fought back by bold public works and capital expenditures such as the TVA (Tennessee Valley Authority), the WPA (Works Progress Administration), and highway building. Especially massive interstate highways have become the backbone of economic growth for the last 40 years. New economic dislocations caused by the double shocks of energy and ecology and the historical necessity for the transition into postindustrial society require equally radical remedies. This social investment must also be economically viable. These remedies should modernize the economical infra-structure, make the economy internationally more competitive and contribute to the longlasting postindustrial prosperity.
The building of new ELECTRONIC SUPER HIGHWAYS will be an even bigger enterprise. Suppose we connect New York and Los Angeles with multi-layer of broadband communication networks, such as domestic satellites, wave guides, bunches of co-axial cables, and later, the fiber-optics laser beam. The expenses would be as high as moon landing, but the ripple effect 'harvest' of byproducts would be more numerous. Long distance telephone will become practically free. Multi-point color TV conference calls with sophisticated input-output units will become economically feasible. While not energy consuming in maintenance, (except for the initial copper), it will cut down air travel and snarling airport-downtown limousine service forever. Efficient communication reduces social waste and malfunction in every corner, resulting in exponential savings in energy and ecology. They will cease to be just an Ersatz (a substitute) or lubricant but will become the springboard of unexpected new human activities. One hundred years ago Thoreau wondered: 'Even if the telephone company succeeded in connecting people in Maine with people in Tennessee, what would they have to say to each other?' The rest is history.

Published in German in 1976 in the catalogue 'Nam June Paik. Werke 1946–1976. Musik-Fluxus-Video', ed. by Wulf Herzogenrath, Kölnischer Kunstverein, Cologne 1976, p. 165–166.

stole my Idea"

1993 Electronic Super Highway "Venice → Ulan Bator"

"Information as Art, Art as Information", 1993
Chase Bank Manhattan
Photo: Blair Thurman

"Rehabilitation of Genghis Khan: 'Nomad' Work in Progress", 1993
Photo: Chris Gomien (courtesy of Carl Solway Gallery, Cincinnati)

APRIL 12, 1993 $2.95

TIME

Coming Soon to Your TV Screen

The Vancouver Summit

The Info Highway

Bringing a revolution in entertainment, news and communication

During the 1992 presidential campaign, Clinton and Gore made building a "data superhighway" a centerpiece of their program to revitalize the U.S. economy, comparing it with the government's role in creating the interstate highway system in the 1950s. The budget proposal the Administration submitted in February includes nearly $5 billion over the next four years to develop new software and equipment for the information highway.

(p. 53)

45. VENICE BIENNALE

TV SPOTS

HIGH TECH GONDOLAS

21 "High Tech Gondolas" 15-30 seconds each
by Nam June Paik, Paul Garrin, Marco Giusti

**Gratefull acknowledgement
to the following individuals
and organisations:**

Postperfect INC., New York City
Broadway Video INC., New York City
WNET TV, TV tab, New York City
WGBH TV, New Television Workshop, Boston
RAI 3 (Blob Show), Milano
Sony HD Softcenter, Tokyo
"Leningrad" TV Station
WDR 3, Cologne
KBS TV, Seoul

Computer Graphics:
Hans Donner
Paul Garrin
Judson Rosebush
Lester Weiss
Dean Winkler

Performers / Staffs:
Laurie Anderson
David Bowie
John Cage
Kyungwha Chun
Myungwha Chun
Merce Cunningham
Hiroe Ishii
KBS Sinfonie Orchestra
KODO Japanese Drummer
La La La Human Steps
Jungsung Lee
Charlotte Moorman
Lou Reed
Ryuichi Sakamoto
Popular Mechanix (St. Petersburg)
Seoul Performing Art Highschool
Die Toten Hosen
and all the staffs of 3 satellite shows:
"Good Morning Mr. Orwell" 1984
"Bye Bye Kipling" 1986
"Wrap around the World" 1988

ELECTRONIC SUPERHIGHWAY

In the Electronic Superhighway
Room 1: Mirage at the Desert of Gobi
Room 2: Sistine Chapel Before the Restoration

**Credit and Thanks to all the names
in the High Tech Gondolas
plus the following:**

Computer Graphics:
Rebecca Allen, Kraftwerk, EMI N.I.T.

"Joan of Arc of Mongolia":
Ulrike Oettinger (Berlin)

Participants include:
Alvin Ailley, Dance Theatre (Junior Group)
Dick Cavett
Le Combas
Philip Glass
Peter Gabriel
Amy Greenfield
Keith Haring
I & S Inc., Tokyo
Janis Joplin
Sankai Juky
Eun-Yim Kim
Sun Ock Lee
Living Theatre
Jonas Mekas
Issei Miyake
Yves Montand
Seibu Art Museum, Tokyo
Stan Vanderbeek
Ben Vautier

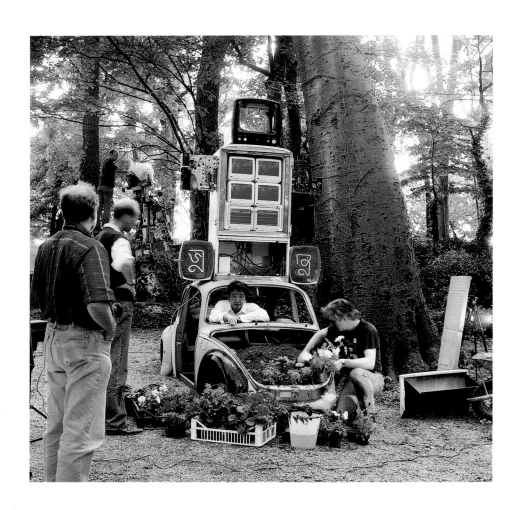

FLORIAN MATZNER
A SHORT TRIP ON THE ELECTRONIC SUPERHIGHWAY WITH NAM JUNE PAIK

Florian Matzner: This afternoon you told me that you are NOT Andy Warhol! For that reason we make this short trip on the Electronic Superhighway with the almost unknown artist Nam June Paik in the last few years cherished by colleagues and art critics as "Father of Video Art" and "Cultural Terrorist". Owing to your taking part at the Venice Biennale, a new title is to be added: "Ehren-Gast-Arbeiter" ("Honorable Foreign Worker") of the Federal Republic of Germany.

Nam June Paik: The history is that the decision of my contribution to the Biennale was published in autumn 91. One of my assistants, Jochen Saueracker, told me that he heard over the radio that I'll be the representative of the German Pavilion. When I telephoned with Klaus Bußmann I told him that it's a great honor for me that a little Korean guy can represent the big Germany and I also told him that I don't have a German passport. It's also important that this is the first Biennale after the German reunification and normally they would have chosen one artist from former East Germany and one from former West Germany. I mean, this would seem a logical thing. So Klaus Bußmann said to himself: If I have to take one artist from East I would rather choose one from FAR East, from very very Far East. And I think that he had hard résistance from Auswärtiges Amt in choosing a Korean guy as German artist, you know. Therefore Klaus Bußmann decided to publish his decision QUICKLY to the press and to the radio and to make it a fait accompli, so that it was too late for Auswärtiges Amt to complain. Therefore, I understand that Klaus Bußmann made an original and courageous decision which I salute!

FM: Klaus Bußmann not only chose the Korean guy from Far East but also an artist from the FAR WEST, namely, the German artist Hans Haacke, who also lives in the USA!

NJP: It is a Jungian coincidence. The first time my picture ever appeared on the cover of a magazine it was a photo taken by Hans Haacke in Schloß Morsbroich in 1960, Hans was only 24 years old. Also Hans' family and me/Shigeko lived very close in the same complex in 1971 and 72 – we always met in the supermarket.

FM: Far East and Far West in the German Pavilion: this coalition of Haacke and Paik had already been declared by the Biennale administration as symbol of the whole Biennale; its motto is: "The Four Cardinal Points of Art: East and West, North and South", or, "The Artist as Modern Nomad". Anyway, Haacke and Paik devided the German Pavilion among themselves: Haacke took the central room with its apse and its imposing main facade dating from the Nazi times, while Paik has at his disposal the four lateral rooms and the garden area next to and behind the Pavilion.

NJP: That was very important: I had the impression that Klaus Bußmann would have liked to have me in the central room because my work is more colorful than Hans Haacke's. But I thought that video needs the sound, or, even if video doesn't need the sound all the time, if there is a sound it can always help a video installation. But the problem is that sound can enter into the other rooms. I thought to have some little sound in three or four rooms, it's better than to have it only in one central room. Therefore I chose freiwillig smaller rooms. I said to Hans Haacke: You take the big room on the condition that I may have to disturb your tranquility and this has been big political problem, because now Hans Haacke has taken the big room and now I can't have big sound, all right in any way – next question!

FM: Let's talk about your concept, your main theme of your contribution to the Biennale: it's generally titled "The Electronic Super

◄
Marco Polo (in progress), 1993

►►
Alexander the Great, 1993

►►►
Catherine the Great, 1993

►►►►
Tangun as a Scythian (?) King
45. Biennale d'Arte, Venice, German Pavilion

Courtesy Carl Solway Gallery, Cincinnati
Photos Roman Mensing

"Joseph Beuys said: 'There was no desert
of Gobi, the desert of Gobi was a GREEN!'
That means there must have been a lot of
communication in the desert of Gobi, so that
was Beuys's chance, because, do you know
that many German soldiers, intellectual and
well educated German soldiers have had
good contact with the Crimean Tatars, but
only Beuys had a spiritual liaison with them,
because he was the only one who knew
something about their aesthetic structure.
And because for Beuys the desert of Gobi
was green, this is the aspect that I wanted
to mention on the Green, in the back of
the German Pavilion: there is NO desert
of Gobi!"

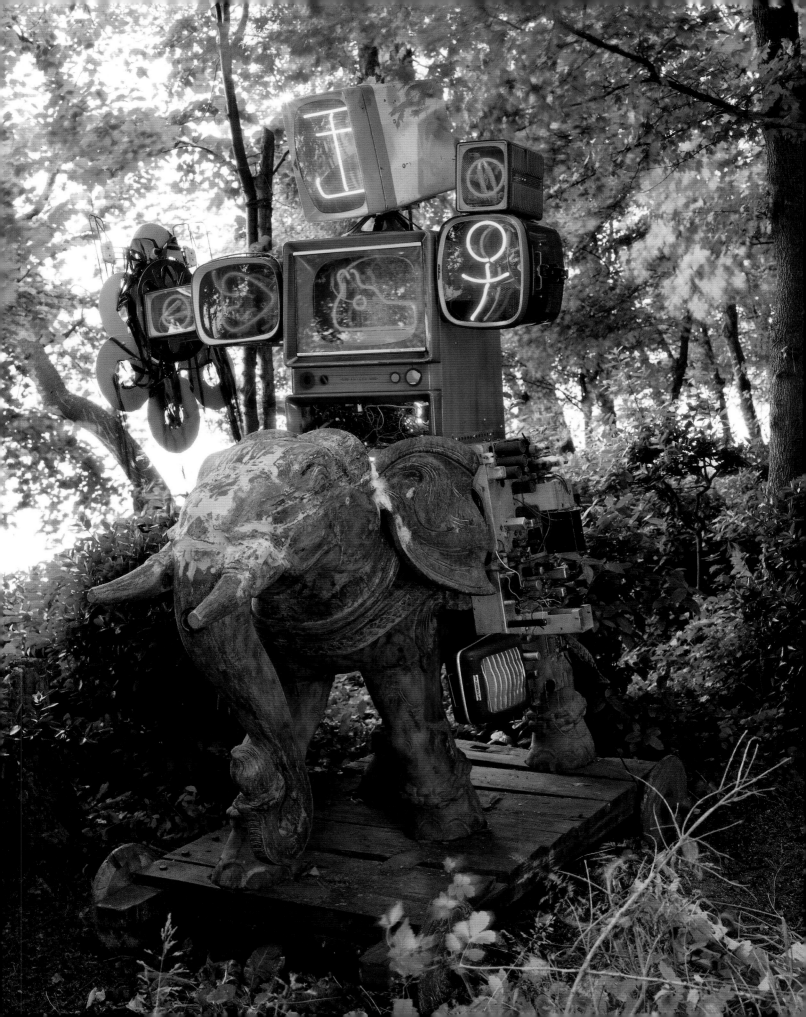

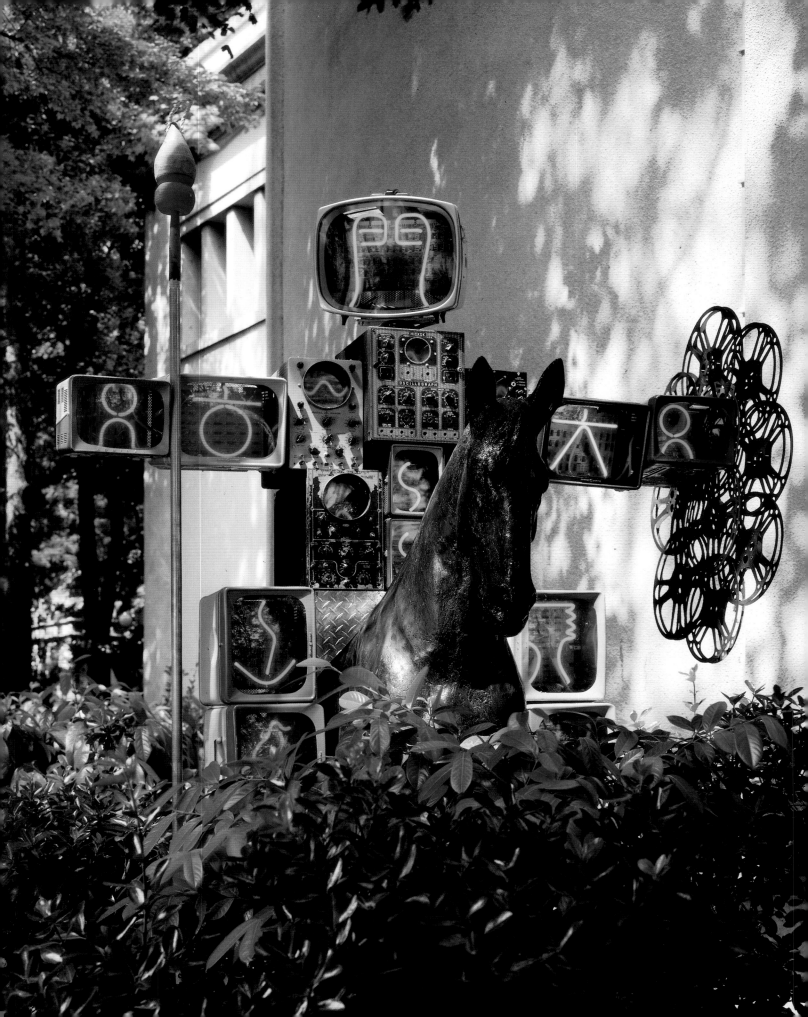

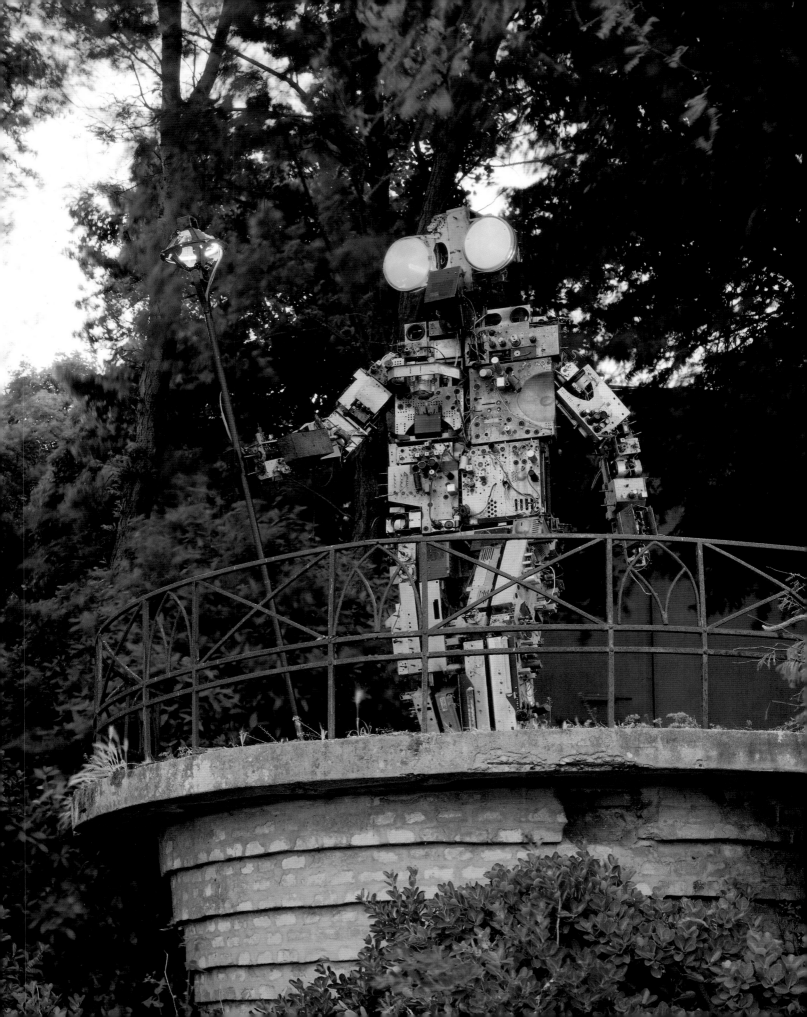

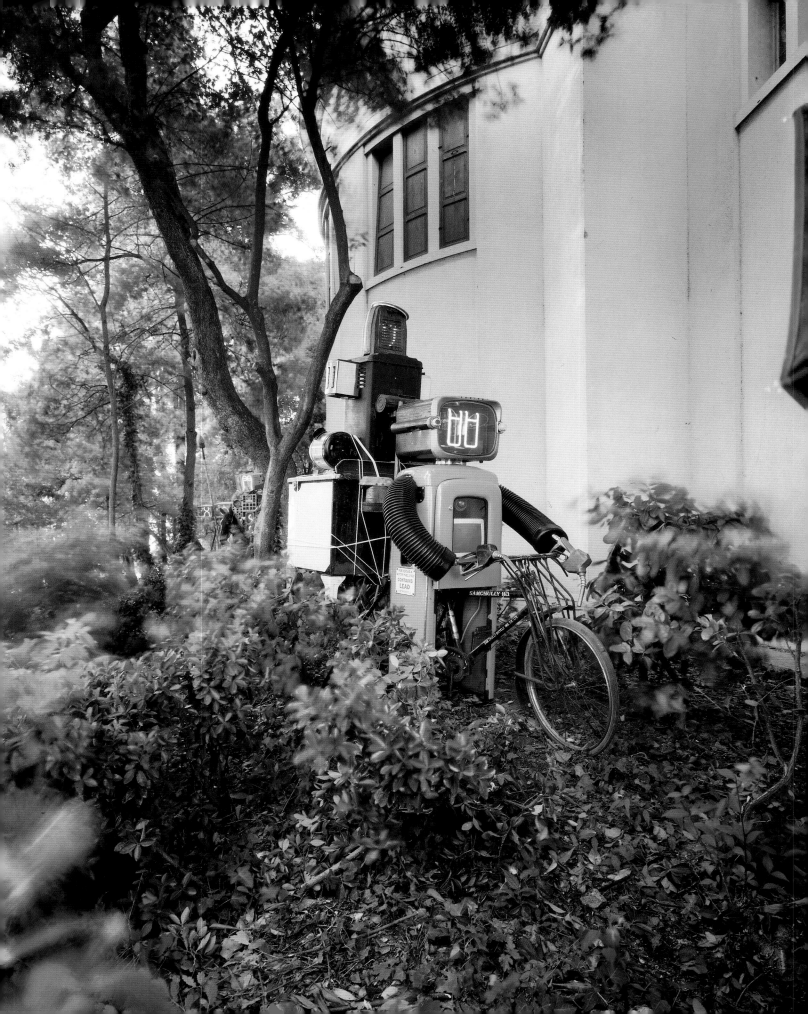

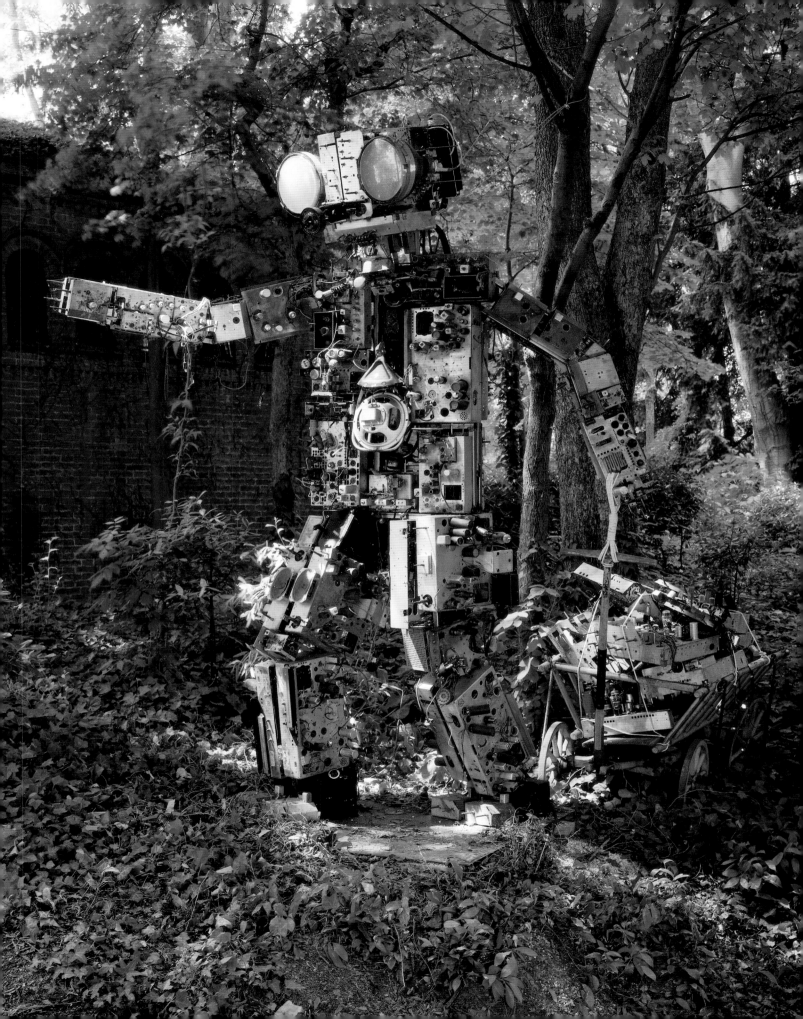

highway – From Venice to Ulan Bator". It's surprising that about 70 or 80% of the pieces shown are absolutely new and made exclusively for the German Pavilion ...

NJP: If you include the video projection "Sistine Chapel before Restoration" that we already rehearsed for the Biennale in April at Holly Solomon Gallery then you are right: 80% is neu, ja!

FM: Would you explain, roughly, the different rooms and the garden area? The two large rooms are dominated, on one side by the video projection, by the three-sided video wall "Electronic Superhighway", and by the installation "Phasen-Verschiebung", while in the two smaller rooms ...?

NJP: Okay, I give you now the history of the Verwandlung of a concept: Marco Polo was important for the relationship between West and Far East and also for the Americans. Obviously if Asians think about Venice, they think about Marco Polo, you know ... So I thought that two rooms could symbolize the East – Mongolia, China, Korea, Japan – and the other two the West, and the background – that means the garden around and behind the Pavilion – could have meant the desert of Gobi ... so I decided to put three or four bandits there who ruled the desert of Gobi for 1.000.000 years. So then we chose for the outside a "Marco Polo" statue, a "Genghis Khan" statue, a "Attila" statue – the King of the Huns –, then a monument for the "Crimean Tatar", who saved the life of Joseph Beuys, never thanked for by the German officials, you know ... so we have to have a monument for this Tatar ... and then "Tangun" the first Korean king, because when you pick up Korean graves you find many Scythians, and Korea only exists because this guy and the nomad Scythians have also been in Greece ... Scythians sind dieses alte nomadische Volk, das bei Herodot vorkommt ... and when they opened graves in South Korea they found many Scythians that means that these nomads went from Europe to Asia, to Korea NOT much in Japan ... and even today you can't drive from South Korea to Greece, but in that time they did it! You know, my Japanese friend and art critic Junji Ito told me that in early Italian paintings like those by Cimabue and Giotto there are people with thin Chinese eyes because in this time people idealized China ... then later on – for example in the Quattrocento – sculptures, paintings resemble Italians, because in this time, the Seidenstraße was very wichtig! ... Moreover we even bought a "Mongolian tent" for 23,000 US $; and it was harder to get it out than to pay it, because the Mongolian embassy in Korea protested against it. The embassy official said, this is our Kulturgut and you can't get it out without our commission! This guy is a real communist, because with the price of this Mongolian tent you can live in Korea more than 5 years, in Mongolia for 50 years! Talking about the relationship between Italy and Asia, did you know that Spaghetti came from China? Anyway, we made these seven statues for the outside including "Catherine the Great" and "Alexander the Great".

FM: That means: "Marco Polo", "Genghis Khan", "Attila", "Crimean Tatar", "Korean King Tangun", "Catherine the Great" and "Alexander the Great". As an iconographical system every outdoor piece means another kind or way of transport, of traffic, of communication, but the titles suggest power, reign, rulership, exploration and reconquest ...

NJP: For that reason we made TWO kinds of Highways: the other one – the Electronic Superhighway – is part of the Wahlpolitik of Mr. Clinton. Already in 1974 I proposed to the Rockefeller Foundation an important official paper – they paid 14,000 US $ for it:

◄◄
Crimean Tatar, who Saved the Life of Joseph Beuys

◄◄◄
Attila, the King of the Huns, 1993
45. Biennale d'Arte, Venice, German Pavilion

Courtesy Carl Solway Gallery, Cincinnati
Photos Roman Mensing

I made a research for one year and there I proposed that the Americans should build up Electronic Superhighways for solving their economical, social and political problems. This research was printed in 1976 in 3,000 copies, and then Mr. Clinton came and stole MY idea for his electoral campaign in 1992! ... Because he understood that economic growth is not possible without environmental progress and program, without Energieverbrauch! I mean, exactly at that time the Club of Rome said that every economic growth is wrong and the Club of Rome was a club of important politicians. Therefore I proposed the Electronic Superhighway as a policy to counter unemployment, securing economic growth without using heavy energy or power. That means I proposed an economic growth not based on hardware but on software, because software growth does not involve energy! – For all these reasons I believe in the Electronic Superhighway and Mr. Clinton used MY very words and I thought I read actually MY report from 1974, when I read Clinton's speech from 1992.

FM: So, at the close of the 20th century, Marco Polo's historical highway from Venice to Asia 700 years ago, or Christopher Columbus', dating back 500 years, are substituted by the Electronic Highway of world-wide satellite communication.

NJP: So you see, Electronic Superhighway is the broadband communication, the compression of complex information – if you want you can even make Electronic Sex. So I made a big piece of 48 projections or 500 television sets in a small room which not only became a disco, but you can also make an intellectual experiment about the question of how much information you can absorb. And anyway, we can give the people a maximum of information at minimum cost, you know: this is a kind of reproductive art, this is very important for me! I mean, this directly opposes the collector mentality.

FM: Let's still talk about your Highways and Venice ...

NJP: In 1958 John Cage said on Italian Television, when the people asked him, which town do you like most in Italy: "Venice is the most advanced city in the world, because it has already abolished the automobiles!" A town without automobiles is the most progressive town in the world, Venice is a living model for a life without automobiles for thousand years, but don't tell this Mr. Agnelli! – Anyway, there is also a famous comment of Joseph Beuys: "There was no desert of Gobi, the desert of Gobi was a GREEN!" That means there must have been a lot of communication in the desert of Gobi, so that was Beuys's chance, because, do you know that many German soldiers, intellectual and well-educated German soldiers had good contact with the Crimean Tatars, but only Beuys had a spiritual liaison with them, because he was the only one who knew something about their aesthetic structure. And because for Beuys the desert of Gobi was green, this is the aspect that I wanted to mention on the Wiese, on the green backside of the Pavilion: there is NO desert of Gobi!

FM: When about half a year ago, you suggested to us the title "Electronic Superhighway: Bill Clinton stole my idea!" for your Biennale contribution, we did not believe you, frankly. However, reading Time Magazine's April edition[1] and two articles that appeared yesterday (May 17) in the International Herald Tribune[2] and Der Spiegel[3], we have grown wiser: the Electronic Superhighway is no longer the crazy fiction or an intellectual utopia of a little Korean guy, but is already becoming reality, being built, not only in the USA, but also in Europe. Is Paik the prophet of international electronic communication?

NJP: No, no, I thought with John Cage: 95 % of the world is dumb, otherwise poor guy from Korea could never make a living in Manhattan! – and Cage agreed! So, you see: I don't think I'm smart but I don't think other guys are smarter.

FM: Thinking about the history of the highway that dates back at least 700 years ...

NJP: ... or even 7,000,000 years ...

FM: ... the complex world affaires at the close of the 20th century once again acquire, through the services of the Electronic Superhighway, the intimacy of a medieval village square.

NJP: Yes sure, this is the great problem, that for example Watteau has been living ONLY in the 18th century, Voltaire could understand only a little bit of history, he couldn't travel, he visited only Switzerland and France and Prussia. – Now, we can travel to India, Pakistan, Iran, Ghana or Tansania ... we can live at the same time in the age of Watteau, of King Solomon or of the Empire of Napoleon, we can live in the SAME time TEN times, we can live simultaneously in New York and in Venice, and then take the aeroplane to Kazakhstan ... so, thanks to technology we can live not only in the future, but also in the past and in many different kinds of past ...

FM: ... and sometimes in the present ...

NJP: ... sometimes, yes, of course! If you want naked economic truth in Europe and America and Japan, which is full of depression ... The reason for the depression in the mature economy of the USA, Europe, and Japan is that people have already bought everything. They have every kind of hardware from Wash-Machine to VCR. There is nothing more to buy! – Only a NEW SOFT BOOM or a big war catastrophe can make capitalism work again. However who needs a home PC? There is a problem! We artists must help society INVENT something better / more profound than NINTENDO tv games. Therefore, enjoyment of past history in Venice becomes an important way to invent new software and stimulate economy. In the 1930s the artist was the enemy of capitalism, in the 1990s the artist may be the SAVIOR of capitalism (this is for Hans Haacke!). Okay, back to past, present, and future: One of the important contents is that we relive history: you will be in the future, and you will be in the past travelling to Rome and watching movies on Tannhäuser: We have to go back and forth, we have to split somehow and if human beings will not begin to create the software culture, there really will be stagnation of the further or advanced countries: we have to try harder to make art interesting!

FM: That's what you call "information as art, art as information" ...

NJP: ... Yessir!

FM: Let me ask you two final questions ...

NJP: ... yes, that's good, then I can go to sleep ...

FM: In this context of "Art as Information" you produced the official TV-Spot for the Biennale, a commercial called "High Tech Gondolas", in 21 versions, each between 15 and 20 seconds.

NJP: That is my present to Achille Bonito Oliva, because Achille and his Italian friends protected me many times in the seventies, you know. I had some legal problems because this spot is for television, which means we had to get the legal clearance from every Rock'n Roll star again. We bought worldwide rights for three years, and after these three years we have to make the contract again with David Bowie, Peter Gabriel, Lou Reed and those guys – I know I can make good video clips, but legal and financial problems are another thing, so I just took chance. So I made 21 ver-

sions with Paul Garrin who is a great genius, and Mr. Giusti, who collected some Italian material for me and I tried to emphasize old Venice and modern Venice. So, you, Matzner, sent me a lot of color slides of works of Biennale artists. Color slides make good great art, but color slides do not make great TV. So I ignored them and took only three of them (from Shigeko), and then I made a High Tech version of Venice – normally when you make ONE TV-Commercial, ten people have to work for two months, but Paul and me, we made 21 versions in ONLY three days! We are Super-Genius, we are Meta-Andy Warhol! – Now last question!

FM: Do you know, that it is expected of a conscientious foreign worker to retire at 64 and return to his native country?

NJP: According to the German Pensionsgesetz you have to work 15 years to get your Pension, so, when I began to work – it was at some Öffentliche Anstalt – when I was hired by the Düsseldorf Kunstakademie, Norbert Kricke very seriously asked me: "How old are you? If you are too old we don't hire you!" I was only 48, so they could hire me. Anyway, I was not able to visit the academy very often, because I was too busy, but I have some very good students: one third of the videos of a certain quality in Germany is from MY class, and after my Pension we will make a big exhibition! But, as I told a German collector: "Look, I don't really feel good about not visiting the academy often but getting such a very high Pension!" he answered me: "Your Pension is not only from the Kunstakademie but from the whole German Kunstwelt!" – Anyway, Harald Szeemann was the first who said: "I'm a Geistiger Gastarbeiter" ... now last question, Sir ...

FM: In 1990 you said: "Now that I'm almost sixty, it's time for me to practice a bit of dying. People of my age in older times in Korea went out in the mountains, accompanied by a geomancer, in search of a propitious site for a grave." – Now you ARE sixty and a few days ago you told me when you will die!

NJP: Yes, it will be in 2010! You see, ONLY when an artist dies, will he make money ...

FM: ... this is really a problem ...

NJP: ... when I die Shigeko will take 50% first then the resty pie for No. 1: I donate 10% of my income to Amnesty International and when I die they should have all, No. 2: I will make my grave on the sky, it's a beautiful sculpture, but then, No. 3: every cable station in the world should have one public art channel (MTV is a kind of art channel, but I like unpopular art), so I will buy from my artworks cable channels everywhere in the world – India, Monaco, Kongo – that every evening at 8 o'clock you can see everywhere ONE video art, and not only my work. The problem of the art community is that we have good artists everywhere in the world – but 5 in Texas, 10 in Wyoming, 100 in San Francisco, 200 in New York ...

FM: ... 2 in Venice ...

NJP: ... yes 15 in Venice, and they all are strong, rich, powerful people, but they should ALL meet at night for a cable TV communication. So I want that Friday evening all over the world you have only ONE communicating art community. Anyway, there are still two important general things: No. 1: this Biennale is the first Biennale after the collapse of communism, and Fluxus has actively taken part in it, because the artist Milan Knizak in Prague was arrested 300 times – he was as famous as Havel – and in the radio president Nobotony said: "Knizak is a Klassenfeind". I mean, this is incredible, because for example Adenauer or even Strauss never mentioned Beuys. No. 2: Landsbergis of Lithuania was a contribu-

► Genghis Khan (in progress), 1993
Courtesy Carl Solway Gallery, Cincinnati

►► Electronic Superhighway, 1993

►►► Phasen-Verschiebung, 1993

45. Biennale d'Arte, Venice, German Pavilion
Photos Roman Mensing

►►►► (p. 138–143)
Sistine Chapel Before Restoration, 1993
Rehearsal for: 45. Biennale d'Arte, Venice, German Pavilion
Courtesy Holly Solomon Gallery, New York

tor to Fluxus in 1962, and he founded the official opposition party in Lithuania called Sajudis – and in Lithuanian "SAJUDIS" means "FLUXUS": so, officially the Fluxus party overthrew communist government and overthrew the whole Soviet Union. I mean, in the history of art NO artist party won over a government. Can you imagine that this little Lithuanian Fluxus guy took on all the Soviet Union – and the chairman of Fluxus, George Maciunas, was a COMMUNIST! ... that's a great IRONY ...

Interview with Nam June Paik, Venice, May 18th, 1993

1 Time Magazine, April 12th 1993, Ph. Elmer-Dewitt:
"Electronic Superhighway", p. 50–55

2 International Herald Tribune, May 17th 1993, Steve Weinstein:
"Building the Electronic Superhighway", p. 15.

3 Der Spiegel, May 17th 1993, "Wir bauen die Datenautobahn",
p. 272–284.

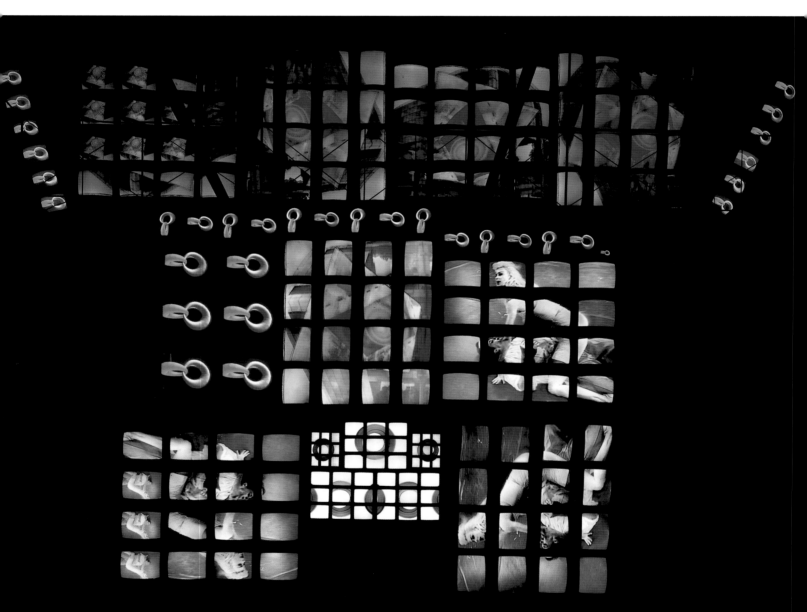

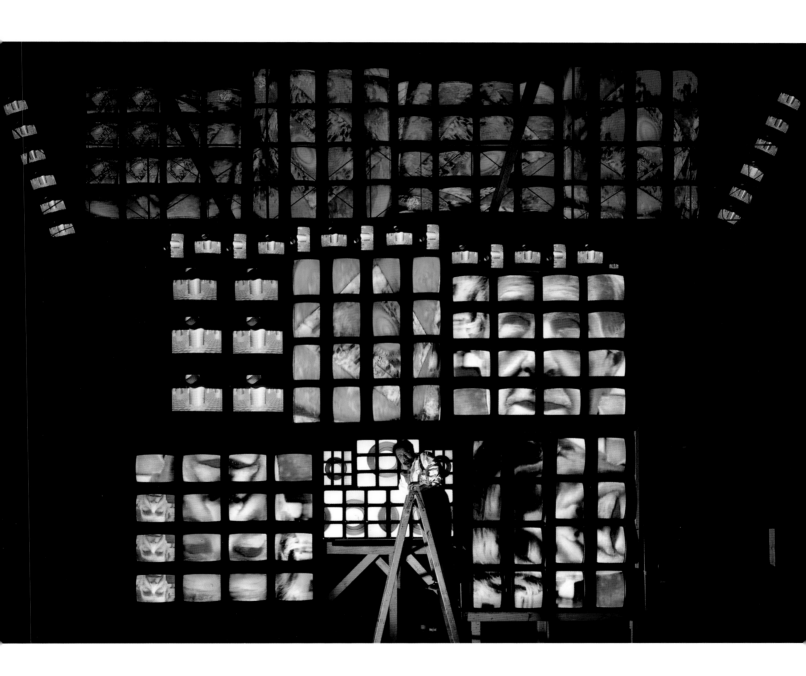

PAIK MOSAIK

Shuya Abe ✍ Genpei Akasegawa ✍ Jean-Christophe Ammann ✍ Pyonguk An ✍ Eric Andersen ✍ Tom Armstrong ✍ Akira Asada ✍ Akira Asahi ✍ Christine van Assche ✍ Mats B. ✍ Vyt Bakaitisf ✍ Burt Barr ✍ Lorenzo Bianda ✍ Michael Bielicky ✍ Marieluise Black ✍ Ursula Block ✍ Wibke von Bonin ✍ Dominique Bozo ✍ Earl Brown ✍ Elliot Caplan ✍ Pablo Casals ✍ C. Caspari ✍ Rosanna Chiessi ✍ Daryl Chin ✍ Gwin Joh Chin ✍ Y. J. Cho ✍ Henning Christiansen ✍ Chunghon Chung ✍ Russell Connor ✍ Thomasin Countey ✍ Dieter Daniels ✍ Wolfgang Drechsler ✍ Robert H. Dunham ✍ Viktoria von Fleming ✍ Henry Flynt ✍ Simone Forti ✍ Ken Friedman ✍ Martin Friedman ✍ Si Friel ✍ Grace Glueck ✍ K. O. Goetz/Rissa ✍ Shalom Gorewitz ✍ Hans Haacke ✍ Otto Hahn ✍ James Harithas ✍ Detlev Hartmann ✍ Jon Hendricks ✍ Dick Higgins ✍ Ralph Hocking ✍ Shinja Hong ✍ Byung-ki Hwang ✍ Toshi Ichiyanagi ✍ Takahiko Iimura ✍ Jay Iselin ✍ Hiroe Ishii ✍ Junji Ito ✍ Sukhi Kang ✍ Tai Hee Kang ✍ Szeto Keung ✍ Hyun Ja Kim ✍ Hyunsook Kim ✍ Songwu Kim ✍ Won Kim ✍ Hong Hee Kim-Cheon ✍ Billy Klüver ✍ Milan Knzak ✍ Alison Knowles ✍ Richard Kostelanetz ✍ Takehisa Kosugi ✍ Shigeko Kubota ✍ Soo Oh Kwang ✍ Kyungsung Lee ✍ Oh-Ryong Lee ✍ Oryong Lee ✍ Se Duk Lee ✍ Won Hong Lee ✍ Kim Levin ✍ Hi Joo Limb ✍ Barbara London ✍ Jackson Mac Low ✍ Gino Di Maggio ✍ Judith Malina ✍ Jan-Olaf Mallander ✍ Laurence Mamy ✍ Alan Marlis ✍ Toshio Matsumoto ✍ Barbara Mayfield ✍ Issey Miyake ✍ Aiko Miyawaki ✍ Fumio Nanjo ✍ Roger Nellens ✍ Hermann Nitsch ✍ Yoko Ono ✍ Jerald Ordover ✍ Suzanne Pagé ✍ Syeunggil Paik ✍ Kyu H. Park ✍ Rhai Kyoung Park ✍ Mark Patsfall ✍ Hala Pietkiewicz ✍ Frank C. Pileggi ✍ Klaus Rinke ✍ Osvaldo Romberg ✍ Ulrike Rosenbach ✍ Dieter Roth ✍ Ryuichi Sakamoto ✍ Itsuo Sakane ✍ Wieland Schmied ✍ Chaeung So ✍ Harald Szeemann ✍ Yuji Takahashi ✍ Jean Toche ✍ Yasunao Tone ✍ Larry Warshaw ✍ Etsuko Watari ✍ Emmett Williams ✍ William S. Wilson ✍ Jud Yalkut ✍ C.J. Yao ✍ Souyun Yi ✍ Tadanori Yokoo ✍ Jun-sang Yu ✍ Yasuhiro Yurugi ✍ Antonina Zaru

LA BIENNALE DI VENEZIA
XLV ESPOSIZIONE INTERNAZIONALE D'ARTE

Prof. Dr. Klaus Bußmann

Kommissar des Deutschen Pavillions

Westfälisches Landesmuseum
Domplatz 10, D - 4400 Münster
Tel. 0251/5907-257, Fax 5907-210

Name
Adress

to friends of N.J.P.

Münster, January 27th, 1993

Dear ...,

I will edit a multilingual Nam June Paik-catalogue for the German Pavilion of the Venice-Biennale in June 1993, designed as «book as artwork» by Paik himself. A large portion of this book will be devoted to a section called «Paik-Mosaic» in which many friends of Nam June Paik are invited to contribute a short essay in English, German, French or Italian ranging from only 5 lines to 800 words.

In order to avoid repetative boredom, we urge you to choose only a narrow slice of pie in his life and art, that means a single episode or an event to which you are familiar with, or a single art work, which you like most or hate most. We welcome negative criticism, sarcastic of funny view, or even the Mad Magazine-kind of comical or irrelevant comment. Also instead of an essay you may draw a drawing or a comic strip. Since there will be a separate essay on his biography and summary of his art works you don't have to go into the generally available informations. We certainly want to invent an original format in art catalogues making. Your fee will be two lithos, a limited edition, signed by Nam June Paik, that will be ready around June 1993.

Your contribution must arrive by March 30th in Münster (Germany), Westfälisches Landesmuseum. If you still have any questions call me or my assistent Dr. Florian Matzner (Tel. 0251/5907-212, Fax: 0251/5907-210).

Yours sincerely,

(Prof. Dr. Klaus Bußmann)

SHUYA ABE TOKYO
Nam June Paik, 1993

It was 1963 when I first met Nam June Paik. It might be at about 2 o'clock in the afternoon on Saturday of the end of September, at the cafeteria on the second floor in Radio Store in Akihabara. I had heard that he was the ›very famous artist‹, so I was interested in what he wanted to realize. He told what he wanted to do in a soft voice, as he does so still now.

One was to produce a robot, the second was to deform the deflection circuits and the video amplifier of TV set by controling them from the outside, and the third was to create new color images with a color TV set.

After I met him, I remembered the art column with a photograph of Asahi newspaper a half year or one year before, reporting the oriental artist Nam June Paik, who broken into two a violin with a knife on the instant. So I did not feel that it was the first meeting with him. He was a leading member of Fluxus and Neo-Dadaist, therefore the robot and the TV would be a result of the development of his thought. My faith in Dadaism induced me to get on familiar terms with him, and we talked about many things, collaborated with each other. Thus thirty years have passed. His motto is "the more…, the better." I am convinced that these two blank spaces will be always filled with the infinite combination of his new act and new thought.

GENPEI AKASEGAWA TOKYO
A bit of electric wave slips out of Mr. Paik, 1993

Nam June Paik uses the electric wave today. However, he used a kitchen knife and a plane before.

It was in 1964. Two pianos were on the stage. Paik scrapped one of them with a kitchen knife, and shaved rapidly the black shining lid over a keyboard of the another one with a plane. I felt as if someone had slashed my face with a sharp knife.

He used rice too. Having poured a lot of water and shaving cream over himself, he baptized himself with rice falling like a cascade.

For the first time, I watched him as a performer at his recital. When we had met outside of the stage, he always looked like a convalescent with a slight fever. And he spoke in a soft voice, even feeble. So, it was shocking. I was awakened to have seen him treating a kitchen knife, a plane and rice. Something had revealed itself before me at the moment, although I could not answer what it was.

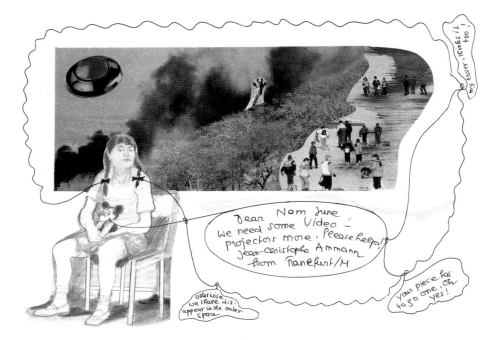

JEAN-CHRISTOPHE AMMANN
FRANKFURT/M.
"Zeichnung", 1993

Pyonguk An SEOUL
No. 1 Guru, 1993

A few years ago when Namjune Paik came to Seoul, he sent me a letter written in large letters on a gray paper.

"Dear Teacher An Pyonguk:
I thank you for not forgetting my name. In fact, I lost my long music 'Dry Field' to be dedicated to you during the Korean War. Last year I bought your book, 'The Theory of Happiness' in New York and gave it as a gift to my New York Guru with the following inscription. 'An = No. 1 Guru, John Cage = No. 2 Guru and You = No. 3 Guru.'"

ERIC ANDERSEN KOPENHAGEN
Five hundred words..., March 29, 1993

five hundred words faxed for a
multilingual Nam June Paik-catalogue for
the German Pavilion of the Venice-
Biennale in June 1993 could form
more than five lines

TOM ARMSTRONG
PRAGUE/NEW YORK/PITTSBURGH
A brief anecdote, March 24, 1993

When Nam June had his great retrospective exhibition at the Whitney Museum of American Art in 1982, the fourth floor of the museum was dark except for the light from hundreds of video monitors. There were monitors everywhere – assembled into walls, arranged on the floor, attached to walls, and a great number suspended from the ceiling. To accommodate viewing of the latter, mattresses had been placed on the floor to allow viewers to lie down to enjoy the ceiling performance.

Prior to the opening, I escorted Kitty Charlysle Stair, the distinguished and very elegant chairman of the New York State Council on the Arts, through the exhibition with Nam June as our guide. And, of course, he insisted she join him on a mattress. As the three of us lay there together in the dark watching goldfish swim across the ceiling, Nam June in his most mischievous voice announced, "many babies born after exhibition".

AKIRA ASADA TOKYO
A Cloth Wrapping Time and Space –
A Preface For the Satellite Art, 1993

From the moment when he launched into the experiment of video art with a tiny magnet in his hand to the present day in which he has realized the dream of satellite art to all TV stations in many countries, Nam June Paik has been always standing in the frorefront of technology and art. His main subject is clear,

although his activities vary and look crooked. I would like to call his work "collage of time and space".

Far from the tableau completed as a plane, the TV monitor is incessantly re-woven with the electric scanning. Time is an essential factor here. This electronic woven stuff is disentangled with an unimaginably high speed and interlaced again in every instance, different from the ordinary cloth. To intervene its process was the purpose of the switch-over of images by magnets or of the video synthesizer. With these apparatus, a usual TV set receiving a normal broadcast could be transformed into an extraordinary art work. The video art of Mr. Paik was "the collage of time and space" using the existing systems of TV set and TV broadcast.

AKIRA ASAHI TOKYO
Paik who gazes into the distance –
Nam June Paik = Paik san, 1993

A Japanese way to call someone's name, Paik san, sounds more familiar than Mr. Paik for me. It immediately evokes his personality, his appearance, and even his somewhat restless elocution.

When I was a chief curator of The Metropolitan Museum of Tokyo, which organized his exhibition "Mostly Video Nam June Paik" (1984), I learned from his work much about the artist in a new age, the relations between human beings and nature, between technology and mankind, which are the philosophical base for us. He is the philosopher who knows the natural view of Oriental people, the nature of human beings, and the agony of the moderns.

He gave me his autograph in the catalogue of exhibition in Tokyo. The precious scrap for me is put between its pages, which is an an obituary notice and a memorial article about Joseph Beuys.

It was in Kassel where I found Mr. Paik gazing in the distance absent-mindedly. He was alone, without his friends or video monitors. Recalling Joseph Beuys and John Cage, he will gaze into the further distance in Venice.

CHRISTINE VAN ASSCHE PARIS
Lettre ouverte à Nam June Paik, 1993

Créée en 1965 dans le contexte de tes expérimentations sur les déformations d'images sans enregistrement préalable, mais par une simple manipulation magnétique du signal électronique émis, "Moon is the Oldest TV" semble être l'œuvre fétiche que tu protèges.

La cause de ces soins particuliers vient-elle des images représentées (les différentes phases de la lune) et/ou de la notion de temporalité qui la sous-tend ou encore de celle de méditation qui s'en dégage?

Cette œuvre semble être dans ton corpus celle qui demeure "ouverte", celle que tu ne désires pas achever, celle que tu te plais à transformer à chaque présentation, celle qui n'a pas trouvé son repos, et de même son statut définitif.

MATS B. STOCKHOLM
Collage, 1969/1993

"Moon is the Oldest TV" est pour le conservateur une œuvre attachante certes, même si problématique. Elle dénote un charisme très fort auprès du public et suscite un questionnement resté sans réponse auprès de l'amateur d'art.

Un roman écrit en 1985 par Florence de Mèredieu et intitulé "Télévision, la lune", témoigne de la résonance attachante de cette œuvre.

Que cette lettre ouverte soit l'occasion d'une question officielle et ce catalogue d'une réponse.

In 1969 he wanted to stop wars – but look what happened!

VYT BAKAITIS NEW YORK
Letter to N.J.P, 4. 11. 1990

I thought to share "Time Piece, for George" with you as a souvenir of our departed friend Maciunas. It actually happened to me recently upstate that while I sat by a stream in the woods I was reminded of a friendly exchange George and I once had regarding reincarnation. It was years before, in June 1975, in NY City, he had told me he could see himself reviving as a frog, and then, years later, just as I was remembering this, there was the frog, right in front of me, about to jump by the edge of the stream. So the poem is what I saw, then and there. Of course, as you may know, George had little tolerance for poems, at least in the time I was acquainted with him; he had made the point, when I was trying to show him a poetry journal with my translation of a Lithuanian poem by his colleague Jonas Mekas, of refusing to open it "unless it has something visual". It was partly in deference to this conviction that I decided to keep my dedication to him first-name only. (Earlier, I had tagged a full formal dedication to a "visual" shaped poem which I managed to cook up as presumably more acceptable to him; though it's not been published and George never got to see it, but that's another story.)

148 B

BURT BARR NEW YORK
Two episodes, 1993

1. One day in the neighborhood where I live, I saw Nam June on the sidewalk. That is where I usually see him. We were talking for awhile, when I put my glasses on to see what a work-man was doing, several feet away. Nam asked if I needed glasses to see the man. I said that I've needed reading-glasses for a number of years, but now I need glasses for other things as well, including my being able to see the man who was fixing the sidewalk.
"Don't you need glasses?" I asked.
"Only when I read the stock-market", Nam replied.
"Don't you need them to look at video?" I asked.
"I never look at video", Nam said.

2. During a screening at the Museum of Modern Art, I was sitting between Shigeko and Nam June. Shigeko had been sitting there. When I arrived I sat one seat away from her. Minutes later Nam June arrived and sat one seat away from me.
Nam began telling me he was making out his will, that stated that anyone in the world

could take his videos, in their entirety or any part of them, and use them in any way they wanted. And he said that there would be no cost – that they would be absolutely free.
I thought about this, realizing that most artists take all kinds of precautionary measures to protect their works – whether they're alive or after, in their wills. I further realized that if his works were to be readily accessible and totally free of cost, that many would make use of them, and that his name would grow and grow – and that his fame would soar. Immortality would be insured.
I soon replied, and said that was the most brillant thing thing I ever heard of. Shigeko spoke out, and said that was the stupidest thing she ever heard of.

LORENZO BIANDA VERSCIO
Nam June Paik, Biennale Venezia
16 Marzo, 1993

La prima volta che incontrai Paik, all'occasione di un seminario a Parigi, rimasi stupito nel verificare la relativa importanza dell'uso della parola. La mia conoscenza della lingua inglese era al tempo assai scarsa e la sua rimane per sempre una versione *coreana* di quell'idioma. Non so come fu possibile intenderci; la parola era risultata un mezzo, per lo più formale, per esprimere all'altro l'intenzione di avere qualche cosa da comunicare.
Questa sensibile immediatezza, nell'usare il mezzo di comunicazione come supporto in sé irrilevante, la riscontro regolarmente nelle sue opere.

MICHAEL BIELICKY DÜSSELDORF/PRAG
Big sleep, 1993

Paik kam zu den Treffen mit seinen Studenten ziemlich selten und unregelmäßig. Wobei das nicht bedeutet, daß es schlecht gewesen wäre. Den meisten von uns war es recht und auch von Nutzen.
Es gab immer wieder neue Studenten, die sich bemüht haben, Schüler von Paik zu werden. So sagte er zu ihnen immer, er sei ein schlechter Professor, da er sowieso nie anwesend sei. Davon ließen sich die Neubewerber aber nicht abschrecken, und sie drängten darauf, daß der große Meister sich ihre Videobänder anschaue. Er fragte dann immer, wie lang die Bänder wären, und dann ging das Licht aus und die Videos wurden vorgeführt. Nervös und voller Erwartung warteten die Kandidaten auf den Kommentar. In den meisten Fällen, nachdem das Licht wieder eingeschaltet wurde, schlief Paik. Dann

wachte er auf und meinte: "Nicht schlecht, aber vielleicht ein bißchen zu lang."

"Paik (Nein, ich bin Experimentalist)", 1986

MARIELUISE BLACK NEW YORK
"A portion of the transcript from the 1992 inaugural events for the Center for Curatorial Studies at Bard College: Nam June Paik joined Eric Fischl, Jeff Koons, Tim Rollins and Fred Wilson in a panel discussion entitled 'Contemporary Art and Exhibition'. Ingrid Sischy moderated." April 3, 1992

Nam June Paik:
Waiting in this kind of panel for my turn to come is like waiting in the dentist's waiting room that my turn comes.
So, now we continue. So I can make either a list of the propaganda of my schools, or I can do something else. Maybe I do something else.
It is maybe about time that artists self-analyze our own hypocrisy. Artists live on the crumbs of the super-rich, yet artists always say the most radical things. They tend to bite the hand which they feed (sic), but they don't quite bite, you know, they just nibble. And then ... we live either on super-rich money or tax money of the middle class... Middle class made Nazis. Don't think Nazis were made by power. In Germany, his power didn't want Nazis. (The) so-called hand-worker class... like, you know, Archie Bunker – these people – made the Nazis at the beginning of National Socialism.
So, then, art is the same thing. We live on the crumbs of the this so-called (?), like Citibank... (?) So, we are the prime example of what long time ago Mr. Marcuse said – repressed paradox. It is better to have some paradox than nothing. Also, it's about time, since socialism is gone. Of course, we try to live on National Endowment of the Arts, and that's middle-class tax money. And, then they control, and the middle-class control is much worse ...

▶
Fin de Siècle II, 1989
Installation in the Whitney Museum of American Art, New York, for the Exhibition "Image World: Art & Media Culture"

▶▶
Mirage Stage, 1988
Courtesy Carl Solway Gallery, Cincinnati

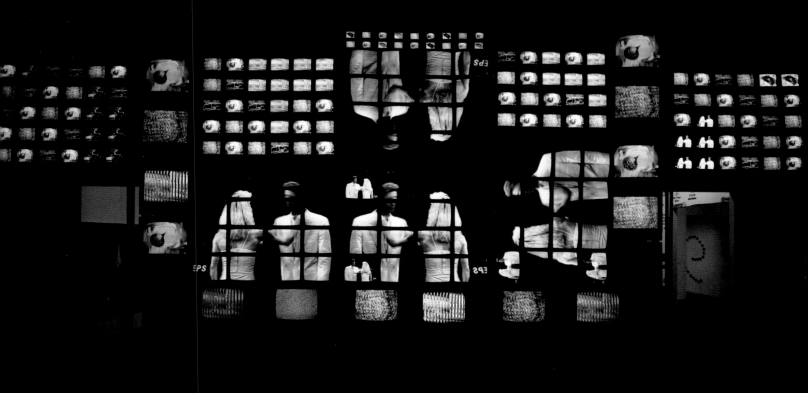
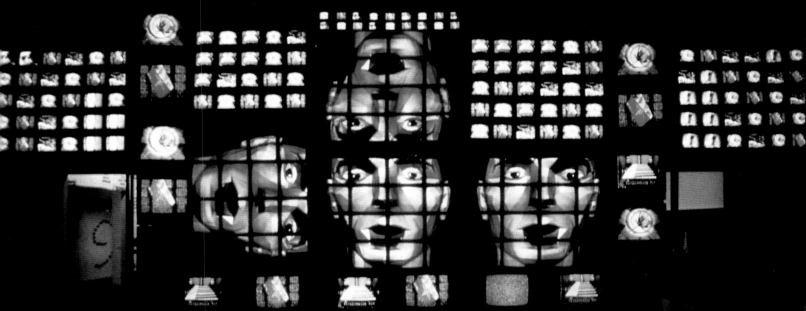

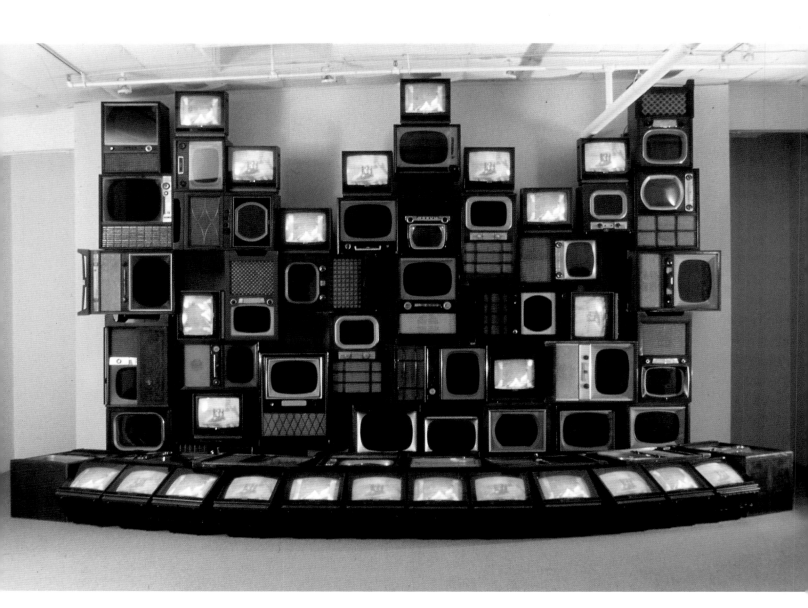

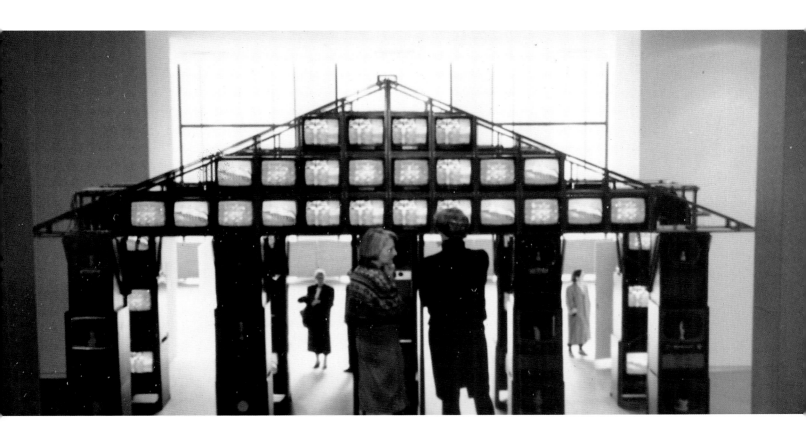

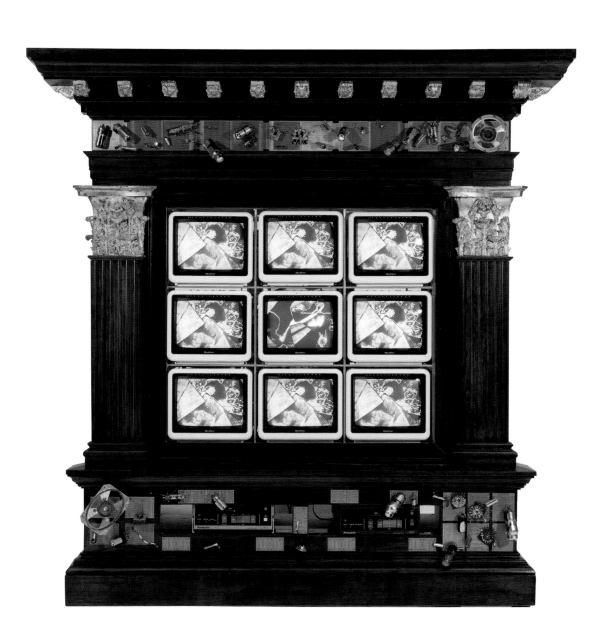

And then so it is about time that artists should say what we wrote. We must come forward … (?)

I have been waiting from Jean-Luc Godard for a long time – not that video. He didn't say. But he should have said why he supports Mao Tse Tung's Cultural Revolution – who killed so many people, including many French and German – these continental people – not physically, but they gave up their brilliant careers to do the revolution. And Jean-Luc Godard keeps making great movies supporting (?) It's supported by tax. Many young people … follow him. That's hypocrisy. So, it's about time.

And then the number two hypocrisy is the art movement and market force. And market force created the art movement. It was not so bad, I think. Even I can make a living … so. According to ABC, it happens with our price range…(?) [LAUGHTER] I'm sorry. I don't speak about Fluxus video, but I shall speak, but I shall speak…

Woman:
Sorry. Can I interrupt? Somebody in the audience asked me to explain it. Nam June suggested that the seating arrangement here is according to the price range of our artworks. I think by the end, we will have totally restructured the art market.

URSULA BLOCK BERLIN
Tagebuchnotiz, 3. November 1978

Paik kommt zu Besuch – er verteilt sein Gepäck auf die verschiedenen Räume – es entsteht ein Chaos aus Gummiüberschuhen, Handtüchern, Hemden, Papieren, Unterhosen, Hosenträgern, Plastiktüten – er redet – er lacht – er schläft – er trinkt Mineralwasser – er badet (Otto muß pinkeln) – er wäscht sich die Haare – ich treffe ihn in der Küche – er beugt sich über den Gasherd – er schwenkt den Kopf über der offenen Gasflamme: er trocknet sich die Haare – er spielt Klavier mit Anna.

◄
TV is New Hearth, 1989
Courtesy Carl Solway Gallery, Cincinnati

◄◄
Madeleine Disco, 1989
Galerie Beaubourg, Paris

WIBKE VON BONIN KÖLN
Do it yourself. TV Lesen, März 1993

Müde bin ich vom langen Tag. Vorbei ist das Schäfchenzählen, das einlullende Bockspringen der raunenden Wollmäuse von Orange nach Blau, von Farbe nach Schwarzweiß. Ich starre auf den Schnee meines nachmitternächtlichen Fernsehschirms: Weiße Zeilen auf Schwarz, oder weiße Seiten, unbeschriebene Welten, undefinierter Klang, relative Ruhe. Ende, endlich.

"Lies alle weißen Seiten sehr langsam (mehr als 3 Sekunden). Du solltest nicht einfach 'lesen' wie gewöhnlich, sondern solltest es 'wirklich' 'erleben' oder versuchen, es zu erleben, oder dir wenigstens vorstellen, all die Dinge selbst zu erleben."
(Paik, DO IT YOURSELF, Antworten an La Monte Young, 1961-62)

3. November
Paik kommt zu Besuch – er verteilt sein Gepäck auf die verschiedenen Räume – es entsteht ein Chaos aus Gummiüberschuhen, Handtüchern, Hemden, Papieren, Unterhosen, Hosenträgern, Plastiktüten – er redet – er lacht – er schläft – er trinkt Mineralwasser – er badet (Otto muß pinkeln) – er wäscht sich die Haare – ich treffe ihn in der Küche – er beugt sich über den Gasherd – er schwenkt den Kopf über der offenen Gasflamme: er trocknet sich die Haare – er spielt Klavier mit Anna

Paper TV, 1974

Ich lese im flirrenden Weiß meines Schirms und träume vom Frühling. Wann kommt er? "Die erste Schwalbe, die du im nächsten Frühling triffst, – dies ist meine erste Performance." (Paik, a. a. O.)

Und ich sehe sie oben rechts in der Ecke meines leeren Fernsehschirms, sie fliegt den Schwalben nach, die bereits geflohen sind – in die Freiheit meiner Phantasie. Realitäts- und fernsehmüde beginne ich zu träumen, zu spinnen, zu lesen, zu zählen und zu rätseln. Neben dem Fernseher hängt Paiks Heliogravure (Paper TV), Fernseher zum Nahsehen. Die Elemente aller möglichen Fernsehgeschichten sind da aufgereiht, Zeile für Zeile: Alle Typen von Eierköpfen zu Querköpfen, von Grinsern zu Heulern, Zornigen zu Ängstlichen; von Vamps zu braven Mädchen, Opas zu Gören. Kopffüßler en face und im Profil, mit Stoppelhaar und Wallemähne, mit Kinnbart und mit Scheitel, mit Lockenwicklern und mit Pfeife, mit Hut oder Baseballcap. Vier Zeilen Singles, zusammen 166 Hauptdarsteller in imaginären Dramen, dazu eine Zeile küssender Paare, 29 an der Zahl – oder ist es ein einziges, das sich durch die Zeilenzeit liebt und links nach rechts und über die Ränder hinaus? Who knows? Wieso eigentlich von links nach rechts? Das ist meine Leserichtung, doch alle Autos fahren von rechts nach links, die 30 PKW sowie die 30 Pickups und LKW aller Marken und Größen, die Eisenbahn mit ihren 30 Waggons und die 33 Schiffe, ob sie segeln, dampfen

oder unsichtbar auf ihrer Zeile gleiten. Nicht anders als mit der Nase nach links, die Luftgefährte aller denkbaren Bauarten ... Paik hat sie wohl von links nach rechts schreibend, zeichnend ins Leben gerufen, wie auch die Fische mit ihren Flossen und Schuppen, mit den absurden Mäulern und den Kulleraugen. Diszipliniert schwimmen sie die zwei ihnen zugedachten Zeilen entlang, fein differenziert am linken, zu Kringelwürmern aufgelöst am rechten Rand ihres TV-Aquariums. Ähnlich die Vierbeiner, Hunde, Katzen, Schafe, Ziegen – oder sind das lauter mißglückte Promenadenmischungen?! Paiks Haustierzoo der 52 Viecher wäre allein jede Woche des Jahres eine Sendung im Vorabendprogramm wert. Zu später Stunde dann – eine Uhrenzeile zeigt die Zeitflucht an – Sex and Crime: auf dunkelrunde Busentupfen und 33 Pistolen, von Geisterhand gegeneinandergerichtet, folgen am Ende, am unteren Bildrand, 49 Dollarzeichen ... (Ach, Paik: "If I had a million dollars...") Zählen und erzählen – es könnte immer weitergehen: 990 Zeichen auf 30 Zeilen geben doch viel mehr her als ein Pixelprogramm auf 30 Kanälen mit 625 Zeilen! Die oben zitierte Anweisung an La Monte Young gilt einer Komposition. Ohne Noten geht es auch in Paiks Paper TV nicht ab. Zweimal gibt's Notenlinien und zweimal auch Schrift, doch die kann ich nicht entziffern (vielleicht koreanisch?). Leichter läßt sich

diese Hieroglyphen-Zeile übersetzen: Ein Fragezeichen plus ein Fragezeichen gleich zwei Fragezeichen. Ein Fragezeichen minus ein Fragezeichen gleich Null. Ein Fragezeichen plus ein spiegelverkehrtes Fragezeichen gleich ein Herz – das heißt "Happy end". Ich freue mich mit Paik, den der Humor nicht verläßt, selbst wenn die noch nicht gelöste Aufgabe lautet: Wurzel aus yellow chairs plus minus Wurzel aus blue sky minus Wurzel aus six nine gleich plus minus sorry mal Wurzel aus red apple plus minus Wurzel aus red TV... Do it yourself.

DOMINIQUE BOZO PARIS
Une lettre, 1er octobre 1984
On peut rêver sur l'évolution incommensurable des publics instantanés. Ainsi, l'art de Nam June Paik, relayé par satellite lors de l'émission du nouvel an "Good Morning Mr. Orwell" au Centre Pompidou, appartient aux légendes du vingtième siècle – fugaces, mais lumineuses, justement, par leur superbe fragilité.

EARL BROWN
Planned Panichood, 1962
(published in the Anthology ed. by Young/ MacLow, 1962)
Yes Virgil, there *is* an avant-garde ... in Cologne its name is Nam June Paik ... a kind of Oriental Kammerkrieg ... a place for war-surplus bravery, fear, heroics, aggression, hot and cold running sweat, cruelty, exhilaration, love, and other more or less unsettling responses which we would rather think about (detatchedly) than experience (actually) ... it's not easy to make something (or not make something) (or to make a no-thing) (or to not make a no-thing) in which you and others find yourselves (by) getting lost in the present of ... (to frightening and dangerous and involved[ing] and care-full) ... the difference between *things in time* and *time in things* ... the former we do right away ... as for the latter; later ... (too difficult and dangerous and unknown) ... there's hardly time to classify and file away, for future abuse, one's so busy being there and knowing it. Paik seems to feel rather out of things ... the new academies, stylistic puritanisms, inverse egoism, a myth is as good as a mile isms, etctraisms ... unfestivalized, unculted, untimed, unknown and more than a little unstrung (not avoiding but bending with it) now and again ... the best laid plans of mice and

Paik etc. but it doesn't change things … just makes them different … so far (as I know) one only hears (sees, feels) Paik performed by Paik … which is (I think) why things are so *total* … nothing is lost in translation… very traditional in the East for master to give directly to pupil (a whack on the head) the sound, of the experience rather than a lecture or an indirect (notational) directive … Paik doesn't tell somebody, he up and does it … come hell or no water … (he was heard to say, after finding that they had figuratively pulled the plug in his tub; "Kunst ist tot"… he makes no bones about kunst but he notices things like the poverty in and around it (him)… a Paik is a Paik becoming a Paik (by any other name) … and its a real something(?) to have happened to one … more than like a translation its like a transfusion (its a good idea to know your blood type before you get there … incidently) … nothing is lost in transfusion or confusion … an additive with all the impurities left in … less discrepancy between TIME *in* the piece (performance) and TIME *during* the piece than with anything recently … and you can't hardly get that recently anymore yet.

Gertrude Stein said many things when you come to think about it for a few minutes (I suggest 183,765,432,109 minutes for a starter) but one of the more profound and prophetic was that she was completely conscious of the peaceful penetration of the Orient into the art and philosophy of the West … maybe. I'm rather outnumbered but I do believe that Paik's Penetration (as it will be referred to in official reports from the avant) is a peaceful one … ("terror is *good* for you"…"good old no-count terror") I got pretty nervous too and so would you, what with not knowing if Paik, me, a friend, an enemy, or a piano is eventually if not NOW going out that 3 story window into the Rhine, or if the scissors will stop at (with) the necktie, or if beejeezes the day of rechnung is upon us all … I wonder if he has a theory and an idea and a philosophy and a reason and a no- reason and a have-to and thinks good like an artist should … tis not something you have time to think about until you're on your way to pick up your suit (Suite) from the cleaners.

ELLIOT CAPLAN NEW YORK
500 words about Nam June Paik, 1993

Nam June Paik asked me to write 500 words about him. I think he uses Merce Cunningham and John Cage too much in his imagery. It's lucky he switched to Humphrey Bogart.

Here is a poem John Cage wrote when he was 4 1/2 years old.

run little girl
run to a tree
run to a rabbit
run to a bird
run run to me

sing little yellow
bird to a little bird
jump little rabbit

hop little rabbit
to a big girl

I met Nam June Paik on the street in 1977. He used to go for walks, everyday. A year earlier at a media conference in Milwaukee, he said that he and his crew had just returned from eating steak. He liked his crew to eat steak. "Gives them strength to set up video". He then said to the few of us assembled, "Too much work, not enough fun. Now, we have fun". He started "Global Groove", rock n'roll and strip tease.

The following year, I moved to New York and would see Paik walking in Soho. I would say, "Hello". He would say "Hello". Then, in 1981 I was hired by the Whitney Museum to work on his video retrospective, the first ever given to a video artist. Together with Callie Angel and curator John Hanhardt we slowly pieced together one of the best museum shows I had ever seen. I worked in Paik's loft several days a week sifting through boxes of papers and photographs in order to construct some sense of his past for the biographical sections of the exhibition catalogue. During this time, we ate sushi, and drank water out of a pitcher filled with rocks.

We spent time searching Canal street for used cast-iron heaters. We spent time fixing his elevator. We spent time reading the newspaper and eating over-cooked vegetables in Greek coffee shops. It was all interesting. Though, the most difficult part was to figure out a way to document his videotapes in still photography. I wanted to eliminate the raster lines and feature a full video field of information. I thought about it like a photograph became the cover of the exhibition catalogue. Paik used to say, "One general makes, thousand bones dry." I think that's true, sometimes.

We still see each other – on the street, naturally or at the theater when Merce is performing. We have coffee. "David Tudor was fantastic tonight", he said. We speak about

John's loss. Our meetings are brief. There is work to do.
Here is the Fluxus spell checker for Paik:

pack	pain	park	peace
peaks	peek	spiece	pix
paid	pair	pace	peck
pick	pike	poach	pail
pais	piss	pack	peak
peek	pics	pique	pock

Here is the Fluxus spell checker for Fluxus:

fluxes	luxus	flaxes
flexes	floozfes	floss
fluxes	phloxes	

PABLO CASALS
… Media = Tao? …, 19. 8. 1973
(published in the Los Angeles Times)

"I have just read about a concert in which every member of a symphony orchestra was asked to play whatever pleased him at the moment. Then there was something about a piece for piano in which the pianist was not allowed to touch the keys. And, of course you know about the lady who plays the cello wearing nothing here…"
Casals pointed to his venerable chest and smiled faintly.
"Experimentation is fine," he summarized. "But they should not call it music. They should call it something else."

► John Cage, 1990

Cage Age, 1988

►► Edgar Allan Poe, 1990

Gertrude Stein, 1991

Courtesy Carl Solway Gallery, Cincinnati

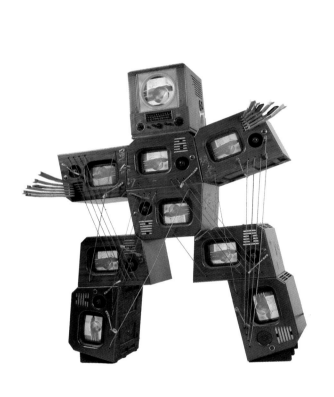 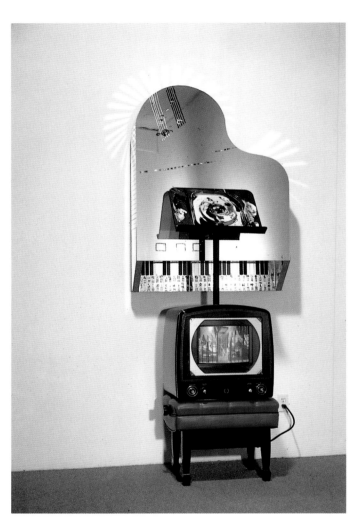

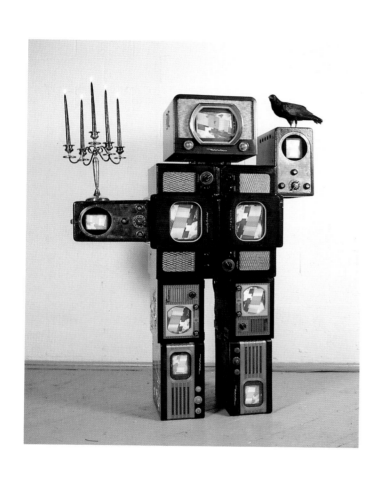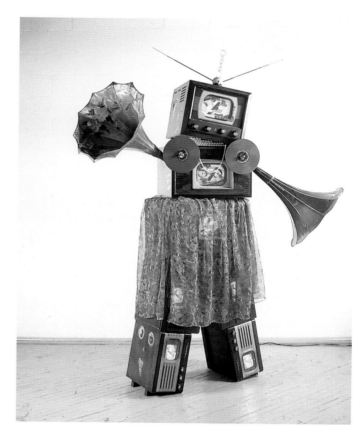

C. CASPARI
EIN LABYR IST KEIN LABYR, 1993
Zeichnung

ROSANNA CHIESSI CAPRI/NAPOLI
Un breve testo su Nam June Paik, 1993
Tanto é stato scritto e detto su Nam June
Paik, tutto vero!

Io da parte mia vorrei dire alcune cose sulla
sua grande umanità. Nel 1974-75 pubblicai (in
collaborazione con altri) una grande edizione
di 90 foto, documenti, originali, disegni e ma-
nifesti di Paik e Charlotte Moorman: 1964-
1974 titolo della edizione. Era il primo grande
lavoro che usciva in Italia, e penso anche in
Europa, così completo. Lo presentai a Basilea
nel 1975 abbinandolo alle loro performances
che venivano presentate nel mio stand e per
alcuni giorni convivemmo con questo grande
spettacolo dell'arte. Nel caos più totale
dell'organizzazione Paik si sedeva per terra
sotto una scala e ci osservava sorridendo e
accondiscendendo ad ogni nostra richiesta
con grande disponibilità. Pagai il viaggio dei
due artisti da New York a Basilea e l'impegno
economico, sia per l'organizzazione che per
l'edizione fu molte alto. Paik era preoccupato
che io non vendessi: infatti allora, vendere un
pezzo fluxus era une impresa. Ogni volta che
lo incontravo, negli anni successivi mi do-
mandava sempre se avevo venduto il lavoro e
io rispondevo sempre di no: mi regalò a quei
tempi un suo autoritratto dedicato che con-
servo gelosamente. Quando Charlotte Moor-
man si ammalò gravemente lui l'aiutò moltis-
simo regalandole dei suoi lavori che Char-
lotte avrebbe poi venduto.

A New York, in una serata di performances, la
Moorman interpretava un pezzo di Paik: lei
doveva prendere un violino e una volta alzato
piano piano con tutte e due le mani l'avrebbe
dovuto abbassare violentemente e romperlo

sopra un tavolo. C. Moorman non ebbe la for-
za fisica di romperlo e Paik allora andò da lei,
prese il violino e lo ruppe.

Nel 1990 feci con il Comune di Reggio Emilia
una grande esposizione di Paik. Venne a casa
mia e come sempre la sua disponibilità fu in-
finita. In seguito feci un video-catalogo della
mostra.

Ringrazio Paik per tutto quello che mi ha dato
e spero, in tempi migliori per la nostra econo-
mia, di avere ancora dei nuovi rapporti di la-
voro con lui e magari incontrarlo a "Casa
Malaparte" a Capri dove ora vivo e lavoro.
Grazie ancora.

DARYL CHIN NEW YORK
Nam June Paik: Some Reminiscences,
March 1993
When I think of Nam June, first I think of Nam
June, the artist. I think of his performances
with Charlotte Moorman, an artistic marriage
made in heaven: infectious good humor, high
spirits, anarchistic comic confusion. In my
mind, there are images of Charlotte lugging
around that cello, with a soundtrack of
Charlotte's inimitable Southern cackle making
some wonderfully self-deprecating remark
about the performance task at hand. And
there's Nam June, sometimes very intent,
sometimes beaming with bemusement as the
best-laid plans seemed to lay an egg. But you
could never be sure that the egg wasn't Nam
June's intention all along.

Then I think of some of his works, like that
ramshackle metal contraption that he called
a robot, spewing beans to and fro. Nam June
always said that it was a robot built to eat
and shit. Then there were those incredible TV
walls, like the one built for the "Image World"
show at The Whitney Museum, of the large
construction that's at The American Museum
of the Moving Image in Astoria, New York.

Andy Warhol once said that paintings should
be like wallpaper; Nam June went one fur-
ther, and turned the TV set, which is usually
regarded as furniture, into the wall.

Then I think of Nam June, the friend. Over the
years, I've seen him wandering the streets of
Soho, almost always with a scarf wrapped
around his waist. He once told me (if I'm re-
membering this correctly) that it was be-
cause he had some health problem (intesti-
nal? kidney?) and had to keep that section of
his body warm. He usually has on a white
shirt and a tie; many's the time when I've had
the irresistible urge to take a scissor...

When I think of Nam June, the friend, I think
of him in conjunction with Shigeko Kubota, an
actual marriage made somewhere in William
Blake country, i.e., somewhere between
heaven and hell. I think of their loft on Mercer
Street, with all those television sets. If there
is such a thing as the elephant graveyard,
well, this must be the television graveyard. At
one time, there were what seemed like miles
of television sets that were strung up and
hanging from the ceiling: Nam June, the tele-
vision vigilante. I remember the period when
the kitchen and the bathroom weren't separ-
ated from the rest of the loft (there were no
walls). This seemed to mortify Shigeko at
times, but I think this was intentional on Nam
June's part. It was just like his robot: you
could eat and shit at the same time.

Over the years, Nam June has come up with
statements that made you laugh, but which
actually contained good advice. Once, at one
of those art events where too many perfor-
mance artists were trying to do too many
superfluous performance bits, and video was
used like visual musak to lull the audience
into mindlessness, Nam June suddenly said,
"To be artist nowadays means to be party
boy." Then he saw Kit Fitzgerald nearby, and
added, "Or party girl". I laughed, and yet he

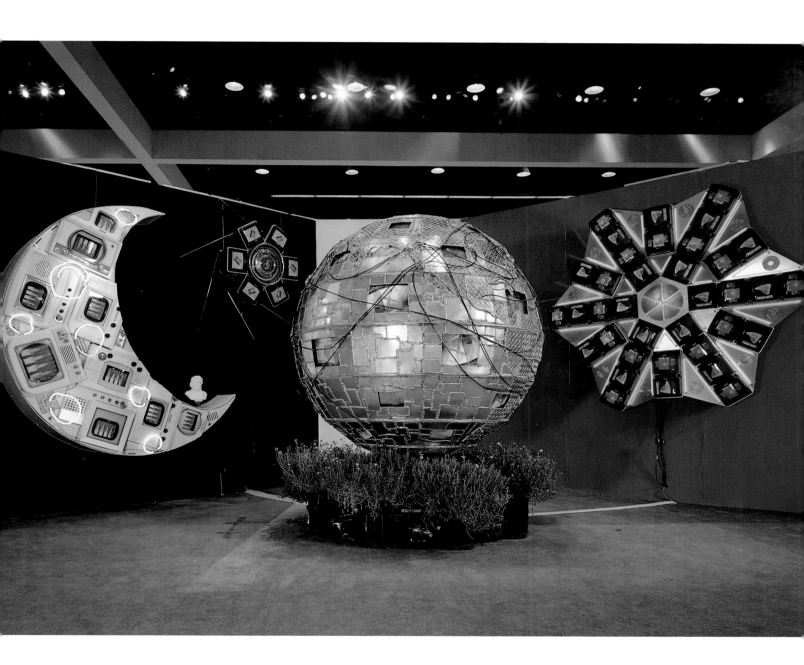

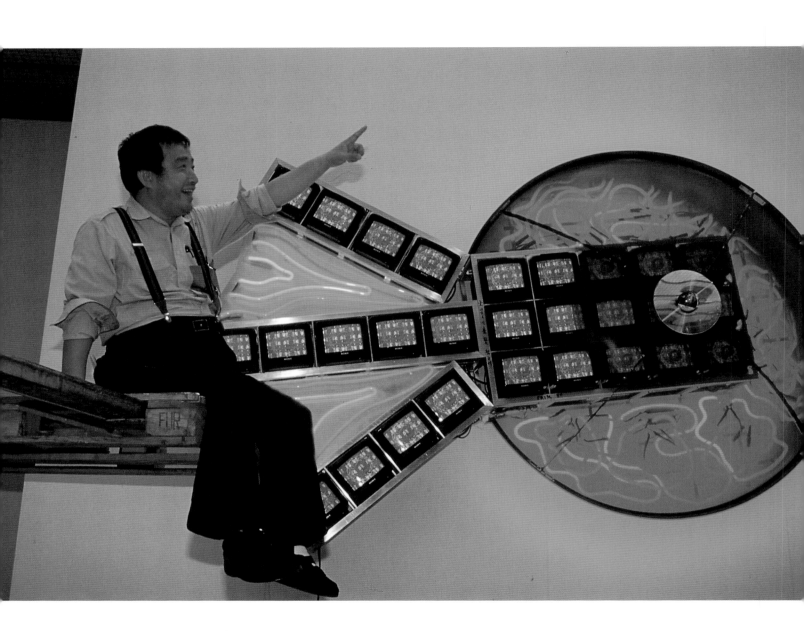

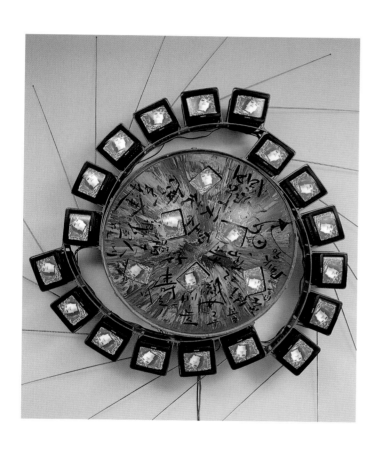 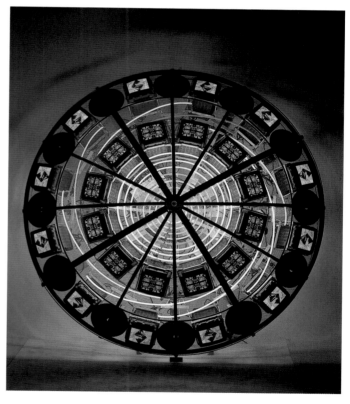

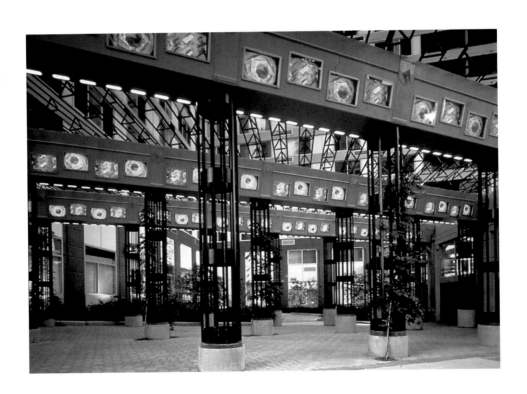

was right: to be an artist in the 1980s and 1990s has meant not doing serious art work, but making the scene, and getting people to talk about you.

There was a dinner party that Nam June and Shigeko gave for some visiting Japanese artists. This must have been around 1980. Nam June was having fun, introducing everybody as "genius" ("Japanese genius artist", "girl genius video artist", etc.). Then he turned to me, suddenly serious. He said, "You boy genius performance artist now, but white artists be more famous first. If Eric Bogosian take five years to become famous, it take you ten, maybe twenty years to become famous. But don't give up. Be patient. Not Zen. Just reality in America." And once again, he has been proven right. I'm still at the point where, when I file my income tax returns (to quote Laurie Anderson), I feel like crossing out "occupation" and writing in "hobby", while most of my compatriots (Bogosian, Stuart Sherman, John Jeserun) have attained levels of visibility which certainly haven't been accessible to me.

And there's a whole new generation of Asian-American film and video artists. They're feeling the frustration of seeing their work ignored or slighted or dismissed. Some of the ones that I've tried to help include Jon Moritsugu, Roddy Bogawa, Rico Martinez, Gregg Araki, Rea Tajiri. And when they confront the inequities, I tell them not to give up, be patient. Not Zen. Just reality in America. Better to be party boy or party girl, and have fun.

GWIN JOH CHIN NEW YORK
A tribute to Nam June Paik, January 8, 1993
A composer, musician, inventor, an artist, performer ... a pioneer, a guru, a father of video art

Nam June Paik is all of the above – and more. Not a household name yet, but undoubtedly millions of television viewers around the world have witnessed segments of Paik's remarkable antics on global hookups: 1984's "Good Morning Mr. Orwell", "Bye Bye Kipling" two years later, and "Wrap Around the World" in 1988.

Since the 1960's, it hasn't been always easy for *Paikaficionados* to explain many of his creations; in fact, there have been times when the public – as well as some mainstream critics – has found it difficult to categorize a Paik installation. Yet everyone is in agreement that Paik has made a significant contribution to popularize the video-art form alongside esthetic medium.

His vision of global communication has helped to bring about the establishment of video art courses at schools and to build special centers for exploration of the new medium. His influence on emerging video artists has been deep, and Paik has helped to attract new audiences for his difficult art form.

He is a brilliant technician and among his many futuristic innovations is the Paik-Abe videosynthesizer, which was constructed with Shuye Abe. This extraordinary mechanism mixes colors and images from several television cameras and electronically produces patterns and distorted forms.

Nam June Paik is disarmingly shy but, at the same time, impish and irreverently witty. Despite his disheveled hair and flopping unbuttoned sleeves, he is a master politician. As noted by The New York Times TV critic John J. O'Connor, "Mr. Paik is silly like a fox".

After nearly 30 years of a career that has shaken up the art establishment, Nam June Paik is now being honored by retrospectives in Europe, Asia and the U.S. He is known as the "father of video art". To his fellow countrymen in Korea – some of them still skeptical about his work – he is either a *chon-jae* (genius) or *ki-in* (eccentric), or both.

"paikaficionado", March 28, 1993
nam june paik
enlightened baby
see no hear no speak no.

musician, composer, inventor, artist
music is not sound, painting is not art,
drama is not theater.

pioneer, guru, father of video art
video buddha, traveling buddha,
family of robot, grandfather.

earth, moon, sun, venus
i am a poor man from a poor country,
i have to be entertaining all the time.
global groove, digital zen
"toujours amusants, souvent beaux,
quelquefois sublimes."

my faust ... voltaire
nam june paik ... chon-jae*.

* genius

意豪、意豪、意豪 ‥‥‥‥‥‥ 衰相、幻豪！
聲音、馨音、聲音 ‥‥‥‥‥‥ 雜音、竽音！

For Nam June Paik

Y.J. Cho 93

Y.J. CHO NEW YORK

HENNING CHRISTIANSEN BERLIN
A letter, 1984

'Good Morning mr. Orwell'
1984
Was a very good
Cabaret
flying
<u>on</u>
the world

CHUNGHON CHUNG SEOUL
Artist Namjune Paik Who Sells Modern Myths, 1993

"Half of art is deception. A high class deception. It's to deceive and to be deceived. Art is what makes the people perturbed."
This was what Namjune Paik said in a solo interview in Seoul to which he came back in 1986, after 34 years of absence. When this story was printed in a newspaper the following morning it "perturbed" the artists of all kinds in the town.

RUSSELL CONNOR "A MOVEABLE TYPE" NEW YORK
Nam June Paik catalogue comment March 28, 1993

There was a young fellow from Seoul
With an attitude really quite droll
His music was antic
(And anti-pedantic)
And the Video played rock and roll.

Nam June. A catalog is no place for sentimental tributes, but I confess I am moved at the idea of such an important exhibition. If I were to contribute an anecdote, it would be about his generosity or his humor. But it's all there in the work. The work never stops giving. The idealism behind Global Groove and the rest is real, and the laughter hurts my sides. I mean the falling down, tears on the cheeks, liberating sort of laughter, the craziness of the mad monk on the hill. I don't understand Zen, or Dada, or Fluxus, but I understand Seijong the Great, who invented moveable type in Korea fifty years before Gutenberg, and he would be very, very proud.

THOMASIN COUNTEY NEW YORK
For: Paik Mosaic, 1993

My first memory of Paik is of him asleep on my parents' couch covered with several blankets, his coat and a few rugs.
At that time he was working at Stonybrook, where my father taught. I witnessed many of his performances, they were mystical, poetic and funny. His musical arrangements were also very enjoyable. One which I remember called "Violin with String" in which he pulled a violin on a string across an airstrip seemed a revolution in musical awareness.
The past couple of years I have had the pleasure of working with him in collaboration with his paintings. His use of my sculptural jewelry gems has been inspirational to me.

DIETER DANIELS KARLSRUHE
Paik around the world, 1993

Paik in Berlin 1979, when Shigeko Kubota has a DAAD grant. I was the guest of a guest and slept at the studio for several days. Next to my mattress stood a big piece of steel, into

which I ran one night and hurt myself. Maybe this inititial shock brought me into art and video ... Years later I saw this piece of metal back – as part of Shigekos installation "The River".

Paik in New York 1987, organizing "wrap around the world", all the time on the telephone which is hanging from the ceiling on a long cord, so that it can be pulled around across the room, without conflicting with Shigekos videosculptures, which stand all over the place. On a big balcony at the back of the loft a collection of old TV-sets – "my Rentenversicherung" Paik smiles.

Paik in Cologne 1989, inviting friends to a splendid dinner at a Korean restaurant after the opening of the Videoskulptur-show, but everybody is so busy meeting people, that nobody has time for dinner.

Paik in Wiesbaden 1990 at his appartment, appointment for an interview. Ten years ago, when he became Professor at the Düsseldorf Academy, he looked for a place in Germany with hot springs, which would also help to get back his health. He checked out Wiesbaden and Bad Neuenahr – but in Bad Neuenahr he was the youngest of all, so he chose Wiesbaden. Now, last year he moved to Bad Neuenahr. Everything at the right time. No, we can not say in advance, in which of his many languages the interview will be – just let it happen.

Paik in Karlsruhe 1991, at the Multi-Mediale discussion, with Vostell, Weibel, vom Bruch, Shaw, Klotz etc., – taking a nap on the podium and re-entering the discussion with new inspiration afterwards.

Negotiating with Paik how his "Arche" from the collection of the ZKM could be adapted to a new exhibition situation in Barcelona: Getting rid of some of the animals? – "o.k." – But what about the water, which was taped in Hamburg the year before? – "Why don't you put Goldfisch-Aquarium under the Arche – but be careful to feed the fish regularly and instruct the guard to take out the dead ones, otherwise people will complain..." – No please, that is too complicated. Wouldn't a TV-garden around the ship look good? You know, Noah's boat back on earth after the flood ... "Yes, Paul Garrin could make a new tape, something with water and digital effects? Yes, yes, ask Paul ..."

Missing Paik in Tokyo 1992, because the fax was lost in the gallery office. Hoping to see Paik in Venice 1993, curious what he will make out of the serious piece of architecture, called the German Pavillion.

WOLFGANG DRECHSLER WIEN
Zwei Begegnungen mit Nam June Paik in Wien, 26. März 1993
26. April 1979: Eröffnung des neuen Museums moderner Kunst im Palais Liechtenstein. Einen der Akzente der Erstaufstellung bildete die erst wenige Monate zuvor erworbene Sammlung von Wolfgang Hahn mit ihren Schwerpunkten auf Nouveau Réalisme, Fluxus und Happening. Sie enthält zum Beispiel auch 14 Werke von Nam June Paik, darunter so wesentliche wie "Urmusik", 1961, oder "Klavier Intégral", 1963-68.

Bedingt durch die zahlreich erschienene politische und diplomatische Prominenz, wurde damals der Eingang des Museums von einem starken Polizeiaufgebot überwacht. Diesen Hütern von Recht und Ordnung war das in ihren Augen obskure Äußere eines der Einlaß Begehrenden verdächtig, und sie verweigerten dieser Person – mit dem Hinweis, daß hier Betteln verboten sei, – den Zutritt. Das war meine erste Begegnung mit Nam June Paik.

Endlich doch im Museum, entdeckte Paik, daß die das Fernsehbild manipulierende Stromspule bei seiner Arbeit "Zen for TV", 1963/75, frei lag. Dies könne gefährlich sein, meinte er, nahm seinen bunten Wollschal und umwickelte mit diesem die Spule. Später schützten wir sie mit einer Acrylhaube und sandten den Schal zurück.

26. Februar 1992: Einen Tag vor der Eröffnung seiner großen Retrospektive im Museum des 20. Jahrhunderts kam Nam June Paik nach Wien und kontrollierte den nahezu abgeschlossenen Ausstellungsaufbau. Er zeigte sich sehr zufrieden, verlangte aber eine Änderung: "Violin with String", 1961, durfte nicht in die vorgesehene Vitrine gelegt werden, sondern mußte in der offenen Transportkiste bleiben und so gezeigt werden, wie Paik das Stück vorgefunden hatte.

Diese "kleine" Intervention unterstützte nicht unwesentlich unsere Absicht, in Wien die beiden vorangegangenen Ausstellungen in Basel (Video Time) und Zürich (Video Space) zu einer Conclusio zu verdichten, um so ein, wie mir scheint, wesentliches Element der Kunst Paiks anschaulich zu machen: sein ständiges Pendeln zwischen extremer Einfachheit und höchstem technischen Aufwand – und somit deren Gleichwertigkeit.

ROBERT H. DUNHAM NEW YORK
A letter, March 18, 1993
Dear Sir, I used to help Paik + Charlotte Moorman at their avantgarde festivals in the 60's. At intermission, half the audience would storm out muttering about the performers "They're all phonies". Then Paik would appear to say with great satisfaction. "We got rid of the phonies!"

MARIO FERNANDEZ
There was once a lecture ..., April 9, 1993
There was once a lecture held at S.V.A. amphitheater. The subject matter of the lecture escapes me now but one of the guest speakers, I remember clearly, was Nam June Paik. It was my first seeing him in person. From where I was, he seemed radiating from both near and far in perspective. It was clear to me even then that he was different. At once confident and nervous Nam June began to speak. The warm light flooded the crowded amphitheater causing brilliant waves to wax and wane. Immediately, my vision became paralyzed. In the manner of fluxus, his voice was the ringing of bells simple yet diverse, from places of various arrangement in scales ascending, descending. Like the temples of the past or to the majestic landscape of time not squandered.

This moment of vision emerged and stayed with me from the early period of my life as an artist when I was seduced by everything and nothing. Nam June was full of surprises. Even during his talk out of nowhere he would start pulling off his socks in an amphitheater filled with people. He was childlike, unaware, totally aware. This combination caught my attention.

What was explicitly important for me was the clarity of his spirit as an artist, unobstructed. Like a bird flying, like a school of acquatic animals swimming, freely. Stimulating me, my emotion was the dynamic of Nam June as an artist.

Nam June went on. The lecture went on as well. From that night on, he became permanently a part of me. Though I knew not much of him then as a person, I developed through his work an intimacy. For me, that closeness was an inspiration, allowing me the possibilities of what I can be as an artist from the east living in the west.

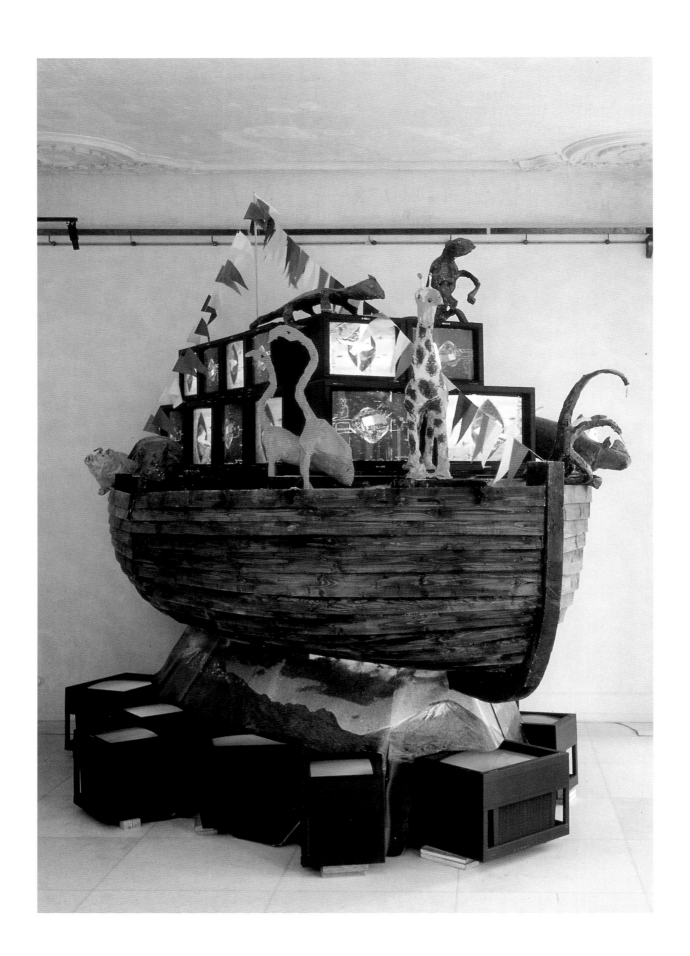

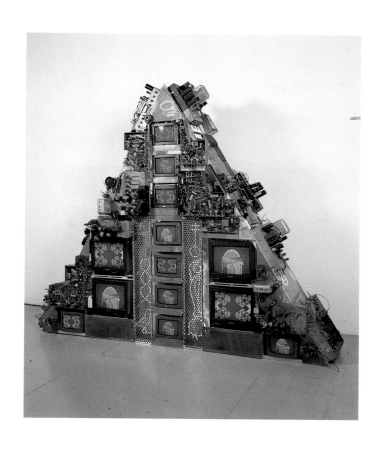

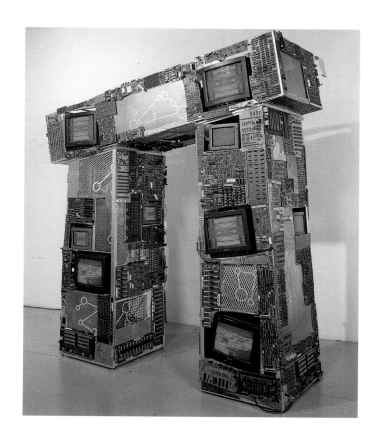

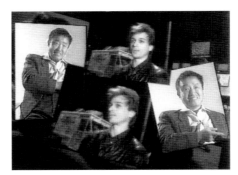

VIKTORIA VON FLEMMING HAMBURG
2 Zitate, 1990/1991

1. Interview-Ausschnitt für "Kultur aktuell", 24.10.91 zur Kaiserring-Verleihung in Goslar
V.v.F.

Eigentlich ist der Kaiserring ja nur ein cleverer und glänzender PR-Trick einer deutschen Provinzstadt. Fühlen Sie sich benutzt?
Nam June Paik

Nicht so schlimm. Ein Ling ist ja alte Symbol von Mensch seit alte Steinzeit. So ist es überall, in China und in Indien und hier.
V.v.F.

Ihre Projekte sind so teuer, hätten Sie nicht lieber Geld gehabt?
Paik

Oh ja – ich nehme alles ab.
V.v.F.

Aber Sie werden ihn sicher gleich verlieren.
Paik

Ja, vielleicht sollten wir dieses Ei (der Installation "Video-Eggs") aufessen und Ling put there instead. Ling wird morgen geklaut, you understand. Wenn geklaut wird, das ist viel besser für Goslar, weil das mehr Publicity bringt you know.

2. Montage aus Interviews mit Paik und Paul Garrin (dem virtuosen editor von Paiks Tapes und selbst ein mehrfach preisgekrönter Videokünstler) für "Experiment Video" von mir, NDR 17. 12. 1990
Paik

Ich kann das alles auch nicht selbst machen. Ich habe ein Genie hinter mir, das heißt Paul

◄

Ramses III, 1991
Courtesy Carl Solway Gallery, Cincinnati

Celtic Memory, 1991
Courtesy Carl Solway Gallery, Cincinnati

◄ ◄

Video-Boat Arche Noah, 1989
Courtesy Carl Solway Gallery, Cincinnati

Garrin, ein Computer-Genie. Und ich hänge mich an ihn, you know.
Paul

I've definitely been influenced by Nam June Paik. There is no question about that. Nam June always says: you know, this tape that you made for me looks so good. You should use it in your own work. And I do, but in another way, from another tradition.
Paik

Armer Paul. Er darf keine solchen Effekte benützen wie für mich. Denn auch wenn ich ihn kopiere, sagt jeder, er kopiere mich, you understand.
Paul

Working with Nam June liberated me from the tyranny of the studio. So now when I go in, I'm very free with the way I approach the technique. We use all the same type of trick. But the difference is: Nam June's work is more open to chance and for me it's more structured, more under control. For Nam June it's like if you have an orchestra and every instrument plays every note that it possibly can and at the same time, just to see what happens. And for my work I use only the effects which will communicate the medium that I'm looking for.
I use it whenever it's necessary and Nam June uses everything that's possible.

HENRY FLYNT NEW YORK
For Paik-Mosaic, 1993

In his 1963 Avant-garde Hinduism document, Paik says, "I am just more self-conscious or less hypocritical than my anti-artist friends." One must look at the whole paragraph. Paik implies that the practitioners of "happenings" are anti-art, or claim to be.
Who were Paik's *friends* who were ant-art in 1963? Where was the tidal wave of anti-art which Paik opposed by declaring his traditionalism? Why were people so willing to credit this menace of anti-art? Surely I was the only activist with a real anti-art position.

SIMONE FORTI
A king and a master musician

(published in: A handbook in motion, Halifax/New York, S. 114)

One day I was having dinner at Nam June Paik's house. He was talking about one of the classical histories of China. He picked up a volume and started translating the page it opened to. The story was about a king and a master musician. The king commanded the musician to play for him the saddest music in the world. The musician refused, saying that the king was not ready to hear it, and that therefore it would be disastrous. But the king insisted. The musician played, and the king was overwhelmed by the beauty of the music. When the musician stopped playing, he told the king he had not played the very saddest music in the world. The king insisted again on the very saddest, and again the musician refused, repeating that the king was not ready to hear it and that it would be disastrous for the entire kingdom. But still the king insisted. As the musician started to play, three dark cranes appeared in the sky, and flew down to the gates of the palace. At this point Nam June closed the book. I don't know the rest of the story.

MARTIN FRIEDMAN NEW YORK
Contribution to the Nam June Paik catalogue 1993

In 1967, the Walker Art Center presented an exhibition "Light Motion Space" that sought to illuminate the breadth of the burgeoning art and technology movement. Nam June Paik's contribution was an antique, blond wood television set heavily doctored with magnets that wildly distorted the flood of images on its screen. I especially remember one of President Nixon's face that kept expanding, contracting, and changing color in a disturbing fashion.

Shortly after the exhibition opened, Paik's video monitor emitted a mournful pop, rapidly filling the gallery with acrid smoke and instantly emptying it of visitors. When I phoned Paik in New York to report the tragedy, there was a long period of silence. Within only hours, it seemed, he arrived in Minneapolis and, after feverishly tinkering with his creation, soon had it humming again.

A year or so later I received a letter from Nam June advising me that he was applying for a Rockefeller Foundation grant that could save him from starvation. "Please, Mr. Friedman, do not expose me," he wrote. Of course I didn't, and evidently neither did anyone else. He got the grant.

SI FRIEL NEW YORK
April 5, 1993

GRACE GLUECK NEW YORK
Piece for Nam June Paik mosaic, 1993

When I first met Nam June Paik in New York twenty-five years ago, I could hardly understand a word he said. His English and my Korean did not jibe. But his unkempt appearance (he still does not button his sleeves), his clever maneuverings with television sets — including his performances with Charlotte Moorman — and the two brilliant ideas a minute that he somehow managed to get across to me convinced me that he was a genius. And I have never had occasion to change my mind.

KEN FRIEDMAN OSLO
Four drawings about video, March 31, 1993

Prof. K.O. Götz

FAX 02638-6733
D-5451 Niederbreitbach-Wolfenacker
Waldstr. 24 · Tel. 02638/5176
— 4. 3. 1993 —

Prof. Rissa

FAX 02638-6733
D-5451 Niederbreitbach-Wolfenacker
Waldstr. 24 · Tel. 02638/5176
— 4.3.1993 —

— Hedgehogs do not eat electronic chickens. —

Rissa

— Dear NJP, some of our digitalized chickens are underestimated or overestimated. —
Best wishes,
K. O. Götz

K.O. GOETZ/RISSA
NIEDERBREITBACH-WOLFENACKER
Für Nam June Paik von K.O. Götz und Rissa 4.3.1993

SHALOM GOREWITZ NEW YORK
Paik 500, 1993

I wasn't stunned when he approached wearing the computer belt around his waist. Caught in a personal upheaval, I'd just returned from Haiti where the sewers run open in the street. This is the real shit. His feet were lifted off the ground as he searched for the next images. Trickster, playing games with the invisible, releasing synthetic waves, touching the electronics without getting shocked. In Haiti, we went throught the City of the Sun. Children playing in garbage, in the mud around the public toilets. Art reinvented. We exchange faces by twisting dials or by running fingers through the key. We fly low over Attica and try to swoop the prisoners to freedom with the blasting camcorder trigger. Breaking things, tearing print, blurring distinctions. Travel, always travel, keep moving. In Haiti, the boat called Deliverance is at the end of the read; trashpods blanket sea. I ask the reacher how to make video induce the scent sense. He pointed at pentacles, five by fifty, buzzing a pyramidic palette. Beautiful Japanese models march across the burning flag. I've never seen it, but can imagine. There is a myth about creation. Hunting mushrooms quietly detailing. Don't try to explain what can't be explained. He called me a Stony Point hippy. He drove slowly through the streets of L.A., never taking the freeway, always following a circuitous route, always finding his way home. Sleeping. Intrigue. The night the house was busted. The trial. The crooked deal the judge made. The key to the Catholic girls' school where he hid his inventions. I'm tired of you telling me to "take the dog out". The robot dominates the street. The city pulses with radioactive waves. Determinacy, chance; multimedia; energism; orgasmic media. In the US there is a waste proposal disposal problem. Everyone is very polite, they sleep on the job, dreaming measures of interracial romance. I'm not surprised by his mix of English, Korean, German, and Japanese. The artists' eyes darted, as though watching everything with continuous sweep. In Haiti, this is part paranoia, part reality: the spy lurks on the corner, spirits materialize in the air. Meanings are reduced to economic imperatives. The bank battery fueled by the muse. Network newtalk is multilingual. It's not the words, it's the action. They follow the zodiac's spiderweb flames easing the global traverse, through the neighborhoods, terminating at the exit channel where the projections of the communication patterns trigger interlacing zigzag lines bouncing beams of pounding light slamming commercial messages, spraying concepts that collapse with thought (it is about experience). The buildings sag, dead fish piled on the corner, ideological parasites spill with a quick leak as light streams through a language that doesn't waste power by making noise, heart beating prized possession, infused with the same electronic flood, it was recurrent, standard, the snakes swirled around stones providing information about eliminating meanings, the incoherent phrases, the language of nature, stellar, slash, the same principles, walking on the street, very conspiouous, switching, cutting.

ANTJE VON GRAEVENITZ
AMSTERDAM/KÖLN
"My Faust" von Nam June Paik

Das Negative schlägt in eine positive Qualität um: man erkannte, was man nicht erkannte – ganz im Sinne des Faust-Mythos – und man sah auch: Der Strom nicht ablassender Bilder gehört ganz dem Fernsehen und scheint nicht wirklich für jemanden gemacht. Paik verglich diese technische Natur dennoch mit der Natur, als er an anderer Stelle über Video-Spiele äußerte: "Die Veränderung um der Veränderung willen ... und das ist das Wesentliche unseres Stoffwechsels ... wie der Mond und die Gezeiten." Die nicht zu entschlüsselnde Information, die allgemeine Konfusion bleibt als ein Gleichnis für Vergänglichkeit übrig, das dann wohl in Bedeutung, daß heißt in Information umschlägt.

Natur und Technik gleichen sich; sie sind für Paik kein Dualismus. Damit steht er auf einer Linie mit Martin Heideggers Auffassung, den dieser in einem Vortrag vom 27. Juni 1957 in der Stadthalle Freiburg über "Den Satz der Identität" äußerte. Der Philosoph betrachtete darin Natur und Technik nicht als Gegensätze wie sonst üblich, sondern definierte beide gemeinsam als zum Sein gehörend. Im selben Jahr begann Paik bei Wilhelm Fortner in Freiburg zu studieren. Wenn er auch vielleicht Heideggers Festvortrag nicht persönlich gehört hat, so konnte er doch die Schallplattenaufnahme davon kennen. Heideggers Worte könnten Paik in den Ohren geklungen haben: "Auch Technik ist Sein, gehört zum Sein, gehört nicht nur dem Menschen, gehört zum Sein." Schon 1963 formulierte Paik Sätze, die durchaus an Heidegger anzuknüpfen scheinen:

In meinem experimentellen TV meint das
Wort QUALITÄT nur
CHARAKTER und nicht WERT
A ist verschieden von B,
was nicht heißt, daß
A besser ist als B.

HANS HAACKE Souvenir an einen jungen Koreaner im Schloß Morsbroich, 1960

OTTO HAHN PARIS
Nam June Paik – Interview, 1992

You frequently use the figure of Buddha in your videos. Why? Are you a Buddhist?
No, I'm an artist. And not a particularly religious one at that, I use Buddha as a symbol which I find easy to work with.

Some people link your work to the Zen philosophy.
Because I'm a friend of John Cage, people tend to see me as a Zen monk. But I also like Johann Sebastian Bach and, when I listen to his music, I feel something close to transcendence. Communists, if there are any left in the world, must also share the same feeling. Even Georges Marchais forgets his materialism when he listens to Bach. I'm not a follower of Zen but I react to Zen in the same way as I react to Johann Sebastian Bach.

Do you know Knokke?
Yes, I've been aware of Knokke for a long time. I was invited to take part in the Festival of Free Expression in 1968 but I wasn't able to make it. In 1974 I received an invitation from Jacques Ledoux, then director of the Cinématheque at the Palais des Beaux-Arts in Brussels. He was showing underground films there at that time. Ledoux was the only person spending any money on alternative cinema. I showed my "TV Buddha" at this festival. I also wrote my essay on the video in Belgium. It was published in the Christmas '74 edition of the Knokke-Heist magazine. In it I discussed a discovery which still influences my work. At the time I was preoccupied by the ancient theory of "mimesis" which maintains that sculpture imitates forms, painting imitates idols, that music imitates bird song.

And I asked myself, "What does video imitate?" I discovered that the art of video imitates the essence of time passing. The French language contains very interesting expressions, such as "faire passer le temps" or "le temps se passe bien ou mal". In English you can't say "time passed itself". The Germans say "Zeit vergeht". Time slips away. Only French grammar manages to accommodate the concepts of video.

Do you apply these theories in your exhibits at the Casino?
I'm showing four characters of universal stature at the Casino Knokke: Leonardo da Vinci, Galileo, Newton and Darwin. It's a form of paying homage to them but expressed using contemporary technology. I am also presenting a work on a Egyptian bas-relief that I bought in New York. Video enables me to go

back in time; I can bring the past into the present and plunge the present back three thousand years into the past. Television is the only medium which allows you to metamorphose and feedback time.

JOHN G. HANHARDT NEW YORK
Remembering the Whitney Museum of American Art, 1982 April 13, 1993

Opening Whitney 4/29/82
Photos Francene Keery
Courtesy Whitney Museum of American Art

JAMES HARITHAS
FORWARD, January 1973
(published in: Videa 'n' Videology: Nam June Paik 1959–1973, The Everson Museum of Art, Syracuse, New York)

Nam June Paik's pioneering vision of a global art based on television technology is becoming a reality. Following his decade-old lead, increasing numbers of artists on several continents are experimenting with the medium. Video art is also becoming a crucial issue for museums, E. T. V. stations and other institutions, such as foundations and universities and is beginning to reach significant audiences in various parts of the world.
Paik continues to make new and increasingly important contributions to these developments through his writtings, exhibits, and T. V. performances.
As an artist, Paik's work encompasses a wide range of video expressions and visionary theoretical speculations. He creates aesthetically complex video tapes and performance events which are characterized by a profoundly imaginative use of the medium as well as by an indeterminism which has roots in Zen Buddhism and in contemporary Western philosophy and science. Paik also researches and invents his own cybernetic tools. The most ambitious are the Robot K-456, the video-synthesizer which he developed with Shuye Abe in 1968 and the T. V. cello for Charlotte Moorman in 1971. As art, his video creations are not only profoundly moving and original; they are the structural elements basic to his formulation of an aesthetically motivated video methodology, which Paik terms "videa-videology", and for which he provides a theoretical foundation in his writings. "Videa-videology" is essentially an ontological discipline, one which is meta-creative, and in some of its effects, similar to events or happenings aimed at audience interaction and participation. "Videa-videology" clarifies the relationships of scientific discoveries basic to television (such as frequency modulation of carrier signals and color encoding) creative serendipity and aesthetic input/output.
Paik's aesthetic position is based on broad cultural experiences. In part, his thought and work show the effect of Buddhism, his training in classical and electronic music, his involvement, his penetrating interest in the work of John Cage and Norbert Wiener, among others, and his incessant experimentation with cybernated systems and television.

This volume is the first to document Nam June Paik's important thoughts, letters, essays and interviews as well as his most significant inventions and works of art. It is designed to provide the reader with a real insight into the processes and ideas which are essential to his remarkable contribution to the video field. The volume also forcefully communicates Paik's profound concern that cybernetic media be used constructively to establish a global culture humanely in tune with man's innate creative spirit.

DETLEV HARTMANN PREUNSCHEN
Mein Blatt für das Paik Mosaik
15. März 1993

ALANA HEISS LONG ISLAND
Nam June Paik and the Jitterbug
April 23, 1993
Once, during a late '70s rock-and-roll loft dancing party, I spied Nam June Paik and asked him if he wished to dance. He appeared surprised, even slightly flustered, and replied that he, poor Paik, poor Korean, had a limited knowledge of American popular dance. I immediately offered to teach him any dance he liked. He looked at me wistfully and said he had always to learn ... THE JITTERBUG!
A circle quickly formed around us as word leaked out that Nam June Paik was about to do ... THE JITTERBUG. We approached each other formally and assumed a waltz-related dance position. My role as teacher was fraudulent, as I had no notion of how to do the jitterbug, but felt confident a Korean would know even less.
I moved into a basic Charleston routine, trying to come down solidly on the first and third beats while kicking crosswise short, jerky movements on the second and fourth beats. Paik quickly removed his hands from my waist, placed them on my shoulders, looked

me straight in the eye, and jumped up and down with both feet, on every beat, 1 – 2 – 3 – 4, in something resembling that old suburban favorite, the bunny hop.

However, after being kicked painfully and rhythmically in the shins 14 or 15 times on my second- and fourth-beat cross-kicks, Paik readjusted his foot movements to correspond to mine, and did so with great panache. Simultaneously, Paik began a series of curious hand movements, slapping his head and back with one hand, whilst moving his other hand in a strange counter-clockwise circular motion on his tummy.

We were both aware that an even larger crowd had gathered and that we needed a quick and dashing finale. I dropped into the splits; Paik lurched over me, grabbed my arms and hoisted me over his back. (He was panting hard and I understood him to say he had seen this in an old Elvis Presley movie.) We fell into a demented cha-cha for our exit from the large circle. Paik accepted the many congratulations while mopping his brow and saying, "Just a little (pause) jitterbug."

HOTEL TALES

When in Paris, Nam June Paik always stayed at the Louisiane, an overpriced artists' dive with small cramped rooms, no lobby, one public telephone in a dingy foyer, and an arrogant, unhelpful desk staff.

Paik is blissfully content at this hotel; he can't understand the languages around him anyway, enjoys the privacy afforded by the non-delivered messages, and likes the smell of the rotting fish from the market outside.

I was in Paris working on an exhibition, and my assistant, a brilliant but unstable man was ensconced in the corner room, a room usually occupied by Paik. My exhibition was a frustrating and demanding one, and late one night, my colleague, overwhelmed by a combination of drugs, drink and fatigue, had a physical confrontation with one of the artists at the hotel which caused him to have a nervous breakdown.

I was called at home by the irate hotel manager and arrived to find the hotel in some disarray, my assistant naked but for a towel tied around his waist and speaking into the receiver of the lobby telephone, which he had ripped out of the wall. The other guests had all wisely retreated to their rooms and locked their doors, but as I chased my colleague up and down the three flights of stairs trying to grab him, I saw Paik in his robe sitting on the stairs calmly watching us. Up and down I went, passing Nam June several times in the

process. At last I got a grip on my assistant's leg and maneuvered him into a corner position. Paik got up and walked quietly to his room, saying to me as he passed, "You are always doing the JITTERBUG!"

MARRIAGE AND TELEVISION

My first husband and I separated and I decided to buy myself a costly self-indulgent present. As I expected to be alone a great deal, I chose entertainment over service, i.e., a color television instead of a refrigerator.

Always a believer in experts, I telephoned Nam June Paik to ask him to choose a T.V. set for me. He seemed confused and I tried to explain the situation several times. Finally I said, "I want to buy a T.V. to replace my husband. What model should I buy?" Paik laughed hysterically and said, "What model was your husband?"

(He liked this joke so much he would often embarrass me by introducing me as the lady who replaced her American husband with a Japanese television. Fortunately, his English is so bad that no one can ever understand him, but I'm sure many Koreans know this story.)

JON HENDRICKS NEW YORK
"Collage", April 1993

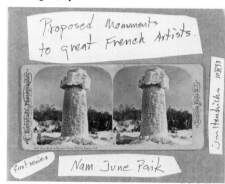

MARIANNE HESKE OSLO **Paik-Petrifaction Tafjord, April 1993**

DICK HIGGINS NEW YORK
A letter, 17. 2. 1993
Once I was at a public art discussion panel on which were both John Cage and Nam June Paik. As usual Paik's contributions to the discussion were interesting and succinct, though at that time, perhaps the early 1970's, Cage was far better known. Someone in the audience asked Cage the very stupid question, "Mr. Cage, if you were to die tomorrow, what do you think you'd miss most?"
Without hesitating, Cage replied: "The conversation of Nam June Paik."
I know what he meant.

RALPH HOCKING NEW YORK
Contribution, March 28, 1993
Paik, what can I say about you? I have tons of your detritus dating back twenty-some years. I could show you you-from old tv sets to the old clothes you left here at various times. I don't throw anything out, just build buildings to put it in. When you called the other day I asked you if you wanted this to be good or bad. You said bad. Predictable. I have been worrying for days, trying to come up with something bad. It hasn't been easy. Damn little of our relationship has been bad.
I finally remembered the time you deliberately broke one of my machines in the name of "art". During a performance at Binghamton University in the early seventies, you smashed a beautiful tiny grand-piano with a dancing lady on top. I had just gotten the thing and hadn't had time to savor it. It was a player piano with a punched paper roll inside just like the big ones and showed great promise as an idea irritant. It was even made in Japan. You asked to borrow it. I told you ok if you didn't hurt it. Hurt it? You fucking destroyed it. I stomped out of your performance and wouldn't speak to you for months. I was pissed. Art hell. Fluxes, Shmuxes. You can only push people from Ohio so far and then we become Ohioans.
A package arrived one day and inside was a smashed violin. You outfoxed me. How could I stay mad? But I haven't forgotten and I will never forgive you. If you die first, I am going to bury the piano with you. If I die first I will leave it to you hoping that you will be haunted by the fact of what you did. Just wait 'til you die. Or I die. If we die. You'll see.

PETER HOENISCH KÖLN
einst Sony/heute RTL, 1993
Seit der Paik-Retrospektive 1976 im Kölnischen Kunstverein weiß ich, wie spannend das Medium Fernsehen und seine Gerätschaften zur Vermittlung künstlerisch intellektueller Botschaften eingesetzt werden können. Dafür bin ich Nam June Paik dankbar. Ich empfand es immer als Glück, ihn in den Jahren seither – über Sony – unterstützen zu können, von einzelnen Projekten über documenta VII bis hin zur "Video Art 89" in Köln und Berlin. Er hat mir mit folgendem Brief gedankt:
"Dear Hoenisch Since 77 you changed the course of Video Art History and dabei art History itself. 3 drawings small geschenk for 3 Million $ donation. Paik 89."
Ich werde – nun über RTL – mit Vergnügen seine Arbeit auf der Biennale 93 in Venedig unterstützen.

SHINJA HONG SEOUL
A Blind Audience, 1993
I'm a dancer and one needs an eye to appreciate my trade. There's a time when I appreciate more a blind audience that one thousand with open eyes. Nam June Paik is such a case. He said he attended my performances several times but each time he slept away the whole duration of my laughter.

He could have given a definition of art if he so wished, but instead of saying yes, he simply said no. No was more honest answer that yes in this context. In fact, everybody lives his own life, but if one were to be asked what was life, they all laugh it away. Man lives his life before giving definition to life.

PONTUS HULTEN
Paik's manipulation, 1968
Paik's manipulation of the TV set has the subtle brutality of judo, which turns someone's own force against himself. It is a direct frontal attack on the principal modern machine for manipulating men's minds for commercial or ideological reasons. Paik's counter-terrorism is, of course, based on ridicule.
Only someone who had been deeply involved with the possibilities of the television medium could handle it with such precision. Paik has, in fact, a great faith in TV:
Someday artists will work with capacitors, resistors & semi-conductors as they work today with brushes, violins and junk.

I have treated cathode ray tube (TV screen) as a canvas, and proved that it can be a superior canvas. From now on, I will treat the cathode ray as a paper and penn ... If Joyce lived today, surely he would have written "Finnegan's Wake" on videotape, because of the vast possibility of manipulation in magnetic information storage.

BYUNG-KI HWANG SEOUL
A Very Eccentric Man, 1993
On a certain day in the autumn of 1967, I had made a dinner date with Namjune Paik at a Chinese restaurant near the Pennsylvania Station in New York City. I arrived there at the appointed time and waited for his arrival. He came a little later than the appointed time in full dress with a necktie. He was sweating profusely. Because he was carrying with him a very weighty sack of what looked like flour. "What's this?" I asked him. He was to visit his friend on Long Island after dinner. He said "please open it if you're curious". I opened it to find the sack was full of earth. Although I laughed, I was inwardly very much surprised. In the midnight he was bringing a sack of earth as a gift to his friend on Long Island. I thought that he was indeed an eccentric man, a natural eccentric like earth which is not contaminated by man-made filth.

►
Peking Man, 1992
Courtesy Carl Solway Gallery, Cincinnati

Java Man, 1992
Courtesy Carl Solway Gallery, Cincinnati

►►
Ohm, 1992
Courtesy Carl Solway Gallery, Cincinnati

Faraday, 1992
Courtesy Carl Solway Gallery, Cincinnati

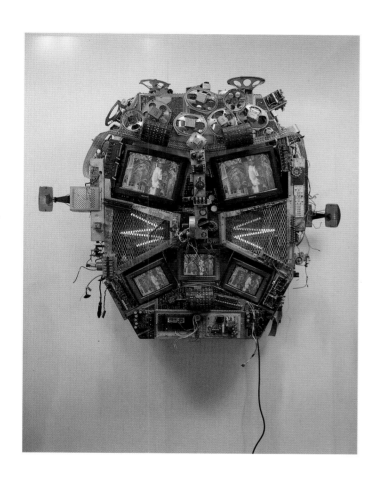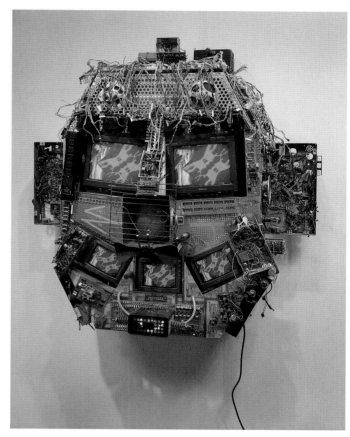

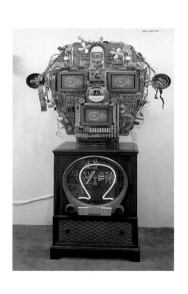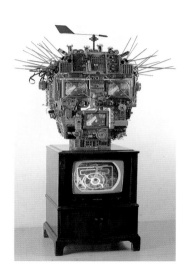

TOSHI ICHIYANAGI TOKYO **To Paik Nam June from Toshi Ichiyanagi "The Way", 1993**

TAKAHIKO IIMURA TOKIO
The Happening of Arrest by Paik, 1993
Among happenings by Paik, the memorable one is the scene of arrest in the "Opera Sextronic" performed at Cinematheque in New York, 1966 – Jonas Mekas was its director.

It is a very famous happening where Charlotte Moorman attached tiny TV monitors on her breast and played the cello, namely the back of nude Paik. Then the policeman came in, and put handcuffs on Moorman.

It was such real happening that some people enjoyed the scene without knowing that the policeman was not a performer but a real one. I had just arrived at New York, so I was very confused and in dumb surprise among the people who protested against the police. In enthusiasm, I wrote a report for a Japanese magazine.

JAY ISELIN NEW YORK
A letter, January 1st
nam june

a few of the intercontinental glitches only added to the excitement and the spontaneity of your dazzling welcome party for 1984 – and the age of Orwell – from New York, the latest Paik creation was a stunning achievement and delightful event – congrats and thank for launching the new year so propitiously.

HIROE ISHII TOKYO
With Heartful Thanks to Mr. Paik, 1993
It was in 1981 when the idea to organize the exhibition of Mr. Paik in Japan came across my mind. I was yearning to see the video art pieces directly as I had only information through books, and I also felt eager to acquaint Japanese people with how fascinating the video art is. I talked over my idea with Mr. Yurugi, curator of The Metropolitan Museum of Tokyo, and Mr. Nanjo, art critic, to make a proposal to the museum's exhibition project meeting. In 1982, the project plan was adopted by the museum fortunately, and Sony accepted the request for equipment support. Thus the retrospective exhibition of "Mostly Video Nam June Paik" (1984) was realized in Tokyo.

At that time, there were few experts to install the video art pieces, therefore Mr. Yurugi appealed to the art students to participate in the installation. It was a voluntary job, but they felt gratified to assist Mr. Paik in his work. However great an artist is, he or she could not accomplish the art work alone. All of us shared a feeling, that is, the pleasure to take part in the art work of Mr. Paik.

After that exhibition, I produced the video soft "SAT-ART III", 3 volumes, contained in a box made of paulawnia and wrapped with furoshiki, Japanese style wrapping cloth. Though being overwhelmed with the great-

ness of Mr. Paik as an artist, I have been always touched with his warmhearted personality. Now I am much obliged for having got acquainted and for having been able to realize some projects with him.

ARATA ISOZAKI
A robot, 1988
Nam June made a robot, which can shit and piss and fall down. When Nam June made a huge wrapping paper to wrap around the world in the Satellite telecast, it has a few holes in it, so that we can creep in ...

JUNJI ITO
Satellite Orchestra, 1986
(published in: Assate Light, 1986)
In retrospect, it seems clear that Paik's satellite art originated from ideas already present in his work "Tricolor Video" exhibited in 1981 at Centre Georges Pompidou in Paris. At the time, I was fortunate enough to be living in the same Paris apartment block as was Paik and to see at first hand the creation of "Tricolor Video" in progress. It was a breathtaking experience to see the contrast of the high technological process and its aesthetic effect. Four hundred systematically aligned TV monitors were divided into four piece units each projecting four types of video tapes. The tricolors – red, white and blue – were floating in wave like shapes through each of the monitors in succession. There were two remarkable aspects to this work: the synergistic effect of these elements; and the limitation of the images to terminal surfaced and the networking of their multiplication which allows us to grasp the importance of the imaginative element central to its concept. There is another aspect that should not be overlooked: the establishment of a temporal axis charged into the tricolor waves. Throughout the history of the fine arts, the problem of "time" has remained unsolved until the emergence of video art. Time always passes in the world external to that of a work of art. Art and society have always been separated by the impossibility of sharing time. This has been, without doubt, one of the great shortcomings of the realistic trends that followed the beginning of Modernism.

Reflecting historically, it is clear that the style of performance that developed from the Dadaists' soirée were, at the beginning of the 20th century, seen as a revolutionary phenomenon – as were the objects of Marcel Duchamp. Both were attempts to incorporate

the dynamism of time: the former by abandoning the conventions of form in a work of art, and the latter by transforming the very notion of what consituted a work of art. Similarly it would not be unreasonable to recognize in the repetition of tricolor waves on the final images surfaces of Paik's work the raison d'etre of video art.

When one analyses "Tricolor Video" from this perspective, it is easy to show how this image monument became a significant landmark for the development of satellite art. For example, while it is a work that presents pictorial images, it breaks with historical conventions of the two-dimensional picture plane. Now, the canvas surface has been replaced by the video monitor surface. Antithetical to consistency in expressive function by its very nature, the video monitor strictly maintains its autonomy as an object while processing its changing images within a temporal framework. In other words, the monitor's constant fluctuation between the categories of "art" and "object" defines it as a ready-made articulated by time. Furthermore, since changes in the monitor's surface values are the consequence of changes in the electric signal, the signal itself must be seen as the source of art and ultimately art itself. This signal – this invisible being.

"Tricolor Video" is one of Paik's most representative works of video art. Because technology theoretically allows the infinite multiplication of images (as long as the signal can reach the monitor surfaces) the meeting of Paik's Duchampian concept with modern technology is inevitably directed towards the ultimate self-expansion. "Good Morning Mr. Orwell" is video art that holds the possibility for infinite surfaces, unfixed spatial expansion and a complex notion of time that breaks from the limitations of video art itself to become digital art. The ultimate purpose in the exercise is to show that, even more important than the pictures projected on the monitor screens, the possibility of receiving these "art-signals" is wholly dependant upon the presence of the monitor itself.

SUKHI KANG SEOUL
A Real Pornography, 1993

In September 1969, I commissioned Namjune to compose a music for the first modern music festival I was organizing in Seoul. He sent over a sex music entitled "Composition" dedicated to me. In this music, a man and a woman lie down on the piano, play the instrument with their feet, pull down the panty and make love, and when the woman under the man has an orgasm she pounds the keys rapidly with her feet and this sound is amplified like breathing. This was the first link between Namjune and I.

TAI HEE KANG SEOUL
Different from other video artists ..., 1993

Different from other video artists like Douglas Davis who made an attempt to get a new video communication via satellite, Nam June Paik tries to communicate with as many people as possible under the common and objective notion using video.

His thoughts are like this: video is basically a media of communication and an artist's performance is to fulfil the duty of cultural messenger between the different cultures. And this is one of his "VISA" series started in 1970. "Media Shuttle; Moscow/New York" 1978 or "You can't lick the stamps in China", those video tapes also belonged to the series. It will be too long a story to talk about that all now, but his satellite shows of 1980's always mean the possibilities of cultural exchange between the East and the West.

The greatest result from those shows is that Nam June Paik's personal messages are spread all over the world. Do we need a comparison? There is a similar series of Rauschenberg called "ROCI" – introduction and exhibition of primitive cultures to the West – but the effects are totally different since his works are based on traditional painting and combine procedure, on the contrary, Nam June Paik's performances are usually based on using mass media.

Joining Cage has great meaning in Nam June Paik's early age of artistic career. On the other hand, being with Beuys who has a strong obssession for Shamanism – is closely connected to his future career.

We expect his cultural and anthropological interest to be extended over the Ice Age or the Stone Age, of course, it matters the East and the West at the same time.

He claims himself Antenna of whole mankind and his vision is a lot more than a little artist's body.

It is a great dream of him towards the future of humankind.

ALLAN KAPROW
Nam June Paik, 1968

Nam June Paik wurde uns in den frühen sechziger Jahren als Kulturterrorist bekannt.

HYUN JA KIM SEOUL
In his greatness ..., 1993

I saw him last August for the first time when he joined me for "Nam June Paik's Performance & Kim Hyun Ja's Dancing". I was a lot prepared on my own to see this great master of art. But when I confronted him, I was astonished at his naivety and simplicity.

After that, I've seen him only a few times, but whenever I am in front of him, I feel great mountains in him and the feeling doesn't come from any other man. It is his energy only, a huge and marvelous spirit coming from a deep space.

I was almost absorbed in it. It was a shock. It took time for me to think about that. It is his driving force and now it becomes Nam June Paik.

If he suddenly gives up his art and explores another field whatever, he would succeed in it anyway without fail.

I really envy him. He has his own generative power in him and makes great steps in his life.

HYUNSOOK KIM SEOUL
King Koi of Paekche Kingdom, 1993

While we were preparing for his "Nam June Paik Videotime – Videospace" exhibition in 1992, I received a fax from him asking me to obtain a copy of The Reminiscences of the Three Kingdoms. I simply wondered why of all the books theses ancient legends and history of Korea?

When the preparation for the exhibition had almost been made, there was no mention of the book. I simply thought the book was cancelled out. However, just one day before the opening of the exhibition, he asked me to produce a section of Kind Koi of Paekche from the reminiscences. When I opened up the section for him, he tore a page from the book, and transcribed Chinese characters on a large wooden horse from the torn page. I was disappointed at seeing his easy-going attitude. He began to say abruptly:

"I chose a Paekche king as a gesture for reconciliation with the people from the Honam region." Originally I thought of the Regent Namjune has ever raised during the school days.

SONGWU KIM SEOUL
My Art is How Best to Play, 1993

I hang up the first New York Times review of my work at this exhibition. At the time the reviewer, Grace Glueck asked me, "Why do you do this kind of work?" I retorted to her, "I have to do something simply to beat off ennui." She made this the headline of her story. The more a society is being industrialized, the more man is being deprived of his work. We've to create something which makes our life happy. And then, how best to play? My art can be summed up as how best to play. This is a surrealistic theme of aimless behavior. My earlier works of happening came back to me, this time in the guise of electronics.

I'm not a sentimentalist. But when you went out to the New York street at eleven in the evening, buy a newspaper, go to a Korean restaurant by a taxi, eat a beef and rice soup with a dish of sliced radish kimchi, or a bowl of abalone gruel, then you feel reassured that you are treading on earth. When I was growing up, there were in my country Korea so many patriots that I made up my mind not to become one myself. I will find contentment in my becoming a specialist in a certain field.

WON KIM SEOUL
A Wrong Letter in a Right Address, 1993

I corroborated with Namjune in erecting the 1,000-TV-set Spiral Tower (The More, The Better) in the National Museum of Contemporary Arts in Seoul.

Later I received a letter from him. The envelope was addressed to me but the letter itself was addressed to the Mayor of the Special City of Seoul. The gist of the letter was: Kim Won is a talented architect, therefore should be commissioned to draw the plan for the Municipal Museum. Of course, his proposal was not adopted.

Later when I was drawing a masterplan for the redevelopment of the P'il-dong area in Seoul, I proposed to the city government of Seoul to establish a Namjune Paik Museum on the site. This proposal of mine was also rejected.

HONG HEE KIM-CHEON
The psychological medium, 1989

(published in: Nam June Paik's Video art: Participation-TV as an extension of Happening – a postmodern practice, A thesis in the Department of Art History, presented in Partial Fulfillment of the Requirements for the Degree of Master of Arts at Concordia University Montréal, Québec, Canada March 1989, p. 125-127)

Verlaine wrote: "It rains in my heart, as it rains in the city." I say: "It rains in my computer, as it rains in my heart" – "Il pluit [sic] dans mon computeur" will be my first piece. It is the mix of real rain and simulated rain in the computer. My second piece will be called "La computeur sentimentale."

The Baudelairean correspondence between art and nature in Verlaine's verse is being transformed by Paik into a McLuhanesque correspondence between machine art and human nature, a "cybernated video sphere." As Jacques Lacan noted, the anthropomorphism of the machine was manifest in the case of the automobile:

The relation between this Homo psychologicus and the machines he uses are striking, and this is especially so in the case of motor car. We get the impression that his relationship to these [sic] machines is so very intimate that it is almost as if the two were actually conjoined – its mechanical defects and

breakdowns often parallel his neurotic symptoms. Its emotional significance for him comes from the fact that it exteriorizes the protective shell of his ego ...

Jean Baudrillard regards this close interconnection between the machine-object and the user-subject as a symptom of the communication era of "screen and network". For him, the fascination for the "obscene" communication – a type of communication occuring not from a scene but only from an off-scene, transmitting information in total transparency and visibility due to the "harsh and inexorable light of information and communication" – creates a "state of terror" of an "unclean promiscuity", where one experiences a "too great proximity of everything". This fascination is symptomatic of schizophrenia; the same schizophrenia that Fredric Jameson refers to as an "historical amnesia", a "fragmentation of time into a series of perpetual presents" characteristic of the postindustrial consumer society.

HOWARD KLEIN
Paik und die Rockefeller Foundation, 1991

Über fünfzehn Jahre hat Paik mich und damit die Rockefeller Foundation mit seinen praktischen und visionären Ideen beliefert. Ich kombiniere die beiden Wörter "praktisch" und "visionär" bewußt, weil damit die Verbindung hervorgehoben wird, die die gemeinnützigen Einrichtungen brauchen, um ihr Mandat zu erfüllen. Zahlreiche seiner Ideen blieben leider – weiterer konkurrierender Interessen der Rockefeller Foundation wegen – auf dem Papier, andere kamen jedoch zur Ausführung.

BILLY KLÜVER
BERKELEY HEIGHTS, NEW JERSEY
A letter, 20. 2. 1993
Dear Paik,

You ended up in New York at the time when the locals didn't welcome foreigners. Nobody really knew about your universities in Germany. When I saw you and your robot on the sidewalk of the north side of 57th Street, it was wonderful, but I don't think I understood how wonderful it was. You were far ahead of me.

I do remember making a midnight requisition of a very heavy (3 kilos or more) and very strong horseshoe magnet that was sitting under my bench at Bell Laboratories, which I had requested for some experiment that didn't work. You immediately put it up to a television screen and excitedly watched the distortions of the image.

We were sitting at the Mandarin in Paris a few months ago, you had completed your impeccable installation of the Arc de Triomphe at Beaubourg, while I was struggling with the uncertainties and electronic problems of Robert Rauschenberg's "Oracle". You told me, "Billy, you do one-of-a-kind technology, and I do off-the-shelf technology." But, Paik, where are we heading? I still remember the robot on 57th Street.
Love,
Billy.

MILAN KNÍZÁK PRAG
6 stories on Paik, 1993
1

Kdyz jsem v roce 1968 prijel do New Yorku, tak jsem si koupil malou televizi, abych se pomocí sledování programů rychle učil anglietine.
George Maciunas, který pro mne televizi vybíral, mne jí podal se slovy: "Nikdy jí nepujeuj Paikovi. Všechny televize znieí."
(Als ich im Jahre 1968 nach New York kam, habe ich mir einen Fernseher gekauft, damit ich mit Hilfe verschiedener Programme schneller Englisch lernen konnte.
George Maciunas [der den Fernsehapparat ausgewählt hatte] hat ihn mir mit den Worten übergeben: "Leiht niemals dem Paik einen Ferseher aus. Er zerstört alle Ferseher.")

2

Paik je v podstatě módní tvurce. Myslím tvurce módy, ponevadˇ používá oděvní soueásti zcela netradiením zpusobem a tak vlastne tvorí jejich nový design. Všichni, co Nam Juna známe, víme o jeho košilích a svetrech omotaných kolem krku, pentlích od spodku plazích se po zemi a obrácených límcích. Ze všeho nejvíc mne Paik připomíná rockovou hvězdu. Něco jako Bowie nebo Madonna.
(Paik ist im Grunde ein Modeschöpfer. Ich denke deshalb an einen Modeschöpfer, weil er Kleidungsstücke auf ganz unkonventionelle, nicht traditionelle Art und Weise benutzt und dadurch eigentlich ein neues Design schafft.
Alle, die Nam June kennen, wissen von seinen Hemden und Pullovern, um den Hals gewickelt, von seinen langen Unterhosen, die sich auf der Erde schlängeln, und von seinen nach innen gedrehten Kragen.
Am meisten erinnert er mich an einen Rockstar, etwa wie Bowie oder Madonna.)

3

Ale Paik je ureite hvezda. Je velice chytrej s velkou kombinaení schopností. A samozrejme dokonalý businessman. Paik dovede do Fluxu dokonale proniknout a zároveň se od nej dokonale distancovat. Zvláštní je, že této polarity si nikdo zvlášt nevšímá.
(Aber Paik ist bestimmt ein Star. Er ist sehr intelligent und schlau mit besonderer Kombinationsgabe. Und bestimmt ist er ganz und gar Businessman. Paik versteht den "Fluxus" vollkommen zu durchdringen und sich gleichzeitig von ihm zu distanzieren. Das Besondere daran ist, daß keiner diese Polarität beachtet.)

4

Mám rád Paika.
(Ich habe Paik gern.)

5

Ale nekdy mi leze na nervy.
(Aber manchmal geht er mir auf die Nerven.)

6

Nejlínejší STAR PAIK.
(STAR PAIK ist der Faulste.)

▶
The Twentieth Century
Decades, 1992:
1900–1910
1910–1920
1920–1930
1930–1940
1940–1950
1950–1960
1960–1970
1970–1980
Photo Carl Solway Gallery, Cincinnati

180 K

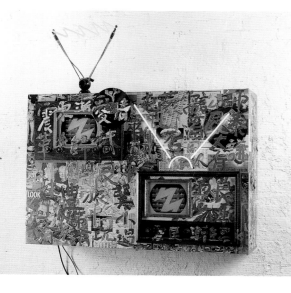
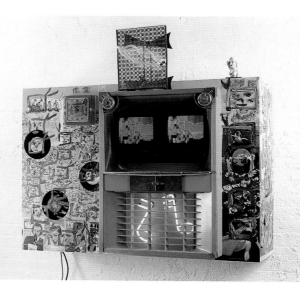

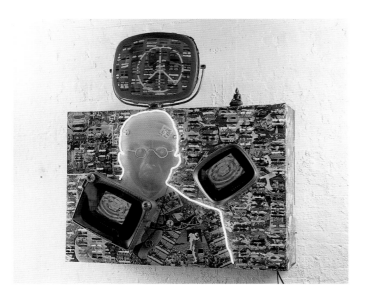
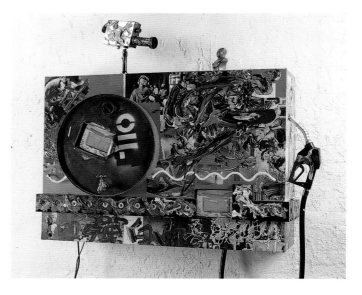
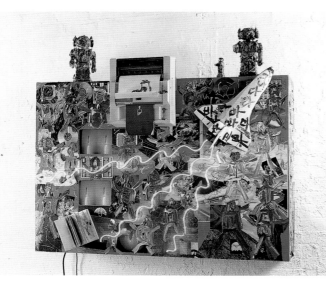
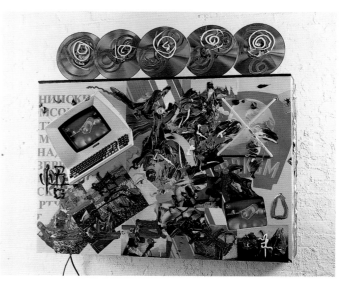

Wenn zu perfekt - Gott böse

Bei der Ausstellung >von hier aus< 1984 j. w. d. am Rande Düsseldorfs, schon im Niemandsland in einer riesigen funktionalen Messehalle, gab es 2 Cafés für die Besucher, um das organische Zentrum zu verwischen, so wie die Ausstellung vom Budenzauber die fiktive Stadtlandschaft simulierte, in der die ausstellenden Künstler ihre Räume schaffen könnten. Das Spiel zwischen kleinem Innen (Tomas Schmit) und großem Außen (Per Kirkeby) oder großem Innen (Georg Baselitz) und kleinem Außen (Hermann de Vries) wurde durch die Stadtkrone von Nam June Paik auf die Spitze getrieben. Paik hatte den Kontakt zu einer koreanischen Elektronikfirma für uns hergestellt, und 120 Fernsehmonitore wurden der Ausstellung für den TV-Trichter zur Verfügung gestellt.

Um uns dem generösen Sponsor dankbar zu erweisen, haben wir im Vorfeld der Eröffnung zu einem Pressegespräch eingeladen. Die Stichworte für die Boulevard-Presse *Elektronische Sixtinische Kapelle* kamen listig und unerkannt vom Künstler selber. Schon in der Ankündigung hatten wir quantitativ argumentiert: 120 Fernsehgeräte als übergroßer Kronleuchter - als Videoinstallation, die in fünf konzentrischen Kreisen kegelförmig angeordnet in einer Gesamthöhe von 16 m drei Videotapes abspielten.

Kurz vor der Eröffnung bei dem Pressegespräch hatte Paik das Werk jedoch ausgedünnt. Ein Journalist hatte sich die Mühe gemacht, die TVs zu zählen: 21 weniger als angekündigt. Und auf die bohrende Frage, warum dieser Schwindel und wenn schon, warum dann nicht wenigstens hundert, kam Paiks Antwort:

Wenn zu perfekt - Gott böse

ALISON KNOWLES NEW YORK
Contribution to the Paik Mosaic, 1993

KASPER KÖNIG FRANKFURT
Wenn zu perfekt – Gott böse, 27. April 1993
Bei der Ausstellung "von hier aus" 1984 j.w.d. am Rande Düsseldorfs, schon im Niemandsland in einer riesigen funktionalen Messehalle, gab es 2 Cafés für die Besucher, um das organische Zentrum zu verwischen, so wie die Ausstellung vom Budenzauber die fiktive Stadtlandschaft simulierte, in der die ausstellenden Künstler ihre Räume schaffen konnten. Das Spiel zwischen kleinem Innen (Tomas Schmit) und großem Außen (Per Kirkeby) oder großem Innen (Georg Baselitz) und kleinem Außen (Hermann de Vries) wurde durch die Stadtkrone von Nam June Paik auf die Spitze getrieben. Paik hatte den Kontakt zu einer koreanischen Elektronikfirma für uns hergestellt, und 120 Fersehmonitore wurden der Ausstellung für den TV-Trichter zur Verfügung gestellt.
Um uns dem generösen Sponsor dankbar zu erweisen, haben wir im Vorfeld der Eröffnung zu einem Pressegespräch eingeladen. Die Stichworte für die Boulevard-Presse <I>Elektronische Sixtinische Kapelle kamen listig und unerkannt vom Künstler selber. Schon in der Ankündigung hatten wir quantitativ argumentiert: 120 Fersehgeräte als übergroßer Kronleuchter – als Videoinstallation, die in fünf konzentrischen Kreisen kegelförmig angeordnet in einer Gesamthöhe von 16 m drei Videotapes abspielten.
Kurz vor der Eröffnung bei dem Pressegespräch hatte Paik das Werk jedoch ausgedünnt. Ein Journalist hatte sich die Mühe gemacht, die TVs zu zählen: 21 weniger als angekündigt. Und auf die bohrende Frage, warum dieser Schwindel und wenn schon, warum dann nicht wenigstens hundert, kam Paiks Antwort:
Wenn zu perfekt – Gott böse

RICHARD KOSTELANETZ NEW YORK
Paik: remembrance, 1993

I appreciate your invitation to contribute to the Nam June Paik festschrift, which I look forward to seeing, if only because your invitation is open and generous enough to encourage reading surprises rarely offered by exhibition catalogues. Since you've written me just after I've drafted an entry on Paik for A Dictionary of the Avant-Gardes (A Cappella, late 1983) and your book will appear before mine, it seems appropriate to include it here with more recent interpolations, such as this preface, in italicis/bold.

PAIK, Nam June (1932). Born in Korea, educated in music in Japan and then Germany, where his work earned support from both John Cage and Karlheinz Stockhausen, Paik came to America in 1964 as a celebrated young international artist. *I recall meeting him on Canal Street around October 1965.* His initial forte was Electronic Music, thanks to three years of work at a Cologne studio. He was among the first to realize a lesson since lost – that training in high-tech music might be a better preparation for video than education in film and visual art and thus that video programs belong in music schools rather than art schools. After several audacious performance pieces in Europe, many of them in Fluxus festivals, some of them involving genuine danger (e.g., leaving a stage on which a motorcycle engine was left revving, thus filling a small space with increasing amounts of carbon monoxide), Paik installed the first exhibition of the new medium in a gallery in Wuppertal, Germany – thirteen used television sets whose imagery he altered through manipulating the signal through the use of magnets among other techniques.

Though he continued producing audacious live performance art, his video activities had greater impact. Late in 1965, he showed a videotape made with a portable video camera he had purchased earlier that day and soon afterwards had an exhibition that depended upon a videotape recorder. He was among the first artists-in-residence at the Boston Public Television station WGBH, where he also developed a Video Synthesizer that, extending his original video-art principle, could radically transform an image fed into it. Another often-repeated move involved incorporating television monitors into unexpected places, such as on a bra worn by the cellist Charlotte Moorman (1938-92), amid live plants, or in a robot. Into the 1980s, if any exhibition included some video art, the token

representative was usually Paik. Interviewed on national telefision, he typically embarrassed the program's star-host.

Precisely because the most sophisticated American television stations and private foundations concentrated so much of their resources on Paik's career, there has been reason for both jealousy and disappointment. From the beginning, his art had remarkably few strategies, most of them used repeatedly: performances that are audacious and yet fundamentally silly; tapes that depend upon juxtapositions of initially unrelated images, which is to say collage that had become old-fashioned in other arts; installations that depend upon accumulations of monitors that show either the same image or related images; expected placements of monitors. Nonetheless, Paik was the first video artist to have a full-scale retrospective at the Whitney Museum of American Art.

As this sober entry misses his essentially comic sensibility, I recall reading that he „speaks five languages badly," because all of his New York friends have had the experience of hearing him become excited until whatever he is saying besomes incomprehensible. Even his narcolepsy is turned to humor, my favorite story concerning his request to take a nap in a couch in the office of a museum mounting an exhibition of his work. "Must make some esthetic decisions," he declared as he dozed off. With such writing as "Danger Music for Dick Higgins" ("Creep into the VAGINA of a living WHALE") he contributes to the osscure tradition of Conceptual Dance (soon to become an anthology of mine), which is to say choreographic instructions that are best read about, because they cannot easily be done. Caveats notwithstanding, his work and example remain a continuing inspiration to me, among others.

TAKEHISA KOSUGI
To N.J.P., 1965

I came to New York, to teach "how to be shy..."

SHIGEKO KUBOTA NEW YORK
From Video Birthday Party for John Cage 1974

Video is Vengeance of Vagina
Video is Victory of Vagina
Video is Venereal Disease of Intellectuals
Video is Vacant Apartment
Video is Vacation of Art
Viva Video...

KYUNG-HEE LEE
Prinz und Prinzessin, 1991

Nam June vergnügte sich mit den Bilderbüchern, die er um sich ausgebreitet hatte und die fast den ganzen Raum ausfüllten. Er schaute mich nicht an. Er hatte viele Bilderbücher von Kodansha. Immer wenn ich ihn besuchte war sein Zimmer voll von Bilderbüchern. Es gab viele interessante Bilder in diesen Büchern, und Nam June wußte genau, daß ich die Bilderbücher sehr gern mochte.

Dann endlich waren wir uns nah genug, um die Bilderbücher auf den kleinen Hügel zu tragen und auf einem Stuhl aus Stein nebeneinander sitzend zu lesen. Wir verbrachten einige Zeit zusammen, ohne etwas Wichtiges zu sagen, bis meine Mutter mich zu sich rief.

KYUNGSUNG LEE SEOUL
Art is a Deception? 1993

"Namjune Paik: Videotime-Videospace" was a stunning success and the talk of the town in August 1992. In the evening of the 14th, meet the artist program was held in a 600-man capacity auditorium with more than 800 persons in attendance. The program was conducted in a question and answer session. Many interesting questions and answers were exchanged. Namjune impressed the audience with his honest and unceremonious manner and personality.

When a professor of philosophy asked him "What is art?" he said that honestly he didn't know what art is. At this the audience broke out into performance. I know he meant. Since he always took so much medication because of his poor health, that medicine drugged him into sleep. Otherwise, his frequent overnight works drive him to catch up his lost sleep. How lovely is it for him who, knowing that he would sleep away the entire time, nevertheless comes to see my performance! He might be the only person who fell sleep during my performance, he nevertheless is the only person who makes me happy. I would like to make a longer work so that he could sleep to his content.

OH-RYONG LEE NEW YORK
An Episode, April 16, 1993

Here I remember an episode which you, Mr. Paik, have told me before. In 1942, when you were in the elementary school in Seoul, there was an assignment to create a contrivance for the Day of Invention. One of your classmates didn't present anything and he said

that there's nothing to invent because other people had already created everything. You said that this kind of person didn't need avant-garde, for he enjoyed exploring unfamiliar road more than routine way because there were more new and interesting things to watch.

SE DUK LEE SEOUL
About Nam June Paik, 1993

It is not a long time since I saw Nam June Paik. However, I've kept an eye on him for a quite long time seeing his artistic career with keen interest.

He has come a long way here, not so fast but without hesitation, making common language and way of living for our generation.

He doesn't forget his motherland. He is always feeling it inside, being aware of it and cannot get out of it.

We regard him as a man obsssesed with Korean traditional shamanism living in Korea itself. He spent quite many years abroad and his nostalgia for his motherland naturally comes out from his every single behavior, from the way he talks and surely from his works. It brings us together being with him as Koreans and we feel the blood and tradition of our own strongly.

WON HONG LEE SEOUL
Unlimited world of art, 1993

Nam June Paik opened an unlimited world of art. He transformed the conception of vision. And he put a wing to the human imagination. We are so deeply touched by his monument in the Seoul National Museum of Contemporary Art which tells us a never-ending story. The name itself is "The more, the better". It is a heavenly world when we look at it down to the ground.

It is the Tower of Babel. When we are in front of it, we travel the wonderland of consciousness with him. That's why we Koreans don't forget Nam June Paik.

He assassinated Big Brother. Accordingly, he set our will free. He assassinated Kipling. He integrated the Orient and the Occident by doing it. He conquered none of these but just made them one. It provided our will with refreshed air just like God created a human being with dust of earth and made them alive by blowing them by the nose. George Orwell, Asian Games and Seoul Olympiad could be a worldwide stage for him, as it could be a great discovery for Koreans.

Nam June Paik lives in our consciousness.

His every single behavior stuns us. Young artists regard him as their future. That's what he did and its fruits are here. He will exist simultaneously in the Orient and in the Occident. We all expect his other world for future.

KIM LEVIN NEW YORK
Two images, March 30, 1993

First, Nam June Paik, the most international of artists – at home in europe and america, crucial in the early days of fluxus, inventor of video art, crossing paths with Joseph Beuys and everyone else, part of the recent history of western art – wandering onto the stage of a huge theater in Seoul last summer, as if oblivious to the standing-room crowds who had come to see his performance. Like a lost urchin, with one suspender slipped from his shoulder, he stood there surveying his audience, bemused, as if he hadn't expected anyone to be there.

Second, Seoul, a frenetic city where every surface seems crammed with the hypnotic urban patterning of flashing signs, geometric hangul lettering, high key color, and consumer goods. A city where ancient traditions remain absolutely intact under an infinitely thin hypermodernized and superwesternized surface. Despite the fact that he has long lived abroad, Paik's work – seen in Seoul, a vast retrospective – became an uncanny expression of the contemporary reality of that city. Or rather, the city echoed his vision. In the context of Seoul, Paik's conflation of state-of-the-art electronic imagery and shamanistic ritual gains another meaning, and suggests that cultural identity can be cumulative. In the context of Paik's art, that city will never look quite the same to me again.

HI JOO LIMB SEOUL
One Candle, 1993

Video installation, 1988
Museum für Moderne Kunst
Frankfurt am Main

Nam June Paik's small exhibition room cornered on the 2nd floor of Frankfurt Museum of Contemporary Art.

It is intentionally lined up with his comrade Joseph Beuys' corner and very tranquil and rather dark in its best condition. One lonely candlelight slightly cast a shadow on the white wall through multi-monitoring.

It is a cozy and homely space for tranquility and meditation.

One Candle, 1988

Space for Silence
Space for Prayer
Beautiful drawing of stillness waves calmly. Sublime beauty and nobility, mystic space for everlasting ontemplation, this is the very spot of an Oriental Nam June Paik and the most civilized technology.
One candle specially holds my soul.
It's just a beautiful poetic work of art.

BARBARA LONDON NEW YORK
Nam June Paik: Visionary, 1993

Over the nineteen years that I have known Nam June Paik, I have seen him in such farflung places as Woodstock, Paris, Düsseldorf, Tokyo, and Seoul. Talking over a bagel, cafe au lait, hamburger, sushi, or Korean barbecue, I have always been intrigued by the sparkle in his eyes and the complexity of his mind. His perspicaciousness is revealed through his art, as well as by the books he reads, and the newspaper articles he clips and sends his friends. A joy to visit with, he is the most open, generous, and unassuming person I know – a remarkable team player, artist, and businessman.

Paik comes from an ardent culture with traditional "color bar" clothing, hot springs, and friendly mountains. There people are curious and tenacious, and as strong as their kim chi. Like his Mongolian ancestors, Nam June is comfortable out in the world. An international soul, his home is found in both warm and cold climates. A modern man, his being consists of well integrated diversity.

Nam June Paik is an indispensable bridge. Linking past and future, East and West, individual and collective, he is the common ground between video game players and Leonard Bernstein listeners. Now on the eve of a new millennium, he is guiding us as we move from an analog to a digital culture. Paik is the lynch-pin of the Museum's extensive Video Collection. His videotapes, catalogues, articles, and drawings that we own reflect the extraordinary depth, breadth and change found within art-making today.

JACKSON MAC LOW NEW YORK
My Favorite Paik, March 18, 1993
It was drawn in india ink directly on a repro-type paper recommended to me by one of my publishers (George Quasha, of Station Hill Press, Barrytown, NY, USA) for printing out my book *42 Merzgedichte in Memoriam Kurt Schwitters* as *camera-ready copy*. Station Hill will publish this 230-page book (written 1987-89) later in 1993. They will reproduce the poems – which are typographically difficult – from camera-ready copy printed out on this same type of paper. So you should have no difficulty in reproducing the drawing.
You will, no doubt, recognize the work to which I allude in the drawing.

My Favorite Paik

Jackson Mac Low
18 March 1993

GINO DI MAGGIO MILANO
**Breve filastròcca per Nam June Paik
(A ditty for Nam June Paik), 1993**

Nam June l'orientale, il tedesco, l'americano ma anche un po' l'italiano anzi il napoletano
Nam June il vagabondo del mondo
Nam June il buddista che è anche un po' materialista
Nam June il musicista che fa musica tagliando la cravatta di John Cage come fosse un cordone ombelicale
Nam June il visionario che gioca con le immagini e ha lo stupore del bambino che guarda il suo primo aeroplano
Nam June il futurista che si mangia l'elettronica come il pane quotidiano
Nam June l'utopista che non lo dice ma qualcosa del mondo vorrebbe cambiare
Nam June il sentimentale che pensa: vale la pena provare, ci si può aiutare
Nam June che anche quando dorme ci sa fare
Nam June l'amico che anche se gli fai uno sgarbo fa presto a dimenticare
Nam June il radicale che poi sorride perchè non c'è nulla da drammatizzare
Nam June che per andarlo a New York a trovare un'altra casa ti fa attraversare dopo aver attraversato il mare
Nam June che pensa che al mondo siamo tutti diversi ma anche tutti eguali
Nam June che con il satellite tutto il mondo vorrebbe accomunare
Nam June il non ambizioso che diventa una star mondiale
Nam June il grande artista che ci rallegra ogni giorno con le sue invenzioni straordinarie.

Nam June The Oriental, the German, the American but also a bit the Italian, indeed the Neapolitan
Nam June The world-class vagabond
Nam June The Buddhist with a touch of the materialist
Nam June The musician who makes his music by snipping John Cage's tie, as though it were an umbilical cord
Nam June The visionary who plays with images with the amazement of a child as he faces his first toy airplane
Nam June The Futurist who dines on electronics as though it were his daily bread
Nam June The utopian who refuses to talk about it but still who would make a few changes in the world
Nam June The sentimentalist who harbors the thought: it's worth the effort to try, we can probably help one another
Nam June Who even does a good job sleeping
Nam June The forgiving friend even when you've managed to slight him
Nam June The radical who subsides into smiles becomes one shouldn't overdo it
Nam June Whom you visit in New York by flying across the sea and passing through other people's houses
Nam June Who thinks that everybody on earth is different but equal
Nam June Who would like to make use of satellites to bring the whole world together
Nam June The man of no ambitions who becomes a world famous star
Nam June The great artist who discovers daily happiness in his extraordinary inventions.

▶
Pre-Bell Man, 1990
Deutsches Postmuseum, Frankfurt/M.
Photo Timm Rautert

▶▶
Video-Wall, 1992
Chase Bank, Manhattan
Photo B. Thurman

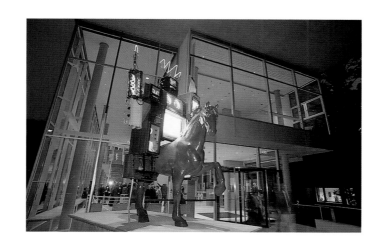

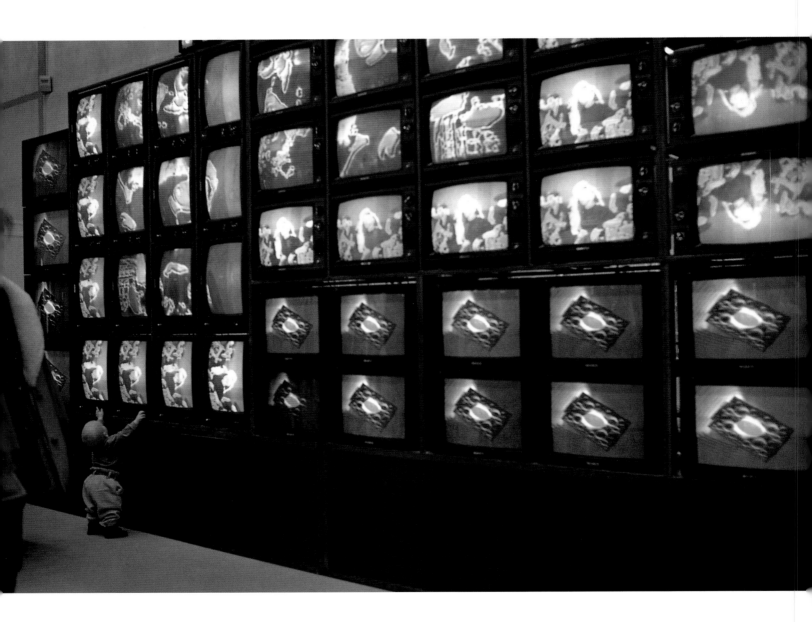

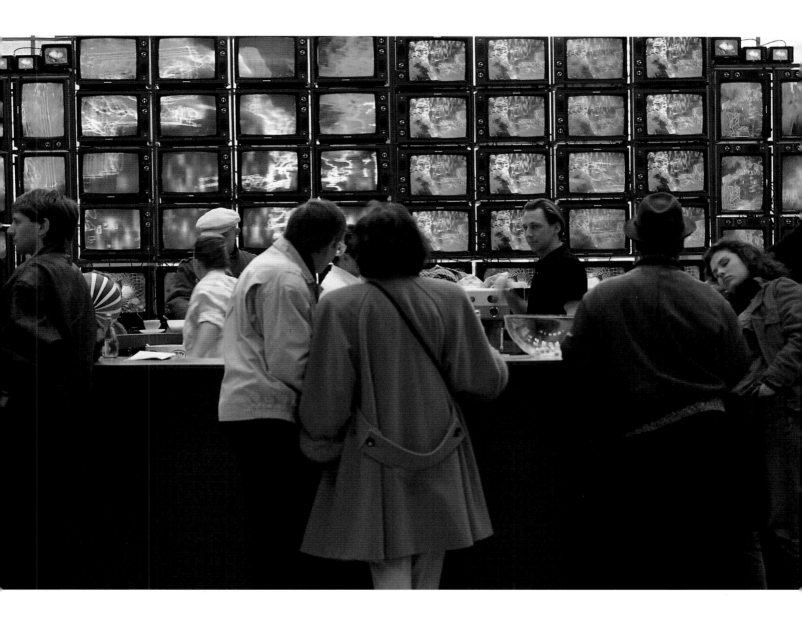

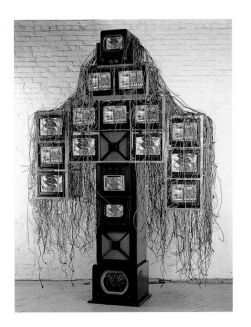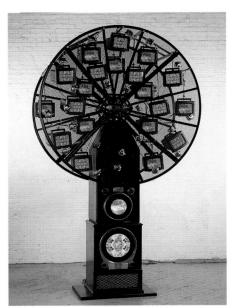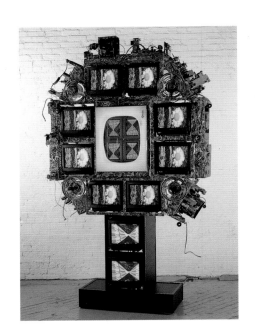

JUDITH MALINA NEW YORK
Contribution to Nam June Paik's catalogue, 1993

Nam June Paik put a TV in the gallery and turned the art on.

Nam June Paik survived the Japanese occupation of Korea, the Korean Communist movement, and turned as anarcho-pacifists on.

Nam June Paik brought Ryuchi Sakamoto to my living room in New York and turned me on to All-Star Video.

Nam June Paik put video cameras in The Living Theatre bus in Switzerland and, Living With The Living, turned them on.

Nam June Paik sends me royalty checks without my ever asking – What a turn-on.

Nam June Paik put a hundred TV sets in the museum and turned the culture on.

◄

Willow Tree, 1992
Courtesy Carl Solway Gallery, Cincinnati

Satellite Tree, 1992
Courtesy Carl Solway Gallery, Cincinnati

Flower Tree (Working Title), 1992
Courtesy Carl Solway Gallery, Cincinnati

◄◄

Video Wall, 1992
Mediale: Art & Fair, Hamburg

ZEN FLESH, ZEN BONES

1. The Search for the Bull

In the pasture of this world, I endlessly push aside the tall grasses in search of the bull.
Following unnamed rivers, lost upon the interpenetrating paths of distant mountains,
My strength failing and my vitality exhausted, I cannot find the bull.
I only hear the locusts chirring through the forest at night.

Comment: The bull has never been lost. What need is there to search? Only because of separation from my true nature, I fail to find him. In the confusion of the senses I lose even his tracks. Far from home, I see many crossroads, but which way is the right one I know not. Greed and fear, good and bad, entangle me.

138

10 BULLS

2. Discovering the Footprints

Along the riverbank under the trees, I discover footprints!
Even under the fragrant grass I see his prints.
Deep in remote mountains they are found.
These traces no more can be hidden than one's nose, looking heavenward.

Comment: Understanding the teaching, I see the footprints of the bull. Then I learn that, just as many utensils are made from one metal, so too are myriad entities made of the fabric of self. Unless I discriminate, how will I perceive the true from the untrue? Not yet having entered the gate, nevertheless I have discerned the path.

139

ZEN FLESH, ZEN BONES

3. Perceiving the Bull

I hear the song of the nightingale.
The sun is warm, the wind is mild, willows are green along the shore,
Here no bull can hide!
What artist can draw that massive head, those majestic horns?

Comment: When one hears the voice, one can sense its source. As soon as the six senses merge, the gate is entered. Wherever one enters one sees the head of the bull! This unity is like salt in water, like colour in dyestuff. The slightest thing is not apart from self.

140

JAN-OLAF MALLANDER AIJALA/HELSINKI
Paik and the oxherding pictures taking the TV by its antennas …, Monday, 28th March 1993

Nam June Paik's work has many faces – His retrospective in Basel and Zurich 1991 was a Revelation for us; something like a "Finnegans Wake" for media intellectuals. Contemplating his œuvre, however, another parallel emerges very vividly – its similarity to the famous "10 Oxherd pictures". So I took up the task to throw some light on this connection here. Its based on the version printed in "Zen flesh Zen Bones" but interpreted quite freely.

1. In the first image **the Bull is not seen** even. The Boy is searching for it "lost upon the interpenetrating Paths to the Mountain", as the root verse says.
This corresponds with Paik's early Fluxus years in Germany. Few know what he was up to. His (TV) mission is barely emerging. The State of TV in Europe is backward and boring. No Art lover can find anything nourishing therein. There are no alternatives either. TV is totally corny. It's so sad …
But Paik experiments with some rudimentary TV work. Maybe the most telling, for the future, is "Zen for TV"…

2. The **footprints of the Bull are found** – "under the grass", "deep in the mountains"… We live in the mid 60ies … Che Guevara breaks through in every Western media, in some way or another. The Chinese cultural revolution is on the move. In the West Pop Art takes over the scene. John Cage publishes "Silence". There is a great (two year long) cultural debate in Europe: Cage vs. Brecht (Bertold) etc. Fluxus is loose, too …
In his secret studio, outside Cologne, Paik works on the birth of his TV Art. Maybe he is finding out what the root verses says, that "just as many utensils are made from one metal, so too the many entities (seen on TV) are made of the Mind" …
Understanding TV one can see the Bull – Paik, however, dismantles the arrogant Super Ego dreams of manipulative TV people. He distorts and jolts with the unexpected in his "prepared TVs", in the famous "Exposition of Music" 1963. Somewhere there TV-Art actually starts.

3. **Perceiving the Bull** – this very lyric verse deals with the meeting of the Boy and the Bull: of which only the rump and tail is seen. "What artist can draw that massive head, those majestic horns" asks the root verse, rhetorically.

This scene corresponds perhaps with Paik's mid-60ies. There is war in Vietnam: hippies look for alternative life styles etc. In the Media world, McLuhan rules supremely, for a few years. New magazines emerge; there is a lot of talk of expanded cinema and mixed media. "As soon as the six senses merge, the gate is entered"...

Paik fiddles around with the cathode tube, plays with his Robot, before entering the Gate of TV Art. He even hangs the bloody head of a dead Ox over the entrance to one of his exhibitions!

Around 1965 he arranges a series of shows of Electronic Art. "Opera Sextronique" becomes a scandal, thus a media success. Suddenly TV Art is here. The first video generation emerges.

4. **Catching the Bull** – the root verse tells of a terrible struggle with the Bull, whose power seems inexhaustible. In this context it can symbolize the power of commercial TV, Show business, and the energies of the rock and roll-scene.

But Paik takes the Bull by its horns – (i.e. takes the TV by its antennas) – "TV has tortured intellectuals for 20 years: now we can torture it back" he states.

By that time – the early 70ies – many Eastern views and traditions come to the West. Buddhism starts to take root in America. Paik says, in a TV interview, that he is very curious "to see what the Americans will do with the Oriental heritage ..."

Most Art is about "aboutism" however ... Paik struggles to create a counter *cultural second* vision, with his "Participation TV". "Global Groove" becomes a hit for the Video Generation. I meet Paik for the first time in Soonsbeek, Arnhem 1971. He stays in front of three video cameras and monitors, playing with a living candle "This is my version of the endless mirror" he says; Paik with magnet.

5. **Tamina the Bull**. Could correspond with Paik in the mid 70ies. – There is a lot of High Tech talk, speculations of Utopias and Video Revolutions etc. But the root verse warns us: "The Whip and the Rope is necessary ... Hold the nose ring tight, and do not even allow doubt ..."

This is clear enough. The nose ring is the magnet Paik uses, to manipulate TV bullies – the whip is his Video synthesizer he developed in Japan 73-74. The artist tames the energies and images of the US video scene, preoccupied as it is with images of power, money, beauty, success, violence, disaster

10 BULLS

4. Catching the Bull

I seize him with a terrific struggle.
His great will and power are inexhaustible.
He charges to the high plateau far above the cloud-mists,
Or in an impenetrable ravine he stands.

Comment: He dwelt in the forest a long time, but I caught him today! Infatuation for scenery interferes with his direction. Longing for sweeter grass, he wanders away. His mind still is stubborn and unbridled. If I wish him to submit, I must raise my whip.

141

ZEN FLESH, ZEN BONES

5. Taming the Bull

The whip and rope are necessary,
Else he might stray off down some dusty road.
Being well trained, he becomes naturally gentle.
Then, unfettered, he obeys his master.

Comment: When one thought arises, another thought follows. When the first thought springs from enlightenment, all subsequent thoughts are true. Through delusion, one makes everything untrue. Delusion is not caused by objectivity; it is the result of subjectivity. Hold the nose-ring tight and do not allow even a doubt.

142

etc. Paik has the right distance to the juvenile US culture. He is now middle aged – cynic, maybe; but lyric too. He writes an excellent manifesto: "Expanded Education for the Paperless Society". Many of Paik's works could illustrate this phase but maybe the Video Aquarium, Moorman's TV cello sonatas, and other mood pieces, show this stage well. Paik also broadcasts a 4 hour long program for WBGH in Boston.

"When the first thought springs from Enlightenment, all subsquent thoughts are true ..."

6. **Riding the Bull Home** – "The struggle is over, gain and loss are assimilated" – The Boy is seen riding the Bull, playing a flute, directing the rhythm with his hand beat. In this phase "all experiences take the form of a Mandala" the comment says.

This corresponds with Paik's work in the late 70ies – culminating in his great retrospective show in the Whitney Museum 1982. This retrospective brings out Paik's vision in full scale. About this time the era of rock videos begin, Music TV takes off, and satellite communication grows enormously. The Third Video generation takes over – and Paik is something of a hero.

The photo of Paik posed on a staircase, looking down at us, smiling – with "Fishes fly in the sky" (a spiral of monitors) above, illustrates this state of mind very well indeed ...

7. **The Bull transcended**. – In the root text we see a boy sitting in front of a Hut, staring at the Moon ... The Bull is gone, and no TV is in sight. There is no need to manipulate anything, in this Ur-scene. Watching the Moon may well be equated with watching TV, as Paik observes.

Of this state of mind Paik makes a remarkable work of Art – a Buddha (statue) watching its reflection in a TV ... Many images meet here: solid and electronic, East and West technology and mystic insight, past and future etc. etc.

No antennas or satellites are needed – not even any program. Even Fluxus is transcended! The million dollar question is:

Has the TV Buddha Nature?

This is the only work my old mother remembers from the big show of contemporary art ARS 74 in Helsinki ...

8. **Bull and Self Transcended** – "Whip, Rope, Person, Bull – all merge into Nothing" the root verse says. Only a circle is seen ...

The TV is empty, the artist is gone ... All he left is some exclusive drawings, where birds

6. Riding the Bull Home

Mounting the bull, slowly I return homeward.
The voice of my flute intones through the evening.
Measuring with hand-beats the pulsating harmony, I direct the
endless rhythm.
Whoever hears this melody will join me.

Comment: This struggle is over; gain and loss are assimilated.
I sing the song of the village woodsman, and play the tunes
of the children. Astride the bull, I observe the clouds above.
Onward I go, no matter who may wish to call me back.

143

7. The Bull Transcended

Astride the bull, I reach home.
I am serene. The bull too can rest.
The dawn has come. In blissful repose,
Within my thatched dwelling I have abandoned the whip and
rope.

Comment: All is one law, not two. We only make the bull a
temporary subject. It is as the relation of rabbit and trap, of fish
and net. It is as gold and dross, or the moon emerging from a
cloud. One path of clear light travels on throughout endless
time.

144

8. Both Bull and Self Transcended

Whip, rope, person, and bull – all merge in No-thing.
This heaven is so vast no message can stain it.
How may a snowflake exist in a raging fire?
Here are the footprints of the patriarchs.

Comment: Mediocrity is gone. Mind is clear of limitation. I
seek no state of enlightenment. Neither do I remain where no
enlightenment exists. Since I linger in neither condition, eyes
cannot see me. If hundreds of birds strew my path with flowers,
such praise would be meaningless.

145

fly in an out of the screen, and a candle in an empty frame ...

Only Paik could get away with something so simple.

"Here are the footprints of the Patriarchs"...
But where is Paik? – Asleep, I suppose, or out eating, at some favourite restaurant in the neighborhood.

9. **Reaching the Source**

"Poised in Silence he observes the forms of integration and disintegration ... of what is creating and destroying ..."

After experiencing Emptiness, everything becomes alive again – full of potential and meaning ... Everything is living communication!
"Avec le Vide les pleins pouvoirs" (Camus).

This is the expanded Paik of the 80ies ... We can look again at the "Zen for TV" in a new way; contemplate the TV Garden; restfully watch the video aquarium; relate to our Time through the Laser Clock, and have fun with the Robot Family etc ...

Everything is just a Show, anyway ...

10. **In the World**. In this final image was seen the pot-bellied Sage wandering around, with a sack full of gifts. He deals with the World in an utterly direct and simple way, and everyone who meets him gets a glimpse of Enlightenment.

The Paik we know in the last 10 years has something of that quality ... What he offers us is a bag of insights, blown-up to full scale, for the people of the Global Media Village, to be delivered through Satellite TV ... Heavy dualistic views (East/West) are dissolved ("Bye Bye Kipling") and major fears have vanished: Orwell was wrong – there is a happy side to the watching business; and Paik celebrates that.

In the 90ies the insights of Art are projected into Rock Videos; Music TV rules the Scene – Maybe tomorrow we will have Wall-to-Wall TV, mind-to-mind visions, as Paik has foreseen. Perhaps we do not even need any Utopias anymore – the Future belongs to the Unprogrammed.

9. Reaching the Source

Too many steps have been taken returning to the root and the
source.
Better to have been blind and deaf from the beginning!
Dwelling in one's true abode, unconcerned with that without –
The river flows tranquilly on and the flowers are red.

Comment: From the beginning, truth is clear. Poised in silence,
I observe the forms of integration and disintegration. One who
is not attached to 'form' need not be 'reformed'. The water is
emerald, the mountain is indigo, and I see that which is creating and that which is destroying.

146

10. In the World

Barefooted and naked of breast, I mingle with the people of the
world.
My clothes are ragged and dust-laden and I am ever blissful.
I use no magic to extend my life;
Now, before me, the trees become alive.

Comment: Inside my gate, a thousand sages do not know me.
The beauty of my garden is invisible. Why should one search
for the footprints of the patriarchs? I go to the market place
with my wine bottle and return home with my staff. I visit the
wineshop and the market, and everyone I look upon becomes
enlightened.

147

M 195

LAURENCE MAMY PARIS
Paris, le 3 décembre 1991, 1 avril 1993

Paris, le 3 décembre 1991

ALAN MARLIS NEW YORK
Travelling The Streets With Paik, 1993

Nam June Paik's genius shows itself in his hands and feet. Always inquisitive and interested, anything put in front of him immediately goes into his pockets to be analysed and dissected – edited at home. His slow gait, plodding down Spring Street makes him fair game to all the artists, writers, producers and wannabes in our neighborhood (there are thousands), and they all get his time-and-a-half. He is the Korean global democrat who includes people, places and memories of four continents in his work.

His ambition is monumental. It is electrical ambition which comes from a more serious source than your typical studio trained artist's. He marches to the sounds of Empire-building cowboys like Kipling, Political-genealogists like Orwell, and sweet and sour music masters like Schoenberg and Cage. Yet his spiritual scorecard is Asian and echos through the sound track, the video montage, and the architecturally balanced TV console the Al Jolson/Arlo Guthrie refrain: "Don't you know me, I'm your native son."

Never alienated from the woman's body, Nam June and topless Charlotte Moorman did a one-upsmanship on Eduard Manet's "Luncheon on the Grass", transforming the musical stage into a more natural habitat.

Mixing German energy with French tact Paik can develop an idea symphonically and/or isolate a precious note. He shares this supple adaptability with his friend & colleague Joseph Beuys.

Always sensitive to acts of loyalty on the part of artists (not their strong suit), and a loyalist himself both politically and generically, Paik holds no grudges – there is too much to do, to say, and you have to stop the cycle somewhere.

Nothing tight comes close to Paik: not his shirts, pants, shoes – no up-tightness, and he's not tight with money or credit. Never caught in the tight noose of expectations, he's as fresh and loose as a breezy spring day, and as fluid as the holly & ivy, those festive perennials.

Taking fragments from willing collaborators Paik has designed a focus, a locus, an artistic hocus pocus that throbs all through the night past sadness, melancholy & euphoria – a stray cat singing his endless plaint, no longer

196 M

Je soussignée Laurence Mamy atteste que Monsieur Nam June Paik est

vivant à la date d'aujourd'hui.

Eric Fabre
P/O
Laurence Mamy

mysterious because it has been outside our windows all these years & there are no words to entice it into our homes with their simple A/C D/C currents. The merry rush, the merciless crush of his art have described us & posed the question that bedivils us: "Is it really love, or just a game?"

TOSHIO MATSUMOTO TOKYO
Memories of the Past, 1993

Paik and I spent the campus life in a same seminar. He studied music, and I studied art. He was an earnest and gentle student. So it was a great surprise for me that one Japanese newspaper reported about him as a Fluxus performer several years after graduation.

A few years later from that time, he was an active pioneer of video art. I was absorbed in the experimental film then, and I also came to make video art pieces from 1968. We two were so pleased because it is as if we met again in a same plaza in spite of the different ways each one chooses.

About 1970 when I traveled to the United States several times in order to see the experimental films and video art, I received much assistance from Mr. Paik and his wife, Shigeko Kubota in downtown New York. He is a kind-hearted obliging person, who is also a henpecked husband. We discussed much about art and philosophy until late at night in his loft. He lived needy circumstances then. I remember those things fondly and vividly as if they ocurred yesterday.

LARRY MILLER NEW YORK
Holographic "Statue", 1976

NAM JUNE PAIK
20th. Century American Artist

A video toast to Nam
June Paik

who put all the world
in sync

and showed us all how to
celebrate our globe in a
high-tech media form called
SATELLITE ART

and a prize to
the German pavillion
to claiming/celebrating
this art world
multi-national at the
Venice Biennale

Barbara Mayfield
New York
3/30/93

BARBARA MAYFIELD NEW YORK
A video toast for Nam June Paik ...,
March 30, 1993

JONAS MEKAS
Über neue Richtungen, über Anti-Kunst,
über das Alte und das Neue in der Kunst,
11. November 1965
... Aber heute nach fünf, sechs, sieben Jahren fügt sich auch diese sperrige Anti-Kunst in den tausendjährigen Schatz aller Kunst ein. Dies wurde mir plötzlich an einem Abend bei einer Aufführung von Nam June Paik bewußt. Seine Kunst – genauso wie die von La Monte Young, Stan Brakhage, Gregory Markopoulos, Jack Smith oder sogar (zweifelsohne) Andy Warhol – wird von den gleichen tausendjährigen ästhetischen Regeln bestimmt und kann in gleicher Weise wie jedes andere klassische Kunstwerk analysiert und erfahren werden. ...

M 197

ISSEY MIYAKE TOKYO
A drawing, 1993

AIKO MIYAWAKI TOKYO
Dear Nam June Paik ..., March 8, 1993

Ē. A.

Dear Nam June Paik —

Always desiring to have
a long talk with you.

Aiko Miyawaki
mar. 8. 1993

BARBARA MOORE NEW YORK
Story of a Paik Artwork, 1993
In the mid-70's, in a junk shop near our house, Peter & I spotted a handsomely-shaped old wood TV case, minus its insides, and bought it as a gift for Paik. He turned the tables and christened it as an artwork he made for us.
In about 1976, a year or so after "Candle TV II" was made, the piece was borrowed by Paik for some European exhibition. The next time we saw it was in 1977 during the Paik/-Beuys satellite transmission from Documenta. There on our home TV screen was the wood cabinet, so distinctive that it was unmistakeable, sitting, sans candle, on top of a stack of TV sets in a (West) German studio 3000 miles away. As I, in New York, leaned forward to see the image better, Paik suddenly picked up our "artwork" and hurled it across that distant room. There was an off-screen crash and the piece was not seen on the program again, presumably destroyed.
Well, not so. The next time we spoke to Paik he said it had been slightly damaged, but not irreparably, and he assumed we'd gotten it back. However, no one could locate it; it had completely disappeared.
Not too surprisingly, as often happens with "lost" work, the piece resurfaced in the hands of a well-known curator and was shown, with virtually invisible repairs, in one or more exhibitions in Europe in the early 80's, for which catalogues document its travels.
It finally arrived home on Nov. 14, 1983, after an absence of 7 years. The Moores celebrated its return in an unauthorized manner: In lieu of a Christmas tree that year, we displayed "Candle TV II", containing not one but half a dozen candles burning simultaneously throughout the holidays. It was a beautiful sight.
During the work's European tour, asbestos panels had been added to the interior as a safety precaution. I asked Paik whether this alteration had his approval. He claimed to welcome the protection and even speculated about going further by drilling a hole in the top to allow heat to escape. "I want candle always burn, but don't want museum to burn up and don't want reputation that my work is dangerous", he said.
When we first owned the piece, the candle was placed on a saucer within. The asbestos additions made the floor higher, so the candle was set directly on the asbestos panel. Paik said this change was of no import.
As one can see, the "making" of this piece often involved third parties. In the early years of our friendship with Paik I wondered how

this affected "authenticity": in one instance he handed us a TV set and a bag of parts and uttered some vague instructions about our putting them together ourselves. Now, when I see how, at each change of hands and circumstances, he effects "improvements" or has others do them, I accept this as the way he works. Each person who has touched "Candle TV II" has enriched its history.

Eventually, "Candle TV II" was sold to the Staatsgalerie Stuttgart, at which point Paik retitled it "Wooden TV and Candle" to prove, he said, that it was unique, rather than just another version of his first "Candle TV".

At that time he also insisted on signing it and writing up a set of instructions on how the museum might continue the work's evolution.

Candle TV II, 1975,
Photo by Peter Moore

FUMIO NANJO TOKYO
Fragments on Mr. Nam June Paik, 1993
The garden where images are scattered, is it the dream of a futurist? The golden fish and the moon in the TV monitors, are they the Japonaiserie of a romantic? The dialogue with Beuys, is it a circus of information media?

Robots made of TV monitors, although they symbolize the future of mankind, look rather out-of-time.

The candle whose flame flickers across the whole wall transforms everything into a phantom, and it seems to represent a will to bury the whole in a gloom of information.

Nam June Paik sees the future from the past,

but he also sees the past from the future. After all, existence must be only in the memory of images.

ROGER NELLENS KNOKKE
Some anecdotes, 1993
During a dinner party after the opening of his show in N.Y., Roger Nellens had the pleasure to gather at his table celebrities like Frank Stella, Illeana Sonnabend, George Segal, Leo Castelli, etc. ... Then arrived Nam June very late with a big smile on his face, suspenders that hold his pans from falling with a watch hanging from them and big shoes with holes. "I just came back from watching a movie" he said while sitting down at the dinner table by Frank Stella's side. "What film?" asked Frank. "I don't know" replied Nam Jun. "I took a nap. I love taking naps during movies. I had a great time!" "Me too", concluded Stella, "I also love sleeping during movies."

In the game room of the Casino of Knokke, Nam June Paik just won $ 50 on his first try. He got really exited and walked in every different direction with the money he just won and waving it in every different directions. "It is the first time that I win in gambling" declared Nam June. He could not hold himself from joy anymore just as if luck and coincidence was something totally new for him.

In a room of the Majestic Hotel (in Knokke Belgium where Nam June had a show in summer of '92) explains Roger Nellens they gave Name June one of their nicest rooms. When the maid would come in in the morning, she would find Nam June sleeping on the ground covered with orange skins that he pealed off. The skin of the oranges were all over the room including the bath tub.

HERMANN NITSCH
PRINZENDORF, ÖSTERREICH
Textbeitrag für den Biennale-Katalog über N.J. Paik, 1993
Im Happening-Buch von Wolfgang Becker und Wolf Vostell, welches 1965 erschien, sah ich zum ersten Mal Fotos und Partituren von Nam June Paik. Seine Arbeiten beeindruckten mich sehr, ich sah ihn als einen Klassiker der frühen Fluxus-Aktionen an.

1968 wurde ich von Jonas Mekas nach New York und Cincinnati eingeladen, um Aktionen zu realisieren. Zur Aufführung meiner ersten Aktion in der New Yorker Cinemateque kam Nam June Paik. Freunde teilten mir während des Ablaufes der Aktion mit, daß Paik sehr begeistert sei. Das stimulierte mich aufs

Äußerste, weil ihm vor allem wollte ich diese, meine blutige Kunst zeigen. Als die Zuschauer Blut aus gefüllten Reagenzgläsern in die aufgeklaffte Wunde des Schafes gießen sollten und Paik sich sofort daran beteiligte, war es für mich eine große Bestätigung und Huldigung meiner Arbeit. Ich wußte, dieser Mann hat mich verstanden. Der weitere Aktionsablauf steigerte sich zu einem großen Erfolg. Trotzdem gab es nachher, nachdem die Beifallsbekundungen sich erschöpften, große Bestürzung wegen des chaotischen Zustandes, in den das Aktionsereignis die Räumlichkeit versetzt hatte. Überall Blutlachen, herumliegendes Fleisch und Gedärm. Paik krempelte sich die Hemdsärmel auf und begann aufzuräumen. Das war für mich die Geste einer großen Persönlichkeit und die größte Anerkennung, die mir widerfahren konnte. Solch ein großer Künstler setzt sich auf diese Art für meine Arbeit ein. Paik war wirklich begeistert. Er meinte, wir beide würden "crazy art" machen. In der Folge des Abends gingen wir in "maxi's kansas city". Wir tranken viel Bier. Paik und ich prosteten uns immer wieder zu.

In Cincinnati konnte ich eine Aktion von Paik sehen, die er gemeinsam mit Charlotte Moorman aufführte.

Ich war ebenfalls schwerstens beeindruckt. Solche Aktionen hatte ich noch nie gesehen. Er führte alles mit dem Temperament eines Asiaten durch. Seine Ekstase war anders als die des Europäers, sie hatte etwas Raubtierhaftes und wurde von einer offenen Sinnlichkeit, die unverhüllt ihre Wurzeln in der amorphen Naturkraft zeigt, getragen.

Als ich Paik all mein Lob sagte, das ich zu sagen fähig war, gab er mir wieder eines der größten Komplimente zurück, das sich Künstler sagen können. Er sei nach der Abhaltung seiner Aktion weniger müde, als nach der Teilnahme an meiner Aktion in New York.

Ich habe jetzt absichtlich viel persönliches über Paik geschrieben, das mit meiner Arbeit zu tun hat, aber sein Verhalten hat mich damals so betroffen und glücklich gemacht, daß ich mich nicht schäme, es als persönliches Erleben dieses Mannes festzuhalten.

Welch großer Künstler er ist, brauche ich nicht zu sagen.

KWAN SOO OH SEOUL
Returned to Seoul, 1993
Nam June Paik returned to Seoul in 1984 after 35 years of his being abroad. At that time, his Korean language seemed to be one of 1940's. He still speaks quite old Korean of 35

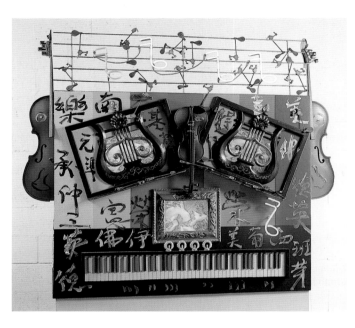

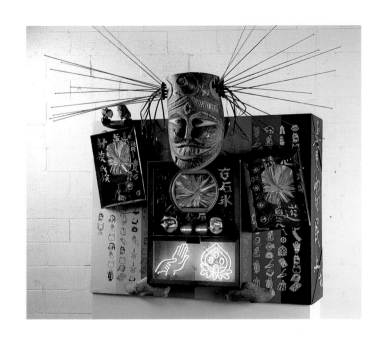

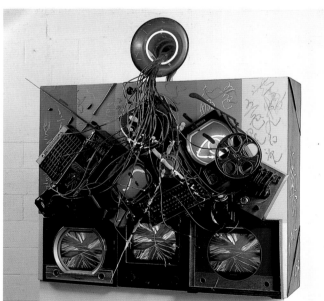

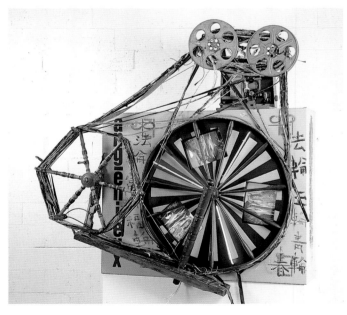

years ago. His words are no longer used and somewhat awkward to us. It was a real surprise that an ultra-modern video artist like him doesn't speak similar avant-garde Korean language. Like this, he is constantly looking for a new method for his performance, but paradoxically, his actual thoughts are getting back to the past times more and more.

"Moon is the oldest television" – this work implies Mongolian legend, certain cultural background which can be understood only by lunar-charactered people. His works tell us the history of European Continent, tracks of his ancestors remained in Korean Peninsula through Siberia. His artistic world continously extends its wing over the past and the future. Can we call it "harmonized discord"?

"Art is a fraud." As he says, his art accordingly makes harmorized discord.

YOKO ONO TOKYO
For Nam June Paik, 1993

nam june paik is a window
opened
to the west & the east
to the past & the future and
to chance & design

it is
a window of reminder
a window of change
a window i remember
and cherish its view

JERALD ORDOVER NEW YORK
All about Nam June Paik, March 29, 1993

The most distinctive memories I have of Nam June Paik, as I think back over the 28 or so years I have known him and served as his lawyer, are of his not being there. And of his being there when I least expected him. Or of his being there for reasons other than the logical ones I assumed had brought him to my office.

He will call and leave a message that he must see me about a very important matter and then I hear nothing more. I call and fax notes to him. No reply. And then, a few days or weeks or sometimes a couple of months later, he appears, unexpectedly.

"Where were you?" or "What about...?" I ask. And, of course, his answer is completely logical and timely. The important matter of last month has evaporated or its time has only now come.

My failures to locate him are explained: It was his time to be in Germany to teach; or he had to go to Korea or to Cincinnati for a project; or he wasn't at home or at Studio A or Studio B because he had lately been working at Studio C, the place, he had told me, he never used anymore, except for storage.

We talk about the matter, or the two or three, that have brought him to me. One maybe the case I thought he had come to discuss. But there will often also be some new items, a proposal he has received, a new project he is just starting to develop.

I am given the facts, the problems and the desired results and I go to work. The notes he leaves with me or sends to me later may look disjointed, but, on careful reading, make perfect sense.

But, just as often, I am told that he will soon send me or will be back with more information. But he doesn't. Or not when I expect him.

But it seems to me that he is there – or here – more often in the last year or two. Maybe I have adjusted to his timing. Or maybe it is because his dry cleaner and laundry are now located just down the block from my office.

SUZANNE PAGÉ PARIS
A Nam June Paik, 29 mars 1993
au dormeur qui éveille les étoiles,
à l'allumeur qui dissout les ombres,
à l'incendiaire qui embrase les rêves,
au nomade céleste, à son sourire séraphique.

SYEUNGGIL PAIK SEOUL
A Real Cosmopolitan, 1993

I always thought Namjune was a real cosmopolitan because, even though he dabbles in Korean, Japanese, German, English and French, I have never heard him speak any one of the above with a semblance of accuracy. It is time for a cosmopolitan to invent his own language. The video language.

KYU H. PARK SEOUL
Robot on a horse, 1993

Robot on a horse, 1991, 335 x 244 x 549 cm
Sonje Museum of Contemporary Art, Korea
It is a robot on a horse which represents a spiritual relic of the Unified Shilla called "Wharangdo". Nam June Paik exceptionally put his robot on a horse this time and it is considered an outsider of his robot family series made of televisions.

He usually reflects Korean and Oriental spirits to his works and this product is well-harmonized with its regional peculiarity. That's to say, Sonje Museum of Contemporary Art – which contains this robot on a horse – is located in Kyongju, the capital of Ancient Shilla for around 1000 years.

Kyongju still has lots of spiritual and material relics of Shilla Culture.

He installed actual-sized plastic horses and nine antique televisions from all over the world. And he made a real scientific robot based on the computer graphics with those televisions. Although this horse cannot run, constantly moving images on the television screens enable us to see it running. It represents a manly chevalier of ancient Korea and Nam June Paik harmonized spiritual "Wharangdo" – Korean traditional chivalry – with ultra-modern technolgy of the West.

RHAI KYOUNG PARK SEOUL
The scope from 0 to 9, 1993

Nam June Paik usually takes numeral figures to explain his performances and life. Surely, it is done within the scope from 0 to 9.

It was when we held his memorial exhibition "Nam June Paik, Video Time, Video World" in our museum, last summer in 1992. I asked him what his favorite numbers are. He said "I like 4 and 5. And they make 9." I am not sure whether those numbers are playing meaningful roles in his life of sixty years. But I am just thinking of the number 9 for a while.

We have our traditional card games called "Whatu". They have monthly countable figures and nine is the smallest number within the winning points. Therefore, it means the least fortune in life. It also explains Nam June Paik's simple and naive wishes longing for the fortune of his life through the numbers 4, 5 and 9.

◄

Aimez-Vous Brahms, 1992–93
Courtesy Carl Solway Gallery, Cincinnati

Tribal Groove, 1992-93
Courtesy Carl Solway Gallery, Cincinnati

Roland Barthes' Symphony, 1992-93
Courtesy Carl Solway Gallery, Cincinnati

Wheel of Fortune, 1992-93
Courtesy Carl Solway Gallery, Cincinnati

MARK PATSFALL CINCINNATI
**Some of the things one learns during
ten years of working with Nam June
April 17, 1993**

1. The history of Korea
2. The politics of art
3. The art of politics
4. The politics of politics
5. "English is the most efficient language"
6. Economics
7. Some Chinese calligraphy
8. Less is less
9. Loyality
10. Eat often and very slowly
11. "In art any mistake will later be seen as a stroke of genius"
12. How a TV works
13. How to make a TV not work
14. "De-control"
15. "East is west, west is east"
16. Where the most beautiful women in the world are
17. "Fluxus invented India"
18. Dropping a Buddha on your toe can lead to a catastrophic chain of events stretching from Wiesbaden to ...
19. With Nam June everything is subject to change at the last moment, and will
20. "Life takes precident over art"
21. *Nothing* works unless it is plugged in
22. Can't put this one in print
23. "Light is the most efficient form of information transmission"
24. James Joyce was right
25. "Parking is the most serious problem confronting 20th century man"
26. Pay your taxes
27. What a "Shadow warrior" is
28. etc.
29. etc.
 etc.

HALA PIETKIEWICZ ROCKPORT, TEXAS
An episode, 1993

In the mid-sixties we (husband, two daughters, one bull terrier) had the pleasure to have Nam June, this religious man of post-modern times, with about seventeen other wonderful New York artists, all uncommitted for the holidays, over Christmas Eve as guests in our Glen Ridge, N. J. home. The evening progressed lively, the weather regressed miserably and transportation to Manhattan ceased.

The crowded sleeping conditions prompted Marc Kaczmarek to innocently ask Paik to share a bed with him and Miriam (Marc's girl friend). With a polite, "Thank-you. I will now go out and meditate on the Christ child", Paik went into the cold night only to return at 4 a.m.

FRANK C. PILEGGI NEW YORK
A letter, March 21, 1993

It was March of 1976, my wife (cellist, performance artist) Charlotte Moorman and I had been in Australia for about one week, soon to be joined by her partner, Nam June Paik.

In the time we had been there, Charlotte had been performing daily, mostly works by Paik. To our amazement the morning newspapers carried the reports of her doings with front page stories.

Australia had truly adopted her and were eagerly awaiting the arrival of Paik. They were scheduled to do performances at the Adelaide Festival as well as the Gallery of New South Wales in Sydney.

When Paik called us from the airport to tell us he had arrived, Charlotte and I were in our hotel room watching a TV special that Australian Television was presenting about the two of them.

I was obviously excited, telling Paik to take a taxi directly to the hotel, he would still be able to see the last part of the program, that I had daily newspapers to show him and that I was holding his room key, # 502 for him.

There were still about 15 minutes left when he arrived. He watched the end of the program sipping an orange juice, barely acknowledging that which we were viewing. As soon as the show ended, I shut the set and presented him with newspapers of the previous 4-5 mornings. Paik glanced at the headlines, then pushing the papers aside he looked at me and sternly said, "We are here to work, not for publicity".

He told me to meet him in the hotel restaurant for a very early breakfast so that we could plan our activities.

The next morning, upon waking I checked the morning newspapers that had been delivered to our room. Once again the front page featured a performance Charlotte had done the previous day of one of Paik's works.

I took the paper to breakfast with me to show it to Paik. He never bothered to look at it, once again reprimanding me for caring about publicity.

I have to admit, knowing the value of front page articles (for funding, grant applications, etc. etc.) I did care about the publicity.

I told Paik I was going to the bathroom. Instead I went to the hotel newsstand to purchase extra copies.

Surprisingly, although it was not yet late, the morning paper was sold out!

The following 2 mornings were exactly the same. We met very early for breakfast to plan our day. Each morning the front page featured Charlotte and Paik. Each morning I showed the paper to Paik. Each morning he refused to look at it. Each morning he lectured me to "concentrate on work not publicity".

Also, each morning the hotel newsstand was sold out.

Sold out? How could a morning newspaper be sold out each of the past 3 days before 6.30 a.m.?

Finally I had to ask the man at the newsstand how this could be.

"It's very strange", he told me. "As soon as I open up in the morning, a little oriental man buys up all of my papers and charges them to his room, # 502."

A few weeks later, Paik, Charlotte and I flew from Australia to Guadalcanal, Solomon Islands.

As we went through customs, Charlotte and I pretended not to notice as officials opened suitcases (they were Paik's) filled with newspapers.

▶

Fin de Siècle Man, 1992
Courtesy Carl Solway Gallery, Cincinnati

Van Gogh, 1992
Courtesy Carl Solway Gallery, Cincinnati

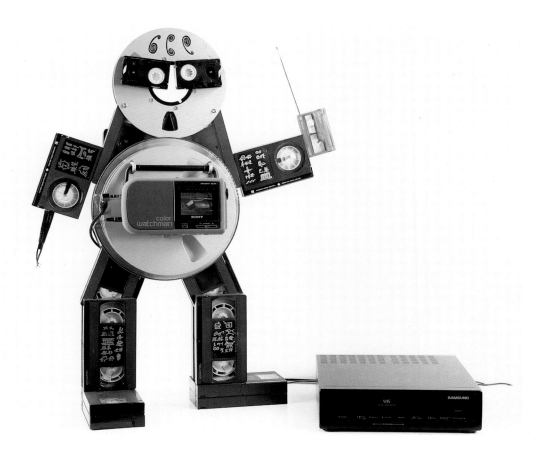

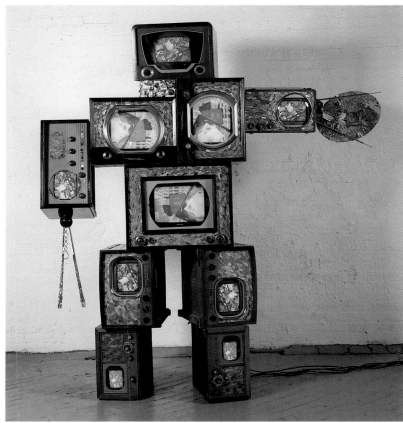

KLAUS RINKE VENICE, CALIFORNIA
German Buddha – Fernost – Far East
Japan 1970 – to Nam June Paik

OSVALDO ROMBERG NEW YORK
About Nam June Paik, 1993

I met June Paik for the first time in Europe in the early 70's. We met in different cities in Europe: Paris, London, and Antwerpen as a result of the International Video Symposiums at that time. He was already not only one of the fathers of Video Art but also an energetic and unpredictable contributor. In the end of the 70's when I was directing the art department at Bezalel Academy in Jerusalem he came with Allan Kaprow and Pierre Restany to make a film in Israel and because of that he worked with students in the school.

I have had a second experience with June Paik as a team worker. During the last years we have met at Spring and Broadway in New York and talking about life over breakfast. After all of these years my impression of him has never disappointed me and it feeds my image of a great artist not as a commercial producer of iconography, but as a curious cultural terrorist who always explores new ways of nonverbal communications.

ULRIKE ROSENBACH HOMBURG
Brief an N.J., 1993

Hey Nam June,
I know both of us will never forget this one event at the airport of Düsseldorf, when we were waiting for our plane to take off to N.Y.

City for five hours. You had just come from Paris, having had to look at the Pompidou for your big show there. While trying to kill time by chatting and drawing plans of ideas for installations you had to listen to me about this fabulous idea for a video installation in the open pub-basement inside the hall of the Pompidou centre.

I had been really turned on by that square place and the idea of a lying installation, which only could be viewed from the hall above. We had great fun inventing an installation for your show in that place while waiting for the plane, and it became that big-flag-piece later. I always liked this event, because it was one of the rare moments where we worked together on an idea – which for sure should happen more often …

Thanks for the Chickenyear and have a good-one too.

Love Ulrike

DIETER ROTH MOSFELL S-BAER, ISLAND
A letter, 10. 2. 1993

Rala, 10 Febr '93

hi, Nam June,
1 handshake from Dieter

To
Diter Roth
Mosfell S-Baer, Haus Bali
P.O.Box 213
Island

LA BIENNALE DI VENEZIA
LV ESPOSIZIONE INTERNAZIONALE D'ARTE

Prof. Dr. Klaus Bußmann
Kommissar des Deutschen Pavillons
Westfälisches Landesmuseum
Domplatz 10, D - 4400 Münster
Tel. 0251/5907-257, Fax 5907-210

February 1st, 1993

Dear Diter Roth,

I will edit a multilingual Nam June Paik-catalogue for the German Pavilion of the Venice-Biennale in June 1993, designed as «book as artwork» by Paik himself. A large portion of this book will be devoted to a section called «Paik-Mosaic» in which many friends of Nam June Paik are invited to contribute a short essay in English, German, French or Italian ranging from only 5 lines to 500 words.

In order to avoid repetative boredom, we urge you to choose only a narrow slice of pie in his life and art, that means a single episode or an event to which you are familiar with, or a single art work, which you like most or hate most. We welcome negative criticism, sarcastic of funny view, or even the Mad Magazine-kind of comical or irrelevant comment. Also instead of an essay you may draw a drawing or a comic strip. Since there will be a separate essay on his biography and summary of his art works you don't have to go into the generally available informations. We certainly want to invent an original format in art catalogues making. Your fee will be two lithos, a limited edition, signed by Nam June Paik, that will be ready around June 1993.

Your contribution must arrive by March 30th in Münster (Germany), Westfälisches Landesmuseum. If you still have any questions call me or my assistent Dr. Florian Matzner (Tel. 0251/5907-212, Fax: 0251/5907-210).

Yours sincerely,

(Prof. Dr. Klaus Bußmann)

hi, Dr. Bußmann, send the lithos to ; give letter (after printing in catalog.) to Paik, please!

P.S. You know, I remember something now – which I really want to share with you because it is really funny.

I never told you that I was very much in love with you when I was a romantic twen still – that was when I saw your concert with Charlotte Moorman at the Parnass-Gallery-event: 24 Studen. It was in Wuppertal, where I lived at that time and it was long before I saw you again in the video-Art-scene. I looked at those beautiful photographs Ute Klophaus had made and thought that you were the most good-looking guy I had ever seen or met or looked at. Don't laugh and don't become jealous – Shigeko – it is really long ago – about 20 years and more. Also much later, after this event, we met as artists both of us – again – at Parnass Gallery in Wuppertal – and at that party I sat on your Cap Nam June ... Do you think also, that this was a late realisation of the earlier forme-romantique?
Have fun, Ulrike.

RYUICHI SAKAMOTO TOKYO
The Time of Adagio, 1993
(Extracted from the text first published in "SAT-ART III")

Laurie Anderson says that performance vanishes. Even while the video records it as an image, performance itself does not exist any longer as soon as it has finished. When I joined Nam June Paik's satellite project "Wrap Around The World", I played a folk song of Okinawa, "Chinsagu no Hana", with three young girls from Okinawa and Indian tabors in the same style as I performed it in New York in June, 1988. I always play with a dimly obscure, stringlike or choruslike sound, in recalling the adagios by Mahler. On that day, the effect was perfect. I felt satisfied to be praised by Mr. Paik and Mr. Asada.
Now it is the time of adagio, as I expected.

ITSUO SAKANE TOKYO
Artist of Generosity – A Homage to Nam June Paik, 1993

Paik's charisma is not that of a solemn genius; rather it is the affable charisma of a natural and witty personality.
Similarly, Paik's amazingly unique works mix the otherworldly with mundane human characters in a manner which is entirely contemporary while avoiding empty academicism or ostentatious references to Western philosophical tradition. Looking at Paik's work is a humanizing experience similar to that of appreciating a chipped porcelain bowl or a collage of variegated fabrics. His work possesses a generosity which both transcends and tolerates all kinds of cultural and ethnic differences.
It is hard to imagine exactly how Paik has developed such an extraordinary charisma, but it most probably derives from an intuitive power bordering on the instinctual which arises from his vast experience with other cultures and his insight into the deepest philosophical and political levels of human society. His perceptions of the intellectual and emotional differences between Korea and Japan, or between Japan and the West, or between East and West, are intuitively translated into his medium, both a collage and a fabric of many textures woven from the thread of his sensibility. Certainly, it transcends the limits of conventional Western logic.
It is as if the confrontational aspects of his subconscience are revealed in the different media he uses, and in his combining of the material and the spiritual, the scientific and the artful, Yin and Yang, West and East to forge a new strength for survival.
It is not surprising that Paik's activity as an artist has coincided with the beginnings of multi-media performance. His "Wrap Around The World" project connecting TV stations all around the world continues to reveal the "generous art" of Nam June Paik.

WIELAND SCHMIED BERLIN
A letter, 13. November 1984

I would have hated
Video perhaps all my life
without having met
Nam June Paik

MIEKO SHIOMI
Fluxus Balance, March 25, 1991
Dear Nam June Paik
For the BALANCE POEM series which is planned to be presented at the International Intermedia Festival in Madrid in 1992, I would like to invite you to take part in a Balance Game.
Please write down in the square on the other sheet of paper what you want to balance with something another artist wants to balance, and send it back to me. You can think of either an object (objects) or a concept either indicating or not indicating its weight.

Please use twenty words or less in English.
Hope to receive your reply by June 30th.
Thank you

CHAEUNG SO SEOUL
Caught in the Red Hunt, 1993
We lived our student lives in the most turbulent period in our history, from the nation's liberation in 1945 to the outbreak of the Korean War in 1950.
Namjune never joined the then fashionable left-leaning Reading Circle nor did he ever behave in a manner to be misunderstood as a leftist, but this son of the richest man in the country was caught in the Red Hunt by the extreme rightist group, and was so thoroughly flogged that he could not attend school for several days. His family lodged a strong protest with the school. This was the only controversy Taewongun, but the people from the museum said that they could not sell him because of his negative image. So I chose a Paekche King, Munyong as a compromise. I wanted the Regent to hold a torch in his hand, but the museum people dissuaded me from doing so.
I was captivated by an idea in which the Regent had an antenna on his head, a torch in one hand, and was galloping on a wooden horse toward the future. The beats of horses' hoofs, the rising dust and the noise ... What would have happened to Korea if the Regent's antenna were a little higher? The Regent who closed the country so tightly from foreigners!
I still refuse to be awakened from my dream in which I see the sixth century Paekche King Nunyong being reborn as the Regent Taewongun in the late nineteenth century.

HARALD SZEEMANN TEGNA
Offenes Genie, 17. April 1993

Nam June Paik
ist ein offenes Genie
so kann er Genie(s)
ausmachen das/die nicht
er selbst ist/sind usw.

YUJI TAKAHASHI TOKYO
Paik – the Rapper, 1993
(Extracted from the text first published in "SAT-ART III")

They say "time is many"/ Information condensed into a reel of tape, it's the time transformed into a digital code/ Satellite video is a

bank, planetary-scaled huge bank/ Wait a moment, cause the avant-garde art is close to death with overissue of credit cards/ Look! what's happened to the avant-gardists in the '60s/ Allen Ginsberg is singing with a tie/ Everyone is pop and well/ Beuys has gone and the video turned into his tomb/ The living are also impressed a rainbow zero on their backs/ a candle burns behind the cathode-ray tube."

Paik said "I come from a poor country. What I can is to entertain everybody"/ Now I wanna ask someone how the poor life could be on such a rich planet."

JEAN TOCHE NEW YORK
Contribution for the Nam June Paik catalogue (452 computerized words, plus date and signature), February 12, 1993

Standing in front of the kitchen sink in his Staten Island home in New York, Nappy was slowly decanting a jug of beef blood that he kept in the dungeon refrigerator. Sitting on his shoulder, comfortably snuggled against his neck, was Lady Isabella, a chocolate brown Devon Rex cat. Rubbing against his legs was a wild-looking but very laid-back tortoiseshell Maine Coon cat named Dame Pandy Lu. On the stove was a tub in which he was boiling an old dirty pair of jeans.

While decanting the beef blood, Nappy was watching on the kitchen VCR a monumental 1984 video by Nam June Paik entitled "Good Morning Mr. Orwell". It brought back warm memories of Paik. Nappy also remembered an aggressive light-and-sound environment that he had presented in previous years in Brussels, for which Paik had written an introduction, describing it as "a sort of negative katsura Rikyu. Katsura Rikyu, the most famous garden in Japan, and doubtlessly one of the earliest examples of mixed media temporal environments ..."

Through the large window behind the sink, Nappy occasionally glanced at the fierce snow storm that was violently shaking the trees in the garden. This has been preceded by a freezing rain which had rendered the garden extremely slippery.

Having decanted the beef blood, he slowly drank two glasses of the mixture, a ritual that he had been performing daily since he was a young adult. This would heal any stomach ulcer, in the opinion of his erstwhile doctor from his native Belgium.

Nappy carefully opened the kitchen door leading to the garden as there was a very strong wind. He wanted to throw the empty jug in the garbage can outside, but slipped on the icy ground. Thrown out by the fall and the wind, some leftover blood from the jug splashed over Nappy's face and eyes to quickly freeze and cake, blinding him. Nappy somehow got up and started to wander blindly around the garden. Through the open door of the kitchen he could hear the amplified sound of Charlotte Moorman tapping the strings of her TV-CELLO with the bow and sliding the bow up and down the strings in Nam June Paik's video. Nappy fell again, this time by the icy waters of the fish pond, and passed out.

When he came to, there was a strong smell of burned clothes in the air. He could hear the sirens of the fire department approaching in the street. Through his blood-caked eyes, he could see that the snow storm had subsided. Flames coming out of the kitchen window were slowly reaching the second floor of the house. "Sweet dreams, Paik", Nappy said, as he passed out again.

LARRY WARSHAW NEW YORK
Raster-Man, March 21, 1993

```
                Raster-Man

  I met Nam June Paik when Charlotte Moorman
  I met Nam June Paik when Charlotte Moorman
was arrested for playing a cello with his invention
  was arrested for playing a cello with his invention
of a video bra that was the only thing she wore.
  of a video bra that was the only thing she wore.
We all ran to the police station demanding their release.
  We all ran to the police station demanding their release.
It was the first electronic event in N.Y.C. that caused a
  It was the first electronic event in N.Y.C. that caused a
riot in the streets of Manhattan.
  riot in the streets of Manhattan.
He wore oversized pants and a giant  sash      while his
  He wore oversized pants and a giant sash      while his
round face seem to float on top of these clothes with the wonder
  round face seem to float on top of these clothes with the wonder
of a child that first discovered that the stars came out at night.
  of a child that first discovered that the stars came out at night.
He would speak so fast in a clipped manner so that I would have to think
  He would speak so fast in a clipped manner so that I would have to think
in slow motion to understand him. This was my first experience in Holistic
  in slow motion to understand him. This was my first experience in Holistic
thinking for I would have to think of what he meant rather than what he said.
  thinking for I would have to think of what he meant rather than what he said.
This really helped me learn how to listen to people without having to
  This really helped me learn how to listen to people without having to
respond with facial gestures.
  respond with facial gestures.
His video art is like american jazz in light.
  His video art is like american jazz in light.

                                    Larry Warshaw
                                    March, 1993
                                    N.Y.C.
```

YASUNAO TONE
If I have a million Dollars for a new satellite project (written for Nam June's anthology: satellite and art, but it turned out to be too late, Nov. 28 '84)

What is in common between Maurice Branchot and Nam June Paik? Answer ... Name: both names mean white! Yes indeed, Paik is white, is white, is white ...

Isn't this enough to justify my following proposal? That is, satellite simulcasting of an international white painting exhibition. There are many white paintings in the world, "White on white" by Malevich, Rauschenberg's, Castellani's, Manzoni's, and Sam Francis' white paintings to name a few. If this project is realized, we will finally be able to see a sort of empty TV show for the first time in the history of TV broadcasting.

MARIA VELTE
As a curator ..., 1993

As a curator for a private collection in Wuppertal in 1960-1962, I bought quite a few artworks by Mary Bauermeister which supported Mr. Paik's activities there.

ETSUKO WATARI TOKYO
A Letter, April 1, 1993

Dear Mr. Nam June Paik:

August 1980 in Tokyo – I still remember that it was a hot summer that year. I think it was my last summer vacation as a university student, and I was starting on my graduation thesis.

"How do you think of this flower of morning glory?"

He suddenly asked me as he took me to show the morning glories blooming freshly on a tiny bit of soil remaining at the back alley nearby. Later he made a new piece by placing this morning glory together with the soil in an old TV monitor.

This was our first and striking meeting; me and Mr. Paik and Tokyo, which was at the time developing into a High-tech kingdom as it is now. "VIDEA" was the title of the exhibition we had shown then.

Time passed, summer of 1993, in Tokyo again. It is the same season, and this time I am meeting Mr. Paik coming here from Venice. Just like when I was impressed with that "Morning Glory TV", will I experience the same fresh marvel again through Mr. Paik and his exhibition?

Just like Mr. Paik had predicted, the city of Tokyo has even changed technology into one of the most primitive techniques. Mr. Paik has always unfolded in front of me many stories of things going on in the world.

I am looking forward to seeing Mr. Paik again at our new museum in Tokyo.

EMMETT WILLIAMS BERLIN
The Beggar's Opera and a Treasure From Mongolia, March 1993

The chief exports of the Republic of South Korea are electronics, textiles, clothing, motor vehicles, ginseng, and Nam June Paik. According to Nam June, all Fluxus artists are "spoiled brats." He ought to know, he was one of the earliest of us, and one of the best.

Nam June introduced me to Korean culture the September of 1962, the year Fluxus was born in Wiesbaden. It was after a performance of my Opera. The Opera lasts several hours. Although there are three voice parts, the dominant sound is the almost incessant beating on a tin can with a spoon. Nam June said that it had reminded him of street beggars in Korea, who beat incessantly on tin cans until someone clinks in a few coins. (Nam June is always saying nice things: I am cross-eyed, but he refers to this as my "stereovision".)

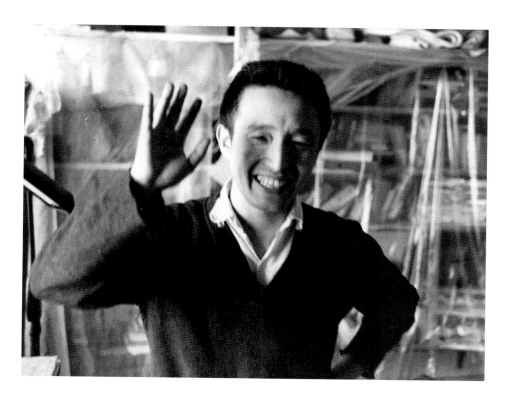

Earlier this month, on my first visit to Korea, I performed the Opera in Seoul with an all-star cast including Alison Knowles, Benjamin Patterson, and Ay-O. Remembering what Nam June had told me about the beggars in 1962, I was afraid that the Koreans who came to the performance would misunderstand Ay-O's ceaseless banging and start throwing coins at us. But they didn't. It was the other way around: they paid a steep price for admission, and probably didn't have any loose change left to throw at us.

The very next day, there were people in Seoul who were in the mood to throw things at Nam June (in absentia). We were hanging an exhibition at the Kyundai Gallery. Nam June's contribution still hadn't arrived. When, finally, it did arrive, it weighed 50 tons, crated. Fifty tons! It was a Mongolian round tent – you could call it a house – with a video installation to go inside. No one at the gallery had the slightest idea how to put the thing together. In desperation they asked the Mongolian Embassy for help. The embassy was reluctant to help, and wondered how and why this important Mongolian cultural treasure was in Seoul in the first place. Well, they did help, in the end, and several days later there it was, dominating the large courtyard of the gallery, the the pièce de résistance of the exhibition. Nam June had stolen the show again. And me, I felt like beating on a tin can.

WILLIAMS S. WILSON NEW YORK
Paik as Hearing-Aid, April 1, 1993

When Nam June Paik lived on the 4th floor of my Manhattan brownstone in the mid-1960s, the large double front door of the house was frequently left open. We didn't have a bathroom on the 4th floor, but on the third-floor landing, a toilet survived in a room no larger than a closet. Paik had carried into the house at least sixteen television sets which were kept chained together. One afternoon, as I mounted the outside stairs and entered the upstairs hall, I asked the two men in suits who were walking down the stairs from the 3rd floor who they were and what they were doing. One of them waved toward the paintings hanging in the hall and said, "We came to look at the art", as they continued empty-handed out the door and down the stairs to the sidewalk. Because we dwelled among improbabilities, I believed for a moment that they had come to look at the art, but see now that they might not have known that it was art they were looking at upstairs. They had, most likely, come to find stolen merchandise or equipment for spying. A woman who lived in a public-housing project across the street, and who looked into my house, and life, as into a television set, may have counted sixteen TVs entering the building, and have called some office to report spies. She, who watched out for all of us, may have been re-

sponsible for the ominous twoness of those government agents on my stairs.

Anyway I went upstairs where I saw no one, and nothing unusual, but as I walked downstairs, Nam June Paik came out of the toilet on the 3rd floor landing, saying that he had been in the toilet when he heard the men come in. He explained that he used the toilet at the same time every day, and that "they" had been watching him with binoculars for a long time and knew precisely when he would be in the toilet: "They know my every move", he said. Back on the fourth floor, we saw a small olive-drab case which Paik said that was not his – that the men had left it, and that it was a bomb. I inspected the "bomb" and opened it: inside the box was a United States Navy sextant, which I brought downstairs, and kept for many years.

The wonder is not what those men, in the debased twoness of similar blue suits, could have thought about sixteen TV sets chained together in a room with two robots, one female and one male. The wonder is that Nam June Paik came out of wherever he came out of in Korea with a sensibility closer to mine than the people I had grown up with and gone to school with. We were, from the beginning, in improbable rapport among the improbabilities: and with his nephew, Ken. Wonder and delight and rapport: Paik dedicated a work to my infant son, Ocean, whom he saw as responding to the Moon, which Paik said is the first television set. The adjustments of vision in comparisons like the moon and TV were complemented by adjustments of hearing. Many times, Paik emancipated me from aural limitations I hadn't known I had until I could feel them being lifted off me, like a net-gain in buoyancy. And once, yet another increase in the available sounds, Paik sat down upon a piano-bench and played "Tea for Two". Yes, even he had begun, as great artists often do, by rethinking coupling.

JUD YALKUT YELLOW SPRINGS, OHIO
"Electronic Zen. The Underground TV Generation", 1967
(published in: Westside News, 10. 8. 1967, p. 6)
"You cannot exclude anyone from TV", declares Paik, "so really delicate important subjects like politics, philosophy, sex, and avant garde activity are not shown. But videotape can supplant commercial broadcasting with highly selective programming to be played back anytime at all. When you have a screen 3-D color videotape recorder, it will kill 'Life' magazine just as 'Life' killed 'Collier'".

"Like radio ham operators, we will have amateur TV. Combinations of Xerox with videotape will print everyone's newspaper at home. The video-record will become cheaper and easier than videotape for mass reproduction, with no threading and instant playback. As the collage technique replaced oil-paint, the cathode ray tube will replace the canvas." "Medical electronics and art are still widely apart; but these two fields can also change each other's fruits, e. g., various signals can be fed to many parts of the head, brain, and body, aiming to establish a completely new genre of DIRECT-CONTACT-ART. The electromagnetic vibration of the head might lead the way to Electronic Zen."

C. J. YAO NEW YORK
Drawing for paik mosaic, 1993

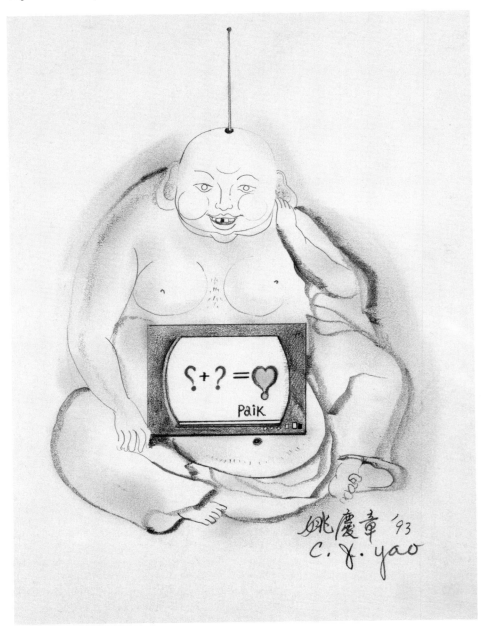

SOUYUN YI NEW YORK
An essay for Nam June Paik's catalogue
February 2nd, 1993

I first heard about Nam June Paik during my college years in Seoul. In the summer of 1979, a handsome young man who was attending the rival art college was introduced to me by a mutual friend. We met in a cafe and talked about art n general. He once asked me what I thought of Nam June Paik's work. When I told him that I didn't know who that was I could see his clear disclain directed towards me. I was quite puzzled by this artist that I was supposed to know about.

During my study at the Sorbonne University, someone lent me a Nam June Paik exhibition catalogue at the Whitney Museum for my thesis. I didn't understand at the time the implication of this exhibition and eventually didn't even use the catalogue since my focus was shifted to a different period.

Before I opened my gallery in New York in 1987, a Korean artist gave me Nam June Paik's phone number and urged me to go to see him. To my surprise, this supposedly famous artist received me at his loft. He announced to me that he had only forty-five minutes because the time was set for the machine he was experimenting on. Our conversation ended abruptly when Nam June stood up and dragged me to the door pointing to the clock on the wall. It was so blunt I didn't ever realize what happened until a few minutes after Nam June shut the door behind me. I wasn't sure if I was insulted or it was another gesture of a genius who transcended the conventional norm.

One day I was walking down the street in Soho and noticed a bum poking through a pile of garbage. It ws actually a pile of broken chairs and old furniture et cetera. It was not an unusual sight in New York where homeless people are an integral part of the street scene. I almost passed him buried in my own thoughts when something made me turn my head. I was quite shocked and embarrassed to see Nam June wrapped with several layers of worn out sweaters. He casually responded to my greeting and said, "You know, you can really find interesting things in here." It was the first answer to my series of puzzles with Nam June Paik.

TADANORI YOKOO TOKYO
Great Master Paik, 1993
(Extracted from the text first published in SAT-ART III)

I was very puzzled when he called me "great master Yokoo". I felt uncomfortable because he is the great master I respect so much. The prefix does not sound ironical but friendly, when Mr. Paik adds it to someone's name. Everybody accepts it willingly when he calls his or her name with it. Myisterious phenomenon.

Mr. Paik removes utterly the distinction between the others to the extent that he assumes all of the artists are brothers and sisters, assimilated to each other. I wonder that he might transcend his self. While most artists still shut themselves up in the shell of the self, Mr. Paik alone flies lightly as if he had wings on his back.

The lightness induces Mr. Paik to realize such a large project in a global scale. Thus the lightness is the mystery of life and of art.

GENE YOUNGBLOOD
Jud Yalkut: Paikpieces, 1969

Recognized as one of the leading intermedia artists and filmmakers in the United States, Jud Yalkut has collaborated with Nam June Paik since 1966 in a series of films that incorporate Paik's television pieces as basic image material. Yalkut's work differs from most videographic cinema because the original material is videotape, not film. They might be considered filmed TV; yet in each case the video material is selected, edited, and prepared specifically for filming, and a great deal of cinematic post-stylization is done after the videographics have been recorded.

In addition to Paik's own slightly demonic sense of humor, the films are imbued with Yalkut's subtle kinaesthetic sensibility, an ultrasensitive manipulation of fomal elements in space and time. Paik's electro-madness combined with Yalkut's delicate kinetic consciousness result in a filmic experience balanced between video and cinema in a Third World reality.

The two films illustrated here – Beatles electroniques and Videotape Study No. 3 – are part of a forty-five-minute program of films by Yalkut and Paik, concerning various aspects of Paik's activities. The other films include P + A – I = (K), a three-part homage to the Korean artist, featuring his concert Happening performances with Charlotte Moorman, Kosugi, and Wolf Vostell; his robot K-456 walking on Canal Street in New York; and his color televi-

sion abstractions. Other films in the Paik-pieces program are Cinema Metaphysique, a nontelevision film in which the screen is divided in various ways: the image appears on a thin band on the left side, or along the bottom edge, or split-screen and quarter-screen; and two other films of Paik's video distortions, Electronic Yoga and Electronic Moon, shown at various intermedia performances with Paik and Miss Moorman.

Beatles Electroniques was shot in black-and-white from live broadcasts of the Beatles while Paik electromagnetically improvised distortions on the receiver, and also from videotaped material produced during a series of experiments with filming off the monitor of a Sony videotape recorder. The film is three minutes long and is accompanied by an electronic sound track by composer Ken Werner, called "Four Loops", derived from four electronically altered loops of Beatles sound material. The result is an eerie portrait of the Beatles not as pop stars but rather as entities that exist solely in the world of electronic media.

Videotape Study No. 3 was shot completely off the monitor of the videotape recorder from previously collected material. There are two sections: the first shows an LBJ press conference in which the tape was halted in various positions to freeze the face in devastating grimaces; the second section shows Mayor John Lindsay of New York during a press conference, asking someone to "please sit down", altered electronically and manually by stopping the tape and moving in slow motion, and by repeating actions. The sound track is a political speech composition by David Behrman. In his editing of these films, Yalkut has managed to create an enduring image of the metaphysical nature of video and its process of perception.

JUN-SANG YU SEOUL
The Human Use of the Human Machine, 1993

Some 20 years ago, Nam June Paik used to be called "the Michelangelo of electronic art", "a visionary missionary", or "the father of video art".

However, the sense of empathy I hold toward him precedes such decorative descriptions. My own feeling I gained in my direct experience of him over the past 10 years has been that he is an extraordinary "workman". "Work" here implies an equivalence between the physical and the mental. At any rate, he buries himself in his work day and night. When he was inhis late twenties, he once

used the German word "Gesehen" in describing the attribute of the genius in the meaning of "He is given". However, his genius seems to have been self-made by himself rather than given by heaven. As has been well- known, he possesses an extraordinary power of memory and analytic power almost to a point of computer-like human machine. This machine goes on ticking day and night, and we are taken by surprise to find that the informaton output from that machine is far from being mechanical at all because the output is neither accurate nor precise but rather human and humane. In this sense, we may say that it is not that man emulates a machine but a machine emulates man and here lies the gist of his art. And this is one consolation humankind can find in the latter part of the 20th century.

YASUHIRO YURUGI TOKYO
One Meeting – One Life – on the Planet Earth, 1993

The chance had come suddenly. They told that the future exhibition one year after with the support of a newspaper company had become hopelessly impossible. The chief curator conferred the matter with us at the meeting. It was the spring of 1983. If there had not been such an accident, we would have been forced to make a detour to realize the exhibition of Nam June Paik.

On the first of January in 1984, he had just succeeded in multi-dimensional broadcasting "Good morning Mr. Orwell", which allied Europe, the United States, and some areas in Asia. Because none of the Japanese TV stations participated in this experimental network, the presentation of VTR of this satellite event was a great topic among the installations at The Metropolitan Museum of Tokyo.

The exhibition in Tokyo was supported by so many people in addition to the collaborated partners acknowledged in the catalogue: his Japanese friends who had got acquainted with him from the 50's to the 60's and his respected teachers: people in New York, Seoul, Kyoto and Osaka. The collaboration of the museum staffs and the cooperation of the art students have been impressed into my mind.

After the exhibiton, I had new friends through Mr. Paik; they come from Austria, Croatia, Holland, the United States, and even from my own country. The friendship with these people might be a momentary contact, as Mr. Paik says. But touching and appreciating different cultures is the origin which energizes me every time.

ANTONINA ZARU ROME/WASHINGTON
About Nam June Paik, 1993

I was fascinated by Nam June Paik because I was brought up with traditional art and I was searching for another kind of beauty – the beauty of the future. I was struck by the quality of Nam June's personality as well; he is indefatigable, always capable of renewing himself. Most artists are exhausted after forty of fifty years of working. Not Nam June, perhaps because his art surprises him as well as others.

He has an incredible curiosity, the sort of curiosity which usually disappears after an artist's youth, one which he has managed to keep alive, and which continues to feed him and give him the strength to innovate.

He is the child amused by the toys he himself makes, and he wants us to enjoy them, too. He recycles images, reaminating them with the original spirit of discovery in his videos. Unlike other artists, he cannot repeat himself. No two moments are alike.

For me the excitement is the surprise and discovery of going to his studio, unable to imagine what I will find there. And indeed there is always something new, something exciting, amusing, but also serious and at times profound. All of Nam June's art is imbued with his special personal philosophy. Naturally, Zen is part of it; there is also a constant interplay between casualness, which appears to be lack of discipline, and the fact that he is incredibly disciplined, as an artist and as a person.

The wonderful thing is that Nam June has this remarkable sense of irony and that he manages to incorporate the past into the present, making art out of his life. His joy is in telling about his past with his friends, the Fluxus group: John Cage, Charlotte Moorman, Beuys, etc. When he tells me, for example, stories about his collaborations, it is always with his magical sense of irony and comedy which one finds in his work as well as in his personality.

Paik has no faith in the system. I remember a story about a German dealer who refused to pay Paik because he said his performance was a disaster. N. J. Paik had to pay, but he had no money. So, he called the dealer's son and told him to come to the hotel. Then, he told the porter to ask the young man to wait in the lobby – which gave Paik the opportunity to throw his suitcases out the window, grab a sheet, drop it down, and slide down to the street. The dealer wanted to get the best of him, but in the end it was the dealer who paid, good performance or bad. When Paik

tells this story, you can see he is the thinking about leaving the dealer holding the bag. He loves the idea that he can beat the system which wants to destroy the artist. He lives as though people should be able to read his thoughts, but, in fact, nobody manages to read his mind.

When I think of Venice, I don't think first of Piazza San Marco, I think of Nam June arriving here after escaping from the hotel in Germany, holding his suitcases, climbing into a gondola, enjoying explaining to the gondolier that he left his money in the hotel, and getting off with his suitcases. Smiling, and promising to come right back with the money, he would probably enjoy the delicious memory of the waiting gondolier, and the dealer waiting in the lobby of the hotel in Germany.

Piano Piece, 1993
Courtesy Holly Solomon Gallery, New York

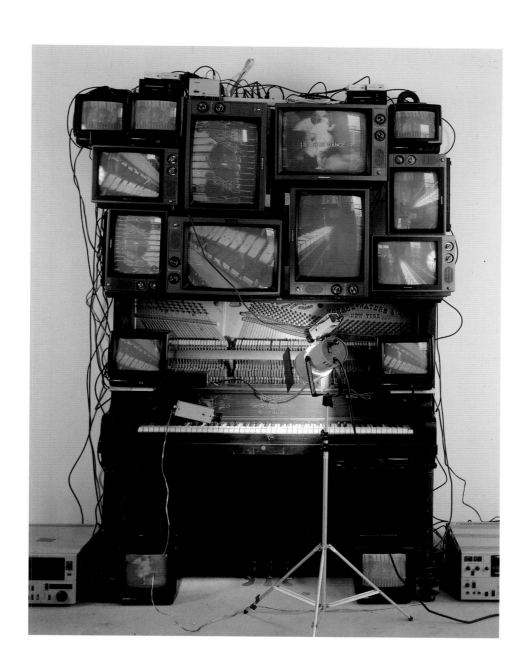

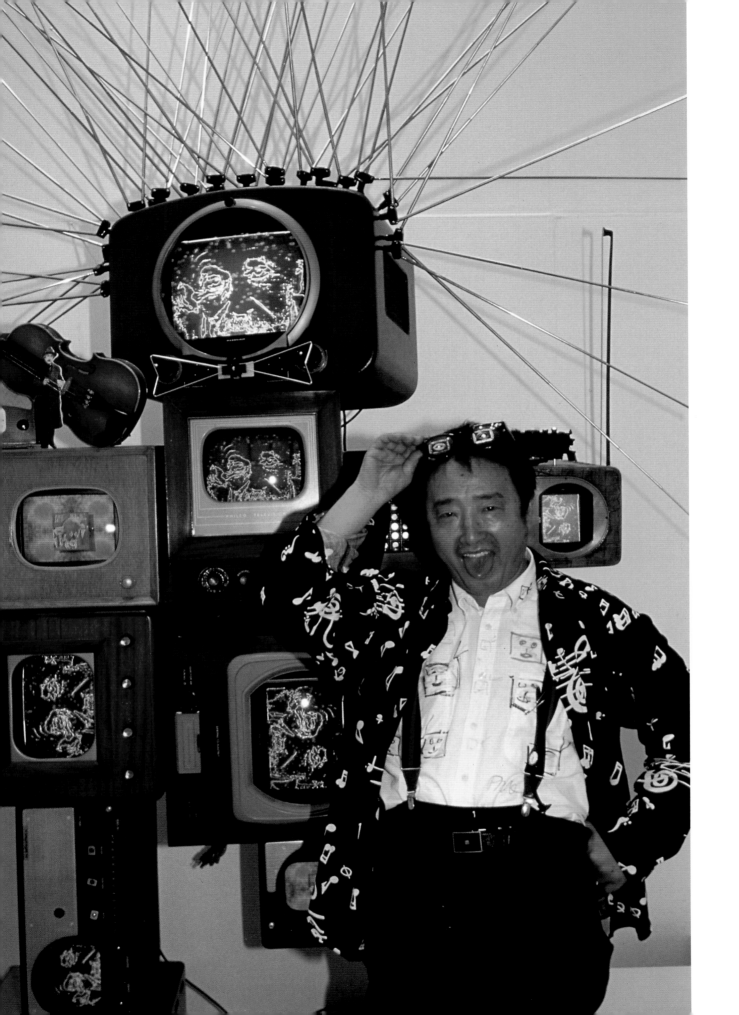

ANJA OßWALD
"TO GRASP THE ETERNITY" – BEMERKUNGEN ZU VIDEOBÄNDERN NAM JUNE PAIKS

"Actually I have no principles.
I go where the empty roads are."

(Nam June Paik, in: "Nam June Paik Edited for Television", 1975)

Das Entdecken von "empty roads" – in knapper Form umreißt dieses Zitat ein die Kunstproduktion der sechziger Jahre grundsätzlich kennzeichnendes Charakteristikum. In der Abkehr von traditionellen Darstellungsformen sollen innovative Konzepte zu einer Erneuerung der Kunst beitragen. In dem Bestreben, die ausgetretenen, wesentlich durch Malerei und Skulptur bestimmten Kunstpfade zu verlassen, manifestierte sich eine Kritik am Zustand der Kunst, die in den zeitgenössischen Happening- und Fluxusaktionen ihren sinnfälligsten Ausdruck fand. Die von der Avantgarde formulierte Forderung nach einer Verbindung von Kunst und Leben richtete sich gegen formalistische Reinheitsdiktate, die in der Nachfolge des Abstrakten Expressionismus zunehmend an Bedeutung gewonnen hatten. Malerische Konzeptionen wie "Hard Edge" oder die "Post Painterly Abstraction" mit ihrem von Ad Reinhardt formulierten Art-as-Art Dogma bildeten dabei den Zielpunkt der Kritik. Durch eine Einbindung der Kunst in lebensweltliche Zusammenhänge sollte das Autonomiekonzept aufgebrochen, der künstlerische Ausdruck wieder Teil einer lebendigen Auseinandersetzung werden. Die Absage an konventionelle Techniken und Darstellungsinhalte ging dabei mit einer allgemeinen Kritik am Kunstestablishment einher. Die von einer jüngeren Künstlergeneration favorisierte Aktionskunst stellte den Versuch dar, sowohl die hermetische Abgeschlossenheit des Kunstwerks als auch die des traditionellen Kunstraums zu durchbrechen.

In dieser künstlerischen Aufbruchstimmung artikulierte sich Fluxus zu Beginn der sechziger Jahre gleichzeitig in den USA und Europa, insbesondere in Deutschland. Eine schlüssige Definition dieser heterogenen, z. T. durchaus auch konträren Bewegung, die sich als Zusammenschluß von Künstlern unterschiedlichster Couleur formulierte, fällt schwer. Die einfachste und zugleich allgemeingültigste Bestimmung gibt vielleicht Joseph Beuys, wenn er "Fluxus" – das Fließen – als "Grundcharakter" der Bewegung herausstellt. Fluxus war als programmatische Verteidigung des Wandels gegen jegliche Art der Erstarrung zu verstehen: sowohl die der Kunst als auch die des in normierten Abhängigkeiten erstarrten Lebens. In diesem Sinne stellten die überwiegend musikalischen Fluxusereignisse konkrete, "gegen das Absichtsvolle, bewußt Formenhafte und gegen die Bedeutungshaftigkeit der Kunst" (George Maciunas) gerichtete Aktionen dar, mit Hilfe derer nicht nur die Kunst sondern letztlich auch das Leben verändert werden sollte.

Paik, der 1956 von Tokio nach Deutschland übergesiedelt war, machte schon bald als "enfant terrible" der Gruppe von sich reden. Geprägt von den Ideen John Cages, den er 1958 in Darmstadt kennengelernt hatte, zielten seine musikalischen Aktionen und Performances auf das Aufbrechen tradierter musikalischer Konventionen ab. Im Gegensatz zu Cage ging Paik, selbst ausgebildeter Komponist und Pianist, jedoch mit bewußt destruktiver Geste vor. Das Umstürzen eines Klaviers in "Hommage à John Cage" (1959) oder das Zerschlagen einer Geige auf dem Tisch, wie in "One for Violin Solo" (1962), stellten Akte der Zerstörung dar, denen gleichermaßen kathartische Wirkung zukommen sollte. Im Angriff auf die Inkunabeln des bürgerlichen Musikbetriebs sollte die Musik befreit, vom ideellen Ballast entschlackt, wieder in einer ursprünglichen Dimension erfahren und erlebt werden.

Im Unterschied zu einer in den Fluxus-Aktionen vollzogenen Demontage tradierter musikalischer Ausdrucksformen betrat Paik mit

seinen ab 1963 entstehenden präparierten Fernsehgeräten künstlerisches Neuland. Die Auseinandersetzung mit einem, bzw. dem Konsumgegenstand der modernen Massenkultur, entsprach dabei den Forderungen der Avantgarde nach einer Öffnung der Kunst. In der inzwischen legendären Ausstellung "Exposition of Music-Electronic Television", die 1963 in der Galerie Parnass in Wuppertal stattfand, stellte Paik seine Fernseharbeiten erstmals öffentlich aus. Für das Publikum mag die Konfrontation mit den bislang lediglich aus dem eigenen Alltag vertrauten Geräten wohl etwas Schockierendes gehabt haben. Die auf dem Boden verteilten Apparate zeigten das laufende Fernsehprogramm, das mit Hilfe vorgenommener Manipulationen verzerrt wurde. Bildstörungen und Verfremdungen, gewöhnlich als lästige Unterbrechungen des Programms wahrgenommen, konnten, abseits eines gewöhnlichen Beziehungszusammenhangs, in den ihnen eigenen Qualitäten angeschaut werden. Darüber hinaus bot die Ausstellung dem Betrachter die Möglichkeit, durch Manipulationen an der Technik selbst aktiv zu werden, die Bildfolgen nach Belieben zu gestalten. Durch Betätigen diverser Knöpfe und Tastaturen oder vermittels akustischer Signale konnte er auf die Gestaltung des Fernsehbildes Einfluß nehmen – der Gebrauchsgegenstand Fernsehen wurde zum kreativen Instrument. In diesen Installationen, von Paik als "Participation TV" bezeichnet, verzichtete der Künstler bewußt auf eine künstlerische Aussage. Ausgangspunkt seiner Überlegungen bildete nicht eine ins Werk gesetzte künstlerische Idee, sondern die Bereitstellung des technischen Instrumentariums, das zur spielerischen Benutzung animieren sollte. Der Aufwertung des Betrachters zum am Kunstwerk beteiligten Akteur stand so die Abwertung des Künstlers als Schöpfer gegenüber. Dem Bestreben, dem traditionellen Mythos vom Künstler bzw. dem "fetiscism of idea" (Paik) zu entgehen, kam der technische Charakter der ausgestellten "Kunstgegenstände" entgegen. So waren die Manipulationsmöglichkeiten an den Geräten zwar vom Künstler vorgegeben, die daraus hervorgehende Gestaltung jedoch vollzog sich im Apparat selbst. Die subjektive Geste, Gegenstand heftiger Kritik in der zeitgenössischen Avantgarde-Diskussion, wurde aufgegeben; die Technik bestimmte die Art und Weise der Gestaltung. Die Verzerrungen von Bild und Ton, die aus der manipulativen Einwirkung resultierenden abstrakten Formationen in Gestalt tanzender Muster oder in sich verschlungener linearer Strukturen, stellten so von künstlerischen Intentionen weitgehend unabhängige Gestaltungen dar, die im Rahmen der Ausstellung ästhetisch erfahrbar wurden.

Die Einführung des tragbaren Videorekorders (von SONY 1965 auf den amerikanischen Markt gebracht) stellte eine Erweiterung der mit dem Medium verbundenen Gestaltungsmöglichkeiten dar. Paik, der 1964 nach New York übersiedelte, war damals einer der ersten Künstler, die diese technische Neuerung nutzten. Im Unterschied zu den in der Wuppertaler Ausstellung präsentierten Arbeiten, die an das laufende Programm gebunden waren, wurde es nun möglich, mit Hilfe des sogenannten "Portapaks" Sendungen aufzunehmen und einer künstlerischen Beschäftigung zugänglich zu machen. Beispiele für eine derartige Strategie, die sich an das gesendete Fernsehprogramm hält und teilweise zufällige, teils bewußt inszenierte Bild- und Tonstörungen beinhaltet, sind das 1965 entstandene Tape "Mayor Lindsay", das einen Fernsehauftritt des New Yorker Bürgermeisters zeigt, und die "Early Study" aus dem Jahre 1966. Letzteres Band dokumentiert Charlotte Moorman, die Akteurin zahlreicher Aktionen und Performances Paiks war, während eines Auftritts in einer Talkshow.

Early Study, 1966
Charlotte Moorman appearing on the
Johnny Carson Show

Electronic Opera No. 1
(The Medium is the Medium), 1969
The distorted Richard Nixon

Darüber hinaus war mit der Einführung des sogenannten Porta-paks die Möglichkeit geschaffen, eigene Aufnahmen herzustellen. Kurz nachdem Paik in den Besitz des neuen Aufnahme- und Wie-dergabegeräts gelangt war, entstand "Electronic TV". Das Band zeigt Aufnahmen vom Besuch Papst Paul VI in New York und wur-de noch am selben Abend im "Café au Gogo" vorgeführt. In dem zu diesem Anlaß entstandenen Manifest "Electronic Video Recor-der" beschwört Paik die künftig wichtige Stellung von Video inner-halb der zeitgenössischen Kunstlandschaft. Video wird dabei als direkte Weiterführung der Happening- und Fluxustradition verstan-den, wenn es programmatisch heißt; "Someday artists will work with capacitors, resistors & semiconductors as they work today with brushes, violins and junk."

Von Bedeutung für die Weiterentwicklung der Konzeptionen Paiks war die Tatsache, daß innovative Sendeanstalten in den USA Künstlern die Möglichkeit boten, in ihren Studios zu arbeiten. Im Unterschied zu Europa, wo sich die Medienlandschaft zu jener Zeit noch auf die staatlichen Sendeanstalten beschränkte, gab es in den USA bereits zu Beginn der sechziger Jahre eine Reihe von Pri-vatkanälen, die aufgrund des untereinander bestehenden Konkur-renzdrucks um die Erschließung neuer (künstlerischer) Darstel-lungsformen bemüht waren. Paik setzte schon früh auf eine sol-che Zusammenarbeit, kam doch die öffentliche Ausstrahlung den Intentionen der Avantgarde entgegen, künstlerische Darstellungs-formen außerhalb des traditionellen Kunstraums zu erproben. Als alternatives Fernsehprogramm stellten sich diese Produktionen in einen außerkünstlerischen Kontext und präsentierten sich als Be-standteil der modernen Unterhaltungskultur. Ähnlich wie in den zeitgenössischen Happening- und Fluxusaktionen, die auf der Straße, in Lagerhallen oder in der Landschaft situiert waren, fand auch hier eine Entgrenzung zwischen traditionellem Kunstraum und lebensweltlichen Zusammenhängen statt: Kunst wurde ins heimische Wohnzimmer verlegt.

Die Aufhebung dualistischer Unterscheidungskategorien, die ihre Entsprechung in den intermediären Aktivitäten der Fluxus- und Happeningbewegung hatte, spiegelte sich bei Paik jedoch nicht nur in der Wahl des Mediums, das abseits des Kunstmarkts und seinen Distributionsmechanismen im alltäglichen Leben verankert war. Vielmehr wurden die Entgrenzungsstrategien in den Video-bändern selbst konsequent weitergeführt. So verzichtet Paik in fast all seinen Bändern auf eine nur aus eigenen – künstlerischen – Aufnahmen bestehende Gestaltung. Er nutzt zwar die Möglichkeit, mit Hilfe des Videorekorders oder, bei der Arbeit mit Sendestudios, mit professionellen Aufnahmegeräten eigenes Material zu produ-zieren, doch wird dieses immer durch aus anderen Zusammenhän-gen stammendes Aufnahmematerial ergänzt. Neben der Einbezie-hung von Film- oder Videoaufnahmen befreundeter Künstlerkolle-gen ist es häufig das Fernsehen selbst, das Paik als "Materialde-pot" beansprucht. Ausschnitte aus Talkshows, aus Nachrichten-sendungen und, vor allem, immer wieder Werbesequenzen gehen als Versatzstücke in die eigene Arbeit ein. Das Paiks Arbeit grundsätzlich kennzeichnende Gestaltungsprinzip der Collage führt dergestalt zu einer formalen und – damit einhergehend – in-haltlichen Durchdringung unterschiedlicher Bereiche. Werbung, zeitgenössische Unterhaltungskultur, Avantgardekultur und politi-sche Sachverhalte werden z. B. in Arbeiten wie "Global Groove" (1973), "A Tribute to John Cage" (1973), "My Mix" (1981) als durch Schnitte voneinander getrennte Einzelsequenzen in der zeitlichen Abfolge des Bandes aneinandergereiht und prinzipiell gleichwertig

einander gegenübergestellt. Eine solcherart in der Werkstruktur angelegte Verbindung verschiedener Darstellungsbereiche, die letzlich auf eine Relativierung kategorischer Setzungen von "Hochkunst" einerseits und "Massenkultur" andererseits abzielt, findet sich exemplarisch im 1972 edierten Videoband "Waiting for Commercials". Es besteht aus zeitgenössischen und vom Fernsehen abgefilmten Werbesequenzen, die durch kurze Einblendungen einer Musikperformance mit Charlotte Moorman ergänzt werden. Gelten Werbeblöcke im Kontext Fernsehen als meist unliebsame Unterbrechungen des Programms, so kehrt Paik die Prinzipien hier um. Schon der Titel weist auf diese Umkehr hin, die sich gegen gängige, gerade durch die Medien maßgeblich mitbestimmte Wahrnehmungsweisen richtet. Als "Störung" werden dementsprechend weniger die gezeigten Werbespots empfunden, als vielmehr die die Abfolge der bunten Konsumwelten regelmäßig unterbrechende künstlerische Darbietung. Die Werbung selbst wird zum ästhetischen Produkt erklärt. Abseits ihres eigentlichen Bezugssystems in einen künstlichen bzw. künstlerischen Zusammenhang gestellt, gibt gerade deren pointierte Herausstellung den Blick auf spezifisch ästhetische Qualitäten der Werbung frei.

In dieser bewußten Hinwendung zu massenkulturellen Phänomenen kann eine Parallele zu Darstellungsformen der Pop-Art gezogen werden. Paiks Entgrenzungsstrategien beinhalten aber gleichermaßen eine Kritik am kommerziellen Medienapparat. Die Abkehr von konventionellen künstlerischen Ausdrucksformen einerseits und die mit Paiks "Participation TV" vollzogene Unterwanderung tradierter medialer Vermittlungsstrukturen andererseits, stehen in einem dialektischen Spannungsverhältnis. Die 1969 am Bostoner Sender WGBH produzierte und im Rahmen der von Künstlern gestalteten Sendung "The Medium is The Medium" ausgestrahlte "Electronic Opera No. 1" beispielsweise enthielt an den Zuschauer gerichtete Regieanweisungen. Mit Aufforderungen wie "close your eyes", "open your eyes" sollte eine rein passive Aufnahme des Gesendeten verhindert werden. Der Zuschauer wurde dazu animiert, sich dem auf dem Bildschirm Dargestellten zu entziehen, um eigene, innere Bildwelten zu erschauen. Natürlich waren diese Anweisungen in erster Linie rhetorisch zu verstehen. Der Betrachter sollte auf sein eigenes Konsumverhalten aufmerksam gemacht und durch die provokante Geste gleichzeitig auf die vom Medium ausgehende Manipulation hingewiesen werden.

Wohl kaum eine Technologie hat sich jemals innerhalb weniger Jahrzehnte so rasch und konsequent global durchgesetzt wie das Fernsehen. Es ist im reinen Sinn ein Massenmedium mit der hervorstechenden Eigenschaft, Botschaften zu übermitteln, die von einem Massenpublikum konsumiert werden. Dies kann nur geschehen, wenn die Botschaften standardisiert und egalisiert übertragen werden in einer Form, die den kleinsten praktikablen Nenner benutzt, um eine größtmögliche Zahl von Zuschauern zu erreichen. Dabei liegt es in der Natur des Mediums, den Konsumenten mit vorgefertigten Bild-, Ton- und Bedeutungsinhalten zu entmündigen – ihn gemäß eines zugrundeliegenden einseitigen Sender-Empfänger-Codes auf die Rolle des passiven Konsumenten festzuschreiben. Es ist eine "Technolgoie des freien Eintritts, die keine praktischen, ökonomischen oder vorstellungsspezifischen Schranken kennt" (Neil Postman) und keinerlei Rücksicht auf individuelle, jeweils veränderliche Gedanken, Vorstellungen und Bedeutungen nehmen kann. Das Fernsehen lebt in erster Linie nicht von Inhalten und Bedeutungen, sondern von Signifikanz, der Signifikanz des bewegten Bildes.

Electronic Opera No. 1
(The Medium is the Medium), 1969
Dancing patterns

Dieser Faktizität des Fernsehens (wie überhaupt jeden Massenmediums) wurden immer wieder Versuche gegenübergestellt, den normierten Distributionsapparat aufzubrechen, das Medium seiner "eigentlichen" Funktion als Kommunikationsmedium zuzuführen. "Aufbrechen des Sender-Empfänger-Codes" und "Aktivierung des Betrachters" formulieren Zielsetzungen, die seit Brecht die medientheoretische Debatte bestimmen. Auf diesem Hintergrund können die in Fluxuskreisen entwickelten Konzepte Paiks auch als künstlerisch formulierte Alternativen zum kommerziellen Gebrauch des Mediums gewertet werden.

Eine spezifische Form der Auseinandersetzung mit den elektronischen Bildwelten und deren Vermittlungsstrukturen entwickelt Paik mit seinen häufig in Zusammenarbeit mit innovativen Sendeanstalten in den USA entstandenen Videotapes, die als "alternatives Fernsehprogramm" im Rahmen des normalen Sendeangebots ausgestrahlt wurden. Die "Electronic Collages", wie ein Sprecher in Paiks Videoband "Suite 212" diese Arbeiten nennt, greifen die Formensprache des Fernsehens auf. Was dort in Form von Nachrichten, Spielfilmen, Unterhaltungsshows und der unvermeidlichen Werbung täglich über den Bildschirm flimmert, entspricht in den Tapes einer Abfolge montierter und collagierter Versatzstücke, die auch einen inhaltlichen Bezug zum Fernsehen herstellen. Im Gegensatz zum Fernsehen jedoch, das über die aus Schnitt und Montage resultierenden Brüche hinweg eine Kontinuität suggeriert, bricht Paiks Tecnik diese bewußt auf. Die Abfolge der aus heterogenen Zusammenhängen stammenden Materialien sperrt sich einer linearen Betrachtung. Das hat Konsequenzen für den Betrachter, der sich dem Dargestellten nicht nachvollziehend annähern kann, sondern analog der diskontinuierlichen Abfolge sprunghaft den Sequenzen folgt. Etwaige Bedeutung erschließt sich auf diese Weise nicht aus dem logischen Nacheinander geschilderter Episoden, vielmehr ist der Rezipient/Zuschauer dazu aufgerufen, selbst aktiv zu werden, die durch Schnitte voneinander getrennten Sequenzen zu kombinieren, um ihnen damit erst Sinn zu verleihen. Dieser immer eigene und persönliche Sinn bricht den traditionellen Botschaftscharakter des Gesendeten auf. Die von Paik kritisierte "one-way-communication" des kommerziellen Medienapparats wird zum wirklichen Dialog im Sinne einer "two-way-communication". Eine wesentliche Funktion erhält in diesem Zusammenhang Paiks Recyclingverfahren. Indem Paik Video weniger in seiner ursprünglichen Bedeutung als "ich sehe" begreift, sondern bereits gesichtetes und insofern kommentiertes, immer schon gedeutetes Material auswählt, hinterfragt er visuelle Kommunikationsprozesse. Durch die bewußte Miteinbeziehung kultureller Codes spielt er mit einer spezifischen Erwartungshaltung des Rezipienten, um sie gleichzeitig in Frage zu stellen. Eine von Paik montierte Werbesequenz etwa verweist zwar noch auf den ursprünglichen Konsumartikel, wird jedoch durch die Einbindung in einen neuen, montierten Kontext in ihrer fixen Bedeutung aufgelöst. Die Montage beinhaltet bei Paik somit immer auch eine Demontage des dem Material eingeschriebenen Zeichencharakters: Als allegorisches Verfahren intendiert Paiks Collagetechnik die Befreiung des Bild- und Tonmaterials aus (scheinbar) eindeutigen Bezugssystemen – der "Aufstand der Zeichen" (Baudrillard) wird anschaulich vorgeführt.

Auch für Paiks eigenes Œuvre spielt dieses Prinzip eine große Rolle. Durch die Neuverwendung bereits bestehender Arbeiten, die neu ediert oder fragmentiert Bestandteil späterer Videoproduktionen bilden, wird ein eindeutiger Verweischarakter aufgebrochen,

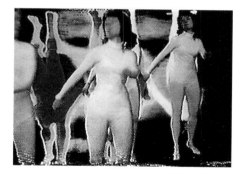

Global Groove, 1973
Tap-dancers

das künstlerisch gestaltete Produkt immer wieder mit anderen Versatzstücken kontrastiert und in einen kreativen Prozeß eingebunden, der ständig neue Spiel- und Interpretationsmöglichkeiten bereitstellt. Die Collage formiert sich als Reihung heterogener Wirklichkeiten, die grundsätzlich gleichwertig nebeneinander existieren. Mit dem ständigen Wechsel, den perspektivischen Verschiebungen, die aus der Neuzusammenstellung der Versatzstücke resultieren, wird Realität nicht als immer schon gewußte und gedeutete gesehen, sondern Wirklichkeit als ständiger Wandel begriffen und erlebt. Die Collagetechnik fungiert als paradoxes Prinzip, indem sie mit dem Medium gegen das Medium arbeitet. Die scheinbare und gerade durch das Fernsehen maßgeblich mitbestimmte Kategoriebildung, die, nach dualistischen Prinzipien ausgerichtet, Bedeutung statisch fixieren möchte, wird in Paiks elektronischen Collagen buchstäblich in Bewegung gebracht; die Realität erhält ihre Vielschichtigkeit zurück. Indem sie Mehrdeutigkeiten zulassen, optische wie auch akustische Erscheinungen nicht einer eindeutigen, fixierbaren Zuweisung unterziehen und damit "dingfest" machen, kollidieren Bedeutungen mit Bedeutungen . . . Wiedererkanntes und Wiedererkennbares, schon Gewußtes und Gedeutetes wird in der Kollision auf einmal frag-würdig. Die Bilder erhalten ihre Unwägbarkeit zurück, oder, so Paik: "The absolute IS the relative, the relative IS the absolute."

Dieser Wechsel zwischen verschiedenen Deutungsebenen wird durch ein mit Hilfe des Synthesizers erzieltes Changieren zwischen unterschiedlichen Darstellungsebenen ergänzt. Der Video-Synthesizer, der 1970 von Paik zusammen mit dem befreundeten Ingenieur Shuya Abe entwickelt wurde, setzt elektronische Impulse in optische Signale um, die auf dem Bildschirm als abstrakte Farb- und Formstrukturen sichtbar werden. Euphorisch auf die malerischen Möglichkeiten dieses Instrumentariums Bezug nehmend, schreibt Paik in seinem Manifest "Versatile Color TV Synthesizer": "This will enable us to shape the TV screen canvas as precisely as Leonardo as freely as Picasso as colorfully as Renoir as profoundly as Mondrian as violently as Pollock and as lyrically as Jasper Johns." Der Bildschirm wird zum Träger – in Paiks Worten zur "Leinwand" – für eine synthetisch generierte "bewegte Malerei", welche die collagierten Bildsequenzen überlagert. Allerdings, und das scheint wesentlich, werden die mimetischen Darstellungen dadurch nicht "zerstört", wie David Ross meint. Vielmehr bilden die synthetischen Bildformationen eine gewissermaßen über die Videoaufnahmen gelegte Bildschicht, die deren Abbildcharakter nicht grundsätzlich in Frage stellt: "Realistischer" und "malerischer" Charakter stehen gleichwertig nebeneinander.

In dieser dekonstruktivistischen Ausrichtung kann Paiks Arbeit mit dem und gegen das Fernsehen in Parallele zu den Ideen Cages gesetzt werden. Wie die bewußte, durch Zufallverfahren wie dem I Ging erzielte Un-Ordnung seiner Kompositionen auf eine Befreiung der Musik aus tradierten Normen und Gesetzmäßigkeiten abzielt, so realisiert die inszenierte Un-Ordnung in Paiks Collagen die Abkehr von den das kommerzielle Fernsehen bestimmenden Kategorien. Beidesmal sollen verkrustete Strukturen aufgebrochen werden, eingefahrene Vorstellungs- und Wahrnehmungsweisen einer vorurteilslosen Anschauung weichen.

Eine direkte Gegenüberstellung von Cages Arbeitsweise und Paiks Umgang mit Video findet sich in dem Tape "A Tribute to John Cage", das anläßlich des 60. Geburtstags des Komponisten im Jahre 1973 am Sender des WNET in New York produziert wurde.

Global Groove, 1973
Charlotte Moorman with TV cello

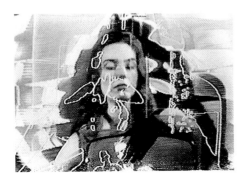

Global Groove, 1973
The alienated Allen Ginsberg

Das Band gibt Einblick in die Arbeiten Cages, indem es Ausschnitte aus Performances und den bekannten "Lectures" des Komponisten zeigt. Darüber hinaus wird die Uraufführung der Komposition "4'33" aus dem Jahre 1953 nachgestellt. Die auf Zeit und damit in einem übertragenen Sinn auf Welterfahrung abzielenden Entgrenzungsstrategien von John Cage nimmt Paik in seiner Videoarbeit wieder auf. Er beschränkt sich dabei nicht auf die Präsentation von Künstler und Werk. Vielmehr wird die Dokumentation durch das Einblenden anderer Versatzstücke immer wieder unterbrochen. Nur scheinbar aber stellen diese einen Kontrast dar. Tatsächlich entspricht die Abfolge heterogener Versatzstücke in Form von Werbesequenzen, aus dem Fernsehen abgefilmten Showeinlagen, Ausschnitten aus dem Film über das Woodstock-Konzert Cages Ideen. Mit der Aufhebung von festgesetzten Normen und Wertigkeiten, der Erkenntnis um die prinzipielle Gleich-Gültigkeit aller Dinge und Erscheinungsformen, die Cages Kompositionen und Performances sinnlich erfahrbar machen, geht eine formale Gestaltung einher, die als collagierte Reihung episodischer Szenen keine qualitativen Unterscheidungen anerkennt und auf diese Weise den Intentionen des Komponisten auf einer strukturellen Ebene folgt.
Deutlich erkennbar wird hier die rhetorische Funktion des Paikschen Collageverfahrens. Die Verwendung heterogener Ausgangsmaterialien geht einher mit einer Ver-Wendung ursprünglich kontrastierender Darstellungsinhalte. Ausgehend von einer durch Schnitt und Montage hervorgerufenen Abgrenzung der Einzelsequenzen, stellt das eigentliche Ziel deren Entgrenzung dar. Diese vollzieht sich in der die Unterscheidungen tendenziell aufhebenden Reihung.
Paiks Aneignung des Materials zielt somit in einem dialektischen Umkehrverfahren letztlich auf eine Befreiung aus Festschreibungen und Deutungszuweisungen; Weltanschauung soll wieder in einem ursprünglichen Wortsinn als Welt-Anschauung verstanden werden.
Von ähnlichen Überlegungen geht auch das im selben Jahr entstandene Tape "Global Groove" aus, das in seiner Komplexität und der Vielfalt des verwendeten Materials als modellhaft für die nachfolgenden Videoarbeiten Paiks gewertet werden kann. Es entstand ebenfalls am Sender des WNET und wurde dort am 30. 1. 1974 zum ersten Mal ausgestrahlt.
Entsprechend der im Vorspann aus dem Off ertönenden prophetischen Vision einer "Video-landscape of tomorrow", in welcher die TV-Programmzeitschriften "as fat as the telephone book" sein werden, zeigt sich das Darauffolgende als bunter Querschnitt eines internationalen TV-Angebots: Gogo- und Steptanzdarbietungen, eine trommelnde Navajo-Indianerin, John Cage, der Anekdoten vorträgt, Ausschnitte aus Performances mit Charlotte Moorman, sowie eine Sequenz aus Paiks "Electronic Opera No. 1", fernöstliche Tanzrituale, ein Werbespot, Szenen aus einer Aufführung des "Living Theatre"... überwiegend musikalisch begleitet, werden auch hier wieder aus den unterschiedlichsten Zusammenhängen stammende Versatzstücke kombiniert. Kein kontinuierlicher Handlungsverlauf, der die Abfolge der Episoden einem erzählerischen Gesamtzusammenhang unterordnen würde, erleichtert das Schauen; der Betrachter sieht sich konfrontiert mit einem Kaleidoskop schnell wechselnder Bild- und Tonfolgen, das in den insgesamt zweiundzwanzig Sequenzen zur Darstellung gelangt.
Die Montage wird auf diese Weise zum Ausgangspunkt einer Geste, die zwar etwas zeigt, aber nichts erzählt. Diesen bewußt inszenierten "Mangel" überbrückt der Betrachter, indem er selbst aktiv Kommentare und Deutungen aufbaut. Die Deutungsrichtung

A Tribute to John Cage, 1973
Still from the Woodstock documentary

steuert Paik durch wiedererkennbare "Restbestände" innerhalb der Fragmente. Die musikalischen Darbietungen aus der amerikanischen Unterhaltungskultur waren dem Betrachter wohl ebenso vertraut, wie die Gogo- und Steptanzdarbietungen oder etwa die montierte Pepsi-Cola-Werbung. Durch die damit kontrastierenden "fremden" Episoden, wie den fernöstlichen Tanzdarbietungen oder den Ausschnitten aus Performances, ergeben sich in der zeitlichen Abfolge Bedeutungen, die mit Begriffspaaren wie Alt-Neu, Tradition-Moderne, Ost-West zu charakterisieren sind.

Durch die Einbindung in einen diskontinuierlichen Kompositionsrhythmus werden die komplementären Deutungszuweisungen relativiert. Unterschiedliche Kulturen und Traditionen verbinden sich in "Global Groove" zu einem globalen Rhythmus medial erzeugter Wirklichkeiten.

Berücksichtigt man die Tatsache, daß das Videoband in Hinblick auf den sich zuspitzenden Vietnamkrieg als künstlerischer Friedensbeitrag konzipiert wurde, so kann die Abfolge heterogener Einheiten als symbolischer Akt zur Völkerverständigung gesehen werden. Mit der Verwendung von Zeichen, die auf die eigene, vertraute Kultur ebenso verweisen, wie auf fremde Länder und Traditionen, werden räumliche und politische Grenzen aufgehoben. Der formalen Entgrenzung folgt hier die inhaltliche: Paiks "Fernsehprogramm" verweist auf eine künftige Medienlandschaft, die keine nationalen Beschränkungen mehr kennt und in der es möglich sein wird, "to switch to any TV-station on the earth", wie es im Vorspann programmatisch heißt.

"Global Groove" kann somit als künstlerische Inszenierung der McLuhanschen Utopie eines "Global Village" betrachtet werden, dessen kommunikative Funktion darin besteht, einen Prozeß internationaler Verständigung ebenso einzuleiten, wie dem Zuschauer eine Reflektion über eigene Wahrnehmungs- und Bewußtseinsstrukturen zu ermöglichen.

War es in "Global Groove" die Verbindung und gleichermaßen Relativierung von Räumen gewesen, die in der künstlerischen Realisation auf künftige medientechnische Entwicklungen im Sinne einer globalen Vernetzung der Welt hinwiesen, so vollzieht Paik im 1977 entstandenen Tape "Guadalcanal Requiem" eine ähnliche Strategie der Relativierung in bezug auf die Zeit. Entgegen der gewöhnlichen linearen Zeiterfahrung montiert Paik Dokumentarfilmmaterial des Zweiten Weltkriegs mit von ihm gefilmten Sequenzen aus dem Jahr 1977 zu einem zeitlich diskontinuierlichen Ablauf. Die von Paik aufgenommenen Sequenzen (Performances von Moorman und Paik selbst) sowie Interviews von Kriegsveteranen wurden auf der Insel Guadalcanal, einem damaligen Kriegsschauplatz, gedreht. Vergangenheit und Gegenwart des Ortes werden so miteinander verschränkt, unterschiedliche Zeiten simultan zusammengeführt. Die dem Dokumentarfilmmaterial eingeschriebenen digitalen Zeitangaben verweisen einerseits auf eine meßbare, fixierbare Uhrzeit, andererseits machen sie in der Konfrontation mit den zeitgenössischen Aufnahmen den relativen Charakter der Zeiterfahrung deutlich. Durch den Wechsel von langen und kurzen Sequenzen entsteht eine diskontinuierliche Folge heterogener Zeiten, in deren Rhythmus der Betrachter eingebunden wird. Im Gegensatz zu einer die Vergangenheit nur faktisch dokumentierenden Erinnerung provoziert die nichtlineare Zeitstruktur eine Wahrnehmung, die im Sinne Prousts als schöpferische Erinnerung verstanden werden kann. Vergangenheit verliert sich so nicht im Dunkel der Geschichte, sondern bleibt gegenwärtig und gerade durch die Zeit-Erfahrung politisch relevant.

Die Collage von Räumen und Zeiten verweist, über die damit intendierten politischen Implikationen hinaus, auf die strukturellen Gegebenheiten der elektronischen Bildübertragung. Wird die internationale Vernetzung in "Global Groove" noch als prophetische Vision vorgeführt, so stellt die am ersten Januar 1984 realisierte Live-Video-Show "Good Morning Mr. Orwell" eine programmatische Inszenierung der medialen Möglichkeiten dar. Die Show, in der ein buntes Unterhaltungsprogramm von Künstlern wie Joseph Beuys, Ben Vautier und Popmusikern wie Laurie Anderson geboten wurde, fand gleichzeitig in New York und Paris statt. Die Aufteilung des Bildschirms durch Split-screen-Verfahren machte die diesseits und jenseits des Atlantik stattfindenden Ereignisse simultan erfahrbar. Musik und Tanz, Aktionen und Performances wurden auf dem Bildschirm zusammengeführt, die globale Vernetzung konnte vom Betrachter sinnlich, qua Musik und Tanz erlebt werden. Der "Video Common Market", von Paik in den siebziger Jahren als Konzept zu einem internationalen Austausch und einer globalen Verständigung eingefordert, wurde der düsteren Orwellschen Vision des "Big-Brother" programmatisch entgegengestellt.

Raum und Zeit sind letztlich auch das Thema des Bandes "Lake Placid", das 1980 anläßlich der olympischen Winterspiele entstand. Dem Rahmen entsprechend werden, musikalisch begleitet von Mitch Riders "Devil with a Blue Dress on", verschiedene Sportarten gezeigt und durch Aufnahmen von den Himmel kreuzenden Flugzeugen ergänzt. Die innerbildlich vorgeführte Geschwindigkeit pirouettendrehender Eisläufer, zu Tale rasender Skiläufer und himmelstürmender Flugzeuge korreliert mit der schnellen Abfolge der einzelnen Sequenzen, die, teils stark beschleunigt, teils die Aufnahmen im Rücklauf zeigend, das Tempo (verstanden als Zeit und Bewegung) rhythmisch strukturieren. Nur scheinbar kontrastierend zu diesen Sequenzen werden Aufnahmen des meditierenden Allen Ginsberg montiert. Tatsächlich bilden Geschwindigkeitsrausch und "langsame" Meditationszeit nur komplementäre Ausprägungen der einen, fließenden Zeit, die, wie schon in "Guadalcanal Requiem", das eigentliche Thema des Videobandes darstellt.

Die Selbstreflexivität des Mediums, die in der Thematisierung von Geschwindigkeit schon in "Lake Placid" anklingt, wird im 1986 entstandenen "Butterfly" noch verstärkt. Die darin eingehenden Bildfragmente werden in der nur zweiminütigen Banddauer zu einem Bilderrausch medialer Wirklichkeiten collagiert, die, elektronisch verfremdet bis zur Gerade-noch-Erkennbarkeit, zum Tanz der Hochgeschwindigkeitssequenzen auffordern, während eine Arie aus der Oper "Madame Butterfly" ertönt.

Es würde im Rahmen dieses Aufsatzes zu weit führen, wollte man Paiks seit den frühen siebziger Jahren entstandene und zum großen Teil für das Fernsehen konzipierte Tapes hier alle im einzelnen aufführen. Betrachtet man jedoch die Videobänder in ihrer Entwicklung, so ist auffallend, daß, abgesehen von Dokumentarvideos wie beispielsweise "Allan and Allen's Complaint" von 1982 oder dem 1989 entstandenen "Living with the Living Theatre", die Montagemethoden im Lauf der Jahre immer subtiler, die Verfremdungen des Ausgangsmaterials technisch immer raffinierter werden. Die Fragmentierung des Materials bis hin zu kaum mehr wahrnehmbaren Realitätspartikeln, die im Hochgeschwindigkeitsrausch über den Bildschirm ziehen, besser: fliehen, markiert die immer schneller sich vollziehende und gerade durch die elektronischen Massenmedien im wahrsten Wortsinn beschleunigte Abfolge von Wirklichkeiten, die alles Fixierbare auflösen und Geschwin-

A Tribute to John Cage, 1973
John Cage during a lecture

digkeit als allein noch mögliche Konstante zulassen. Es stellt sich die Frage, ob mit dem damit einhergehenden Verlust von wie auch immer variierbaren und der gedanklichen Zugabe des Betrachters anheimgegebenen Deutungsmöglichkeiten nicht letztlich die eigentliche, im Sinne McLuhans die "gehaltlose Botschaft" des Mediums zutage tritt. Die zunehmende Distanzierung von mehrdeutig zu verstehenden inhaltlichen Bezugssystemen zieht die logische Konsequenz aus McLuhans bekanntem Diktum "The Medium is The Message". Der ins Monitorbild eingebrachte "Sehrohstoff" zielt nicht mehr auf eine Vergegenständlichung medialer Möglichkeiten im Sinn eines "Globalen Dorfs", sondern dient zunehmend der Konkretion von abstrakten, das Medium bestimmenden Strukturgesetzen, als da wären Verbindung von Raum und Zeit durch Geschwindigkeit, Relativierung von Bedeutung im collagierten Nebeneinander heterogener Wirklichkeiten. – Im visuellen und akustischen "Overkill", wie David Ross die Wirkung von Paiks Videobändern einmal allgemein charakterisiert hat, führt sich das Medium selbst vor: Das Medium ist die Botschaft ...

... Und die Botschaft ist "Musik", visualisierte Musik. Dieser paradoxe Gedanke stellt die Verbindung zwischen dem Videokünstler und dem Musiker Paik her. Neben der Auseinandersetzung mit den das Fernsehen bestimmenden Wahrnehmungsweisen und Strukturgesetzen können Paiks Video-Collagen auch als musikalische Kompositionen verstanden werden. Die "schöpferische Gestalt der Struktur", die McLuhan in der "Mosaikform" des Fernsehens gegeben sieht, organisiert Paik, der im Gegensatz zu anderen Videokünstlern wie Bruce Nauman, Vito Acconci oder Dan Graham von der Musik kommt, nach gewissermaßen musikalischen Vorgaben. Mit einer Partitur vergleichbar, setzt die Collage unterschiedliche, durch Schnitt und Montage strukturierte Einheiten in Beziehung zueinander. Schnelle und langsame, beschleunigte und verzögerte, meditative und nervös-bewegte Sequenzen bilden hierbei Intervalle, aus deren Reihung, den Variationen und thematischen Wiederaufnahmen einzelner Motive ein vielschichtiges Beziehungsgeflecht entsteht. Nicht zufällig tragen denn auch viele von Paiks Videobändern musikalische Titel: "Global Groove, Electronic Opera No. 1, Guadalcanal Requiem, Suite 212".

Über die in den szenischen Episoden innerbildlch vorgeführte (musikalische) Bewegung in Form von Tanz oder musikalischen Performances hinausgehend, strukturiert der Synthesizer – von Paik als "real-time video piano" bezeichnet – die musikalische Bewegung abseits eines gegenständlichen Bezugs. Als visuelle Notationen stehen die abstrakten Farb- und Formstrukturen in direkter Korrelation zum die szenischen Episoden begleitenden akustischen Rhythmus: Zu den oben genannten malerischen Qualitäten treten die musikalischen Qualitäten des bewegten Bildes. Musikalische Zeit (der vorgegebene Rhythmus) und Bildzeit (die Bewegung der synthetisch erzeugten Farbformationen) bilden eine synästhetisch erfahrbare Einheit. Die von Cage initiierte Grenzüberschreitung der Musik wird konsequent weitergedacht, indem die Erforschung "nicht-musikalischer Klangfelder" (John Cage) um die optische Dimension erweitert wird. Aus dem nichtmusikalischen Klang entsteht das musikalische Bild.

Die Frage "Was ist Musik?" beantwortet Paik letztlich ähnlich wie Cage, wenn er sagt: "Musik ist eine Zeitabfolge". Durch den diskontinuierlichen, in der Collagestruktur vorgegebenen Rhythmus "befreit" Paik die Zeit von einer auf Meßbarkeit angelegten Linearität. In der Reihung unterschiedlicher Zeitgestalten führen Paiks Video-Collagen die Zeit als relative Größe vor Augen und Ohren.

Guadacanal Requiem, 1977
Charlotte Moorman at a performance on
Guadalcanal Island

An der Nahtstelle zwischen Fernsehen, Musik (und einer "bewegten Malerei") situiert, dient Video als Meta-Medium zu einer Sichtbarmachung von Zeit: einer rhythmisierten, verlangsamten, beschleunigten Zeit, die auf eine paravisuelle Wahrnehmung der wirklichen Welt, verstanden als steter Wandel und Veränderung, abzielt. Wenn Paik sich Ende der achtziger Jahre von der Single-Channel-Produktion im wesentlichen verabschiedet und sich verstärkt der Konzeption großformatiger Multi-Monitor-Installationen zuwendet, so stellt dies letztlich eine nur logische Konsequenz aus der vorangegangenen Entwicklung dar. "The More The Better", so der Titel eines 1988 für die Olympiade in Seoul konzipierten Projekts, das 1003 Monitore vorsah, gibt in diesem Zusammenhang programmatisch die Stoßrichtung an. Als Bausteine der Collage fungieren nicht mehr nur Ton- und Bildfragmente, vielmehr wird die collagierte Software durch die Hardware der Monitore ergänzt. Diese bilden, miteinander verschaltet und jeweils mit einer collagierten Software gespeist, eine raumfüllende und rhythmisch organisierte All-Over-Struktur. Die die Single-Band-Produktion bestimmende und durch den Monitor vorgegebene Begrenzung wird aufgehoben. Damit entfällt die Möglichkeit einer Distanzierung; der Betrachter wird eingebunden in die Bilderflut einer rhythmisch den Raum strukturierenden Monitor-"Tapete", wie Paik diese Installationen nennt.

In den kataraktartig sich über den Rezipienten ergießenden montierten, fragmentierten und synthetisch verfremdeten Bilderfolgen läßt sich das Verschwinden der Dinge aus den Bildern festmachen, wobei das kurzzeitige Aufblitzen erkennbarer Versatzstücke den Eindruck ihres Verschwindens nur noch unterstützt. Übrig bleibt die Zeit: Sichtbar, im rhythmischen Fluß der Bilder vergegenständlicht vorgeführt als sich verflüchtigende Zeit, welche die zunehmende Relativierung der Wahrnehmung im Geschwindigkeitsrausch unseres "Fin de Siècle" (so der Titel eine 1989 entstandenen raumfüllenden Videoinstallation Paiks) anschaulich macht.

Die Umkehrung liegt nahe: Wo zu viel ist, wird nichts mehr gesehen. Der "Overkill" führt zurück ins Nichts, ins Nirwana des eigenen Bewußtseins. Im Zusammenhang mit der aktuellen Mediendiskussion gehört es zu Paiks spezifischen Qualitäten, daß er im Ausloten medientechnischer Eigenschaften und deren Wahrnehmungsweisen das Medium Fernsehen auf den Punkt bringt und in einem Akt der Überdehnung einen paradoxen Umkehrschluß vollzieht: Der Zustand des Information Overload kehrt zurück – oder wird nach vorn geworfen – in einen Zustand der Null-Information. Kaum verwunderlich erscheint es deshalb auch, daß von den frühen präparierten Fernsehgeräten Paiks eine ähnliche Wirkung ausgeht wie von den späten Videowänden in teils gigantischen Ausmaßen. "Minimal" – so nennt Paik seine frühen Fernseharbeiten – und "Maximal" – die Multi-Monitor-Installationen – sind in diesem Zusammenhang nur als zwei Seiten einer Medaille zu sehen. "Zen for TV", so der Titel einer 1963 entstandenen "Zufallskomposition" von Paik, könnte demnach für die Arbeiten der 80er Jahre übernommen werden. Auf beide Richtungen scheint das buddhistische Paradoxon anwendbar: "Wir können die Leere nur durch die Form begreifen." Der waagrechte weiße Streifen auf dem sonst schwarzen Bildschirm, der in "Zen for TV" durch einen technischen Defekt des Fernsehgeräts zufällig entstand, gibt der Leere ebenso eine Form wie der technisch perfektionierte Bilderrausch. "To grasp the eternity", mit dieser pathetischen Formel aus Paiks Fluxustagen können auch die späten Arbeiten des Künstlers einen Bogen zurück in die Zeit schlagen, als Paik in Wuppertal seine manipulierten Fernsehgeräte zum ersten Mal ausstellte ...

Guadacanal Requiem, 1977
"Dancing skulls"

DAVID ROSS
NAM JUNE PAIK. VIDEOTAPES 1966–1973

Nam June Paik is recognized as one of the seminal forces in the development of video art. The Korean born artist, composer and inventor has been referred to as the "George Washington of Video".

Paik was and still is a member of the group of conceptual artists, poets and performers known as Fluxus. Since the early 60's, Paik and his Fluxus colleagues such as George Brecht, Ray Johnson, Yoko Ono, Allison Knowles, et al have been a major influence on what has developed into the field referred to as "Conceptual Art".

Nam June Paik exposes the ridiculous and the sublime, while providing the viewer with a playful experience (both visually and intellectually). In 1968, Paik invented the Video Synthesizer (with the aid of engineer Shuya Abe). It is a device he uses in many of his videotapes, and as you will see, it is the device that produces the swirling color explosions that seem to take television images and transform them into wonderful distortions of the reality we have come to expect as the television image/reality. Paik uses these images to shock the viewer into the realization that things are never the same from one moment to the next. He also attacks the banal worship of technological salvation as well as the cultures that support such thinking. Although his attack may itself be absurd, with random juxtapositions of images and ideas, the works press the point that there can be not art at all if there is a prevailing belief that everything is obvious.

The tapes in this show all show Paik's debt to the American genius John Cage, whose early compositions affected Paik while he was still a composer living and working in Cologne, Germany. Paik's other influences, though less obvious, are the composer Schönberg, the cyberneticist Norbert Weiner, and of course the dada master Marcel Duchamp. This exhibition is the first review of tapes made by Paik during the past eight years, but in no way does it represent a retrospective of his wide ranging works. Paik, an activist for the expansion of what we have come to accept as video art, feels quite strongly that videotapes are not all of video art, and he is usually quite reluctant to have either his work or the form itself judged by tapes alone.

Nevertheless, the tapes in the exhibition range from early black and white experiments (one Dieter Rot in German made on Canal Street in 1966) to highly sophisticated works like Global Groove, a tape employing video synthesis and computer animation recently completed at WNET's Television Laboratory.

From the Tape "Tribute to John Cage", 1973

HILTON KRAMER
A FAST SEQUENCE OF FORMS CHANGING COLOR AND SHAPE

The pace deliberately subverts any empathetic response we may bring to a specific image.

There is nothing like the acquisition of a new technology for inducing the illusion that art has some radical new function to perform. Novelty of means leads, naturally enough, to great expectations about new ends. Yet art – not our ideas about it, but the experience itself – is not easily dislodged from its traditional functions. Radical change in the way art addresses itself to our emotions is not as easily accomplished as the propaganda emanating from new art movements always assumes. The instrument may

indeed be as up-to-date as the Pentagon's new missiles, but the experience – what actually impinges on the mind of the observer – often remains hostage to familiar associations. The new technology may be little more than a machine for the mass production of clichés.

This is not quite the case, I think, with Nam June Paik's new video composition called "Global Groove", which is currently on view at the Galeria Bonino, 7 West 57th Street, but it is closer to being the case than the artist's various statements (and those of his friends and supporters) would ever lead one to guess. In his latest pronouncement, Mr. Paik claims to be offering us a form of "group psychotherapy on a global scale; preparing for the coming of post-industrial age", and, going further, holds out the promise of an "answer to today's energy crisis". As a copywriter promoting his own wares, Mr. Paik has a gift for hyperbole that would bring a blush to the cheek of even the most hardened Madision Avenue practitioner.

As an artist, however, he is a good deal more innocent and a good deal more serious than these nonsensical claims suggest. He is, fundamentally, an orchestrator of images who employs videotape and multiple screens as a means of achieving a certain acceleration and simultaneity in the projection of those images. "Global Groove", in any case, is a form of video collage in which the given images – some "found", some created – are splintered, synthesized, and spliced to conform to a rhythmic velocity that effectively consumes all its myriad particulars in a headlong rush of perception. It is the accelerated speed and dissonance of the visual rhythm, together with the simultaneous projection of variations of the same tapes on many separate screens, that is the principal focus of interest, not the particular images that have been "consumed" in the process.

From the Tape "Suite 212" 1976/77

From The Tape "Suite 212": "Little Italy" with Jud Yalkut

Indeed, the exact content of the images Mr. Paik employs is of no importance to the artistic substance of his work – though it is of great importance to its public relations aspect. In "Global Groove", there are sequences devoted to John Cage, Charlotte Moorman and Allen Ginsberg, and there are also brief excerpts from Karlheinz Stockhausen's "Kontakte" and Robert Breer's "First Fight". Such sequences and excerpts are certainly sufficient to guarantee Mr. Paik a share of the so-called "avantgarde" audience, but they contribute neither more nor less than the excerpts from a Japanese Pepsi-Cola commercial, say, or the sequence devoted to a Korean dancer. Mr. Paik has simply adopted the old Hollywood technique of using celebrities in "cameo" roles.

What is important, above all, in this medium is the pace at which the screen projects and devours its images. It is a pace that deliberately subverts any empathetic response we may bring to a specific image, for no matter how compelling – or boring – a particular moment may be, it is "cut" to a rhythm that negates our interest in it in order to fasten all attention on the rhythm itself. This is, in other words, a medium in which representational images are used for the purposes of kinetic abstraction.

"Global Groove" is a work lasting 30 minutes, and is projected on 20 television screens simultaneously. At the Galeria Bonino, the spectator stands on a raised platform looking down on what Mr. Paik describes (accurately, for once) as a "sea" or "garden" of televised images. The screens vary in size and angle of vision; some carry black and white images; but most of them are in color and each of the color screens is encoded to provide a different mix. There is a great deal of deliberate distortion, transparent overlays

of color, silhouetting and quick-color change. Some images are absolutely straight, whereas others are given a kind of grotesque science-fiction exaggeration. There is one especially beautiful split-screen sequence of dancing legs – Mr. Paik is much drawn to dancers in motion – and some frenzied scenes of the Living Theater doing its thing. But on a second viewing, the images matter even less than they do the first time. It is the sequence of forms changing color and shape that absorbs all attention.

"Global Groove" is abstract, then, in exactly the same way that a Kurt Schwitters collage is abstract. On our first encounter with the latter, we may be amused or simply interested in noticing that the constituent parts are drawn from discarded cigarette packs, old tram tickets and other bits of rubbish, but the power of the work derives from the rigorous form – usually a cubist form – governing the composition of the parts. In the same way, our initial curiosity in the case of "Global Groove", fastens on John Cage, say, telling one of his innocuous little tales, or on a sexy dancer dissolving into a colored silhouette. But the form quickly overtakes our curiosity about the bits of televised rubbish Mr. Paik has used in the making of his video collage, and it is our experience of the form that is finally what counts.

Once the form itself is apprehended, the work tends, I think, to diminish a little in interest. So much of the history of modern art has prepared us, after all, for this splintering and synthesizing of images, and for multiple projection and repetition. The technology may be new, but the conception has an ancestry, and our awareness of that ancestry is a factor in our experience.

Another factor for the audience that responds to this art is, undoubtedly, the historical scenario Mr. Paik takes such pains to promote. All the claptrap about the "perception of space motion" leading "to a complex flow of multi-lateral aesthetical information", etc., belongs to what Renato Poggioli, in his "Theory of the Avant-Garde", calls "the futurist moment" in every movement claiming an avant-garde status. With its promises of impossible accomplishments not yet realized, it represents, according to Professor Poggioli, "a prophetic and utopian phase, the arena of agitation and preparation for the announced revolution".

Spokesmen for "the futurist moment" are indeed, as Professor Poggioli says, "conscious of being the precursors of the art of the future", and Mr. Paik's pronouncements abound in exaggerated promises his art shows no evidence of keeping. The art one actually experiences is rather modest, its delights are flickering, small-scale and fragmentary, and quickly dissipated. They leave little residue in the memory. They need a certain ideological scaffolding, and it is no doubt for this reason that Mr. Paik is tireless in surrounding his work with so many elephantine claims.

(published in: The New York Times, Art, February 3, 1974)

226

GRACE GLUECK
A VIDEO ARTIST DISPUTES ORWELL'S '1984' VISION OF TV

In his cautionary novel "1984", Georges Orwell wasn't kind to television. He saw it basically as "Big Brother", a tool of the totalitarian state. But today the very first day of that prophetic year – his view will be rousingly challenged, by the Korean-born video artist and impresario, Nam June Paik. "Good Morning, Mr. Orwell", a live satellite-relayed program to appear on public-television stations, including WNET/Channel 13, at 12 noon, is Mr. Paik's pitch for television as an instrument for international understanding, rather than an ominous means of thought control.

Mr. Paik's claim that his work is "the first global interactive use of the satellite among international artists" needs a little explaining. Other video artists, such as Doug Davis, have employed satellite transmission, but the Paik venture is larger and more complex. And while commercial television has linked different parts of the world for informational purposes, Mr. Paik is using works designed specifically for the technology of the satellite itself to relate interactive performances, linking different stages in different parts of the world, so to speak.

"Good Morning, Mr. Orwell" is essentially a global variety show, originating in the United States, France and Germany, but its line-up of performing talent will be more familiar to Mr. Paik's "avant-garde" followers than to fans of network television. And while the program does not directly address Orwell's philosophy, Mr. Paik believes that in presenting established and new young talent from both sides of the Atlantic, it will "celebrate the positive side of the medium".

Among those who will appear, live or on tape, are the rock singers Laurie Anderson and Peter Gabriel belting out the title song (composed and recorded by them especially for the broadcast); on a split screen, the choreographer Merce Cunningham and the composer John Cage in New York improvising to Salvador Dali reciting a poem (on tape), beamed from Germany; the artist Joseph Beuys playing the piano, live from the Pompidou Center in Paris; the poets Allen Ginsberg and Peter Orlovsky singing one of their own compositions; a group of 80 French saxophone players and vocalists known as Urban Sax, and the irrepressible Charlotte Moorman, a cellist famed for playing Paik compositions dressed in almost nothing. (She'll be fully clad for her satellite debut.) Laughs – it is hoped – will be provided by interludes with the comedians Mitchell Kriegman and Leslie Fuller, both formerly of "Saturday Night Live". And viewers will also witness a world television premiere: "Act III", a film stretching the boundaries of electronic graphic display by Dean Winkler and John Sanborn with music by Philip Glass.

Now 51, Mr. Paik still looks, with rumpled clothes and tousled hair, very much the whiz kid who first came to the attention of the art world as a video innovator in the 1960's. "I never read Orwell's book – it's boring", he said recently during an interview at WNET. "But he was the first media communications prophet. Orwell portrayed television as a negative medium, useful to dictators for one-way communication. Of course, he was half-right. Television is still a repressive medium. It controls you in many ways.

(published in: The New York Times, January 1, 1984, S. 21)

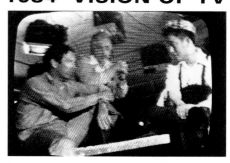

Nam June Paik with Calvin Tomkins and Russel Connor, 1975, from the Tape "Nam June Paik – edited for TV"

227

JOHN J. O'CONNOR
'BYE BYE KIPLING' ON 13, A VIDEO ADVENTURE

From the Tape "Allan 'n' Allen's Complaint", 1982 (with Shigeko Kubota)

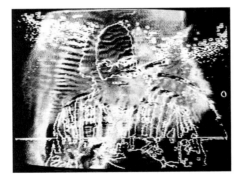

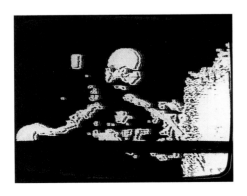

Nam June Paik, perhaps the least threatening of avant-garde artists, is fond of salutations. On the first day of 1984, he presided over a Paris-New York satellite transmission entitled "Good Morning, Mr. Orwell". On Saturday evening, from 9 o'clock to nearly 10:30 on Channel 13, he conceived and coordinated a kind of space-opera variety show that was called "Bye Bye Kipling". This time, with financing from American, Japanese and Korean sources – the title alludes to Kipling's famed conclusion that "never the twain shall meet" – he offered still another splashy and witty demonstration of his favorite subject: two-way, interactive television-communications.

With the New York portions of the broadcast emanating from a new club named 4D, appropriately enough, the program was able to jump by satellite to Tokyo and to Seoul, South Korea, where the 1986 Asian Games are taking place and where cameras were able to pick up a marathon race in progress. The resulting "mix" included live performances and interviews, assorted taped materials and periodic dollops of computerized videos. Some of the material, such as the rock songs of Lou Reed ("This Is the Age of Video Violence"), was great.Some, most notably several visual "jokes" involving the passing of an object from one space frame to another, were rather silly.

Perhaps the most surprising realization about the bombardment of electronic techniques was that so many of them have already besome almost old-fashioned. In a world where the visually new is gobbled up voraciously by everything from MTV to product commercials, from Max Headroom to Pee-wee Herman, novelty and surprise are decidedly ephemeral things. For all of its avant-garde ambitions, "Bye Bye Kipling" opened with the Beatles singing "- Come Together" and ended with clips from the "be-in" days of the old Living Theater.

Despite his up-to-the-minute cast of characters – the composer Philip Glass, the artist Keith Haring, the fashion designer Issey Miyake – Mr. Paik is not really concerned with being trendy or fashionable. He worries about how people perceive each other in a world that television is constantly reducing to the long-promised (or threatened) "global village". His ultimate goal is to set up a gigantic television screen in Times Square and one in Moscow's Red Square that would allow the citizens at either point to talk to each other 365 days a year. "It will cost one-millionth of Star Wars", he argues, "and be a lot more effective".

His "Bye Bye Kipling" extravaganza – the executive producer was Carol Brandenburg – was dotted with technical glitches, none of which were terribly consequential. Mr. Paik has said he sees a lot of his audience as young media-oriented people who "play 20 channels of New York TV stations like piano keys". The switching is the content, he says. The flow of "Bye Bye Kipling" was not helped, however, by the confusion of Dick Cavett, the New York host. Although he spoke several Japanese phrases with seeming fluency, Mr. Cavett kept complaining that he didn't know what was going on. After a gimmick striptease number, he announced: "I have a tiny surprise. One of the strippers – and this is the truest thing I will tell you tonight ..." At which point the picture switched to the marathon race in Seoul and Mr. Cavett could be heard grumbling, "Oh, the hell with it".

The coverage of the marathon, incidentally, was superb, the live completion of the race accompanied by a Philip Glass crescendo for a kind of "Chariots of Fire" effect. Bursting with stunning images, popping with provocative ideas, "Bye Bye Kipling" was an

unusual venture for public television, a refreshing break from the talking heads and British imports. Mr. Paik deserves his own salutation: Welcome back, and come again.

(published in: New York Times, Oct. 6 1986)

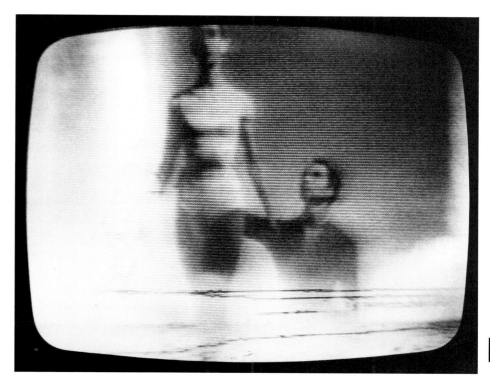

From the Tape "Merce by Merce", 1977

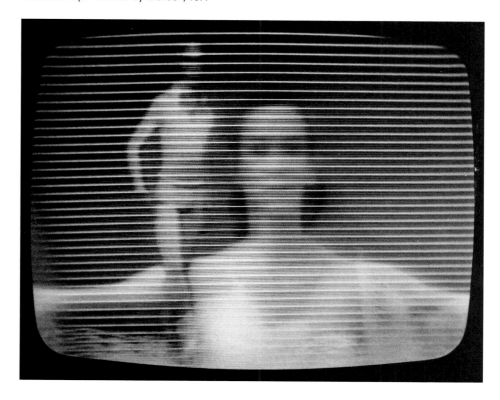

229

CAROL BRANDENBURG
THOUGHTS ON 'WRAP AROUND THE WORLD'

When Nam June Paik began talking a few years ago about producing a live international broadcast that would interconnect as many as twenty countries, I must admit – I was skeptical. We had already done GOOD MORNING MR. ORWELL and BYE – BYE KIPLING, to be sure ... but this would be so much more complex. Where to even begin??

But Nam June – who never doubted that the show could and would happen – exercised his considerable powers of persuasion to convince the Korean Broadcasting System (KBS) that his program would help to promote the 1988 Summer Olympic Games, beginning one week later. KBS committed $ 200,000, provided that at least eight other countries (in addition to South Korea and the U.S.) agreed to participate no later than July 10, 1988. Perhaps even more important, KBS supplied an additional $ 50,000 to cover development costs during the six-month period January-June. That was the crucial first step, which made it possible for me to do the traveling necessary to negotiate co-production agreements around the world.

We began immediately, Nam June and I, making West Germany our first stop last January. We had meetings at WDR/Cologne and then traveled separately to Hamburg (where my former co-production partners at NDR said "yes" the same day) and Munich. I went on to Paris as well for an exploratory visit.

Early in March, I returned to Europe for nearly six weeks, on an odyssey that took me from Stockholm to southern Spain – ten countries in all. By the end of May, we had agreements in principle with NDR/WDR, ORF/Austria, RAI/Italy, TV Asahi/Japan – which Nam June has arranged – and, of course, KBS. Discussions were proceeding with Globo/Brazil, where Nam June's old friend, video-computer artist Hans Donner, was eager to collaborate with us. Seven down, three to go ...

We wanted an interesting and varied international "mix" in the show, so in June I was off to Moscow, Leningrad, Sarajevo and Dublin. My final trip took me to Beijing and August to conclude the co-production deal with China Central Television. And when the broadcast finally took place as scheduled on September 10, the performances from around the world miraculously (it seemed) happened just as planned – or almost.

WNET's engineers provided superb technical coordination in both London and New York. The big question was the programming itself – Would each of the broadcasters do what we had mutually agreed? Would it all work?

To our delight, it did. Oh, there were some mistakes and rough transitions along the way, of course. But mostly it went more smoothly than I had dared to hope.

For me, that was the true and lasting significance of WRAP AROUND THE WORLD: using complex technology to create human interactions that would have been unthinkable just a few short years ago. There was the professional challenge of developing relationships – and mutual trust – with other broadcasters, to make those collaborations possible. And there was the enormous amount of time, energy, creative thought and enthusiasm from each participant, to make its segment the best it could be.

The production and technical staff I assembled in New York – from WNET, other companies and freelancers – did a magnificent job. Some had worked on one or both of the previous live shows; some were new; but everyone worked hard, with great persistence and imagination, to realize Nam June's vision.

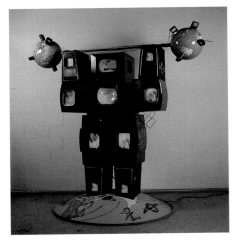

Wrap Around the World Man, 1990
Courtesy Carl Solway Gallery, Cincinnati

230

For all of those experiences – most of all, the experience of meeting and working with so many wonderful people all over the globe – I will always be indebted to Nam June Paik. He gave me a unique opportunity ... and an incredible adventure ... which I shall never forget.

(published in: Sony HD-Software, 1988, p. 24–25)

Global Groove, 1973

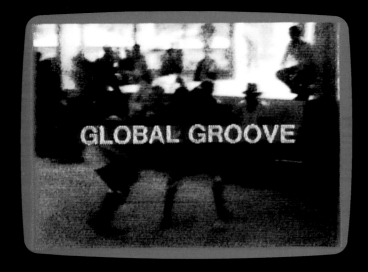

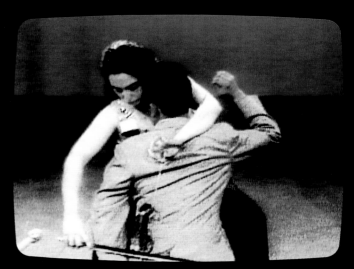

234

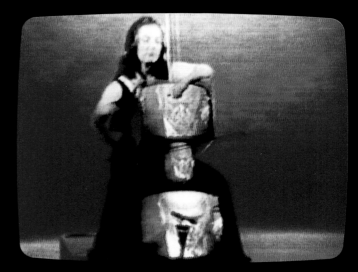

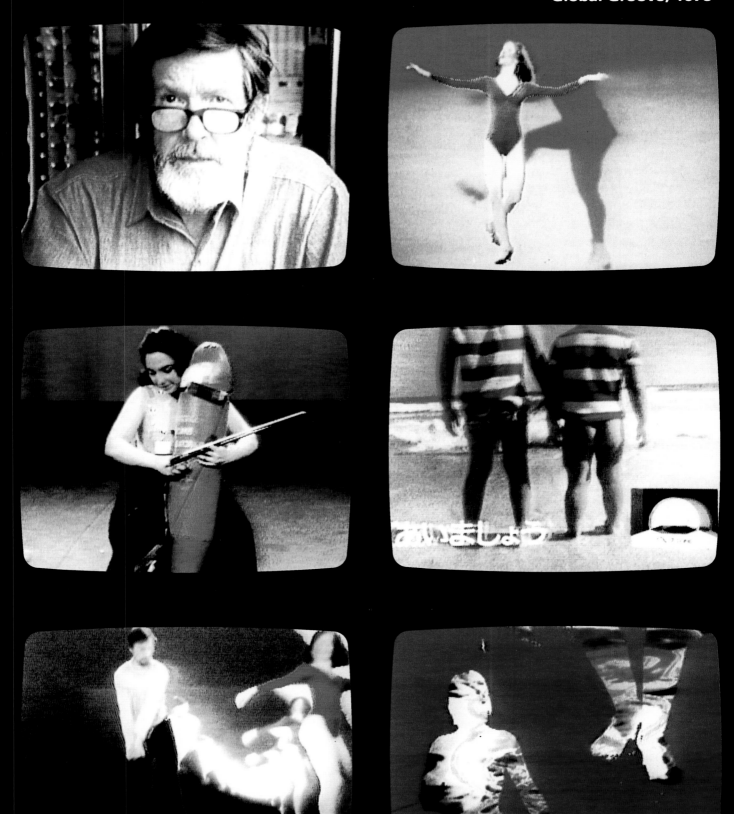

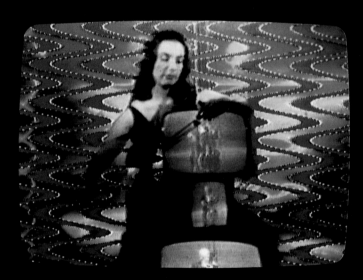

236

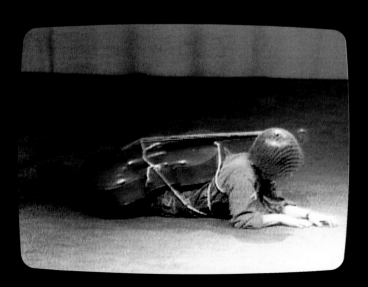
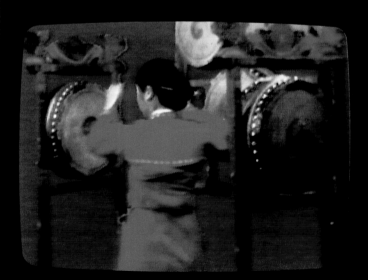

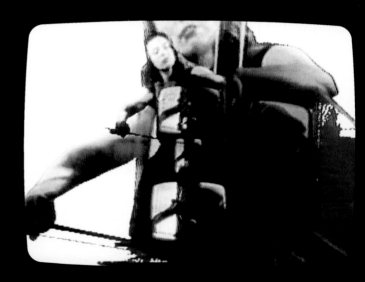

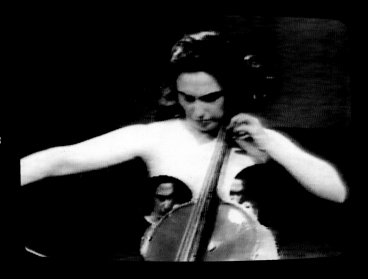

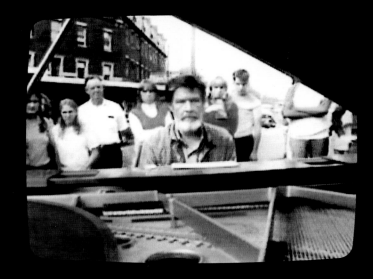

238

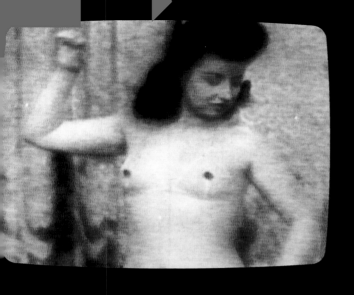
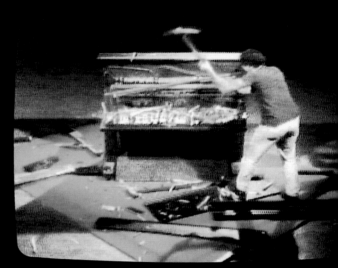

THIRD MOVEMENT

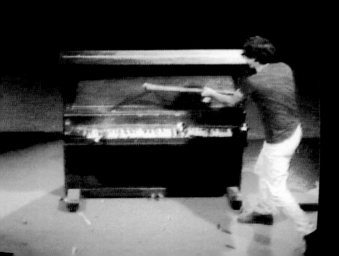
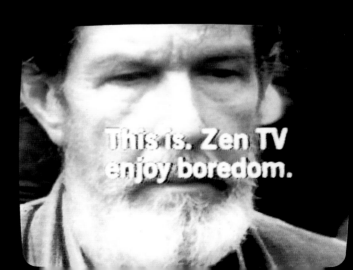

This is. Zen TV enjoy boredom.

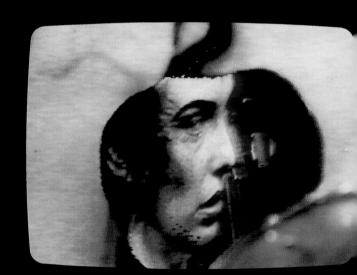

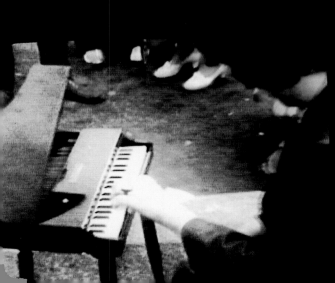

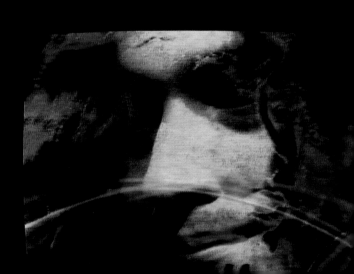

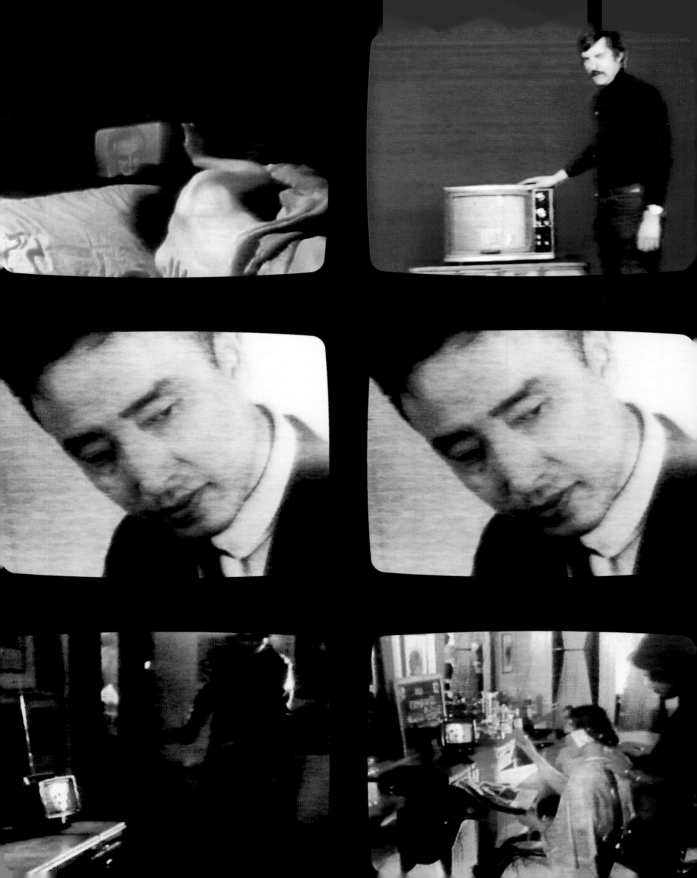

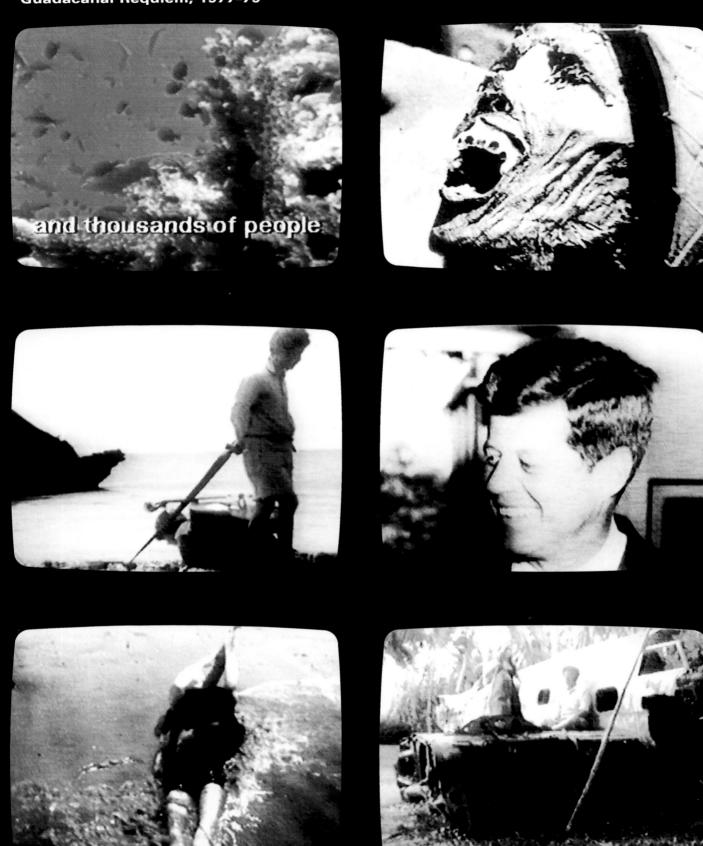

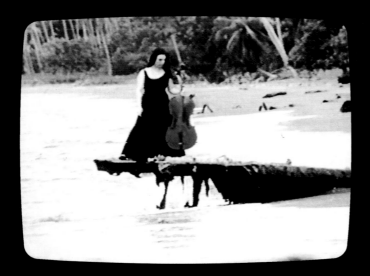

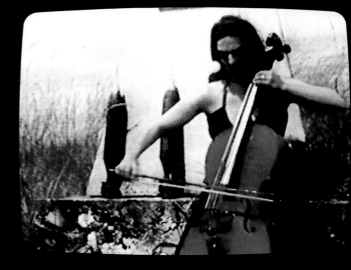

the location of bones an

engines konked out and we s

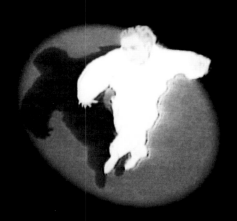

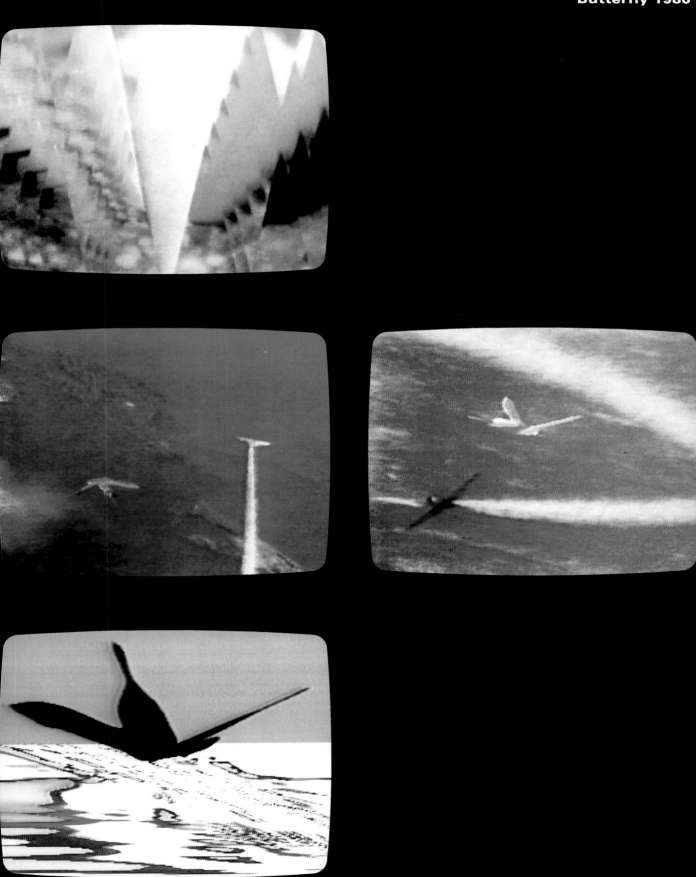

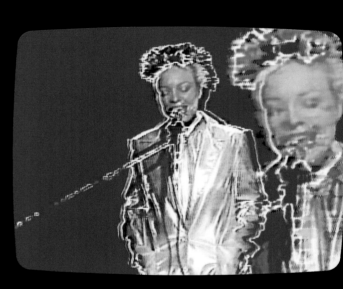

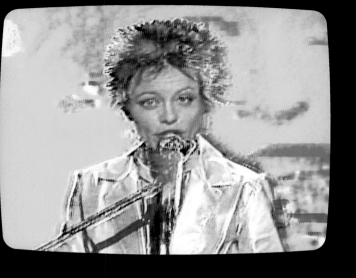

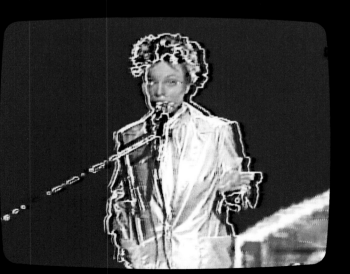

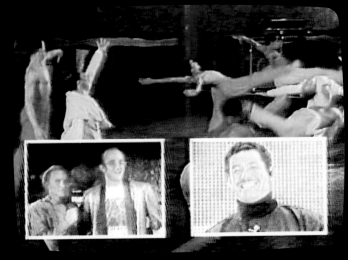

265

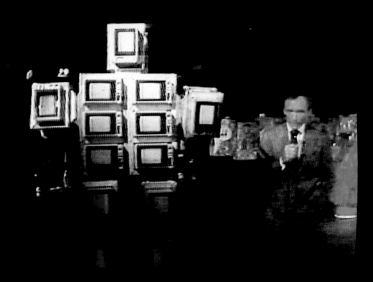

266

270

NAM JUNE PAIK

June 20th, 1932
Born in Seoul (Korea), the fifth son of a textile manufacturer

1950
The Paik family flees from the Korean War, first to Hongkong, and later to Japan

1956
Paik graduates from the University of Tokyo, concluding his studies of the History of Art and the History of Music with a thesis on Arnold Schönberg

1956–58
Studies the History of Music at Munich University; meets Karlheinz Stockhausen; studies Composition at Freiburg Conservatory

1958–63
Meets John Cage; works in the Studio für elektronische Musik at WDR, Cologne

1959–62
Has appearances with pieces of his action music; Stockhausen's "Originale" is performed in Cologne

1963
Participates in "Fluxus. Internationale Festspiele neuester Musik", Wiesbaden; "Exposition of Musik / Electronic Television", the first exhibition including TV monitors, is shown at Galerie Parnass, Wuppertal

1963–64
Travels to Japan; meets Shuya Abe; experiments with electromagnets and color television; visits New York, collaborates with Charlotte Moorman

1965
First solo exhibition "Electronic Art" in the USA at Galeria Bonino, New York; buys the first portable video recorder

1966–69
First multi-monitor installations; works with magnetically distorted TV recordings; "Electronic Opera No. 1" is performed at the live program "The Medium is the Medium", GBH-TV, Boston

1969–70
With Shuya Abe, constructs the video synthesizer

1971
Works at WNET's TV lab, New York

1976
Retrospective at Kölnischer Kunstverein, Cologne

Since 1979
Chair at Staatliche Kunstakademie, Düsseldorf

1982
Retrospective at the Whitney Museum of American Art, New York

January 1st, 1984
Satellite broadcast of "Good Morning Mr. Orwell" from the Centre Pompidou, Paris, and a WNET-TV studio, New York

1987
Elected a member of the Akademie der Künste, Berlin

1988
Erects a media tower, "The more the better", from 1003 monitors for the Olympic Games at Seoul

1990
"Video Arbor" is put up in Philadelphia as a sculpture for the public sector

1991–92
Double exhibition "Video Time – Video Space" at Kunsthalle Basel and Kunsthalle Zürich, subsequently shown in Düsseldorf and Vienna

Numerous grants and awards from, inter alia, the Guggenheim Museum, the Rockefeller Foundation, and the American Film Institute; Will Grohmann Award, Goslar Emperor's Ring, UNESCO's Picasso Medal

Paik lives and works in New York, teaches at Staatliche Kunstakademie, Düsseldorf, and has a second home in Bad Kreuznach

SELECTED BIBLIOGRAPHY
A complete bibliography until 1988 in:
Edith Becker, Paik. Video, Cologne 1988, p. 211–222

1988
Nam June Paik. Satellite après-demain – Icarus Phoenix, ed. Junji Ito, Tokyo 1988

Catalogue Nam June Paik. Video Works 1963–88, Hayward Gallery, London 1988

1989
Catalogue Nam June Paik. La Fée électronique, Musée d'Art Moderne de la Ville de Paris, Paris 1989
Jean-Paul Fargier, Nam June Paik, artpress, Paris 1989

1990
Catalogue Nam June Paik. Beuys Vox 1961–86, ed. Won Gallery / Hyundai Gallery, Seoul 1990

1991
Catalogue Nam June Paik, A pas de loup. De Seoul à Budapest, ed. Won Gallery / Hyundai Gallery, Seoul 1991

Catalogue Nam June Paik. Video Time – Video Space, ed. Toni Stooss / Thomas Kellein, Kunsthalle Basel / Kunsthaus Zürich / Städtische Kunsthalle Düsseldorf / Museum moderner Kunst Stiftung Ludwig Köln / Museum des 20. Jahrhunderts Wien, Stuttgart 1991 (the English edition will be published in 1993)

1992
Nam June Paik, Niederschriften eines Kulturnomaden. Aphorismen, Briefe, Texte, ed. Edith Decker, Cologne 1992

Catalogue Moving Image. Electronic Art, Fundació Joan Miró Barcelona / Zentrum für Kunst und Medientechnologie, München / Stuttgart 1992

Yongwoo Lee, Nam June Paik, Seoul 1992

1993
Nam June Paik. Du Cheval à Christo et autres écrits, ed. E. Decker / I. Lebeer, Bruxelles / Hamburg / Paris 1992

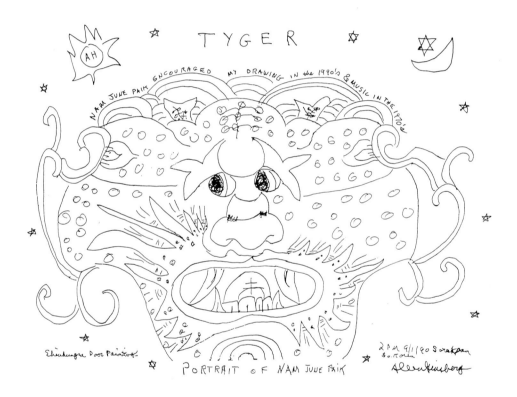

NAM JUNE PAIK ENCOURAGED MY DRAWING IN THE 1990s & MUSIC IN THE 1970s
Allen Ginsberg 2 pm 9/1/90 Soraksan S. Korea

Family Photo Declassified, 1984

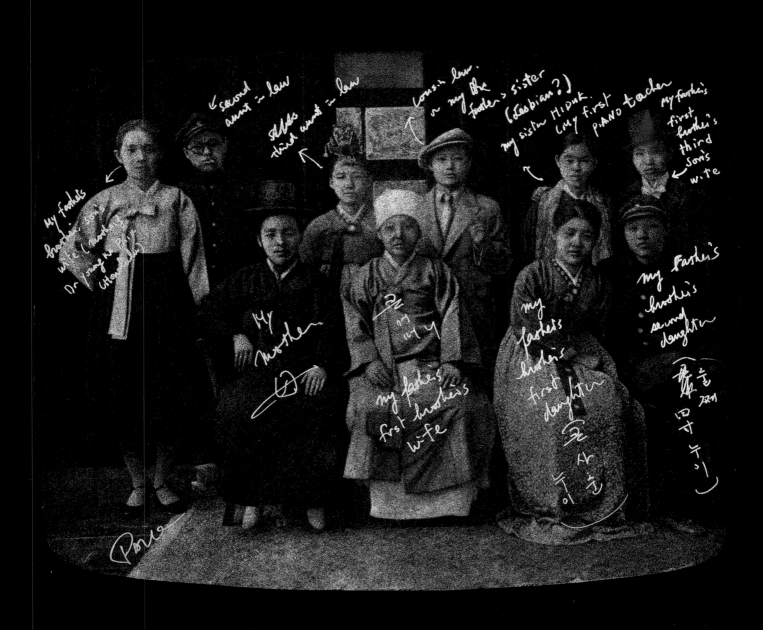

IMPRESSUM | ACKNOWLEDGEMENTS

Ausstellung | Exhibition
Idee, Idea: Klaus Bußmann, Nam June Paik
Organisation: Klaus Bußmann, Florian Matzner
Realisierung, Realization: Norman Ballard, Laura Beck,
Chang Young Jae, Brian Dempsey, Glenn Downing, Jon Huffmann,
Lee Jung Sung, Oh Sae Heran, Mark Patsfall, Jochen Saueracker,
Blair Thurman und Klaus Habicht, Roman Mensing, Richard Schulte,
Paul Vadder, Jürgen Wanjek

**Die Ausstellung wurde ermöglicht
durch die Unterstützung von
This exhibition has been made possible
through the kind support of**
Achenbach Art Consulting, Düsseldorf
Hyundai Gallery, Seoul
Professor Ludwig, Köln
Galerie Hans Mayer, Düsseldorf
RTL Television, Köln
Holly Solomon Gallery, New York
Carl Solway Gallery, Cincinnati, Ohio
Sony Deutschland GmbH
Galerie Weißer Raum, Thomas Wegener, Hamburg

Katalog | Catalogue
Idee, Idea: Klaus Bußmann, Florian Matzner, Nam June Paik
Redaktion: Florian Matzner, Nam June Paik
Lektorat, Desk editing: Cornelia Plaas
Layout: Karin Girlatschek
Gesamtherstellung, Production: Dr. Cantz'sche Druckerei,
Ostfildern-Ruit bei Stuttgart
Herausgegeben von, Edited by: Klaus Bußmann und Florian Matzner
im Auftrag des Auswärtigen Amtes, Bonn

Abbildungen | Illustrations
Cover: Nam June Paik mit "Marco Polo", Deutscher Pavillon, Venedig
(Photo Roman Mensing)
Frontispiz: Erste Konzeptskizze von Nam June Paik für den Deutschen
Pavillon, Köln, 5.10.1992
Backcover: Nam June Paik 1992 (Photo Timm Rautert)

© 1993 Edition Cantz

ISBN 3-89322-556-0 (Hardcover)
ISBN 3-89322-573-0 (Softcover)

Printed in Germany 1993

Die annähernd 150 Autoren dieser "multikulturellen" Publikation über Nam June Paik haben ihre Texte gemäß ihrer Nationalität in englischer, französischer, deutscher oder italienischer Sprache verfaßt (koreanische Beiträge wurden ins Englische übersetzt). Da es nicht möglich war, sämtliche Beiträge aller Autoren in die jeweils anderen Sprachen zu übertragen, konnte nur eine Auswahl der Artikel ins Englische und/oder Deutsche übersetzt werden. Die Übersetzungen dieser Texte sind im nachfolgenden Anhang der Hardcoverausgabe enthalten.

The almost 150 co-authors of this "multi-cultural" compilation on Nam June Paik originally submitted their pieces in their respective mother-tongue (Korean contributions were translated into English). As it proved impossible to translate all contributions in every language into every other, a selection of articles had to be made, and these have been translated into English and German respectively and are included in an appendix in the hardcover edition.

NAM JUNE PAIK
DE-KOMPOSITION
IN DER MEDIENKUNST

Wenn man die amerikanische und die europäische Filmindustrie vergleicht, stellt man fest, daß einer der großen Unterschiede in der Machtposition des Regisseurs liegt. In Europa ist ein angesehener Regisseur vom Kaliber eines Godard oder eines Herzog der unangefochtene Alleinherrscher. Er entscheidet über das Drehbuch, die Besetzung der Rollen und die Gestaltung der wichtigsten Szenen. In Amerika ist selbst ein sehr bekannter Regisseur nur Glied einer Kette, die beim Aktionär, dem Präsidenten der Filmgesellschaft, dem Produktionsleiter und dem Produzenten beginnt und sich bis zum Casting-Director und dem Gewerkschaftsvertreter fortsetzt. Eine sehr kritische Gestalt wie z. B. Donald Duck wurde wohl eher durch die Entscheidung eines Ausschusses als durch Mr. Disney selbst ins Leben gerufen. Ob gut oder schlecht, so sind die Strukturen, die mit dazu beigetragen haben, daß der europäische Autorenfilm heute im Schatten Hollywoods steht.

Auch in der Welt der Wissenschaft ist die Zusammenarbeit, oft über die Landesgrenzen hinaus, mittlerweile eher die Regel als die Ausnahme. Es gibt hier drei klassische Beispiele, die mich schon seit Jahren faszinieren. Paul Erdös, ein Jahr vor Cage 1911 in Ungarn geboren, ist ein exzellenter Mathematiker. Als John Cages Mutter (die für die Los Angeles Times geschrieben hat) dem dreijährigen John ein Klavier schenkte, kletterte der schon auf der Tastatur herum, während die Leute vom Transportunternehmen das Instrument noch ins Wohnzimmer trugen; bis zum 12. August 1992 hat John nicht mehr aufgehört zu spielen (oder das Klavier zu bearbeiten). Ebenfalls im Alter von drei Jahren begann Paul Erdös Zahlen zu brabbeln, und seinen Eltern (beide Mathematiklehrer) fiel auf, daß mathematisch interessante neue Resultate waren ... anders als ein "normales" Wunderkind, das irgendwann aufhört, zu wachsen, hat dieser Mann nie aufgehört, neue Zahlen auszuspucken (ich möchte wetten, er tut es noch immer, zu Hause in Budapest). Er hatte so viele neue Ideen, daß er in der ganzen Welt Mitarbeiter beschäftigt, sein ganzes Leben lang in der Welt herumreist, um Ergebnisse zu diskutieren und das Privileg der Reisefreiheit genießt. Auf dem Gebiet der Mathematik war er eine solche Kapazität, daß man im Zusammenhang mit ihm von G1, G2, G3-Kategorien sprach. G1 sind all die Mathematiker, die direkt mit Paul Erdös zusammengearbeitet haben; G2 sind die mit einem Mathematiker zusammengearbeitet haben, der mit Erdös zusammengearbeitet hat, und G3 sind alle die, die mit G2 zusammengearbeitet haben. Einstein war angeblich nur G2. Erdös leidet unter einer mysteriösen Hautkrankheit und kann nur Unterwäsche aus Seide tragen. Früher begleitete ihn seine Mutter, heute reist seine Tante mit ihm. Jeden Abend, bevor er zu Bett geht, wäscht er seine seidene Unterwäsche. (Quelle: "The Atlantic Monthly", November 1987).

Es gibt noch einen anderen seltsamen Ungarn, der bis vor kurzem eher unbekannt war: Leo Szilard, ein Physiker, der 1931 in Berlin lebte. Eines Tages stand er an einer Kreuzung und wartete darauf, daß die Ampel von Rot auf Grün springt. Das tun Millionen andere Menschen auch millionenmal in ihrem Leben. Plötzlich (so scheint es), sprang dann die Ampel von Rot auf Grün, und Herr Szilard setzte einen Fuß auf die Straße ... in dieser Sekunde kam ihm die Idee einer atomaren Kettenreaktion. In Anbetracht der Gefahren im prä-faschistischen Deutschland überquerte er den Kanal und schrieb von London aus an Einstein, seinen alten Lehrer in Berlin. Zusammen verfaßten sie dann den berühmten Brief an Roosevelt über die Atombombe. Als Szilard jedoch die Detonation der ersten Testbombe in der Wüste von Nevada sah, war er entsetzt über seine Mit-Erfindung und wurde zum Anführer der Bewegung "Stop the Bomb" vor Hiroshima. Er wurde aus Los Alamos gefeuert, und sein Name wurde bis vor kurzem totgeschwiegen. Nachdem er bereits aus der Atomphysik ausgestiegen war, entwickelte er eine neue, Nobelpreis-verdächtige Theorie über genetische Biologie, deren Bedeutung bis heute nicht ganz klar geworden ist ... 35 Jahre nach seinem Tod. Es erübrigt sich, zu sagen, daß Los Alamos zum folgenschwersten Beispiel einer wissenschaftlichen Zusammenarbeit (mit der NASA) geworden ist. (Quellen: "Discovery Magazine", vor einigen Jahren von TIME-LIFE herausgegeben, und eine neue Szilard-Biographie, an der sein Bruder mitgearbeitet hat; die beiden Versionen geben eine in Einzelheiten abweichende Darstellung).

Ich besitze nicht das Genie eines Szilard, teile aber zumindest eine schlechte Angewohnheit mit diesem Mann. Auch er hat es geliebt, lange in der Badewanne zu liegen, manchmal bis zu zwei Stunden; es ist die Zeit des freien Assoziierens, das Zwischenreich, wo geheime Schubladen geöffnet oder geschlossen werden können.

Der Dritte im Bund ist Norbert Wiener, dessen Name bekannt ist. Er hat nicht nur zusammen mit anderen das Zeitalter der Kybernetik eingeläutet, er war auch der erste, der vor den Folgen gewarnt hat. Ich bin mir sicher, daß er sich, ähnlich wie Wernher von Braun, im nachhinein vorgekommen ist wie ein kleiner Junge, der mit Streichhölzern gespielt und ohne Rücksicht auf die Folgen das ganze Haus in Brand gesteckt hat. Norbert Wiener, der zuerst einen technischen Abschluß am Massachusetts Institute of Technology (MIT) machte, ging später nach London, um bei Bertrand Russell Philosophie zu studieren. Später untersuchte er den Unterschied zwischen Newtonscher Zeit (reversibel) und Bergsonscher Zeit (irreversibel) und entwickelte das Prinzip der Zeitreihen, indem er Frösche verletzte und tötete, um zu sehen, wie sie auf den permanenten Stimulus

reagieren würden (weitgehend negativ). Diese Erkenntnisse verwendete er dann beim Entwurf seines Radarsystems. Wenn auf einen Starfighter-Piloten geschossen wird, reagiert er wahrscheinlich ähnlich wie der Frosch, der von einem Wissenschaftler gepiesackt wird. Wieners Radarforschung am MIT war vor dem Ausbruch des Zweiten Weltkrieges schon sehr weit fortgeschritten, als ein Gastprofessor (ein deutscher Mathematiker) der Aufforderung Hitlers nachkam, ins Vorkriegsdeutschland zurückzukehren und dort eine wichtige Stellung einzunehmen. Ein hohes Tier der Regierung Roosevelt war darüber besorgt und fragte Wiener: "Was, wenn er das Ergebnis unserer Experimente an die deutsche Rüstungsindustrie verrät?" Darauf antwortete Wiener: "Machen Sie sich keine Sorgen. Meine Art zu denken ist so anders als die der Deutschen ... Mein Radarsystem gründet sich auf so ambivalente, empirische, induktive, nichtlineare Methoden, daß Hitler, der streng logisch denkt, niemals Geld dafür ausgeben würde." Das anglo-amerikanische Radarsystem, für das Wiener die mathematischen Grundlagen lieferte, hat jedenfalls dafür gesorgt, daß sich das Blatt sowohl im Pazifik (Midway) als auch auf den europäischen Schlachtfeldern (Londoner Blitzkrieg) wendete.

Seine Erfindung fand sogar noch beim Bau der Patriot-Rakete Verwendung. Zu welchem Ergebnis ein paar Frösche, die in der Folterkammer dieses MIT-Professors ihr Leben lassen mußten, doch geführt haben! George Maciunas, der Fluxus-Chef, vertraute seinem litauischen Freund, dem Dichter Vyt Bakaitis einmal an, er würde gerne als Frosch wiedergeboren werden. Ich kann nur hoffen, daß er einem französischen Koch in die Hände gefallen ist, der ihn gleich zubereitet und nicht ans MIT verkauft hat. Norbert Wiener war der Wegbereiter von Mixed Media und der interdisziplinären Zusammenarbeit verschiedener Wissenschaftszweige. Viele seiner wissenschaftlichen Publikationen wurden unter Mitarbeit eines oder mehrerer Co-Autoren verfaßt ... Dieser Mann hatte einfach zu viele Ideen, um alleine damit fertig zu werden. Bevor er völlig unerwartet in Stockholm einem Herzinfarkt erlag, hatte er sich intensiv mit dem Studium der chinesischen Sprache beschäftigt. Ich könnte wetten, daß der gestaltpsychologische, ganzheitliche Ansatz des chinesischen Ideogramms Wiener fasziniert hat, der in einer linearen alphabetischen Kultur aufgewachsen war. Dieses Studium hätte bestimmt interessante Ergebnisse gebracht, wenn ihm zehn oder zwanzig Jahre mehr Zeit geblieben wären.

Mein erster Mitarbeiter war ein junger Mann namens Günther Schmitz, den ich mir 1962 von der Werkschule am Ubierring in Köln holte. Er half mit bei der Entwicklung der horizontalen und vertikalen Zeilenablenkung und anderer Techniken, die später beim Bau des Bildabtasters für den Videosynthesizer verwendet wurden. Er sagte mir, ich solle einen Kondensor vorschalten, bevor ich neue Sinuswellen in das Gitter der Kathodenstrahlröhre einspeise. Er zeigte mir auch, wie man einen Elektroschock überlebt. Für die Ausstellung in der Galerie Parnass 1967 in Wuppertal, "Electronic Television and Exposition of Music", habe ich folgenden Leuten auf dem Flugblatt zur Ausstellung gedankt: P. S. Außerdem lernte ich von Mary Bauermeister den intensiven Gebrauch technischer Elemente, von Alison Knowls "cooking party", von J. Cage "prepared piano" etc. etc. etc., von Kiender die Verwendung von Spiegelfolien, von Klein "Monochromity", von Kopke "shutting event", von Maciunas "Parachute", von Patterson "Terminschaltung und Ansatz zur Elektronik" von Vostell die Verwendung von Stacheldraht und von Thomas Schmit und Frank Trowbridge viele verschiedene Sachen bei unserer Zusammenarbeit. 1963 traf ich Shuya Abe, und 1964 Charlotte Moorman in New York (Abe, "My Best Doctor", Publikation der On the Wing Galerie, Yokohama 1991; wieder abgedruckt in Edith Decker (Hg.) Nam June Paik: Niederschriften eines Kulturnomaden, Köln 1992).

Im Februar 1977 gab ich ein Vermögen aus, um die Carnegie Hall zu mieten und anläßlich des zehnjährigen Jubiläums der Verhaftung bei der Aufführung der "Opéra Sextronique" ein Konzert zu geben. Ich hatte eine abendfüllende neue Oper vorbereitet. Einen Tag vor dem Konzert kam Charlotte in mein Loft in der Canal Street und sagte mir, sie wolle mit der dritten Arie der Oben-Ohne-Oper beginnen, die damals nicht mehr aufgeführt werden konnte, weil wir uns zu diesem Zeitpunkt schon beide im Polizeiauto befanden. In zehn Jahren hatte sich einiges geändert, und in diesen neuen Zeiten ohne Tabus würde die Originalversion keinen mehr schockieren oder irgendwie künstlerisch beschäftigen. Ich bestand darauf, das neue Werk aufzuführen, aber es war zwecklos. Ich protestierte, selbst Mozart habe nicht an einem Tag eine neue Oper schreiben können ... schließlich gab ich nach ... und das Ergebnis?

Wie dem auch sei, Charlotte hat es geschafft, mein Interesse an der Performance von neuem zu wecken; ich dachte, ich hätte schon 1962 damit abgeschlossen. Ich kann ihr für diese Überzeugungsarbeit gar nicht genug danken. Meine Geschichte der Zusammenarbeit erfuhr 1967 bei WGBH-TV eine schicksalhafte Wendung. Bis dahin hatte ich bei jeder Zusammenarbeit das Kommando gehabt. Als ich mich jedoch mit dem enormen Verwaltungsapparat und der technischen Ausstattung eines Fernsehsenders konfrontiert sah, mußte ich meine Machtposition aufgeben. Mit dem verfügbaren Budget konnte ich einen halben Tag Aufnahmen machen, alle 45 Minuten von einer gewerkschaftlich vorgeschriebenen Kaffeepause unterbrochen, und einen weiteren halben Tag hatte ich zum Schneiden; mit den aus heutiger Sicht antiquierten Geräten von 1967 konnte ich nur 16 Schnitte am Tag machen. Man erwartete von mir ein Meisterwerk, einzigartig in der milliardenschweren Geschichte von Film und Fernsehen.

Bei der Arbeit an "The Medium", hingebungsvoll produziert von zwei reichen Damen der feinen Gesellschaft, Ann Gresser und Pat Marx (die kurz darauf

Daniel Ellsberg von den Pentagon Papers heiratete), war ich total in Panik geraten. Ich sagte zu Fred Barzyk und David Atwood: "Ich bin nicht da, macht, was ihr wollt. Ich habe überhaupt keine Ahnung…", und Fred und David schufen ein fünfminütiges Meisterwerk, das mir ein zweijähriges Stipendium der Rockefeller-Stiftung einbrachte. Mit diesem Geld konnte ich Shuya Abe einladen, mit mir die Videosynthesizer in Boston zu bauen. Ich frage mich noch heute, warum die hervorragenden Künstler Barzyk und Atwood nicht etwas Ebensogutes produziert haben, bevor ich zu WGBH-TV nach Boston kam. Mein Anteil an dem Ganzen betrug höchstens 40%.

1972 ging ich zu WNET und wurde inzwischen als Techno-Art-Genie gehandelt; aber ich konnte nicht einmal die zwei Reglerreihen des Mixers bedienen, und ich habe nie den sogenannten Paik-Abe-Videosynthesizer gespielt, den ich angeblich erfunden haben soll. Als der große Tag von "Global Groove" gekommen war, mußte ich den Super-Techniker bestechen: "Bitte, mach', was Du willst; ich bin hier, aber ich bin eigentlich nicht hier. Es ist Dein Spiel. Du bist der 50:50 Co-Autor, und Du bekommst 50% aller Einnahmen." Er bediente meinen Paik-Abe-Videosynthesizer und meine neue Erfindung, einen Bildmischer mit regelbaren Helligkeitsstufen. Oft ist 1 plus 1 gleich 1,2 oder sogar nur 0,8; in diesem Fall jedoch war 1 plus 1 gleich 100 …, wie bei der Zusammenarbeit von Cage und Cunningham. Jedenfalls war ich ziemlich durch die Mangel gedreht, und es gibt einige Passagen in "Global Groove", von denen ich bis heute nicht weiß, wie John Godfrey das gemacht hat. Ich habe ihm die 50% Beteiligung noch immer nicht ausbezahlt. In diesem Herbst werde ich fünf große Bilder machen und es nachholen, versprochen.

Es braucht wohl nicht mehr erwähnt zu werden, daß bei den drei großen Satelliten-Shows "Good Morning Mr. Orwell", 1984, "Bye Bye Kipling", 1986, und "Wrap Around the World", 1988 mein Anteil jeweils ungefähr 30% ausgemacht hat. Ich aber habe die ganzen Lorbeeren eingeheimst, oder auch die ganze Kritik. Das Tragikomische dabei war der Squeeze-Zoom, denn die ganze New-York-Paris-Sendung bestand aus zerknautschten Bildern aus den Signalen von zwei Kanälen. Ein französischer Spezialist saß in der Übertragungskabine; er dachte, ich sei ein Experte; er wußte nicht, daß ich ein Techno-Idiot bin. Respektvoll überließ er mir das Mischpult, kurz bevor die Live-Übertragung für 40 Millionen Zuschauer in Europa, den USA, Kanada und Korea begann. Mein Französisch war zu dürftig, um ihn zurückzurufen, also begann die Livesendung ohne ihn. Ich habe nur deshalb keinen Herzinfarkt bekommen, weil ich damals erst 52 Jahre alt war. Bei allen drei Sendungen war das Geschehen im Kontrollraum eigentlich interessanter als die Show selbst. Wer war der Verantwortliche??? Wessen Sendung war das eigentlich??? Ich weiß es nicht. Ich werde meine letzte Fernsehsendung am 31. Dezember 1999 machen, also sollte ich gesund bleiben. Glücklicherweise kam 1982 Paul Garrin erst zu mir, nachdem ich die Vorbereitungen für die Ausstellung im Whitney Museum bereits beendet hatte, sonst hätte er wohl auch meine Whitney-Ausstellung für sich beansprucht, aber zumindest diese habe ich alleine gemacht. Shigeko lernte ihn in den Anthology Film Archives kennen, wo er für 1,25 Dollar die Stunde arbeitete. Ich gab ihm den Auftrag, meine Schuhe zu reparieren, und das hat er ganz gut gemacht. Dann fand ich heraus, daß dieser 25-jährige Student von der Cooper Union eine seltsame Begabung hatte. Er kaufte ein Auto vom Schrottplatz für 75 Dollar, reparierte es, fuhr es drei Jahre und verkaufte es dann wieder für 300 Dollar. Der Super-Techniker John Godfrey hatte das gleiche Talent. Er kaufte einen alten Rolls Royce Silverghost für 7000 Dollar, möbelte ihn wieder auf und vermietete ihn an die Filmindustrie. Einmal chauffierte Ruth Bonomo Godfrey darin Woody Allen. Später verkaufte er den Rolls dann für 50000 Dollar. Auf diese Art hat er sechs Rolls Royces erstanden und ein großes Herrenhaus mit sechs leerstehenden Pferdeställen gekauft; er wurde der erste Millionär des experimentellen Fernsehens.

"Adio"

Meine Zusammenarbeit mit Paul Garrin jedenfalls ist wie die Improvisation eines vierköpfigen Jazzensembles. Die erste Tenorstimme ist ein digitaler Effektgenerator … "Adio" – "Mirage" – "Kaleidoscope" – "Harry" etc. … Diese schnellen analogen Bildwandler sind Nebenprodukte der Raketenabwehr und kommen oft von Herstellern, die auch die großen Raketenbasen in England und Kanada beliefern. Ohne die gleichzeitige militärische und zivile Nutzung würde niemand die Kosten für eine Technologie zahlen können, die alle vier Jahre schon wieder überholt ist. Wenn die erste Tenorstimme eine neue Maschine ist, so ist Paul Garrin der Sopran, der diese mindestens 200mal so schnell bedienen kann wie ich, d. h. er kann aus einer Maschine, die 1000 Dollar in der Stunde kostet, 200mal mehr herausholen als ich. Die erste Altstimme ist der Haus-Techniker von Broadway Video, der sich sehr gut mit Maschinen auskennt, aber noch keine Gelegenheit hatte, seine Phantasie einzusetzen und dazu verdonnert ist, die üblichen Werbespots zu machen. Diese Männer sind wie frustrierte Piloten, die eine F 16 nur mit der Geschwindigkeit eines alten Starfightermodells fliegen dürfen. Sie arbeiten gut zusammen und bringen es zu erstaunlichen Ergebnissen. Jonathan Howard und Mr. Applebaum haben etwas produziert, das wir auch nach sechs Jahren noch nicht nachbauen können. Diese Star-Editoren sind die Testpiloten aus den Tagen der Gebrüder Wright. Sie stehen an der Spitze der Branche. Worin besteht meine Rolle?? Dieser alte Mann ist nur ein Cheerleader, der um Mitternacht fetten Käsekuchen und Diätlimonade, und um drei Uhr Nachts doppelten Espresso bringt. Seit 1987 arbeiten wir mit digitalisiertem Video. Als erstes verwendeten wir die 3F-Technik aus Freiburg im Breisgau. Die

Leihgebühr betrug DM 1000,– pro Tag und für die 100 Tage der documenta mußten Dr. Schneckenburger und ich DM 100000,– ausspucken.

Seit "Image World" im Whitney Museum 1989 können wir mit Sinsung Electronics in Seoul zusammenarbeiten. Sie versorgen uns nicht nur mit preiswerter Hardware, sondern auch mit phantasievollen Programmen. Oh Seh Hun, Lee Jung Dung und Cho Sung Ku entwickelten weitere digitale Schaltvorrichtungen. Für den Bereich der digitalen Bilderfassung gilt mein Dank vor allem Rebecca Allen (U.C.L.A.), die mir ihre "Kraftwerke Computer-Graphiken" zur Verfügung stellte; sie sind das Ergebnis eineinhalbjähriger handwerklicher und intellektueller Schwerstarbeit. Dieses Band war überaus wichtig für das Gelingen von "Imageworld" im Whitney Museum. Sie hatte eine Engelsgeduld, obwohl ich meistens die Lorbeeren erntete. Von langfristiger Bedeutung ist jedoch die Tatsache, daß mir Hans Donner, Judson Rosebusch und Dean Winkler, drei führende Computer-Graphiker, erlaubten, kostenlos ihre Software zu benutzen. Das entspricht einem Gegenwert von fünf Millionen Dollar und ist nur möglich, weil ich in New York lebe.

Meine Laserarbeiten sind eigentlich gar nicht meine Laserarbeiten. Sie stammen zu 50% von Horst Baumann und zu 30% von Paul Earl (MIT Center for Advanced Visual Study). Ich habe nur die cartoonartigen Figuren von Cunningham ausgewählt. Vielleicht werde ich beim nächsten Mal einfach Donald Duck nehmen. Ich bin gespannt, was mein neuer Laser-Mitarbeiter Norman Ballard mitbringen wird. In Cincinnati haben wir eine Struktur wie in Hollywood. Unser Cecil de Mille ist Carl Solway. Ich bin Hitchcock, Marc Patsfall ist der Casting Director (unbesungener Held in Hollywood und Cincinnati) … und unsere Stars sind Lizzi (Rita Hayworth), Marcello (eine Kreuzung aus Audrey und Katherine Hepburn), Bryant (Brando), Bill (Clark Gable), Chris (H. Bogard), Curt (James Mason) und Steve (de Niro). Medienkunst ist zu komplex, als daß sie von einem alleine gemacht werden könnte, und in New York oder Düsseldorf spielten Jochen Saueracker, John McEvers, John Huffman, Glen Downing, Blair Thurman und Thomas Countey ebensowichtige Rollen, sowohl handwerklich als auch bei der Entwicklung neuer Ideen.

Last but not least … Shigeko Kubota. Nach all den vielen langen Gesprächen ist es nicht mehr möglich, zu sagen, wer welche Idee zuerst gehabt hat. Deswegen haben wir a priori eine Demarkationslinie gezogen … ihr gehört Marcel Duchamp, John Cage in Bremen, Glass, Plastic und The Concept of Death. Ich versuche, diese Linie nicht zu überschreiten. Die Welt ist groß genug für zwei Video-Künstler.

P. S. Vor kurzem gab mir Ulrike Oettinger die Erlaubnis, ihr drei-Stunden-Epos "Jeanne d'Arc der Mongolei" zu verwenden, und ich danke 100 großartigen Performern, für ihre Mitarbeit an den letzten 15 Fernsehshows. Sie sind auf viele verschiedene Museumsinstallationen verteilt. Ich muß diese Leute alle eines Tages bezahlen.

Aus dem Amerikanischen von Birgit Herbst

YONGWOO LEE
NAM JUNE PAIKS JUGENDJAHRE

Das umfangreiche Werk Nam June Paiks ist aus den unterschiedlichsten Blickwinkeln untersucht worden, doch man hat kaum je gefragt, woher seine künstlerische Sensibilität kommt und wie er seine Jugendjahre verbrachte – Jahre, die für einen Künstler sehr wichtig sind. So ist zwar viel über Nam June Paiks künstlerische Tätigkeit geschrieben worden, die Wurzeln seiner künstlerischen Anschauungen blieben dabei jedoch bedauerlicherweise außer acht. Die wichtigsten Etappen im Leben des in Korea geborenen Künstlers sind der Studienabschluß an der Universität Tokio und seine Reise nach Deutschland zur musikalischen Weiterbildung. Seine Kunst aber wurzelt in jenen Erfahrungen, die er in seiner Jugend in Korea machte, noch vor dem Studienbeginn in Tokio. Erstaunlicherweise prägen sie bis heute sein Wirken. Nam June Paik ist kein Chauvinist oder Nationalist, er gilt als ein Künstler, der – so die Sprache der Kunstbranche – die Fähigkeit besitzt, das Interesse eines breiten Publikums auf sich zu ziehen. Diese Anziehungskraft liegt in der einmaligen Begabung, die er in seiner Jugend entwickelte, sie resultiert aus seinen ursprünglichen Visionen und Ideen, die in seine Kunst eingeflossen sind.

Das folgenreichste Ereignis in Nam June Paiks Jugend war die Entdeckung der Musik Arnold Schönbergs. Sie eröffnete dem 16 Jahre alten Schüler der Kyunggi High School – damals eine der erlesensten Ausbildungsstätten Koreas – 1947 völlig neue Perspektiven. Japanische Tonaufnahmen hatten Paik erstmals mit Schönberg in Berührung gebracht, und sofort war er fasziniert von atonaler Musik und Zwölftonsystem – beides Dinge, die in Fernost praktisch unbekannt waren. Die Tatsache, daß Paik bereits damals Schönberg für sich entdeckte, erstaunt um so mehr, als das Korea der Nachkriegszeit sich eben erst von der 36 Jahre währenden Herrschaft Japans gelöst hatte. Für Nam June Paik jedenfalls öffneten sich durch Schönbergs Musik neue Welten der Musik und der Kunst. Während Schönberg zum Judentum konvertierte, empfing Paik die Taufe der neuen Musik; er bereitete sich auf den Sprung in die neu entdeckte Welt vor. Die Entdeckung Schönbergs durch Paik wurde durch seine beiden koreanischen

Musiklehrer begünstigt: den Pianisten Jae-duk Shin und den Komponisten Keun-woo Lee. Sie erkannten das künstlerische Können, ja das Genie ihres jungen Schülers und ermutigten Paik, seine lebhafte Fantasie und seine technische Fertigkeit weiterzuentwickeln. Jae-duk Shin vermittelte dem Schüler der Kyunggi High School eine solide Grundlage im Komponieren sowohl für Klavier als auch für Singstimmen. Mit seinem Interesse für die neue Musik lockte Keun-woo Lee Paik auf das Gebiet neuer Kompositionen. Dessen erstes Werk datiert von 1946, zwei Jahre zuvor hatte er seine beiden Mentoren kennengelernt. Die Komposition ist verschollen, doch Paik erinnert sich an den Titel, "My Elegy", und an zwei Silben. Die zweite Komposition, die zwischen 1947 und 1948 entstand, ist die viersilbige Vertonung des Gedichtes "A Song – Nostalgia" des linken Dichters Pyeok-am Cho. Das Gedicht beschwört auf eindringliche Weise die Heimatstadt des Dichters herauf:

Wenn nur Dunkelheit fiele – dann käme diese einsame Reise zu einem Ende, so rasch wie das Wasser, das durch die Kiemen des Fisches fließt. Heute spiegelten sich im Fenster des Zuges meine Einsamkeit und Melancholie. Wie ein neu geborenes Kalb, suchend und nervös, sehne ich mich nach der Heimat, nach einem nebelhaften Dorf, einem dunklen, behaglichen Dorf.
Ein warmes Nest, hineinzufliegen und sich niederzulassen.

Die Komposition ging im Korea-Krieg verloren, doch Paik konnte die Partitur aus dem Gedächtnis rekonstruieren. Die Vertonung der Gedichte von Young-hun Jin, eines sog befreundeten Klassenkameraden an der Kyunggi High School, ging ebenfalls verloren. Young-hun Jin glaubt sich zu erinnern, Paik habe drei seiner Gedichte vertont; ihm zufolge waren es populäre Lieder, die aber dennoch deutlich avantgardistische Töne aufwiesen.

Mit der Befreiung aus der 36 Jahre langen japanischen Kolonialherrschaft vertiefte sich bei zunehmender gesellschaftlicher Unruhe der ideologische Konflikt zwischen Linken und Rechten. Die linken Ideen, die damals in intellektuellen Kreisen kursierten, nahmen Einfluß auf Nam June Paik. In seiner Jugend bewunderte er neben Jae-duk Shin und Keunwoo Lee den linken Komponisten Sun-nam Kim; die Suche nach neuer Musik, die mit Schönberg begonnen hatte, reizte ihn nach wie vor. Daneben interessierten ihn Bücher über den Marxismus, die er in den Antiquariaten von Insa-dong, dem Kunst- und Antiquitäten-Zentrum von Seoul, fand. Karl Marx und Arnold Schönberg wurden Nam June Paiks Idole, doch die Wirklichkeit war bestimmt von seinen Mentoren, Jae-duk Shin und Keun-woo Lee. Es ist nicht von Belang, inwieweit Paik überhaupt imstande gewesen ist, Schönbergs Musik zu verstehen und zu würdigen – auf jeden Fall fesselte ihn die atonale Musik, die in der Spätromantik für das Streichquartett entwickelt worden war. Damals geriet das Zwölftonsystem in sein Blickfeld, und der beinahe totale Verzicht auf Wiederholungen in der atonalen Musik muß auf Paik seltsam und aufregend gewirkt haben. Selbst jetzt versteht Nam June Paik die Musik Schönbergs nur teilweise, und es ist ein Erfolgserlebnis für ihn, daß er sie überhaupt spielen kann. Paik hat nicht so sehr Ehrfurcht vor Schönberg; er spielt auf sein eigenes "Heimweh" an, wenn er Schönberg als eine Metapher für die Variation über ein Thema verwendet, das in der zeitgenössischen Musik ebenso vorkommt wie bei Fluxus und Videokunst und Spiegelbild. Auf seiner ersten Ausstellung in der Wuppertaler Galerie Parnass spiegelte sich in dem Werk "Random Access" Schönbergs Theorie der strukturellen Funktion von Harmonie. Von den unterschiedlichen musikalischen Kompositionsformen erinnert das Zwölftonsystem am stärksten an den freien Fluß menschlichen Bewußtseins. Wäre Nam June Paik 1949 nicht nach Hong Kong gegangen, hätte er möglicherweise ein tieferes Verständnis für Schönberg entwickelt. Tatsächlich endeten Paiks Jugendjahre, als er an die Loyden School in Hong Kong ging, und bei seiner Rückkehr nach Korea 1950 war es ihm wegen des Ausbruchs des Korea-Krieges nicht möglich, seine künstlerische Karriere fortzusetzen.

Nam June Paik entstammt einer sehr wohlhabenden Familie, die mit der Taechang Textile Company ein großes Textilwerk besaß, das unter japanischer Kolonialherrschaft gegründet worden war. Paik war das jüngste von fünf Kindern, und vom Kindergarten bis zur High School erhielt er die bestmögliche Erziehung und Ausbildung. Kindheit und frühe Jugend waren von einer japanisch bestimmten Erziehung geprägt. Mit vierzehn Jahren aber, in der fieberhaften Atmosphäre des eben befreiten Korea, zeigte sich sein Interesse und seine Begabung für die Kunst. Die Spanne bis zum achtzehnten Lebensjahr war besonders wichtig für Paik, sie nährt bis heute seine künstlerische Produktion. Daran erinnern zahlreiche Elemente seiner Kunst: das asiatische Einfühlungsvermögen, das in den Augen westlicher Betrachter häufig wie Ironie und Witz wirkt; die Anspielungen auf die fernöstliche Philosophie eines der Alltagswelt entrückten, bewußten Lebens; die koreanischen Motive und Symbole.

In dem Werk "Two Teachers" von 1991 verwendet Nam June Paik Erläuterungen zu Jae-duk Shin und John Cage. An Jae-duk Shin erinnert Paik mit den humorvollen Worten: "Wenn Frau Shin die Zither (yanggeum) spielte, mußte ich herumblödeln ..." Und der Kommentar zu Cage: "Cage heißt im Englischen Vogelkäfig, aber er hat mich nicht eingesperrt, sondern befreit." In dieser Arbeit kehrt Paik zurück zu der Empfindsamkeit seiner frühen Jahre, er entwirft in Gestalt einer Video-Skulptur ein Bild von der Beziehung zwischen Sprache und Karma.

In der Zeit, als Paik Schönberg entdeckte, nahm er Unterricht bei Jae-duk Shin (1946–1950) und Keun-woo Lee (1947–1949) – das heißt, seine Kunst war zunächst ganz auf die Musik ausgerichtet. Auf die Bedeutung der beiden Lehrer

für die Entdeckung und Aneignung der chaotischen Werke Schönbergs – noch ein Jahr vor Milton Babbit – wurde bereits hingewiesen. Beide waren seit Anfang der dreißiger Jahre Musiker. Shin wurde die erste koreanische Berufs-Pianistin, später war sie Dekan der Musikfakultät an der Frauenuniversität Ewha in Seoul. Sie starb 1989. Keun-woo Lee führte mit Sun-nam Kim avantgardistische Musik in Korea ein, beide gelten als Hüter und Förderer zeitgenössischer Musik. Eine besonders glückliche Fügung brachte Paik mit diesen beiden Mentoren zusammen. Shin und Lee hatten zwar ihre Ausbildung während der Kolonialzeit erhalten, doch sie wurden allmählich zu den führenden Gestalten eines "nationalen Musikunterrichts". Mit Sun-nam Kim ist Paik nie zusammengetroffen; dieser außergewöhnliche Komponist war jedem japanischen Kollegen der Zeit ebenbürtig und beeinflußte Yisang Yun, einen in Korea geborenen und in Berlin tätigen Komponisten.

Paik entdeckte Schönberg ein Jahr vor Milton Babbit, der nachmaligen führenden Autorität der Schönberg-Forschung in Princeton – das zeugt von dem künstlerischen Bewußtsein und der schöpferischen Freiheit Koreas im bewegten Jahr 1947.

Nam June Paik ging nach Japan und studierte Komposition bei Nomura Yoshio, Moroi Saburo und Shikaishi Aki-O. Sein wahres Interesse aber galt Schönberg als einer "Erweiterung Koreas". Der Titel seiner Abschlußarbeit an der Universität Tokio lautete denn auch "Untersuchungen zu Arnold Schönberg".

Aus dem Amerikanischen von Frank Druffner

PIERRE RESTANY
NAM JUNE PAIK UND DIE KULTURELLE ERNEUERUNG IM DEUTSCHLAND DER FÜNFZIGER JAHRE

Nam June Paik kam 1956 im Alter von 24 Jahren nach Deutschland. Er hatte Seoul mit seiner Familie 1950 während des Korea-Kriegs verlassen und nach einem kurzen Aufenthalt in Honkong Ästhetik und Musikgeschichte an der Universität Tokio studiert; Gegenstand seiner Abschlußarbeit war Arnold Schönberg.

Als der junge Musikwissenschaftler auf dem Weg über Kalkutta und Kairo in Europa ankam, fand er Westdeutschland mitten im Wiederaufbau und in einem Zustand kreativer Gärung. Dabei überraschte ihn zuerst nach seinen Erfahrungen in Tokio das Fehlen eines kulturellen Zentrums und die starke Zerstreuung des kulturellen Lebens. "Ich studierte in München", sagte er 1959 zu Gottfried Michael König und später auch anderen gegenüber, "und ließ mir, der ich von der 'Neuen Musik' begeistert war, sagen, daß in den Darmstädter Ferienkursen, an der Freiburger Musikhochschule und im dortigen Musikstudio, im Kölner Studio für elektronische Musik, in den Düsseldorfer Galerien viele interessante Dinge geschähen ..."

Diese weitreichende kulturelle Dezentralisation, verbunden mit einem Austausch zwischen der "Neuen Musik" und der Avantgardekunst, schuf ein Klima, das für die Persönlichkeitsentfaltung Nam June Paiks außerordentlich günstig war. Seine häufigen Umzüge in die Kunstzentren des Ruhrgebiets machten ihn gleichsam zu einem Nomaden, zu einem Menschen des Überall und des Nirgendwo, der gleichwohl dazusein verstand, wenn es nötig war. Auch heute noch bleibt er, obwohl er mittlerweile in New York lebt, wiederum feste Beziehungen nach Japan und Korea geknüpft hat und die Welt in jeder Hinsicht durchreist, seiner Professur an der Düsseldorfer Kunstakademie verbunden, auf die er unter dem Direktorat des Plastikers Norbert Kricke berufen worden war. Gewiß sind seine Unterrichtsmethoden nicht gerade orthodox, doch seine Schüler schwärmen für den weitgereisten Professor. Einmal abgesehen davon, daß die Bindung an die Akademie zugleich eine Verbundenheit mit dem Rheinland bezeugt, gibt sie ihm eine Art sozialer Sicherheit: "Ich kehre gerne regelmäßig in ein Land zurück, in dem es die Leute normal finden, mich als 'Professor Paik' anzureden", hat er kürzlich Otto Piene auf die Frage geantwortet, welche Bedeutung für ihn der Unterricht an der Kunstakademie habe.

Das für Nam June Paik entscheidende Ereignis war die Begegnung mit Karlheinz Stockhausen während der "Internationalen Ferienkurse für Neue Musik" 1957 in Darmstadt. Durch Stockhausen eröffnete sich für ihn die Perspektive eines neuen, gleichermaßen kreativen und existentiellen Raums: elektronisches Experimentieren, eine "objektive" Beziehung zum Instrument, Kontakte mit der Kunst der Avantgarde ... Diese Welt wurde zu seiner eigenen. Er zog 1958 nach Köln in die Aachenerstraße; in der Nähe wohnte Stockhausen, aber auch die Künstlerin Mary Bauermeister, die damalige Frau Stockhausens, deren Studio zum Ort mehrerer Performances Nam June Paiks wurde. Außerdem gab es dort das Studio für elektronische Musik im WDR, in dem er arbeiten konnte, die Galerie Lauhus, wo Christo 1961 seine "Monuments temporaires de bidons" ausstellte und wo Paik selbst sich an den "Spontanen Performances" Wolf Vostells und Stefan Wewerkas beteiligte.

Auf solche Weise entwickelte Nam June Paik im Kontakt mit diesem experimentellen deutschen Mikrokosmos eine Art von Prä-Fluxus-Persönlichkeit, die auf

5

einer ihm eigentümlichen Hinneigung zur Überschreitung der orthodoxen Ausdrucksgenres beruhte, auf einer genuin "expansiven" Anschauung der Künste. Als er 1961 George Maciunas kennenlernte, bedeutete seine Annäherung an den Geist des Fluxus-New York nur die Bekräftigung einer reinen Evidenz. Inzwischen hatte er, wiederum im Rahmen der Darmstädter Ferienkurse, 1958 John Cage und David Tudor kennengelernt. Damit fand der junge Guru seinen Meister. Seinen Jubel drückte er in begeisterten Artikeln aus, die er aus Köln an japanische und koreanische Zeitschriften schickte. Die Titel sprechen für sich: "The Bauhaus of Music", "The Music of 20,5 century". Das Rheinland wurde sein Bauhaus in musikalischer Hinsicht. Die Galerie 22 (Kaiserstraße 22) in Düsseldorf, geleitet von Jean-Pierre Wilhelm, schlug eine echte kulturelle Brücke zwischen Paris, Düsseldorf und Mailand. Wie bei vielen Intellektuellen dieser Zeit, angefangen bei seinem Freund Manfred de la Motte, galt seine Leidenschaft ebenso dem Informel wie der "Neuen Musik". Anläßlich einer Vernissage Hans-Egon Kalinowskis lud J.-P. Wilhelm Nam June Paik ein, der dort seine erste Hommage für John Cage, die "Musik für Tönbänder und Klavier", aufführte. Diese Hommage ist, genau genommen, ein stilistisches Manifest, das Modell seiner künftigen Performances: eine Montage von Aktionen und Objekten, eine Collage der Gesten und der Töne, für die die Musik den physischen Katalysator oder die algebraische Diskriminante darstellt. Alle, die wie ich Nam June Paik bei dieser Gelegenheit kennengelernt haben, waren verblüfft über die leidenschaftliche Spannung, die der Künstler während der Aktion ausstrahlte. Nam June Paik hatte seine eigene Sprache gefunden, er drückte sich durch ein absolutes Engagement im (Er-)Leben aus.
Die Hommage für John Cage wurde mit einigen Varianten 1960 in Mary Bauermeisters Kölner Atelier wiederholt, 1961 in Skandinavien an verschiedenen Orten in das Programm "d'aktion music" integriert und 1962 wieder während des Wiesbadener Fluxus-Festivals. Zwischen 1961 und 1963 beteiligte sich Nam June Paik an der Seite Macunias' und unter der Fürsprache John Cages an dem deutschen Austausch mit der New Yorker Fluxus-Bewegung. Stockhausen bot ihm einen autonomen Raum, "Zen for Head", bei seiner Aufführung "Originale" im Kölner Domtheater an (26. 10.–6. 11. 1991). Er fügte die Musik von La Monte Young in seine Beteiligung an "Neo-Dada in der Musik" (Düsseldorf 1962) ein. 1962 war für Paik ebenso das Jahr von Alison Knowles! Er widmete ihr eine Serenade, die in Amsterdam gespielt wurde, und einen dithyrambischen Artikel in Vostells Zeitschrift "Dé-coll/age", deren ständiger Mitarbeiter er bis 1964 blieb.
Die Krönung der Glanzpunkt der deutschen Periode ist die "Exposition of Music-Electronic Television", die im März 1963 in der Wuppertaler Galerie Parnass stattfand, eine wahrhaft umfassende Collage der Expressivität dieses "Action-Musikers", der Nam June Paik ist. Direktor dieser Galerie, die seit 1951 ein auf der École de Paris basierendes Programm des internationalen Austausches gestaltete, war Rolf Jährling. Um 1963 gehörte er zur Spitze der Vorreiter der zeitgenössischen Kunst: 1955 hatte die erste documenta in Kassel stattgefunden, die Galerie Schmela in Düsseldorf hatte 1960 mit dem Blau von Yves Klein eröffnet, und Jährling war die geistige Führungsgestalt unter den progressiven Galerien, von denen die Düsseldorfer Galerie 22 und die Galerie Vertiko in Bonn am einflußreichsten waren. Insofern kam seine Einladung Paiks ganz einfach einer Einführung in die kreative deutsche Szene gleich. Thomas Schmit, der Teilnehmer und zugleich Beobachter dieses Ereignisses war, war sich dessen seinerzeit bereits sehr bewußt. Ebenso Macunias: er hatte bereits mit Paik und Patterson 1962 an einem "Kleinen Sommerfest" in der Galerie Parnass teilgenommen. Die Resonanz dieser "Exposition of Music" wurde von allen internationalen Fluxus-Bewegungen aufgenommen und verbreitete sich im Inneren der weltweiten Avantgarde.
Nam June Paik konnte dann nach Japan zurückkehren und sich seit 1964 in New York einrichten. Der westdeutsche kulturelle Mikrokosmos der fünfziger Jahre hatte ihn auf die Bahn gebracht: Er war 1956 gerade im richtigen Moment angekommen, mitten in der Gärung des künstlerisch-musikalischen Experimentierens im Rheinland, das sich im grundlegenden Wiederaufbau befand und das Ende des Informel, das Auftauchen des Nouveau Réalisme sowie des Fluxus einige Zeit vor der Pop Art erlebte. Sein Werdegang seitdem ist vorgezeichnet: der Roboter mit Shuya Abe in Japan, die Begegnung mit Charlotte Moorman in New York, der Gebrauch der ersten Port-a-pack-Videokamera 1965 ... und damit befinden wir uns erst im Jahr 1965!

Aus dem Französischen von Reinhard Loock

GRACE GLUECK
DIE WELT IST SO LANGWEILIG

Manche Leute glauben, Nam June Paik sei das Beste, was dem Fernsehen passieren konnte. Durch Elektromagneten und Signalablenkung verzerrt er Bilder auf dem Monitor, läßt Darsteller zu schillernden Pfützen verschmelzen, verwandelt Deodorant-Werbung in Op-Art und Quizsendungen in impressionistische Landschaft.
"Ich wollte immer die Elektronik in die visuelle Kunst integrieren", sagte Paik kürzlich, als er einen klotzigen Elektromagneten über den Bildschirm eines Farbfernsehers zog, dessen Innenleben er bereits "angepaßt" hatte. Auf dem

Bildschirm explodierte ein zuckendes, halbmondförmiges Samenkorn und wurde zu einer geometrischen Blume. "Die Bilder, die ich hier herstelle, sind 'ästhetisch' genauso wertvoll wie ein Gemälde. Elektronik ist ihrem Wesen nach orientalisch – leicht und flexibel. Übrigens darf man 'elektronisch' nicht mit 'elektrisch' verwechseln, wie es McLuhan oft tut. Elektrizität hat mit Masse und Gewicht zu tun. Bei der Elektronik geht es um Information, die keine Gravität besitzt. Das eine sind Muskeln, das andere sind Nerven." Der vor 36 Jahren in Korea geborene Paik ist ein Mann mit einem enormen Input, der selbst schon viele Daten verarbeitet hat. Er studierte Ästhetik, Kunstgeschichte, Musik und Philosophie an japanischen und deutschen Universitäten und hat sich nebenbei fünf Sprachen (neben seiner eigenen) angeeignet. Mit dem deutschen Elektronik-Musiker Karlheinz Stockhausen hat er im elektronischen Studio des WDR in Köln experimentiert. Er ist einer der wenigen Technologie-orientierten Künstler, die selbst Hand anlegen können. Mit Hilfe eines Stipendiums der Rockefeller-Foundation untersucht er zur Zeit am Stony Brook Campus der New York State University Möglichkeiten, elektronische Medien im Unterricht einzusetzen.
Die Karriere des "TV-Terroristen", der Happenings, Mixed Media Shows und im ganzen Land Konzerte mit der hinreißenden Cellistin Charlotte Moorman veranstaltet hat, begann in Deutschland. Er zertrümmerte Klaviere bei Aufführungen seiner "Aktionsmusik", die "vom europäischen Musik-Establishment erstickt" wurde, wie er erklärt. Als Mann seiner Zeit hat er später Steinway gegen Sony eingetauscht und in das Zeitalter der Elektronik umgeschaltet.
Paik sagt, seine derzeitige Ausstellung in der Galeria Bonino könnte vielleicht seine letzte sein. Er plant, sich in den nächsten Jahren der Forschung zu widmen und eine Art elektronisches Esperanto zu entwickeln, eine computergesteuerte Weltsprache. "Eine bessere Kommunikation zwischen den Völkern ist so viel wichtiger als Menschen auf den Mond zu schicken. Das Weltraumprojekt ist Selbstbetrug, wie Heroin. Dadurch ändert sich gar nichts für uns."
Paik hat viele elektronische Visionen. Dazu gehören erstens die "Instant Global University", eine Universität, aus deren computergesteuerter Bibliothek Videotapes ausgeliehen werden können, die alles lehren – von der Astronomie für Fortgeschrittene bis zum Koto-Spiel, zweitens Filmaufzeichnungen für die Nachwelt von Worten und Taten berühmter Zeitgenossen (Duchamp, Sartre, Bertrand Russell), und drittens will er unter der Mitarbeit von Künstlern Computer mit "Persönlichkeit" entwickeln, die als Lehrer eingesetzt die Schüler während des Unterrichts bei Laune halten sollen.
"Die Welt ist so langweilig", seufzt er. "Ich muß mir ständig etwas Neues einfallen lassen, damit es spannend bleibt." (Erschienen in: The New York Times, Art Notes, 5. Mai 1968)

Aus dem Amerikanischen von Birgit Herbst

DAVID BOURDON
KONTAKTAUFNAHME MIT CHARLOTTE – EINE ODYSSEE DURCH DEN ÄTHER

"Haben Sie schon von der Explosion im World Trade Center gehört?" Ich war zum Essen verabredet und verließ eben meinen Wohnblock im Zentrum von Manhattan, als Nachbarn mit diese Frage stellten. Es ist Freitag, der 26. Februar, und die Situation ist kritisch: zahlreiche Menschen wurden verletzt, die Untergrundbahnen sind lahmgelegt. Als ich wieder daheim bin, schalte ich den Fernseher ein, um die Abendnachrichten zu hören – und muß feststellen, daß ich nur das zweite Programm empfange. In der Stadt herrscht praktisch eine Art Fernsehsperre, denn die meisten Stationen haben ihre Umsetzer auf der Spitze des World Trade Center. Nur Kanal 2 bleibt auf Sendung, da er vom Empire State Building ausstrahlt. Ich traue meinen Augen nicht und springe von einem Sender zum nächsten. Doch anstatt der verschiedenen Programme auf den Kanälen 4, 5, 7, 9, 11 und 13 sehe ich lediglich eine schwarze Mattscheibe, über die geisterhaft weiße Fusseln flirren, begleitet von einem brummenden Störton.
Mein enttäuschter Blick fällt auf eine Videocassette, die mir kürzlich Nam June Paik zugesandt hat und die ich nun in den Videorecorder einlege: Paik zeigt mich als Redner auf einer Gedenkveranstaltung für den Kunstkritiker Gregory Battcock, einen geistsprühenden Bonvivant, der uns mit seiner guten Laune förmlich überschwemmte. Die Veranstaltung war von Paik selbst organisiert worden und fand vor über 10 Jahren in Soho statt. Sie endete damit, daß Charlotte Moorman, unsere charmante Freundin, traurig auf ihrem Cello spielte – während sie auf der Motorhaube eines Wagens langsam durch die Gegend gefahren wurde. Gregory hatte sich Weihnachten 1980 auf seine letzte Reise begeben (sein Mörder wurde nie gefaßt), und Charlotte entschwand am 8. November 1991 in einem letzten Glissando in die Stratosphäre. Der Tod der beiden hat unserem Leben etwas von seiner befreienden Leichtigkeit genommen. Viel lieber wäre mir jetzt ein Videoband über Charlotte und Greogry als über mich selbst – die Nahaufnahme von unten ist nicht gerade vorteilhaft. Aber habe ich nicht Paiks Performance erlebt, bei denen er Klaviere malträtierte und Violinen in 1000 Stücke schlug? Weshalb sollte er da Rücksicht auf mein Gesicht nehmen?
Ich schalte zurück in die gestörten Programme, springe erneut von einem Kanal zum andern. Die vibrierenden Muster und der tiefe Baß des Brummens wirken

allmählich hypnotisierend. Ich fühle mich schwach und verwirrt und nehme körperlose Stimmen und klapprige Geister wahr, die sich in den halbdunklen Zonen des Bildschirms tummeln. Plötzlich ein unkontrollierbares Zucken meiner Augenlider – ich verliere für kurze Zeit das Bewußtsein.

Das Geklimper von Münzen, mit denen etwas ausgelost wird, weckt mich aus meiner Ohnmacht. Es wird begleitet von einer knarrenden, monotonen Stimme; sie klingt wie ein rostiges Gartentor, das nach Öl schreit. Ich blicke auf und erkenne auf dem Bildschirm eine sonderbare Form, die sich allmählich zu dem dünnen, bärtigen Gesicht eines Mannes verdichtet. "Ich habe das I Ging befragt", sagt er, "und zufällig hat eine meiner Münzen die Antenne auf dem World Trade Center getroffen." Sein Lachen zeigt an, daß dies eine witzige Anspielung auf die Gabe ist, durch Zufall unerwartete Ergebnisse zu erzielen. Jetzt erst wird mir klar, daß es sich um John Cage handelt. "Welch unerwartetes Vergnügen", entgegne ich mit gespielter Ungezwungenheit – eine innere Stimme fragt unheilvoll: "Ist er nicht letzten August gestorben?" "Bist Du im Himmel?", frage ich.

"Ich glaube nicht", antwortet er, "denn ich lerne nach wie vor Kontrapunkt bei Arnold Schönberg. So hab' ich angefangen vor fast 60 Jahren in Los Angeles. Dann, als ich Schönbergs Regeln des Kontrapunkts befolgte, sagte er: 'Warum nimmst Du Dir nicht ein bißchen mehr Freiheiten heraus?' Und als ich mir Freiheiten herausnahm, sagte er: 'Kennst Du eigentlich nicht die Regeln?' Durch Zufall bin ich zum Gewährsmann von Nam June Paik geworden, der sich an mich heranpirschte, als er an seiner Arbeit über Schönberg schrieb. Paik war mit seinem eigenen 12-Stufen-Programm beschäftigt, mit dessen Hilfe er sich aus der Abhängigkeit von musikalischen Überlieferungen und Krawatten lösen wollte." "Hat Paik verstanden, was Du getan hast?", fragte ich. "In Wahrheit wissen wir nicht, was wir tun, und genau deshalb schaffen wir es, etwas Aufregendes zu vollbringen. Mein Rat an die Fans von Paik: tragt in Düsseldorf stets Krawatte." "Düsseldorf? Wer spricht hier von Düsseldorf?" Ich höre eine zweite Stimme. Verschwommen erscheint ein eindrucksvolles, ausgemergeltes Gesicht in Nahaufnahme. Ist das Lon Chaney in seiner Rolle als Phantom der Oper? Nein, es ist Joseph Beuys! Ich frage mich, ob er seit Januar 1986 den Erdball umkreist hat. "Ich mag Paik und Paik mag mich", verkündet er laut. Ich will Beuys fragen, weshalb er auf einer Wuppertaler Ausstellung 1963 mit einer Axt auf eines von Paiks präparierten Klavieren losgegangen ist – aber ich schrecke davor zurück (zumal er die Axt noch immer haben könnte).

"Professor Beuys, heute einen Rat für Paik?"

"Paik sollte den Abschnitt seiner Biographie während des Korea-Kriegs aufpolieren. Das Publikum will nicht hören, wie seine Familie nach Hong Kong flüchtet und sein Vater sich im Geschäft mit Ginseng-Wurzeln versucht. Paik sollte vielmehr erzählen, wie er über Nord-Korea Kampfeinsätze flog und abgeschossen wurde und hinter den feindlichen Linien abstürzte. Er sollte erzählen, wie ihn eine Bauernfamilie gerettet hat, wie sie ihn in Kohlblätter wickelte und in einen Topf mit kimch'i steckte, um die Körpertemperatur zu halten. Es ist egal, ob es Rotkohl oder Weißkohl war: menschliche Güte steht jenseits aller Politik."

Beuys wendet sich ab und geht zu einer Wandtafel. Er nimmt ein Stückchen weiße Kreide und schreibt in übertrieben schnörkeliger Schönschrift: "Ich werde nach der Schule dableiben und Schönschrift üben." Er schreibt diesen Satz wieder und wieder auf Dutzende von Tafeln; sobald er fertig ist, wirft er sie auf den Boden. Das Quietschen der Kreide auf der Tafel ist wie Messerstiche für meine Ohren. Der schrille durchdringende Ton verwandelt sich in das klagende Hin und Her eines Bogens, der langsam über ein Saiteninstrument streicht – auf dem Bildschirm erscheint Charlotte Moorman, Cello spielend. Sie trägt Paiks Fernseh-BH für eine lebende Skulptur mit zwei winzigen Fernsehgeräten. "Hallo, David", sagt sie mit strahlendem Lächeln. "Sag' Paik, daß eine elektromagnetische Störung seinen Fernseh-BH lahmgelegt hat. Ich kann die Fernsehbilder nicht chiffrieren." Arme Charlotte. Durch absurde Performances wurde sie einst zur berüchtigsten Musikerin aus Little Rock in Arkansas. Nun hat sie der Saxophonist Bill Clinton in den Schatten gestellt.

Den ersten Auftritt von Charlotte und Nam June habe ich 1964 erlebt bei einer Aufführung von Stockhausens Originale in der New Yorker Judson Hall. Sie hing an einem Balkongeländer und spielte Cello, während er in einer Badewanne untertauchte. Ihre seltsamen Charaktere ergänzten sich hervorragend.

"Ist es wahr, daß Stockhausen darauf bestand, daß du Originale zusammen mit Paik inszenierst, den Du damals gar nicht kanntest?" "Ja. Meine erste Reaktion war: 'Was ist ein Nam June Paik?' Ich kannte ihn nicht vom König von Korea." Aus dem Fernsehgerät dringt explosionsartiger Lärm, blendend weißes Licht zuckt über den Bildschirm. Dann eine gebieterische Stimme: "Wer ruft den König von Korea?" Der Bildschirm teilt sich am 38. Breitengrad in zwei Hälften, im unteren Sektor erscheint das Gesicht eines Asiaten. Er starrt mich an und blickt dann mißbilligend auf Charlotte, die die obere Hälfte des Bildschirms einnimmt. "Ich bin Sejong", verkündet er stolz. "Weshalb stört man mich?" Obwohl ich sein Gesicht nicht kenne, weiß ich, wer er ist: jener König aus der Yi-Dynastie, der im 15. Jahrhundert die Hangul-Schreibweise entwickelte. Er deutet in Richtung Charlotte und fragt: "Han-gung-mal-lo meo-ra-go hae-yo?" (Wie heißt das auf koreanisch?) Ich stelle ihm Charlotte vor und erkläre, daß sie eine enge Freundin und Kollegin von Paik ist. Er blickt auf ihren BH und sagt mit gerunzelter Stirn: "T'e-re-bi-jyeon an na-wa-yo." (Der Fernseher funktioniert nicht.)

Als nächstes richtet Sejong seinen finsteren Blick auf mich. "Sage Paik Nam-June, daß er ein ungezogener Junge ist, der Schande über seine Landsleute

bringt. Weshalb geht er in der Welt herum und nennt sich 'George Washington der Video-Kunst'? Ist es so viel besser, mit einer japanischen Frau zu leben? Das ist doch eine Schande, oder? Es bringt Schande über koreanische Frauen. Und warum trägt er immer einen Wollschal um den Bauch? Sieht aus wie ein Obi, oder? Vielleicht denkt er, er sei selbst eine japanische Frau? Er ist ein schlechter Junge." Der König schnippt mit den Fingern. "Yeo-bo-se-yo" (Hallo), spricht er in die Kulissen. "Imch'i chom teo chu-se-yo." (Man gebe mir bitte mehr kimch'i.) Sejong entschwindet, und Charlotte erobert den ganzen Bildschirm zurück – zu ihrer großen Erleichterung. "Was für ein unangenehmer Mensch", sagte sie. "Kein Wunder, daß Paik Korea verließ." Ich stelle fest, daß sie ihr Kostüm gewechselt hat und statt des Fernseh-BHs nun zwei kleine Propeller trägt, die irgendwie an ihren nackten Brüsten befestigt sind. "Erinnerst du dich, in welchem Stück ich die getragen habe?" fragt sie.

"Natürlich: 'Opera Sextronique'. Es gab ein furchtbares Geklapper, weil sie das Cello berührten, als du beim Spielen einmal vorgebeugt hast. Für mich war das einer der Höhepunkte des Stücks."

Wie könnte ich diese Ereignis an jenem bedeutenden Abend vergessen. Es war der 9. Februar 1967, Paik inszenierte die Premiere seiner "Oper" in der Cinémathèque, Ecke West und 41. Straße. Ungefähr in der Mitte der Aufführung stürmten ein paar Dutzend Polizisten, viele davon in Zivil, von hinten durch den Zuschauerraum auf die Bühne und ließen den Vorhang fallen. Fassungslos lauschte das Publikum dem gedämpften Geräusch des Handgemenges auf der Bühne. Zwischen dem Vorhang erschien das bekümmerte Gesicht Paiks. Er ließ den Blick über das Publikum schweifen und sah mich in einer der vorderen Reihen. Er wollte, daß ich auf die Bühne komme, um mit den Polizisten zu verhandeln. Wahrscheinlich dachte er, daß ich als Mitherausgeber von Life die Krise meistern könnte. Ich eilte zum seitlichen Aufgang und sah, wie die Polizisten auf der Bühne mit Charlotte rangelten, die unter Tränen um ihren Mantel und ihr Cello flehte. Sofort geriet ich in den Sog des Kampfgetümmels. Charlotte und Nam June wurden wegen Erregung öffentlichen Ärgernisses festgenommen und in einer Eskorte von 16 Polizeiautos weggebracht – offensichtlich hatte die Polizei wesentlich mehr nackte Darsteller erwartet. Am nächsten Tag tauchte die berüchtigte Charlotte in den Revolverblättern auf: als "nackte Cellistin". "Es war so nett von dir, David, vor Gericht zu meinen Gunsten auszusagen, auch wenn der Richter dir die Worte im Mund umgedreht hat, um mich der Unzüchtigkeit zu beschuldigen. Wenigstens hat er mich nicht ins Gefängnis gesteckt. Ich wünschte, Gregory wäre auch dagewesen."

Mit einem lauten, Aufmerksamkeit heischenden Räuspern tritt von rechts Gregory Battcock auf den Bildschirm. Er blickt Charlotte an und sagt: "Meine liebe Charlotte, deine Sache war in dem Augenblick verloren, als David in den Zeugenstand gerufen wurde. Seine Garderobe war wie gewöhnlich unbeschreiblich jammervoll. Welcher Richter würde einem Kunstkritiker Glauben schenken, der ein Polyester-Jacket, ausgestellte Hosen und Thom McAn-Schuhe anhat? Es ist ein Wunder, daß du nicht lebenslänglich bekommen hast! Man kann David einige Charakterschwächen nachsagen, aber am fatalsten ist, daß er nicht mit der italienischen Mode mithalten kann. Hast du ihn jemals in einem Armani-Anzug gesehen?" "Das ist zu teuer", protestiere ich.

"Was hab' ich dir gesagt?" schnaubt Gregory. "Nun, wenn wir als Zeuge ausgesagt hätten, dann hätten wir unseren vestito da festa getragen, vielleicht den Kammgarn-Dreiteiler, dazu ein englisches Maßhemd und einen italienischen Seidenschlips. Und vor unserem Auftritt vor Gericht hätte eine Pressekonferenz bei Delmonico's stattgefunden, auf dem man einen erwähnenswerten Champagner gereicht hätte. Nach der Zeugenaussage hätten wir zu einer kleinen colazione geladen: Prosciutto cotto di Parma, Scampi alla veneziana und Risotto con funghi, dazu Insalata mista di stagione und zum Schluß ein Assortimento di formaggi. Und selbstverständlich hätten wir ein paar Pressephotographen dazugeladen."

"Ich habe die Liste der Photographen zufällig bei mir", sagt Charlotte und schwenkt fröhlich ein paar Zettel. Diese Geste löst im Off das Klicken zahlreicher Kameras aus. Einem besonders vertrauten Klicken folgt das zischende Geräusch eines Polaroids, das sich aus dem Plastikgehäuse würgt. Wen würde es da noch überraschen, daß Andy Warhol auf dem Bildschirm erscheint. "Oh, hi, David, ich bin hier oben im Himmel, und es ist gaaanz fantastisch. Jeder, den du gern kennengelernt hättest, ist da, und die Parties sind großartig. Nächste Woche gibt es einen Empfang bei Lillian Gish und Ruby Keeler."

"Bist du sicher, daß du im Himmel bist?" frage ich, "deine Stimme klingt so erdennah. Es könnte ja sein, daß du und Charlotte und Gregory und Beuys und Cage von irgendeiner seltsamen Wellenlänge am unteren Ende des elektromagnetischen Spektrums festgehalten werdet. Oder vielleicht seid ihr alle in einer Art Luftloch eingeschlossen wie in einer Smogwolke. Es ist seltsam, daß ihr alle eine Beziehung zu Paik habt. Er würde einen Heiligenschein einzig dazu benützen, den Fernsehempfang zu stören."

"Weshalb fragst du ihn nicht selbst?" sagt Andy. "Er ist so nett. Ich liebe seine große Fernsehpyramide in Seoul."

"Du meinst diesen aus 1003 Fernsehgeräten errichteten Zikkurat, den er für das National Museum of Contemporary Art gemacht hat?"

"Ja. Was für eine Idee, dasselbe Bild tausendmal, Reihe für Reihe zu wiederholen. Woher hat er die Idee zu diesem Raster identischer Bilder? Warum fragst du ihn das nicht, David?" "Aber Andy, du bist nicht der einzige Künstler, der solche Raster benutzt hat."

"Frag' ihn trotzdem. Hör', was er sagt." Er verschwindet lautlos.
Als ich wieder zu mir komme, braust auf dem Bildschirm noch immer geisterhafter Schnee. Mein Gedächtnis ist wie betäubt, aber langsam erinnere ich mich, daß ich Nam June Paik ein paar Dinge auszurichten habe. Langsam erkenne ich, daß ich Kontakt aufgenommen hatte. Am Ende hat das New Age auch mich gefunden.

Aus dem Amerikanischen von Frank Druffner

GRACE GLUECK
ÜBER NANDA BONINO

"Wir haben während der ganzen Zeit, in der er bei uns war, nicht eine einzige seiner Arbeiten verkauft, aber die Publicity war es wert!", sagt Fernanda Bonino, Nam June Paiks erste Galeristin in Amerika. "Nanda" Bonino, die mittlerweile Galerien in Rio und Buenos Aires besitzt, eröffnete 1963 mit ihrem Mann Alfredo, der 1981 starb, die elegante Galeria Bonino, Ltd. mit der vornehmen Adresse 7 West 57th Street in New York. (Während dieser Zeit nahm Paik auch an Gruppenausstellungen in der Howard Wise Gallery teil.)
Das Zusammentreffen von Paik und den Boninos war eine dieser glücklichen Fügungen, die irgendwie vorherbestimmt zu sein scheinen. Sie brauchten einander: Paik wollte wie alle Künstler einen repräsentativen Ort, um seine Arbeiten zu zeigen, und die Boninos waren auf der Suche nach einem jungen Talent, das ihrem neuen Unternehmen Publicity verschaffen sollte. Der in Korea geborene Paik hatte in Deutschland gelebt und studiert und bereits 1963 eine experimentelle TV-Show in der Wuppertaler Galerie Parnass inszeniert. In einem Interview sagte er kürzlich: "Zu der Zeit, als das Farbfernsehen aufkam und ich damit arbeiten wollte, kam ich über Tokio nach New York, weil hier das Material und die Technik preiswert sind. Ich habe alte Fernsehgeräte gekauft und sie hierher gebracht."
Ende der fünfziger Jahre hatte Paik in München, Köln und am Konservatorium in Freiburg studiert; von 1958 bis 1961 hatte er mit Karlheinz Stockhausen, dem Komponisten elektronischer Musik, im elektronischen Musikstudio des WDR in Köln experimentiert. In seinen Performances hatte er Krawatten abgeschnitten, seinen mit Rasierschaum beschmierten Kopf in einen Waschzuber getaucht und Klaviere zertrümmert. Seine Darbietungen entsprachen der Philosophie von Fluxus, der losen, internationalen Vereinigung von Schriftstellern, Künstlern, Komponisten, Filmemachern und Performern, der auch Paik angehörte und deren Arbeiten in krassem Gegensatz zur traditionellen Kunstauffassung standen. In seiner 1962 beim Fluxus-Festival in Wiesbaden aufgeführten Komposition "Zen for Head" beispielsweise benutzte Paik seinen Körper als Malgerät. Ursprünglich hatte er geplant, seine modifizierten Fernsehgeräte beim Fluxus-Festival in Tokio 1964 zu zeigen, aber George Maciunas, der Spiritus rector der Bewegung, bat Paik, stattdessen in seinem Loft in der schäbigen Canal Street in New York auszustellen. "Als ich hier ankam, habe ich gesehen, daß es in der Canal Street schon so viel Müll gab, daß die Fernseher nicht weiter auffallen würden", erinnert sich Paik. "Ich brauchte eine vornehmere Gegend, die jedoch schwer zu finden war für eine Ware, die sich nicht verkaufen läßt." Er versuchte es in der Green Gallery, aber diese kurzlebige avantgardistische Vorposten unter der Leitung von Richard Bellamy wurde gerade aufgegeben. Zwischenzeitlich hatten die Boninos Mary Bauermeister kennengelernt, eine junge deutsche Künstlerin, die Paik bei Stockhausen begegnet war. Bauermeister, die wunderschöne Collagen aus optischen Linsen und polierten Steinen machte, war von der Faileigh Dickinson University in New Yersey eingeladen worden. "Mary kannte sie alle", erinnert Nanda Bonino, "Johns, Rauschenberg, die ganze Künstlergemeinde. Wir vertraten überwiegend lateinamerikanische Künstler und wollten gerne einen Amerikaner in der Galerie haben." Paik sollte ihr "Amerikaner" werden; Mary Bauermeister, die dann auch von der Galerie vertreten wurde, machte die Boninos mit Paik bekannt.
Die Attraktion von Paiks erster Ein-Man-Show in der Galerie Bonino im Herbst 1965 war der "K 456", ein ferngesteuerter Roboter der gehen konnte, mit seinen Armen weiße und getrocknete Bohnen fallen ließ. Mit seinem Lautsprechermund, dem Papierhut und dem winzigen Ventilator als Bauchnabel war er kein unansehnliches Monster. Seine Gefährten waren etwa ein Dutzend alte Fernsehgeräte, die Paik aus Tokio mitgebracht und so geschaltet hatte, daß aus gewöhnlichen Bildern seltsame elektronische Abstraktionen wurden. Der koreanische "Kulturterrorist", wie Allan Kaprow ihn getauft hatte, schlief in der Galerie, um sich um seine Geschöpfe kümmern zu können. "Wenn ein Kritiker kam, um sich die Ausstellung anzusehen, mußte ich Paik aufwecken, damit er etwas anschaltete", berichtet Nanda. "Alfredo wurde fast verrückt, weil Paiks Gehilfen überall in der Galerie aßen und tranken und der Boden mit Kabeln und Röhren übersät war."
Aber Paik brachte der Galerie die gewünschte Publicity. Zum einen wurden seine und Bauermeisters Freunde aus den Avantgarde-Kreisen zu regelmäßigen Besuchern der Galerie – unter ihnen Paiks Mentoren John Cage, Merce Cunningham, Alan Ginsberg und Allan Kaprow. John Cage verfaßte sogar das Katalogvorwort für Paiks erste Ausstellung. "Kunst und Fernsehen sind nicht länger zwei verschiedene Dinge", schrieb er in einem Text, der so frei fließend war wie seine Musik. "Sie sind beide gleich langweilig. Die Geometrie des einen hat die Kräfte des anderen geschwächt (finden Sie ihre schlechten Angewohn-

heiten selbst heraus); die vibrierenden Raster des Fernsehens haben unsere Kunst auseinanderfallen lassen. Es hat keinen Sinn, die Einzelteile aufzusammeln. Sehen wir den Tatsachen ins Auge: eines Tages werden Künstler mit Kondensatoren, Widerständen und Halbleitern statt wie heute mit Pinseln, Violinen und Müll arbeiten."
Und es kamen auch Kritiker. "Als ausbaufähiges Experiment mit einem neuen Medium ist die Ausstellung zweifelsohne faszinierend", schrieb John Canaday von der New York Times. Viele Besucher kamen in die Galerie, nur um zu sehen, was dort vor sich ging. Dennoch, einem Kunstpublikum, das, an Johns und Rauschenberg gewöhnt, dabei war, auf die Pop Art abzufahren, erschienen Paiks Basteleien etwas abwegig. Andererseits war er immer amüsant und skandalös, und die Presse schenkte seinen Performances mit der Cellistin Charlotte Moorman – die "oben ohne" spielte – große Aufmerksamkeit. Nanda Bonino erinnert sich an das alles als "ziemlich aufregend. Es war eine besondere Zeit in New York, es bestand eine Beziehung zwischen Künstlern, Galeristen, Kritikern und Museumsleuten, die es heute nicht mehr gibt. Man hatte eine völlig andere Einstellung zur Kunst – die Leute kauften, was ihnen gefiel und dachten nicht darüber nach, für wieviel Geld sie ein Bild im nächsten Jahr wieder verkaufen könnten. Selbst Galeristen haben nicht so sehr ans Geld gedacht. In den siebziger Jahren hat sich das alles geändert."
Paik hatte insgesamt fünf Einzelausstellungen in der Galeria Bonino. Bei seiner zweiten Ausstellung im Jahre 1968 lud er seine Künstler-Freunde Ayo (ein japanischer Bildhauer, der mysteriöse Schachteln machte), Christo, Ray Johnson, Mary Bauermeister, Robert Breer (ein kinetischer Künstler, der auch von der Galeria Bonino vertreten wurde), Otto Piene und andere ein, sich daran zu beteiligen. Christo verpackte ein Fernsehgerät, Piene überzog ein weiteres mit Plastikperlen; Bauermeister machte einen Kasten mit optischen Linsen, in dem sich ein Fernsehgerät befand, dessen Bilder von den Linsen reflektiert wurden; Ray Johnson kombinierte eine Reliefcollage mit einem Fernsehgerät und so weiter. Charlotte Moorman, eine unabhängige, freizügige Künstlerin, die sich unbeirrt für die neue Musik und die Avantgarde einsetzte, saß in einem anderen Raum auf einem Podest und spielte morgens und nachmittags jeweils zwei Stunden lang Cello.
In der Zeit zwischen den Ausstellungen war Paik auch nicht tatenlos. Mit Hilfe eines Stipendiums der Rockefeller-Stiftung entwickelte er Ideen, wie man elektronische Medien im Unterricht einsetzen könnte – z.B. die "Instant Global University", eine Universität, aus deren computergesteuerter Bibliothek Videos ausgeliehen werden können, die über alles mögliche informieren, von der Astronomie für Fortgeschrittene bis zum Koto-Spiel; Worte und Taten berühmter Zeitgenossen, wie beispielsweise von Duchamp und Sartre, sollen für die Nachwelt durch Filmaufzeichnungen festgehalten werden, und Künstler sollen an der "Persönlichkeitsentwicklung" von Computern mitarbeiten, die als Lehrer eingesetzt werden könnten, um die Schüler während des Unterrichts bei Laune zu halten. Mit Unterstützung der Rockefeller-Stiftung konnte Paik 1969 zusammen mit dem japanischen Ingenieur Shuya Abe, mit dem er schon oft zusammengearbeitet hatte, den Paik-Abe-Videosynthezizer bauen, der Videobilder zu leuchtenden Farbspielen synthetisiert.
Etwa zu dieser Zeit erhielt Paik von einem weiteren Galeristen Unterstützung. Howard Wise ein reicher ehemaliger Geschäftsmann aus Cleveland, dessen Interesse an der Kunst schließlich dazu führte, daß er die Farbenfabrik seiner Familie verkaufte und eine Galerie in seiner Heimatstadt eröffnete. Eine Zeitlang zeigte er Arbeiten von zeitgenössischen Malern und Bildhauern und eröffnete 1960 eine zweite Galerie in der 50 West 57th Street in New York. Im Jahre 1961 aber begann er, sich für Künstler zu interessieren, die sich mit kinetischen Skulpturen und Lichtobjekten beschäftigten, eine Bewegung, die durch die zunehmende Verfügbarkeit von anspruchsvoller Hardware gefördert wurde. Wise, der nicht darauf angewiesen war, Profit zu machen, konnte es sich leisten, Künstler zu unterstützen, die mit diesen neuen Techniken umgingen, und die Howard Wise Gallery wurde bald zu einem Zentrum für Künstler, die mit Licht, Bewegung und Klang arbeiteten.
Paik war dort in mehreren Gruppenausstellungen vertreten. "Light in Orbit" und "Festival of Light" im Jahr 1967 (für letztere schuf er den "Electronic Zen Tri-Color Moon") und "TV as a Creative Medium" 1969. Für die 69er Ausstellung entwickelte er seinen berühmten "TV Bra for Living Sculpture", den TV-Büstenhalter, den Charlotte Moorman trug: zwei kleine Bildschirme wurden um ihre Brüste geschnallt und durch die Bewegungen ihres Bogens und die dadurch erzeugten Töne des Cellos veränderten sich die Fernsehbilder. (Paik und Moorman wurden 1967 in der Filmmakers Cinémathèque während der Aufführung von Paiks "Opera Sextronique" verhaftet, nach ihrer Freilassung gab Charlotte Moorman eine Pressekonferenz in der Howard Wise Gallery, in der sie den Vorfall erläuterte.) In der Wise Gallery konnte Paik zum ersten Mal eine Arbeit verkaufen – aber es sollte für lange Zeit die einzige bleiben. Dieses Werk, "Participation TV", war für die Beteiligung von Zuschauern gedacht: sobald jemand in das angeschlossene Mikrophon spricht, weitet sich ein farbiges Knäuel von Linien auf dem Bildschirm explosionsartig zu bizarren Gebilden aus. Die Arbeit wurde 1969 von dem Sammler David Barmant gekauft.
1970 schloß Wise seine Galerie, weil er einsehen mußte, daß viele seiner Künstler das Interesse an kinetischen Maschinen und Lichtskulpturen verloren hatten – nicht nur, weil sie schwer instand zu halten waren – und sich stattdessen mit großer Environments befaßten, für die in der Galerie einfach kein

Platz war. Wise selbst wandte sich verstärkt dem elektronischen Medium der Video-Kunst zu, in dem er schon gleich zu Anfang ein einzigartiges Mittel der Ideen- und Informationsübermittlung, besonders im Bereich der Politik sah.
1971 gründete er Electronic Arts Intermedia, eine Non-profit-Organisation, deren ursprünglicher Zweck die Beschaffung von Geldmitteln für Künstler war. E. A. I. wurde zu einer Hilfsorganisation für eine Reihe von Gruppen und Personen, die mit Video arbeiteten; zu ihnen gehörte auch Charlotte Moorman und das von ihr jährlich veranstaltete New York Avantgarde Festival. E. A. I. stellte den Künstlern auch geeignete Räume zur Bearbeitung von Videos zur Verfügung und sorgte allgemein für die Anerkennung von Video als künstlerisches Medium. Auf Bitten der Künstler, die ihre Arbeiten nur schwer verkaufen konnten, startete E. A. I. 1973 einen Videovertrieb, der heute sehr gut im Geschäft ist. Seine zirkulierende Sammlung, bestehend aus Hunderten von Videobändern, ist die größte in den Vereinigten Staaten. Wise, der einen bedeutenden und weitreichenden Beitrag im Bereich der experimentellen Kunst geleistet hat, starb im Jahre 1989.
Während dieser Zeit hatte Paik weitere Einzelausstellungen in der Galeria Bonino. In Zusammenarbeit mit Shuya Abe stellte er 1971 den Videosynthesizer mit Aufnahmen der Performances von Charlotte Moorman vor. Bei seiner letzten Ausstellung in der Galerie im Jahre 1974 zeigte er sein bisher aufwendigstes Werk, "Global Groove", den Vorläufer seiner großen Environments: in einer halbstündigen Video-Collage aus 20 Bildschirmen und zahlreichen Bändern sieht der Zuschauer ein Kaleidoskop aus synthetisierten Bildern; dazu muß er sich auf ein erhöhtes Podest stellen und auf das herunterblicken, was Paik als "Meer" oder "Garten" aus Fernsehbildern bezeichnet.
Der konservative Kritiker Hilton Kramer, der völlig unerwartet seine gesamte Kolumne in der Sonntagsausgabe der New York Times dem "Global Groove" widmete, war der Ansicht, die Bilder seien nicht so wichtig; es sei "die Abfolge von sich verändernden Farben und Formen, die alle Aufmerksamkeit auf sich lenkt." Er verglich das Abstrakte der Arbeit mit einer Collage von Kurt Schwitters. Aber er sagte auch: "Die Kunst, mit der man es dort zu tun hat, ist eher bescheiden, der Genuß daran ist flüchtig, fragmentarisch und schnell vergessen."
Trotz der Beachtung durch die Presse verkauften sich Paiks Arbeiten auch weiterhin schlecht. Obwohl die Galeria Bonino keine Schwierigkeiten hatte, die Arbeiten anderer Künstler an den Mann zu bringen – besonders von den Lateinamerikanern Alicia Penalba, Marcelo Bonevardi und dem Bildhauer Edgar Negret sowie Mary Bauermeister (der Sammler Joseph Hirshhorn kaufte einmal drei ihrer Arbeiten per Telefon) – mußte Nanda Bonino feststellen, daß es für Paiks Arbeiten so gut wie keine Abnehmer gab. Einmal allerdings hätte sie fast seinen "TV Buddha", ein Buddha, der vor einem Bildschirm sitzt, verkauft. Ein Sammler war daran interessiert und wollte die Arbeit dem Museum of Modern Art stiften, aber, so erinnert sich Frau Bonino mit einem Schulterzucken, das Museum lehnte sie ab. (Der Buddha befindet sich heute im Stedelijk Museum in Amsterdam.)
"Einmal gab mir Paik ein Bündel Zeichnungen zum Verkaufen, aber ich konnte nicht einmal diese loswerden, denn das Klebeband auf der Rückseite schaute heraus. Ich habe eine davon verschenkt und sie wieder zurückbekommen. Damals gab es ohnehin nur sehr wenige Sammler. Jeder wußte, wer kaufte: Joseph Hirshhorn, Jean und Howard Lipman und ein paar andere. Aber es war uns wirklich egal, ob wir Paiks Arbeiten verkauften oder nicht, denn er hat zusammen mit Robert Breer und Mary Bauermeister dafür gesorgt, daß die Galerie bekannt wurde."
Paik ist Nanda Bonino noch immer dankbar für ihre "Weitsicht und ihre unkommerzielle Einstellung. Sie war sehr, sehr positiv." Und weiter sagt er: "In gewisser Hinsicht brauchte sie öffentliche Aufmerksamkeit und träumte nicht lange davon, Geld zu machen. Sie richtete einige Einzelausstellungen für mich aus, was ein großes finanzielles Engagement bedeutet hat. Ohne eine Uptown-Galerie hätte ich es niemals geschafft."
"Natürlich", so fügt er hinzu, "Mary Bauermeister und ich haben die Galerie in New York bekannt gemacht."

Aus dem Amerikanischen von Birgit Herbst

KARL RUHRBERG
RESTLESS SLEEPER
The world is a village, and Nam June Paik has vigorously helped to make it one. For himself through a nomad like creative existence without Archimede's principle, for the rest of us through electronics linking time and space, through the simulated totality of experiencing reality in his video towers from Seoul to New York, from Siberia to Tierra del Fuego, from Alaska to the Equator. Musical and visual structures, high and low art, jest, satire, irony and profound meaning – with Paik all this is turned into a classless society. I have the same feeling about him as my friend Wieland Schmied: Although (or because) I had the media that was brand new at the time presented en bloc by Hans Strelow and Konrad Fischer with "Prospect Projection" at the Düsseldorf Kunsthalle in 1971, the long lingering seemingly inseparable tutti frutti of the sublime and the ridiculous easily could have made me hate video all my life, had I not run at the right moment into

Nam June Paik's works whose prize-winning fame another dear colleague, Werner Schmalenbach, still believes to be a gigantic error of the *Zeitgeist*.
But I don't want to ride the high horse, because just under a quarter of a century ago I was just as way out when Paik, in his double role as composer and artistic interpreter, presented in the alternating play of ecstacy and lethargy his loud tribute to the quiet John Cage at the "Galerie 22" of the unforgotten Jean-Pierre Wilhelm, whereby the confusion of a raw egg with a cooked one muddled the neo-Dadaist score considerably. Rereading my review of the time, I still turn red as a beet, especially since I have had few occasions to make good in writing, unless heed is taken of the melancholic German-Korean memorial by Joseph Beuys and Nam June Paik on two pianos in honour of George Maciunas in 1978 at the Düsseldorf Kunstakademie.
Nevertheless, a kind fate has given me the late opportunity to prove that I've learned a bit in the meantime. A year and a half ago I, in conjunction with my jury colleagues, selected Nam June Paik, a pioneer of a new media and a top-ranking trouble-maker in our all too saturated art scene, to receive the Emperor's Ring of the City of Goslar: an "extraordinary phenomenon", as his onetime composition teacher Wolfgang Fortner has dubbed him, the wanderer between worlds, the eternal nomand who likes so much to sleep so often, so intensely and so long when he isn't wide awake whipping up a new creative storm. Paik is one of the artists who don't have any trouble living up to Marcel Duchamp's lofty demand that art be above all intelligent: a demand that is of particularly explosive topicality today.

Translated from the German by William A. Mickens

NAM JUNE PAIK
ÜBER BEUYS
Wenn ich Beuys in seinem Atelier besuchte (natürlich habe ich das so selten wie möglich getan, denn das schönste Geschenk, das ich ihm machen konnte, war es, nicht zuviel von seiner kostbaren Zeit zu beanspruchen), wurde unsere Unterhaltung oft von Telefonanrufen alter und neuer Freunde unterbrochen, die eigentlich nicht so wichtig waren ... er nahm jeden Anruf entgegen und antwortete ausführlich, sehr oft mit echter Anteilnahme. Ich fragte ihn, warum er keine Sekretärin einstelle, die unten sitzen und die Anrufe entgegennehmen und aussieben könnte.
Er sagte, er wolle lieber alle Anrufe selbst beantworten ... John Cage war in diesem Punkt genauso. Ich stellte ihm die gleiche Frage und machte ihm den gleichen Vorschlag und erhielt die gleiche Antwort ... dieses grenzenlose Entgegenkommen hat mit Sicherheit ihrer beider Leben verkürzt.
Das deutsche Wirtschaftswunder hat viele brillante Geister auf der Strecke gelassen ... diese "Drifter" und "Underdogs" brauchten einen Psychoanalytiker-Onkel, der ihnen zuhörte und sie beruhigte. Beuys erfüllte diese Aufgabe in allen seinen Gesprächen und bei seinen Aktivitäten der Freien Universität ... in einer der Versammlungen bei der documenta 1977 sagte ein Arzt in der Menge: "Alle wollen gleich sein und die Demokratie verwirklicht sehen ... aber sehen wir uns an, wie unser Körper funktioniert ... alle Teile sind gleichwertig ... ohne Herz kann man nicht leben, auch nicht ohne Leber ... selbst Hände und Füße sind grundsätzlich genauso wichtig ... aber Hände wollen keine Füße werden, Füße wollen Füße bleiben und nicht die Aufgaben des Gehirns übernehmen ... alle Teile sind gleichwertig, aber sie haben verschiedene Aufgaben ... und sie beschweren sich nicht darüber, die Leber neidet dem Herzen nichts, und das Herz beneidet die Nieren nicht ... es ist ein Organismus, eine Ökologie."
Dieser vorsichtige Hinweis ließ einige der Hitzköpfe abkühlen, die von Beuys direkteres Handeln verlangten.
Im Wirtschaftswunder möchte jeder Aufsichtsratsvorsitzender sein ... oder Terrorist ... Beuys war einer der wenigen Menschen, die mit den Superreichen und den ganz Armen kommunizieren konnten ... beide Seiten vertrauten ihm ... jetzt, in den Wirren nach der Wiedervereinigung frage ich mich, wie Beuys gehandelt hätte. Würde er noch immer in Düsseldorf wohnen, wenn er noch lebte? Vielleicht wäre er nach Halle oder Dresden gezogen, um die aufgeregten Gemüter zu besänftigen, die meinen, sie hätten den Kampf verloren; obwohl sie eher erleichtert sind, daß sie verloren haben ... er wäre vielleicht der ehrliche Makler.
Obwohl er sehr krank war und sein Herzleiden fast das schlimmste Stadium erreicht hatte, wollte er unbedingt zum Friedenskonzert nach Hamburg kommen, um mit mir und Henning Christiansen zu spielen ... nur Eva Beuys' energisches Eingreifen, das ich unterstützte, hat ihn an dieser Reise gehindert. Wir baten ihn, stattdessen durchs Telefon zu sprechen, und über einen Verstärker war seine Stimme dann für alle zu hören. Es gab technische Störungen, und es klang, als rufe er aus dem Paradies oder aus der Hölle an ...
Hätte er wählen können, er hätte sich bestimmt für die Hölle entschieden, denn dort hätte er die Unzufriedenen, all die gebrochenen Herzen, die Underdogs, Terroristen und Drifter trösten können. Er hätte sich in dieser Gesellschaft bestimmt wohlgefühlt.
Beuys schenkte Charlotte eine Filzhülle für ihr Cello, mit der sie sein Stück "Infiltration" aufführte ... ein Sammler schickte jeden Monat eine bestimmte Summe, weil der die Filz-Arbeit nach einiger Zeit erwerben wollte ... diese Zeit kam, und natürlich schickte ihm Charlotte das Cello ...

9

Einmal besuchte Charlotte Beuys zusammen mit ihrem Mann Frank PILLEGI; Beuys nahm einfach eine Schere, ging in sein Filzlager und schnitt ein weiteres Cello aus ... schon wieder ein Vermögen, das er da weggab.

Einmal besuchte ich ihn in der Freien Universität. Er drückte mir ein Bündel 500 DM-Scheine in die Hand und sagte nur, "das ist für Charlotte".

Aus dem Amerikanischen von Birgit Herbst

VITTORIO FAGONE
NAM JUNE PAIK UND DIE FLUXUSBEWEGUNG. EUROPA UND AMERIKA, URSPRUNG UND ENTWICKLUNG DER VIDEOKUNST

Wuppertal 1963 und New York 1965 gelten durch die Arbeit zweier Künstler der Fluxusbewegung, Nam June Paik und Wolf Vostell, inzwischen als "historische" Ursprungsorte der Videokunst. In der Wuppertaler Galerie Parnass analysierten Paik und Vostell das neue Medium, auf dessen enorme Massenwirksamkeit sie aufmerksam machten, indem sie die mechanischen und elektronischen Bildträger zerlegten. Zwei Jahrs später machte Paik in New York Gebrauch von der Möglichkeit des Zugangs zum neuen Aufnahmegerät, die sich eröffnete durch die erste tragbare Hobbykamera, die "Portapak" von Sony, und erprobte eine synthetische Bildaufnahme.

Für ein wirkliches Verständnis der Videokunst dieser Jahre müssen beide Momente zusammen gesehen werden, insofern sich die kritische Analyse der gegebenen Elemente der Telekommunikation und die Entwicklung eines neuen Bildes, das zu jenem der konventionellen Figuration im Widerspruch steht, als zwei stets wiedererkennbare Konstanten erweisen.

Ein derartiges Vorgehen steht in Übereinstimmung mit der Kunstkonzeption der Fluxusbewegung, die zwei fundamentale Ziele verfolgte: Zum einen sollte ein neues soziokulturelles Milieu geschaffen werden, das der schnellen Verbreitung einer neuen ästhetischen Kommunikation auf allen Ebenen zweckdienlich ist, einer ästhetischen Kommunikation, die in der Lage ist, die Distanz zwischen Künstler und Publikum zu verringern und die ein wechselseitiges Engagement in einem einzigen Feld kreativer Sprachbeziehungen anstrebt; zum anderen sollten den Regeln und Konventionen der institutionalisierten Kunst neue offene Modelle entgegengesetzt werden, die imstande sind, eine noch nie dagewesene, neue Maßstäbe setzende Totalität der ästhetischen Verhaltensweisen und des aktiven sprachlichen Austausches herzustellen.

Wenn Vostell und Paik eine Richtung künstlerischen Arbeitens begründeten, die die bildenden Künstler dazu drängte, sich, ohne Unterwerfung, mit dem neuen elektronischen Medium auseinanderzusetzen, es als ein geeignetes Instrument der Dimensionserweiterung der visuellen Bilder zu begreifen, das fähig ist, in einer virtuellen Räumlichkeit die historische Zeit und die innere Zeit der künstlerischen Tätigkeit einzubeziehen in die neue Dimension der realen Zeit – die sicherlich nicht als von der aktuellen, grundlegend veränderten Kunstszene ausgeschöpft betrachtet werden kann –, dann muß auch an den entscheidenden Einfluß erinnert werden, den die für die ganze Fluxusbewegung fundamentalen Theorien und Experimente John Cages auf die Praxis der Videokunst ausübten. Mehr als einmal hat Paik erklärt, daß die Videokunst ohne Cage nicht entstanden wäre. Man darf fragen, was Cage zu dem neuen Experimentierfeld beitragen konnte, innerhalb dessen Paik dann mit Ausdauer und den allseits bekannten, geglückten Resultaten arbeitete. Cage hat sicherlich die Möglichkeit gezeigt, auf andere Weise mit inhomogenen Elementen umzugehen, die gleichwohl auf eine spezielle Kongruenz und Sprachorganisation hin orientiert sein können; und er praktiziert eine reflexive Ironie, die bis zur Verwendung eines negativen Strukturierungselementes (Ton/Stille) ging. Bei Paik tauchen analog Bildeinheit/Zerstreuung und Fragmentierung des Bildes in einer Positionsumkehrung auf. Unzweifelhaft ist auch der Einfluß der konkreten und buchstäblich "aktiven" Musik Cages, die die Videokunst dann in einem wegweisenden Überschneiden von Bild und Aufführungsaktion anwandte. Die Bedeutung der klanglichen Gliederung des audiovisuellen elektronischen Werkes resultiert aus deren genauer Kenntnis.

Auch Vostell hat die Ansicht vertreten, daß, wenn Fluxus – gemäß einem allen avantgardistischen Strömungen des Jahrhunderts zugrundeliegenden Parameter – einige typische Spannungsmomente des fünfziger Jahre-Happenings ausdehnt zu einer totalen Kunst-Leben-Beziehung, es so die Wahl der Musik als Spannungs- und Aktionsfeld sei, in dem sich Menschen und Bilder bewegen, die den besonderen Charakter des neuen Experimentierfeldes ausmacht.

Wenn – wie ich schon verschiedentlich zu unterstreichen suchte – die Beziehungen zwischen den frühen Formen der Videokunst und den schon ausgereiften Erfahrungen des europäischen und amerikanischen experimentellen Kinos, zu dem die bildenden Künstler einen entscheidenden Beitrag leisteten, nicht außer acht gelassen werden dürfen, so trägt die spezifische Beziehung zwischen dem von Fluxus bevorzugten tonalen Bereich und den innovativen Spannungsmomenten der Performance dazu bei, dem neuen künstlerischen Kommunikationsmodell seine formsprachliche Eigentümlichkeit zu verleihen.

Strategie der Videokunst: Formen auflösen – Formen aufbauen

Wenn Nam June Paik und Wolf Vostell erklären, daß der Schlüssel zum Verständnis der Ursachen und Entwicklungen der Videokunst in der komplexen und freien Kunstkonzeption – genauer genommen müßte von Strategien gesprochen werden – der Fluxusbewegung zu suchen ist, so geben sie einen Hinweis, der schwerlich zur Debatte gestellt werden kann, nur damit der unbezweifelbare und grundlegende Beitrag dieser beiden Autoren zur Entstehung der Videokunst berücksichtigt ist oder die ausschlaggebende Bedeutung der Verbindung von verschiedenen künstlerischen Ausdrucksformen mit neuen Kommunikationsmodellen, die von allen Künstlern der neuen Bewegung, Paik und Vostell eingeschlossen, zumindest in den ersten Jahren verfochten und praktiziert wurde.

Setzt man dieses Faktum als unbestreitbar voraus, so müssen meines Erachtens drei nicht weniger relevante Elemente mitbedacht werden: 1) Fluxus entstand gegen Ende der fünfziger Jahre in den Vereinigten Staaten und wurde dort für eine intellektualistisch spätdadaistische Ausdrucksform gehalten, die zu "gefährlichen" anarcho-kommunistischen Utopien neigte und deshalb bekämpft oder an den Rand gedrängt wurde. Dahingegen standen dem in Wirklichkeit dialektischen und innovativen Anliegen der Bewegung in Europa, und besonders in Deutschland, Aktionsräume offen, und die Kritik fand, wenn auch nicht generell, zu einer positiven Würdigung. 2) Wie Shigeko Kubota (Video d'Autore, Taormina Arte, 1990) deutlich gemacht hat, muß als das Ende von Fluxus im Sinne einer realen und ihrer Zeit verbundenen Bewegung das Jahr 1974 betrachtet werden, als George Maciunas und mit ihm die Bewegung starb. Jenseits dieses Datums gab es sicher weiterhin die einzelnen, tätig gebliebenen Individuen der "Fluxus-Künstler", aber weder die Rezeption durch Epigonen, noch die späte "Reue" der Sammler, Händler und Kritiker in ihrer paradoxen Konversion kann ernsthaft in Betracht gezogen werden. 3) In den sechziger Jahren oder zumindest bis in die Mitte der sechziger Jahre war das verfügbare, wenn nicht selbstgewählte, Hauptgebiet der verschiedenen avantgardistischen Experimente jenes der bildenden Künste, die dem aktiven Austausch zwischen den medialen Ausdrucksmitteln der neuen Kommunikationsformen, den konventionellen bildenden Künsten und der Performancekunst positiv gegenüberstanden und ihn in vielen Fällen aktiv förderten.

Zieht man die Gesamtheit dieser Fakten in Betracht, so gewinnt die Videokunst eher den Aspekt einer dialektisch und schnell verlaufenden Entwicklung, als den der amöbenhaften Konturlosigkeit eines naiven und ahistorischen Randgebietes, das sich in einer Art Zwischenreich erstreckt zwischen künstlerischen Ausdrucksformen von hoher expressiver Dichte und neuen Kommunikationsmodellen von lauer Trägheit, wenn nicht Kälte, wie McLuhan meint.

Genauer gesagt: die annähernd dreißig Jahre, die das aktuelle Geschehen von jenen ersten Präsentationen der Videokunst Nam June Paiks und Wolf Vostells in der Wuppertaler Galerie Parnass trennen, vermitteln nicht das Bild einer einzigen Entwicklungslinie. Die lebhafte Dynamik der neuen, von einer wirklichen und konstanten Internationalität geprägten Bewegung weist Momente, Haltungen und unterschiedliche Strategien auf, die es heute je gesondert zu betrachten gilt, um zu einem richtigen Verständnis des Phänomens in seiner Geschichtlichkeit und Aktualität zu gelangen.

Betrachten wir noch einmal die Anfänge: Was zeigte Paik in Wuppertal bei seinem Versuch, das vom Fernsehen monopolisierte und trotz seiner offen zutage liegenden visuellen Qualität den Künstlern in jeglicher Weise verschlossene elektronische Bild aufzubrechen und neu zu definieren? In jeweils unterschiedlicher Weise deformierte Paik auf dreizehn Monitoren ein schwarzweißes Fernsehbild, indem er in die Lichtmodulation dieses Bildes in horizontaler wie in vertikaler Richtung eingriff. Die formauflösende Absicht dieser Operation ist klar. Das elektronische Bild wird in seiner primären Lichtqualität hervorgehoben, jedoch buchstäblich "kontrastiert" (bestritten) im Hinblick auf seine Erscheinung als absolut wahres und deshalb alleingültiges Fernsehbild.

Als Paik 1965 schließlich in der Lage war, nicht nur in den Übertragungsmechanismus, den Monitor, des elektronischen audiovisuellen Gerätes einzugreifen, demonstrierte er – in dem in New York gedrehten und mit einer bemerkenswerten Angabe des Drehortes "Café Gogo, 152 Bleeker Street, October 4 and 11, 1965" betitelten Video – mit welch einprägsamer Subjektivität die Aufnahme eines augenscheinlich banalen Lebensraumes aufgeladen werden kann.

Paik kam während seiner Ausbildung von Korea, seinem Geburtsland, nach Tokio und dann, 1957, nach Deutschland (zuerst nach München, dann nach Köln), einem Weg folgend, der aufs engste an die musikalischen Entwicklungen der Avantgarde gebunden war. In Deutschland fand seine entscheidende Begegnung mit Fluxus statt, insbesondere mit John Cage, von dem die Anregung kam zu einem kreativen Ausflug in unterschiedlichste künstlerische Sprachformen, die durch und auf dem Gebiet des Video praktiziert wurde.

Der Hang zur Formauflösung ist im Werk von Wolf Vostell vielleicht noch deutlicher ausgeprägt. Auch er war unter den Künstlern der Ausstellung in der Galerie Parnass und schon seit dem Ende der fünfziger Jahre anerkannt als eine der herausragenden Figuren der Fluxusbewegung. In "TV de-collage" intervenierte er gewaltsam in den Prozeß von Abbau – Aufbau der aus weit verbreiteten Fernsehprogrammen herausgegriffenen Bilder.

Im Verlauf weniger Jahre verlagerte sich jedoch der Schwerpunkt der Videokunst von Europa in die USA, aus denen, wie schon angedeutet, Fluxus vertrieben worden war. Während das Fußfassen der Videokunst in Europa im

Grunde dem generösen Pioniergeist von Galeristen und Förderern wie Gerry Schum anvertraut war, der zuerst in Berlin, dann in Düsseldorf, schließlich innerhalb des Essener Museums das neuartige Modell einer Video-Galerie vorführte, öffneten sich in den Vereinigten Staaten, wenn auch nur für eine kurze Zeit, Perspektiven von ganz anderer Tragweite.

Video versus Fernsehen, gestern und heute

Ich hatte kürzlich die Gelegenheit zu einem langen Gespräch mit Wolf Vostell über die Gründe, die schon in jener Frühzeit die erklärte Abneigung der Videokünstler gegen das Fernsehen hervorriefen. Neben dem gemeinhin bejahten Motiv einer notwendigen Opposition gegenüber dem neuen Medium als Massenmedium benannte Vostell ein noch klareres Motiv. Am Ende der fünfziger und zu Beginn der sechziger Jahre war es durch die Studios von Radio Köln möglich, eine radikal innovative musikalische Aktivität, an der sich auch der junge Stockhausen und Luigi Nono (mit dem wiederum Paik zusammenarbeitete) beteiligten, anzuregen, die für die neue elektronische Musik von grundlegender Bedeutung war. Die Strukturen von Radio und Fernsehen in Westdeutschland waren in jenen Jahren identisch. Warum also erwies es sich sofort als unmöglich, im visuellen Medium auf dieselbe Art schöpferisch und kritisch tätig zu werden, wie es unter Nutzung der Möglichkeiten des akustischen Mediums geschah?

Jenseits des Hinweises auf die Fetischisierung des Publikums – vom kommerziellen wie öffentlichen Fernsehen frühzeitig gepflegt – und auf die Notwendigkeit, das nicht nur formal, sondern auch sozial äußerst konservative und stabile Fernsehsystem aufrechtzuerhalten, bleibt die Frage weiterhin unbeantwortet. So ist es nicht verwegen, heute die Behauptung aufzustellen, daß sich die wirkliche Ausdruckskultur des neuen Mediums im Videobereich entwickelte als außerhalb der Fernsehwelt gelegene Hypostase.

In den Vereinigten Staaten war die Situation, zumindest anfangs, eine andere. Im Jahre 1965, als Paik schon in New York arbeitete, überwies es die Rockefeller Stiftung der Fernsehgesellschaft Boston WGBH 275000 Dollar zur Förderung experimenteller Programme von Künstlern und Wissenschaftlern (man beachte: nicht über, sondern von Künstlern).

Die so entstandenen Programme wurden regelmäßig ausgestrahlt. Bald richtete sich nicht der Enthusiasmus, aber die Aufmerksamkeit eines Gerry Schum, verständnis- und einflußreicher Galeristen wie Leo Castelli auf diese avantgardistischen Ausdrucksformen. Die Frage des Verhältnisses zwischen Video und Fernsehen ist in Europa wie auch in Amerika bis heute offen und schwierig geblieben.

Abgesehen von der Bereitwilligkeit des britischen Channel Four, des französischen Canal Plus und des belgischen Videographie-Programmes, ist es schwierig, Anhaltspunkte zu finden, die zu einem gewissen Optimismus berechtigten. Was das öffentlich-rechtliche Fernsehen Italiens anbelangt – vom privaten ganz zu schweigen –, so tut man gut daran, in Erinnerung zu rufen, daß der Sender RAI nie den Mut hatte, die raren experimentellen Programme auszustrahlen, die er gleichwohl produziert hatte, und daß er es immer vorzog, die Künstler vor der Kamera zu plazieren anstatt dahinter, um die Möglichkeiten eines neuen visuellen Mediums auszuloten – mit dem für alle Tag für Tag sichtbaren Ergebnis einer generellen Verflachung.

Trotzdem ist eines sicher: die annähernd dreißig Jahre innovativer und bedeutender Videokunst zeigen, daß diese, auch wenn es unsinnig scheint, ohne das Fernsehen auskommen kann und dabei nichts an Elan und Effizienz einbüßt. Wie lange noch, darf man sich fragen, wird das Fernsehen verzichten können auf die Erforschung einer eher kreativen als reproduktiven kulturellen Fähigkeit des von ihm genutzten Mediums, ohne sich definitiv damit abzufinden, den oft auch ungeeigneten Rahmen für alles mögliche zu bilden?

Wenn die Beziehung zwischen Video und Fernsehen in Europa immer noch blockiert ist oder unangemessenerweise nur in einigen Randzonen (Signet, Spot, Clip) funktioniert, so hat sich doch das Verhältnis zwischen Video und den bildenden Künsten verändert. Die hier bestehende Verbindung spielte ja, wie schon erwähnt, eine wichtige Rolle für die Rezeption und Einbindung spezifischer sprachlicher und metasprachlicher Modelle (von der Konzeptkunst bis zur Body Art), und durch sie bot sich ein Aufmerksamkeit heischender Raum an.

Die Rückkehr zur Materialität der gemalten Bilder am Ende der sechziger Jahre und der Geschwindigkeitsverlust bei der Erforschung des Immateriellen und Szenischen auf dem visuellen Gebiet (man denke an den Niedergang der Performance) fielen zeitlich zusammen mit der Abkehr einiger Künstler von der Videokunst und mit einem deutlichen Interessensschwund seitens der fortschrittlichen kunstvermittelnden Institutionen. Diese Situation, die auch einen natürlichen Selektionsprozeß in bezug auf so manche Effekthascherei und oberflächlichen Opportunismus darstellte, befreite die Videokunst von einer allzustarken Abhängigkeit von den bildenden Künsten.

Die Verbindung mit den bildenden Künsten ist produktiv geblieben im Bereich der Videoskulptur und der Videoinstallation. Neben der konsequenten Arbeit von Meistern wie Paik behauptet sich auf diesem Gebiet auch eine neue Generation, die fähig ist zu einer klaren und einflußsamen Raumstrukturierung und -erweiterung des Video. Zu Beginn der neunziger Jahre scheint sich die Videokunst der anerkannten Meister und der jungen Künstler von einer harten und dialektischen Gegenposition dem Fernsehen gegenüber hin zu einer verfeinerten und kreativen "Abart" zu entwickeln.

Die Videokunst befähigt das elektronische Bild, innerhalb der flexiblen Vorgaben einer neuen, immateriellen, intelligenten, komplexen und überdies verführerischen Darstellungsform aktive Austauschbeziehungen ohne Unterwerfung oder Zwang mit anderen künstlerischen Ausdrucksformen und den Kommunikationsmedien aufzubauen.

Fluxus

Das erste Fluxusereignis der Geschichte kann man ungefähr ans Ende des vergangenen Jahrhunderts datieren – um das Jahr 1880 –, als die ersten Telekommunikationskabel über den Atlantik verlegt wurden.

Wie man weiß, nahm die Kommunikation zwischen Washington und London mindestens sechs Monate in Anspruch: hin und zurück! Folglich mußte man damit beginnen, eine Kabelverbindung zwischen London und Amerika herzustellen. Kabel am Meeresgrund. Die amerikanischen Schiffe sollten sich auf dem Ozean begegnen und "einander die Hände reichen", um die entsprechenden Kabel zusammenzuschließen. Natürlich bedurfte es hierfür gewaltiger ökonomischer Ressourcen. Um die Finanzierung dieses Projektes zu ermöglichen, wurden in London, in New York und überall auf der Welt Aktienpakete zum Kauf angeboten. Die Entwicklung und Herstellung der Kabel, die die beiden Länder zukünftig miteinander verbinden sollten, dauerte Jahre. Die beiden Länder trafen sich schließlich mitten auf dem Atlantischen Ozean zur Verknüpfung der Kabel. Als dies unmittelbar bevorstand, verlor jedoch eine der beiden Seiten, ich glaube die amerikanische, ihr Kabel, und das mit soviel Spannung erwartete Ereignis löste sich in nichts auf. Die Arbeit von 4000 km Kabelverlegung war umsonst.

Ich halte diese Episode für ein echtes Fluxus-"event"; ein wichtiges Moment in der Idee von Fluxus. Die Perfektion, die sich in einen Fehlschlag verkehrt, transformiert. Am Ende ankommen und von vorne beginnen müssen.

Video, Kommunikation, Technologie

Es ist wichtig, auf zwei, d.h. reziproken und interaktiven Ebenen der Kommunikation zu arbeiten, denn die einseitige, "one way"-Kommunikation ist sehr verbreitet. Heute bin ich zum Beispiel davon überzeugt, daß die Funktionsweise der Telekonferenz interessante Perspektiven eröffnet. Auch weil sie im Vergleich zum Satelliten wesentlich billiger ist. Die Probleme, denen wir bei der Satellitenübertragung begegneten, hätten vielleicht durch die Telekonferenz überwunden werden können. Damals jedoch, 1984, war diese Technologie noch nicht sehr weit entwickelt.

Die erste "Satellitenidee", die ich hatte, betraf die Möglichkeit, Merce Cunningham mit Baron tanzen zu lassen. Ich war ziemlich naiv. Ich nahm Kontakt zu Baron auf und fragte ihn, ob er zusammen mit Merce Cunningham improvisieren wollte … Die großen Namen … Aber er sagte, er müsse zu einem Neujahrsfest gehen. Die Wahrheit war, daß das Ereignis ihre Professionalität und Reputation nicht in ausreichendem Maße gewährleistete. In ihrem Falle handelte es sich in der Tat darum, ohne Proben zu improvisieren, und das Publikum hätte die Performance fälschlicherweise für eine Art von Wettkampf zwischen zwei illustren Persönlichkeiten halten können.

Dasselbe geschah mit Beuys und Cage, die wir baten, am Klavier gemeinsam ein Duo zu spielen. Können Sie sich das vorstellen? Beuys und Cage … das Ereignis des Jahrhunderts! Aber Beuys zögerte. Auf der einen Seite stand Cage, der im Verlauf vieler Jahre einen äußerst persönlichen Stil entwickelt hatte, auf der anderen Beuys, der sein klares künstlerisches Konzept hatte. Es war undenkbar, daß sie plötzlich ihren Stil ändern würden. Und es war dasselbe mit Beuys und Allen Ginsberg … Für sie war das Fernsehen nicht sehr wichtig. Ich war es, der sie mitzog. Sie waren sehr beschäftigt. Sie sagten zu, weil ich sie zu kommen bat. Aber sie nahmen das Projekt nie ernst. Im Gegensatz dazu nahm Laurie Anderson "Good Morning Mr. Orwell" sehr ernst, denn sie ist eine Multimediakünstlerin.

Das Instrumentarium der Telekonferenz heute zu nutzen, könnte für einen jungen Künstler das Experimentieren mit einer neuen Kunstform bedeuten. Ansonsten habe ich entdeckt, daß die "two way"-Kommunikation sogar sehr viel wichtiger ist als die "Live"-Kommunikation. Ich bin zu diesem Schluß gekommen, nachdem ich eine Million Dollar und acht Jahre für Satellitenversuche aufgewandt habe. Die Direktverbindung zwischen zwei Menschen vollzieht sich immer live und das technische Medium verbirgt immer etwas, wie die Kleidung den größten Teil der Informationen verdeckt, die vom ganzen Körper ausgehen könnten. Das Kleiderstudium ist sehr interessant für den, der sich mit den Medien beschäftigt. In irgendeiner Weise müssen wir uns mit der Camouflage, mit dem, was verborgen wird, beschäftigen.

1984 habe ich mich klar geäußert. George Orwell behauptete, das Fernsehen sei in jedem Falle negativ zu bewerten. Ich dagegen vertrat die Ansicht, daß das Fernsehen nicht grundsätzlich schlecht, daß es nicht das "Böse" sei. In "Good Morning Mr. Orwell" sagte ich genau dies: ich war der einzige auf der Welt, der dies behauptete, und ich bin stolz darauf.

Ich habe immer darauf gewartet, daß die technischen Geräte kostengünstiger würden. 1964 versuchte ich, mit der Digitaltechnik zu arbeiten; aber damals kostete ein Computer Millionen von Dollar, und nur die militärische Industrie verfügte in jener Zeit über Computer. Um diese Technologie nutzen zu können, mußte ich warten, bis sie billiger wurde, und dies geschah 1967. Mein Verhältnis zur Hardware und zu der sie produzierenden Industrie sieht so aus: darauf warten, daß sie billiger werden. Ich kann auch zwanzig Jahre warten.

Also: wenn man über Kunst und Technologie redet, muß man über Geld reden. Es ist hier ein bißchen wie in der Kinoindustrie. Man muß beim Geld anfangen. Ansonsten nutzen wir die Studios der sekundären Produktion, die viele Tausende von Dollar am Tag kosten und die wir uns nicht leisten können. Sponsoren müssen gefunden werden, die uns den Gebrauch der Technologien ermöglichen, die uns die technischen Geräte anvertrauen, um unsere Arbeit voranzutreiben.

Es ist im übrigen wahr, daß die großen Unternehmen uns brauchen. Sie überlassen uns neue Technologien, um sie auszuprobieren, um ihre Grenzen neu zu zeigen. Sie tun dies auch, weil sie es sich nicht leisten können, Wissenschaftler damit zu beauftragen. Also sind es oft wir, die Künstler, die neue Technologien erproben.

Der extrem schnelle Computer, den wir benutzen, wurde ursprünglich für die Raketensteuerung entwickelt. Wenn ein Computer militärischen Ansprüchen genügt, so ist klar, daß er auch für Fernsehspots angewandt werden kann: Die technischen Geräte sind neutral. Die Militärindustrie kann die Technologien entwickeln, weil sie die nötigen ökonomischen Ressourcen besitzt. Außerdem: selbst Marconi wurde von der britischen Marine unterstützt.

Die Militärindustrie entwickelt die Technologien. Ich hege keine Sympathien für die Militärs, aber wir brauchen Mittel, um auf unserem Gebiet zu experimentieren. Ich sage nicht, das sei gut oder schlecht; es ist unser Schicksal. Andererseits war das ganze 20. Jahrhundert geprägt von einem großen Wettstreit zwischen der Medientechnologie und der Kunst. Und die Künstler, die die Herausforderung spürten, waren Priester und Opfer in einem.

Geschichte und Erinnerung

Die Künstler wissen mehr von der Zukunft als von der Vergangenheit. Nicht immer trifft dies zu, das ist richtig, aber im allgemeinen glaube ich doch. Die Künstler waren die Avantgarde der großen Veränderungen: wir liegen nicht immer richtig, aber sicher häufiger als die anderen.

Ich kenne meine Rolle: Ich stehe irgendwo zwischen der Entwicklung von Hard- und Software. Und ich weiß, daß ich die Rolle des Interface gut spiele.

Wir alle wünschen uns gewisse Sicherheiten und ein besseres Leben. Es drängt uns, etwas über die Zukunft zu wissen, und je mehr wir von der Vergangenheit wissen, desto sicherer können wir uns fühlen. Die Vergangenheit kennen, sich erinnern, heißt die Zukunft sehen und verstehen.

Die Erinnerung, jemand nannte sie ein Radar, ist eine kurvenreiche Fahrt zwischen Vergangenheit und Zukunft. Wir befinden uns hier in der Gegenwart, wir kennen die Vergangenheit und können versuchen, die Zukunft zu begreifen. Aber wir sind nicht in der Lage, die Gegenwart zu kennen. Die Erinnerung ist also sehr wichtig, um die Zukunft zu kennen. Das ist der Grund, weshalb ich mindestens zwei Stunden am Tag mit Zeitunglesen verbringe.

Ich betrachte den Einfluß, den der nordkoreanische Schamanismus ausübt, mit großem Interesse. Einmal saß ich zu Tisch mit einem kanadischen Wissenschaftler, der sich mit den amerikanischen Indianern beschäftigte. Ich fragte ihn, welchem indianischen Stamm ich angehört hätte, wäre ich in Amerika geboren. Den Eskimos, sagte er ohne das geringste Zögern. So weiß ich also heute, daß ich der schamanistischen Tradition Sibiriens angehöre. Für mich ist dies aber auch eine Verbindung mit meiner Kindheit. Tatsächlich sind die Schamanen das, an was ich mich aus meiner Kindheit erinnere.

Aber auf dem gedruckten Papier funktioniert das anders ... Die gesamte geschriebene Geschichte geht bis zur Auffindung von "Quellen" zurück, d.h. zur Erfindung der Landwirtschaft, in die Bronzezeit. Aber dies ist nur ein kurzer Zeitraum in der Geschichte der Menschheit. Vor dieser Zeit haben wir schon Millionen von Jahren gelebt. Vor den schriftlichen und archäologischen Quellen ist alles audio-visuelle Erinnerung. Je mehr ich mit Video arbeite, desto besser kenne ich diesen Teil der Geschichte: die Steinzeit, das Neolithikum. Diese Periode unserer Geschichte ist die wichtigste, weil die längste: Millionen von Jahre.

Das ist der Grund, weshalb die gesamte videokünstlerische und audiovisuelle Erfahrung dieser Jahre mithalf, in die Geschichte der menschlichen Dinge einzudringen. Künstler verstehen sich sehr gut auf das Erinnern. Die ganze Erfahrung, die im audiovisuellen Bereich, in der Musik und in der Videokunst von den Anfängen bis heute angehäuft wurde, ermöglicht mir den Zugang zur Erinnerung der Geschichte. Im übrigen gleicht unser Gehirn einem Magnetband. Bevor ich Cage begegnete, war ich ein sehr schlechter Komponist. Er hatte den größten Einfluß auf mich. Er lehrte mich, die Musik als eine Kombination von Dada und Zenphilosophie der "Leere" aufzufassen. Für ihn war der Dadaismus wichtig, für mich deshalb der Dadaismus und Duchamp.

In gewisser Weise bin ich ein Expressionist. Meine ersten Werke sind ziemlich expressionistisch. Den Futurismus lernte ich 1958 kennen, nicht früher. Die futuristische Bewegung ist interessant, weil sie als erste der Komponente "Zeit" Ausdruck verlieh; und Video ist Bild plus Zeit. So war der Futurismus auch in theoretischer Hinsicht von Bedeutung. Die Zeit beeinflußt die Kunst. Deshalb muß der futuristische Beitrag in der Geschichte der Videokunst erwähnt werden. Ich denke, die Entwicklung des Kinos und die der Popmusik stellen die wichtigsten Momente in der Kultur dieses Jahrhunderts dar. Diesen beiden Ausdrucksformen, die im 19. Jahrhundert noch nicht existierten, ist es zu verdanken, daß verschiedene Völker sich untereinander verständigen konnten. Und dieser Prozeß ist noch nicht zum Abschluß gekommen.

12

(veröffentlicht im Katalog "Il Novecento di Nam June Paik", Rom 1992, S. 23–29)

Aus dem Italienischen von Sabine Weißinger

VITTORIO FAGONE
NAM JUNE PAIK AND THE FLUXUS MOVEMENT. EUROPE AND AMERICA, THE ORIGINS AND DEVELOPMENT OF VIDEO ART

Wuppertal in 1963 and New York in 1965 are now seen as the places where video research had its "historic" beginnings, in the work of two artists from the Fluxus movement, Nam June Paik and Wolf Vostell. In the Galerie Parnass in Wuppertal, Paik and Vostell destroyed the new televisual "tool," warning of its standardizing potentiality, and taking apart its mechanical and electronic components to convey a different sort of message. Two years later, in New York, Paik took advantage of the new medium's possibilities, using the Sony port-pack, the first amateur portable television camera. He was able to use this first television camera capable of redefining the electronic image, experimenting with a compendium of shots.

For a real understanding of video research during these years, the two dates must be seen in conjunction, since the critical destructuring of the stable elements of television communication and the constitution of a new image – dialectical with respect to that of figurative convention – remain two recognizable constants in the field.

This kind of strategy is consistent with the poetics of Fluxus, which had two fundamental objectives: firstly, the establishment of a new social-cultural environment, fit for the rapid circulation, on every level, of a new aesthetic communication capable of reducing the distance between artists and public, soliciting their reciprocal commitment within a single field of creative linguistic relationships; and, secondly, the opposing of the canons and conventions of institutional art with new, open models, capable of establishing a new totality that would redefine aesthetic stances and allow the active permutations of languages.

Vostell and Paik began a line of investigation that urged visual artists impartially to consider the new electronic tool as a useful instrument for expanding the dimension of visual images. They felt their work could involve both historical time and the internal time of the art process, in a virtual space and in the new dimension of real time. While Vostell's and Paik's explorations are still significant in today's profoundly changed art world, it is also important to remember the decisive influence that John Cage's theories and experiments had on video research and on the entire Fluxus movement.

Paik has often stated that without Cage, video investigations would not have come about. It makes sense to ask what Cage was able to offer to the new experimental area within which Paik worked with such assiduousness and so successfully. Cage clearly demonstrated the possibility of a different stance toward the heterogeneous elements that can be brought together congruently in a linguistic organization. He practiced a thoughtful irony directed toward the utilization of a negative structuring (sound/silence), similar, with its reversal of positions, to the unified image/dispersed and fragmented image in Paik's work. Cage's use of concrete and literally "active" sound was also influential, and experimental video used these in an innovative crossover between images and performance activities. The value of the sound portion of audio-visual electronics is the intensified result of this precise knowledge.

According to Vostell, while Fluxus expanded upon certain tensions typical of happenings in the Fifties, with a total involvement of the art-life relationship, it was the choice of music as a field of tensions and actions, of persons in movement and stable images, but also of reflections that were simultaneously open and redefining, that constituted the distinctive character of this new experimental area.

While one cannot ignore the relationship between early video and already mature developments in European and American experimental cinema (to which visual artists made decisive contributions), the particular relationship between the area of sound, a field focussed upon by Fluxus, and innovations in performance helped to lend this new model of artistic communication a linguistic specificity.

Strategies of video research: destructuring-structuring

Nam June Paik and Wolf Vostell have stated that the key for understanding motives for and developments in video research lies in the complex and free poetics (strategy might be more precise) of the Fluxus movement. They are hinting at something that is difficult to discuss without addressing the undeniable and fundamental contributions these two artists made to the birth of video-art, as well as the innovative value of the crossover between various artistic languages and models of new communication, supported and practiced, at least early on, by all artists of the new movement, including Paik and Vostell.

Even if this is taken as a given, I think it is necessary to bear in mind three equally relevant factors: 1) Fluxus came into being in the late Fifties in the United States, where it was considered an intellectual manifestation of late Dadaism, with "dangerous" anarchic-communist utopian tendencies, and for this reason it was given a hostile reception and was marginalized. However in Europe, particularly in Germany, the movement's dialectical and innovative stance was appreciated and more or less positively received by critics. 2) According to Shigeko Kubota (Video d'Autore, Taormina Arte, 1990), the real life and historical meaningfulness of the Fluxus movement ended in 1974, when George Maciunas died; indeed, the movement died with him. After this date, the individual Fluxus personalities continued working, but neither their followers and imitators nor the "second thoughts" of converted collectors, dealers, and critics could be taken seriously. 3) In the Sixties, and at least until the mid-Seventies, it was the visual arts that were most open to the various avant-garde experiments (though not always by choice), and it was the visual arts that accepted and in many cases promoted an active exchange between the new languages of communication, the conventional visual arts, and the performing arts.

With all this in mind, video research takes on connotations of a dialectical and rapid progression rather than the amoeba-like vagueness of an ingenuous and ahistorical peripheral space, suspended in a sort of limbo, between expressive high-density artistic languages and the tepidly inert, if not cold, models of new communication hypothesized by MacLuhan.

More explicitly, the nearly 30 years that separate the current scene from the first presentations of Nam June Paik's and Wolf Vostell's video work at the Galerie Parnass in Wuppertal have not been characterized by one single, linear development. The lively dynamic of the new movement, marked by a real and continual internationalism, presented widely varying examples, attitudes, and strategies. It is important to isolate these today, in order to understand correctly the history of the phenomenon and its bearing on the present.

Let us take another look at the beginnings. What did Paik present in Wuppertal, in his attempt to dislocate and redefine the electronic image, until then monopolized by television and precluded to artists, despite proof of its inherently visual character? Using thirteen monitors, he warped a black-and-white televisual image in thirteen different ways, manipulating modulations of luminosity both vertically and horizontally. The destructuring goal was clear. The primary, luminous quality of the electronic image was emphasized, but its televisual appearance of an absolutely veracious and therefore unique image was literally thwarted.

In 1965, Paik finally began using not only the transmission device of the electronic audiovisual apparatus (the monitor), but also the filming device (the telecamera). Using the port-pack, he demonstrated – in a video shot in New York and entitled "Cafe Gogo, 152 Bleecker Street, October 4 and 11, 1965" – how innovatively subjective the shooting of an apparently banal subject could be.

Paik, who was born in Korea, had lived in Tokyo before moving to Germany in 1957 (first Munich, then Cologne), where he followed a path closely tied to developments in avant-garde music. In Germany he encountered the Fluxus group, and, most significantly, he got to know John Cage, which was the beginning of his creative wandering among the various artistic languages, practiced through and in the space of video.

The destructuring attitude is perhaps even clearer in the work of Wolf Vostell, who was one of the artists included in the Galerie Parnass show. As far back as the late Fifties, Vostell was recognized as one of the most prominent members of Fluxus, known for his violent decompositions-recompositions of images extrapolated from popular TV programs.

Within the rapid space of a few years, the center of video experimentation shifted from Europe to the United States, where the catalyzing force, Fluxus, had been banished. In Europe, the development of video explorations was entrusted to the generous pioneering spirit of gallery dealers-promoters like Gerry Schum, who first in Berlin, later in Düsseldorf, and then from within the Essen Museum proposed the original Video Galerie, conceived for the production, presentation, and documentation of artists' videos. But in the United States, the avenues that opened up, if only for a brief period, pointed in quite a different direction.

Video versus television, yesterday and today

Recently I was able to interview Wolf Vostell at length, about the reasons behind video artists' aversion to television, even during that early period. Along with the commonly understood motivation, the need for an opposition to the standardized use of the new medium, Vostell added another explanation. During the late Fifties and early Sixties, the Radio Cologne studies had fostered the birth of a radically innovative musical operation, with the help of the young Stockhausen and Nono (with whom Paik collaborated), and this had a fundamental impact on new electronic music. During those years the radio and television structure in West Germany coincided with each other.

Why was it impossible to exploit the medium of television to achieve the same creative and critical ends that were accomplished using the resources and channels of radio?

Beyond the fetishism of the audience, precociously cultivated by commercial and public television, beyond the need to maintain television's regime of maximum conservative stability, both social and formal, the question remains unanswered. Thus today it seems safe to say that the real expressive culture of

the new medium developed in the video area as an hypostasis, exterior to the world of television.

In the United States, at least at the beginning, the situation was different. In 1965, when Paik was already working in New York, the Rockefeller Foundation awarded $ 275.000 to channel WGBH in Boston, for the promotion of experimental TV programs entrusted to artists and researchers (*by* artists, it may be noted, not *on* artists).

The programs created were aired regularly. Soon this form of avant-garde work captured, not the enthusiasm of a Gerry Schum, but the attention of shrewd and influential dealers like Leo Castelli. The question of the relationship between video and television, in Europe as in America, still remains awkwardly open. Apart from the demonstrative availability of Channel Four in Great Britain, of Canal Plus in France, of the Videographie program in Belgium, it is difficult to find examples that encourage optimism. As for public television in Italy – private television is not even worth mentioning – it should be recalled that RAI never had the courage to broadcast the rare experimental productions it created, and the artists involved always preferred to place themselves in front of, rather than behind the telecameras, to experiment with the resources of a new visual tool, with the result, apparent day by day and for all to see, of a general levelling of quality.

Yet one thing is clear: while this might seem paradoxical, nearly 30 years of innovative and significant video research have demonstrated that video can do without television, and not lose its communicative velocity or efficacy. It is legitimate to wonder how long television will be able to refuse to explore a creative rather than reproductive culture of the medium it utilizes, without definitively resigning itself to being a generic and often inappropriate container? If, within the European panorama, the video-television relationship still remains blocked or obliquely active only in certain marginal zones (commercials, spots, clips), today's video/visual arts relationship has changed. Even early on, the visual arts played a fundamental role, because of the references and inherent similarities to specific linguistic and metalinguistic models (from conceptual art to body art) and because of the space of attention they knew how to offer.

The return to the materiality of painted images that came about during the late Sixties and the slowdown in nonmaterial and behavioral investigations in the visual arts (the waning of performance art) coincided with the abandonment of video by certain artists and with a broad disaffection on the part of progressive art segments. This situation, which also established a natural process of selection, weeding out the merely curious and opportunistic, freed video research from a dependency that was too closely tied to the visual area.

The link with the visual arts, indeed the specific intrinsic relationship between the two areas, remained productive in video sculptures and video installations. In these areas, where masters like Paik continued to work, a new generation emerged that was able to elaborate upon and environmentally expand video, in both a lucid and soft fashion. In the early Nineties, video explorations of recognized masters and young artists seem less a hard, dialectical opposition to television than a sophisticated and creative diversion.

As a result, the electronic image in video is capable of establishing an active regime of exchanges with the expressions of other artistic languages and communication media, without domination or impositions, within the mobile boundaries of a new form of representation, one that is nonmaterial, intelligent, and complex, as well as seductive.

Fluxus

What is perhaps the first Fluxus event in history dates all the way back to the end of the last century, to around 1880, when the first transatlantic telecommunication cables were extended.

At the time, communication between Washington and London took at least six months. Round trip! And so the cables had to be linked between London and America. Cables beneath the ocean. American ships had to meet up mid-ocean and "give each other a hand" to attach their respective cables. Naturally, enormous economic resources were required to accomplish all this. Bonds in order to finance the project. It took years to research the project, to find the cables that would link the two nations. When the two sides finally joined up, in the middle of the Atlantic, one side, I think it was the American, lost its cables and the much awaited event fell through. Thus 4,000 kilometers of work were lost. I think of this episode as a true Fluxus "event"; an important moment in the Fluxus idea – the perfection that becomes error, that is transformed into error. To arrive at the end and to have to begin all over again.

Video, Communication, Technology

It is important to work on two levels of communication – reciprocal and interactive – because unilateral or "one-way" communication is very common. For example, I believe that today, teleconference mechanisms are opening up interesting perspectives, and one reason is that the technology has become much more economical than satellite communications. Perhaps the problems encountered with satellites could be overcome by teleconferences, but back in 1984 this technology was not yet very developed.

My first satellite ideas proposed the possibility of having Merce Cunningham dance with Baron. I was rather naive. I contacted Baron, asking him if he would like to improvise with Merce Cunningham … big names … But he said that he had to attend a New Year's celebration.

The truth is, the event didn't guarantee the degree of professionalism that their reputations merited. In fact, in their case there was talk of improvisations without trial runs, and the public would have been able to trade off between the two performances, in a sort of competition between two illustrious personalities.

The same thing happened between Beuys and Cage, whom we asked to play a piano duet together. Can you imagine? Beuys and Cage … The event of the century! But Beuys wavered. On the one hand there was Cage, who over the course of many years had developed an extremely personal style. On the other hand there was Beuys, who had his own specific artistic program. It was unthinkable for either to change his style, just like that. It was the same with Beuys and Allen Ginsberg … For them, television wasn't very important, and I was the one who won them over. They were very busy, so when I asked them to come, they said yes, but they never took the project seriously. In contrast, Laurie Anderson, being a multi-media artist, was very serious about "Good Morning Mr. Orwell."

For a young artist today, using teleconference tools could mean experimenting with a new art form. I have also discovered that "two way" communication is much more important that "live" communication. I came to this conclusion after spending a million dollars and eight years of research on satellites. A broadcast between one man and another always takes place in real life (on facing the other). The camera always hides something, just as clothing hides much of the information that might be communicated by the body. The study of dress is very interesting for those involved with the media, because in some way it concerns deception, that which is hidden.

In 1984 I took a stand. George Orwell stated that, no matter what, television was negative. In opposition, I stated that television was not always negative, that it wasn't "Evil". This is exactly what I said in "Good Morning Mr. Orwell"; I was the only one in the world to say so, and I am proud of it.

I always thought that equipment would become more accessible economically. In 1964 I tried to work with digital technology, but at that time, that type of computer cost millions of dollars, and only the military was using it. I had to wait for the technology to become more economical before I could use it, and this happened in 1967. This is my relationship with hardware and manufacturers in the industry: wait until the products become cheaper. I can even wait twenty years.

In other words, if you are talking about art and technology, you also have to talk about money. In this field it is a bit like the film industry. You have to begin with money. Moreover we use post-production studios that cost thousands of dollars per day, which is beyond our reach. We need to find backers who allow us to use technology, who grant us the tools for moving ahead with our work.

It is also true that big business needs us. They entrust us with new technologies to experiment with, to establish their limitations. One reason they do this is because they are not allowed to work this way with scientists, and so it is often we, the artists, who experiment with new technologies.

The extremely fast computer that we use was originally developed and produced for guided missile systems. If a computer satisfies the needs of the military, it is obvious that it can be applied to television commercials. The machines themselves are neutral. The military industry can develop the technology because it possesses the necessary economic resources. Indeed, Marconi was supported by the British Navy.

The military industry develops technologies. I'm not fond of the military, but we need funds to experiment in our area; I'm not saying it's good or bad, but it is our lot. On the other hand, the entire 20th century has been marked by significant competition between media technology and art. And artists have been the priests, the victims, and the antennae of this challenge.

History, Memory

Artists know more about the future than about the past. True, it's not always this way, but I think it generally is. Artists have been the avant-garde of great changes; we haven't always been right, but we are more often than others.

I know my role: something in between the development of hardware and that of software. And I know that I'm good at acting as an interface.

We all want a certain security and a better life. We need to know something about the future, and the more we know about the past, the more secure we can feel. Knowing the past, that is, memory, means understanding and seeing the future.

Memory is a series of curves, someone has called it a radar between past and future. We are here in the present, we know the past, we can try to understand the future. But we cannot know the present. Therefore memory is very important for knowing the future. This is why I spend at least two hours every day reading the newspapers.

I'm very interested in the influence exercised by the shaman culture in North Korea. Once I was at a table with a Canadian scholar who was studying Native Americans. I asked him what tribe I would have belonged to if I had been born in America. Without hesitation, he said Eskimo. And so now I know that I belong to the Siberian shaman tradition. But for me this is also a tie to my childhood. In fact, shamans are what I remember about my childhood.

But with the written word it is different … All written history goes back to the individuation of a "proof." This means back to the invention of agriculture, during the metal ages. But this is only an extremely brief period in the history of man.

Man had existed before, for millions of years. Before written and archeological "proofs," there is all audio-visual memory. The more I work with video, the better I understand this part of History. The Stone Age, the Neolithic. This period of our history is the most important because it is the longest. Millions of years.

This is why all the video art and audio visual experiences of these years help me enter the history of human things. Artists are very good at exercising memory. All the accumulated experience of audiovisual work, of music and of video, from their beginnings until now, allow me to enter the memory of history. Moreover our brains are made this way, like magnetic tape.

I was an awful composer until I met Cage. John Cage was my biggest influence. He told me that he thought of himself as a combination of Dada and the Zen philosophy of "emptiness." For him, Dadaism was important; just as Dadaism and Duchamp were important for me.

I am a sort of Expressionist. My early pieces are rather Expressionist. I became acquainted with Futurism in 1958, not earlier. It is interesting because it was the first art movement that expressed the "time" component, and video is image plus time. Thus Futurism was also theoretically important. Time influences art; and so in recounting the history of video, Futurism's contribution should be remembered. I think that the most important moments of culture in this century are represented by the development of cinema and of pop music. Thanks to these two forms of expression, which didn't exist in the 19th century, different types of people have been able to communicate with one another. And this process has still not reached its conclusion …

(published in the catalogue Il Novecento di Nam June Paik, Rome 1992, p. 23–29)

Translated from the Italian by Marguerite Shore

WULF HERZOGENRATH
NAM JUNE PAIK'S PARADIGM CHANGE: FROM MATERIALITY TO IMMATERIALITY TO ILLUSIVE MATERIALITY

I Materialization

Around 1960, with Arte Povera and the Fluxus artists, we experienced the immediate visualization of materials. Fire really burned (Kounellis), wind blew (Haacke), stone turned into sculpture (Long) and water flowed (Rinke).

In the case of Paik, it is the empty film with its physical "flaws", scratches, traces, that becomes the film's content ("Zen for Film", 1964); likewise, the whole piano, the "Klavier Integral" trimmed with a number of sonorous objects becomes a multivoiced orchestra. As an object, the television set is itself sculpture: "Rembrandt Automatik," 1963/76 (the seemingly wrecked set with the screen lying face down). But this is also the case in his early manipulation attempts which Paik called "Participation TV", with a foot-switch interrupting the ongoing programme, with magnets forming abstract images ("Magnet TV", 1965), and with the microphone transforming the sound into pictures. "Zen for Wind – Objets Sonores" from 1963 is a sculpture with objects hanging from a line that gives off sounds at the slight stir of wind"… Count the Waves of the Rhine… If the Rhine Still Exists," a wonderful concrete reference on the fourth from the last page of "Symphony No. 5" (1965).

For Charlotte Moorman, Paik not only devised video objects, he also hoped ultimately to change the practice of musical performance in 1960, he conceived a performance of the "Moonlight Sonata" by a nude player (which was never realised). Charlotte Moorman often performed an important water piece, though; she interrupted her cello recital from "Swan Lake", stepped into a huge vat filled with water and then, soaking wet, continued to play the second part. It was an elementary sight and sound event in which the piece not only sounded different afterwards; as a spectator one physically felt the real penetration of water as well. Paik declared the plastic exterior of the first video reel that he used to be an object, "A painting which exists two times a second," 1965, and in 1976 he repainted an old baking form made of wood to become a "First Transportable TV." On another occasion he put a lighted candle in a completely empty TV casing: "Candle TV" (1975 onwards), where the real candle illuminates television reality.

Here, like others in different creative fields, Paik takes a clear position on the materialization of the objects which develop naturally and straightforwardly.

II Dematerialization

In 1969, together with Shuya Abe Paik developed the first video synthesizer. Artificial images evolve purely synthetically without a camera, and all existing images can be manipulated and changed in every aspect. The leap into the immaterial has been made: the artificial images become ever less assailable. The apparatus does not give any idea of the images. The computer separates from its message.

With the large sculptures and environments, the exterior sculptural form of the TV set is no longer important; the electronic screen conveys the information, and the set disappears behind the foliage of a primeval forest ("TV Garden," 1974),

behind aquariums with guppies ("Fish Art," 1975), in the dark of vast, lofty skies ("Fish Flies on Sky,"), or turns into a projection of light and fire ("One Candle" room, 1989). The TV sets which have been placed on the floor with the screens facing upwards are hidden or hang hovering from the dark ceiling, or they are arranged in accurate rows to create the effect of pattern of screens. The three-dimensionality of the set, its exterior, becomes unimportant; its sculptural quality is supplanted, covered up, becomes immaterial itself; or only the mere projection is chosen which seems detached from any object source and can also be used in combination with other projections.

Paik was fascinated by the idea of "satellite" transmission, and his first work was also a major part of the first satellite transmission of art ever. For the 1977 inaugural activities organised by Beuys, Paik and Davis on the opening of the documenta 6 in Kassel, Paik rehearsed a kind of mini-retrospective of his works, but in the process, also developed an important new piece for this new immaterial inaugural event: the piano performance with the black-and-white handicam. Image and sound are identical, and yet for the spectator it was hardly comprehensible how they related to one another materially. After that, Paik created three more satellite events: "Good Morning Mr. Orwell," 1984; "Bye Bye Kipling," 1986; and "Wrap Around the World," 1988. The contemporaneity of events, the interaction of the musical and the scenic through time and air fascinated Paik.

III Illusive Materiality

Since 1986, the "Family of Robot" has evolved with numerous generations and family members, including grandparents and aunts, lots of babies, and the heroes of the French Revolution as well as friends and fellow artists, horseback riders and cars, they have been shaped and assembled from commensurate TV sets and visualised through appropriate visual material. Here, a three-dimensional object form materializes, and at the same an immaterial level remains and not only in the image presented by the multitude of television screens: a peculiar new illusive materiality.

This illusive materiality resolves itself: it is the as-if world of the media which here only illusively materialises as a "Fountain" in which no water splashes, after all, but "just" blue neon lines. The tree looks as it should, and is shaped as the sign for "christmas tree," but just not as a real tree in the round; moreover (and probably not even noticed at first), the destructive "fire" of the TV sets has not singed them but has only raged illusively. The sets are not burnt (like the object "Burnt TV – for Bob Durham", 1976) but "just" destroyed and scattered on the floor. The fire rages "just" on the TV screens; the real is only represented, simulated. This ironic play with the form of "as if" is Paik's small contribution to the post-Modern discussion; carrying personification and proximity so far that many feel it to be too proximate, he inserts little obstacles – distancing so subtle they are hardly noticed – far the purpose of distancing.

Dedicated to Hermann Pollig on the occasion of his farewell from the IfA, Stuttgart, on 30 April 1993. Written for the 1993 Venice Biennial Catalogue of the Federal Republic of Germany.

Translated from the German by William A. Mickens

ACHILLE BONITO OLIVA
DE HALBSCHLAF DER KUNST
BEI NAM JUNE PAIK

Die Videoinstallation stellt das Kreuzen von Raum und Zeit im Bereich der Kunst dar. Der zeitgenössische Künstler nimmt – in diesem Falle am Ende des 20. Jahrhunderts – die Anregungen und Grenzüberschreitungen in Richtung auf die Dimension des Gesamtkunstwerkes in seine Arbeit auf.

Das Gesamtkunstwerk ist der Zielpunkt eines langen, von Künstlern seit dem Barock beschrittenen Weges. Über das Wagnerianische Theater führt er zu uns, wo der Künstler zum Schöpfer eines Raumes wird, der von der realen Zeit rhythmisiert und durch eine Vielfalt der Materialien gekennzeichnet ist.

Die Videoinstallation ist die Herstellung eines architektonischen Feldes im Kleinformat, basierend auf der Verschmelzung, der Assemblage, der Kurzschlie-ßung verschiedener Materialien innerhalb eines Raum-Zeit-Konzeptes.

Dadurch entsteht die komplizierte Struktur eines Werkes, das mit der Stabilität der einen und der elektronischen Mobilität der anderen Materialien arbeitet.

Die Dialektik von Stabilität und Dynamik stellt das Verweiselement auf die Architektur dar, auf einen von Komplexität, Differenz und Verschiebung beherrschten Raum. Der Betrachter wird konfrontiert mit einer gestalteten Raumeinheit, die sich als Präsentation eines dreidimensionalen und in gewisser Weise "bewohnbaren" Kunstwerkes versteht.

Die Videoinstallation kann frontal und rein kontemplativ "bewohnbar", von außen beobachtbar, sein oder aber die Möglichkeit zur Begehung bieten, zu einer Erfahrung, die aus der polysensoriellen Wahrnehmung des Körpers resultiert, der in das Labyrinth des Kunstwerkes eindringt.

Wenn bei der gewöhnlichen Installation die Körper des Betrachters die Funktion eines lebendigen Meßgerätes übernimmt, das Temperatur und Zeitstruktur des Werkes anzeigt, so dokumentiert hier die kinetische Bilderfolge in der Videoinstalla-

tion eine doppelte Zeitstruktur. Die Duplizität ergibt sich aus einer zweifachen Möglichkeit der Messung. Die eine beruht auf der inneren Zeitstruktur der technischen Anlage, die andere auf deren Begegnung mit den in sich unbeweglichen Materialien und dem stillstehenden oder sich bewegenden Publikum.

In gewisser Weise sehen wir uns einem Werk gegenüber, das sich zunächst selbst Gesellschaft zu leisten scheint, da es auch ohne die Anwesenheit des Betrachters funktioniert. Das Fernsehbild, sei es abstrakt oder figurativ, wird vom unerbittlichen und unaufhaltsamen Tempo der elektronischen Übertragung beherrscht. Insofern weist es eine unfreiwillig ironische Art von Selbstgenügsamkeit auf, als wollte es die apokalyptische Vision einer Welt verkünden, aus der die Menschen verschwunden sind. Gleichzeitig besitzt die Videoinstallation in ihrer aktiven Erzeugung von Zeitlichkeit die objektive Fähigkeit, die eventuelle Anwesenheit des Publikums in dem Sinne zu kontrollieren, daß sie eine kinetische Ikonographie aufweist, die synchron zur Bewegung des Zuschauers abläuft.

Daraus ergibt sich der Effekt einer doppelten zeitlichen Dynamik innerhalb des begrenzten Raumes, den die Videoinstallation definiert. Dieser Raum präsentiert sich bewußt in einer offenen und provisorischen Assemblagestruktur, d.h. es handelt sich um einen Ort, an dem Materialien, Objekte und technische Instrumente interkommunikativ versammelt sind und der gleichzeitig begehbar ist.

Die Begehbarkeit des Werkes erzeugt eine polysensorielle Erfahrung, hervor-gerufen von der Rückwirkung und der Beziehung der verschiedenen Teile untereinander im ästhetischen Feld des Kunstwerkes.

Die Videoinstallation ist eine dem Städtebau vergleichbare Kunst, die bewußte Entscheidung eines Künstlers, der formsprachliche Strukturen verändernd bearbeitet, wie es der Städtebauer mit Stadtteilen tut.

Dieser letztere beschäftigt sich in der Tat nicht nur mit abstrakten, sondern mit von realem Leben seiner Bewohner erfüllten urbanen Räumen. Die Videoinstalla-tion besitzt dieselbe innere Dichte, in ihr lebt eine Art kollektiver Erinnerung, durch die sie sich von der unpersönlichen Stille der Malerei und der Plastik unterscheidet.

Der Künstler erarbeitet einen Weg durch die Installation, der nicht nur an der räumlichen Plazierung der Elemente erkennbar ist, sondern sogar eher definiert wird durch die innerhalb der Grenzen des Werkes bestehende dynamische Struktur.

So befindet sich der Betrachter nicht vor, sondern im Innern des Kunstwerkes, d.h. in einer totalen Kunstrealität, die auf eine fortwährende Überschreitung von Grenzen setzt: seitens der Materialien untereinander und seitens des Betrach-ters in der Form eines Überganges vom realen Leben in das Zeitgefüge der Kunst. Der Betrachter wird zu Alice im Wunderland, zum Protagonisten einer Inversion der Räumlichkeit in pure Zeitlichkeit. Das Gehen durch den Spiegel ist augenfäl-lig und konkret. Der Betrachter überschreitet real die Schwelle zwischen Kunst und Leben. Hier durchlebt er einen Zeitraum, der sichtbar mit ineinander verflochtenen Objekten und Formen ausgestattet ist. Nicht er muß träumen: Die Videoinstallation erzeugt den Traum des Werkes mit Hilfe der Projektion einer ästhetischen Zeit in einen betretbaren dreidimensionalen Raum.

Vom Traum übernimmt die Videoinstallation das Verfahren der Verschiebung und der Verdichtung. Die Materialien werden von ihrem ursprünglichen Ort entfernt und in eine neue Beziehung zueinander gestellt, in der ihr origineller und rein phantastischer Gebrauch begründet ist. Die Verdichtung geschieht durch ein Zusammendrängen absolut willkürlicher räumlicher und zeitlicher Situationen in der Art der Traumerfahrung.

Im Vergleich zum Surrealismus besitzt diese ästhetische Realität zusätzlich die Fähigkeit, die freien Traumassoziationen nicht nur auf der mentalen Ebene zu reproduzieren, sondern auch in an die polysensorielle Totalität des Körpers gebundenes, dynamisches Erlebnis zu erzeugen.

Die Videoinstallation ist also nicht Reproduktion, sondern unabhängige Produk-tion. Sie überwindet die unausweichliche Entfremdung, die dem Fernsehgesche-hen eignet, welches auf der Unbeweglichkeit des Zuschauers basiert und auf perfide Weise garantiert wird durch dessen Auffassung, das Drama, die Realzeit des Ereignisses liege außerhalb. In der ästhetischen Erfahrung gibt es keine feststehenden Räume und Zeiten. Der Betrachter ist selbst aktiv, eingedrungen in den seinerseits aktiven, künstlerisch gestalteten Bewegungsraum. Wenn die Realität beim häuslichen Fernsehen abgeschwächt und auf ein rein zweidimen-sionales, vom Gehäuse des Fernsehers begrenztes und eingeengtes Bild reduziert wird, explodiert statt dessen alles, breitet sich aus im dynamischen Feld der Beziehungen des Werkes mit dem Publikum.

Die Videoinstallation widerlegt die urbane Erfahrungswelt des modernen Men-schen Schritt für Schritt mit deren eigenen Mitteln, der Landschaft von Geräten, dem Überschütten mit Ereignissen. Sie widerlegt die soziale Passivität, kehrt sie um in eine Aktivität, die auf die Eigenverantwortlichkeit des Individuums setzt. Dies ist möglich, weil dieses ästhetische Konstrukt nicht mehr – wie die Formen der Konzept- und Videokunst – auf Information zielt, sondern auf Kommunikation, d.h. auf die intersubjektive Beziehung, die zwischen dem Werk und seinen Adressaten, dem Sozialkörper, besteht.

Wie all die hochkodifizierten Zeichen der Stadtlandschaft erzeugt die Kunst als Information am Ende unvermeidbar eine entropische Paralyse, eine unabwend-bare Verringerung informativer Energie. Die Videoinstallation versucht, dem entropischen Charakter der Experimentalkunst, die allein auf der Entdeckung

neuer Technologien und Materialien basiert, entgegenzuwirken, indem sie die dynamische Qualität der Wahrnehmung nutzt, sie in ein Feld der Erfahrung und der direkten Konfrontation mit dem Werk umwandelt.

Der Künstler tritt der unvermeidlichen inneren Entropie der Form entgegen, indem er das Publikum offen aufruft, der Kunst zu Hilfe zu kommen. Dergestalt soll eine Art Agora geschaffen werden, ein sozialer Ort der Zusammenkunft, an dem ein Gemeinschaftskörper agiert und einen Friedhof der Objekte und technischen Apparaturen in ein System des Austausches und der intersubjektiven Kommunikation transformiert.

In der Videoinstallation scheint eine Hierarchie zwischen Subjekt und Objekt, die mögliche Instrumentalisierung jenes durch dieses, nicht mehr zu existieren. Hier wirken statt dessen beide auf ein gutes Gelingen des Experimentes hin: Die Belebung eines durch eine innere und äußere Zeitlichkeit garantierten Raumes. Interne Zeitlichkeit im Hinblick auf die Bewegung der Maschinen, externe Zeitlichkeit als Frucht des lebendigen und realen Eindringens des Betrachters in den abgegrenzten Raum des Kunstwerkes.

Auf diese Weise entsteht eine Art doppelter Traum.

Der Transformationen erzeugenden ästhetischen Erfahrung unterliegt das Werk selbst und das Publikum. So entsteht ein sensorieller Kurzschluß innerhalb der künstlichen Koordinaten der Videoinstallation, wie er übrigens im städtischen Raum, in dem sich der Mensch bewegt, möglich ist.

Der Unterschied, der zwischen den beiden Dimensionen besteht, ist konkret; beobachtbar ist auch die verschiedene Art des Subjektes zu agieren und zu reagieren. Schließlich scheint auch eine neue Dimension des Objektes zutage zu treten, die es seiner trägen Nützlichkeit enthebt und einer anderen, ungekannten und dynamischen, unvorhersehbaren und ungeplanten Funktion zuführt.

Geplant ist jedoch der strukturierte "Parcours" des Künstlers, der ein magnetisches Feld von Formen herstellt, die Erfahrung nahelegen, ohne sie zu erzwingen, die Antworten provozieren, ohne zu fragen.

Die Videoinstallation verzichtet in der Tat freiwillig auf das metaphysische Wesen der Kunst, jener traditionellen Kunst, die normalerweise einen forschenden und steril analytischen Charakter aufweist, der eher der geistigen Konzentration als der polysensoriellen Erweiterung des Körpers dienlich ist.

Hier sehen wir uns einer ausgedehnten und komplexen Anordnung von vertrauten und alltäglichen Dingen gegenüber, denen nichts Beunruhigendes und Mysteriöses anhaftet, die vielmehr einladen zur Erkundung und Begehung, ohne Mißtrauen und ohne ängstliche Beklemmung angesichts eines rätselhaften und symbolgeladenen Universums. Die Videoinstallation ist nicht von der Poesie einer einzigartigen und bestrickenden Form erfüllt, vielmehr lebt in ihr eine Prosa, bevölkert von Objekten des täglichen Lebens.

Dieses im Kunstwerk anwesende, alltägliche Leben bewirkt, in Gestalt der Verschiebung und der Verdichtung, eine weitere Verschiebung des doppelten Traumes in den Zustand des Halbschlafes, bewirkt die Empfindung eines Überganges, der sich nicht plötzlich, sondern in einer kontinuierlichen Bewegung vollzieht.

Das Werk baut tatsächlich auf die Wiedererkennbarkeit und Vertrautheit der Materialien.

Das Wiedererkennen ist von entscheidender Bedeutung für das Publikum, das sich in die Installation hineinbegibt, zwischen den verschiedenen Formen hindurchgleitet, dabei keine Traumata erleidet. In der Videoinstallation gibt es grundsätzlich keine Traumata, denn sie will die Weltlichkeit der zeitgenössischen Kunst erhalten, bestrebt, das Leben zu verdichten, ohne ein romantisches Anderswo zu phantasieren. Ohne Traumata betritt der Betrachter das Kunstwerk und erkennt in dessen Koordinatensystem die Spuren und Wege eines verdinglichten Universums der Bilder und Materialien, die der Lebenswelt wie der ihr folgenden Traumwelt gleichermaßen angehören. Der Unterschied zu letzterer besteht darin, daß das Publikum sich hier in einem Raum bewegen kann, der in doppelter Weise belebt ist durch die Aktivität des Subjektes und durch jene des Objektes, der gereinigt ist von der Passivität des Alltags. Jetzt muß keine sublimierte Ersatzwelt mehr erträumt werden.

Mit der Videoinstallation bricht die Zeit des Halbschlafes an, verbürgt gerade durch die Existenz eines konkreten Raumes, in dem es möglich ist herumzuschweifen, dabei die persönliche Erinnerung an die Alltagserfahrung zu behalten und eine andere, deutlichere, in sich aufzunehmen mittels einer lebhaften und bilderreichen Erfahrung.

Aus dem Italienischen von Sabine Weißinger

ACHILLE BONITO OLIVA
THE DROWSINESS OF ART
IN NAM JUNE PAIK'S WORK

Video installation represents art's establishment of a crossroads of space and time.

Within his work, the contemporary artist, in this case at the end of the 20th century, re-employs incitements and linguistic transgressions toward a dimension of total art.

Totality is the end point of a long voyage of creative practice, from the Baroque through Wagnerian theater to our own time, where the artist becomes the creator of a space articulated by real time and characterized by a plurality of materials.

Video installation is the establishment of a field of miniaturized architecture, based on the contamination, the assemblage, the short-circuiting of various materials around the project of a journey. This journey constitutes the disseminated structure of a work, resolved with the stability of some materials, and with the electronic mobility of others.

The dialectic between stability and dynamism is the element of cross-reference to architecture, to a space inhabited by complexity, by difference, and by displacement. The spectator finds himself faced with an urban unity, intended as the presentation of a three-dimensional, three-pointed, and in some way habitable artifact.

The habitability of video installation can be frontal and purely contemplative, observable from the exterior, or it can be travelled and experienced, the fruit of a polysensory movement of the body that penetrates the labyrinth of the work.

In the normal installation it is the body of the spectator that acts as a living thermometer and hourglass, measuring the temperature and temporality of the work. But in the video installation it is the kinetic flow of the image that documents a twofold time. Twofold because of a double possibility of measurement, one dictated by the internal cadence of the technology and the other by the encounter between technology and materials that are steady in themselves and the public, either still or in movement.

We somehow find ourselves facing a work that initially seems to stand on its own, in that it even functions beyond the presence of the spectator. The television image, abstract or figurative, is possessed by the inexorable and relentless time of its electronic transmission. It thus reveals its involuntarily ironic aspect of self-sufficiency, as if to indicate the apocalyptic hypothesis of man's disappearance.

At the same time, in virtue of its active production of temporality, video installation possesses the objective capacity to control the probable presence of the public, in that it achieves and inconography that is kinetic and synchronic to the spectator's movement.

Thus we have the effect of a double temporal dynamism within a spatial enclosure defined by the field of the video installation. This field is deliberately presented with the open and provisional assemblage of an encampment, that is, the site where materials, objects, and technological tools coexist in a circumscribed and at the same time accessible space.

The accessibility of the work produces a contemplative itinerary, a polysensory experience solicited by the rebounding and the relationship between the various parts of the esthetic field of the work.

Video installation is urban art, the choice on the part of a creator who manipulates languages just as the urban planner works with sections of the city. In fact, the latter moves not only abstract urban spaces, but spaces that are condensations of experiences and full of the concrete existence of their inhabitants. Video installation has the same internal density; it preserves a sort of collective memory that differentiates it from the impersonal silence of painting and sculpture.

The artist elaborates a path that not only can be discerned through the plastic placement of the elements, but also can be defined by the dynamics established within the enclosure of the work.

In this sense we are not looking at something, but are within, immersed, in a total reality of art based on the continual transgression of materials among themselves and the transgression of the spectator from the space of life into the time of art.

The spectator becomes Alice in Wonderland, protagonist of an inversion of spatiality into pure temporality. The passage through the looking glass is evident and concrete. The spectator actually crosses the threshold of the division between art and life. Here, he finds himself passing through a time visibly equipped with interwined objects and forms. He doesn't need to dream; the video installation produces the dream of the work through the projection of an esthetic time in a habitable three-dimensional space.

The video installation takes on the dream's process of displacement and condensation: displacement of the materials from their original place, linked in a new relationship that establishes for them an original and purely fantastic use; condensation as an intense accumulation of absolutely arbitrary spatial and temporal situations, with the same oneiric modalities of experience.

In comparison to Surrealism, this esthetic reality has another capacity, not only mentally to reproduce the free associations of the dream, but also to produce a dynamic experience tied to the polysensory totality of the body.

And so video installation is not reproduction, but direct production, which overcomes the alienating imposition of the televisual event, based on the immobility of the viewer whose contemplation perfidiously guarantees that the drama, the real time of action, is unfolding elsewhere.

In the esthetic experience, guaranteed space or time does not exist. The spectator is dropped, live, into the heart of the path formalized by the work. If, in the domestic spectacularity of television, reality is refined and turned into pure twodimensional imagery circumscribed and confined by the television frame, here everything explodes and breaks out in the mobile field of the relationships of the work with the public.

Video installation strikes blow after blow with the same means – a landscape of

instruments, the dissemination of events in the urban experience of modern man. It strikes and upsets social passivity in an experiential movement based on individual responsibility.

This is possible because, unlike conceptual and video art, this sort of esthetic construction no longer aims at information, but at communication, that is, at the intersubjective relationship that runs between the work and its addresses, the social body.

Art as information, like all highly codified signals of the city, inevitably produces a final paralysis of entropy, an inevitable diminution of informational energy. Video installation seeks to combat the entropic character of experimental art, based purely on the discovery of new techniques and materials. It does so by utilizing the dynamic quality of contemplation, turning it into a field of experience and direct confrontation with the work.

The inevitable and internal entropy of form results from the confronted artist openly calling the public to assist with art in such a way as to create a sort of agora, a place of social confluence where the whole communitarian body acts and transforms a cemetery of objects and technological equipment into a system of exchange and intersubjective communication.

In video installation there no longer seems to be a hierarchy between subject and object, or the possible instrumentalization of the latter by the former. Instead, both contribute to the successful outcome of the experience, with the animation of a space guaranteed by an internal and external temporality. Internal in that it is annotated by the flow of cameras, external in that it is the fruit of the live and real irruption of the spectator into the enclosure of the work.

In this way a sort of double dream is created.

In its production of transformations, the esthetic experience addresses the work itself and the public. Thus the creation of a sensory short circuit occurs within the artificial perimeter of the video installation, something impossible to achieve in the urban artifact within which man moves about.

The difference between the two dimensions is concrete, and the different way the subject acts and reacts is visible; the object also seems to exhibit a new dimension that removes it from its inert and supine utility, shifting it into another, dynamic, unpredictable and involuntary mode.

However the structured path of the artist is voluntary. He is the creator of a magnetic field of forms that suggest experience without imposing it, answers without questions.

In fact, video installation deliberately rejects the metaphysical identity of art, that traditional identity normally characterized by an investigative and sterilely analytical identity more appropriate to the concentration of the mind than to the polysensory expansion of the body.

Here we find ourselves facing a complex encampment, scattered with familiar and everyday objects, not disturbing and mysterious, but rather inviting to access and contact without anxieties or suspicions about an enigmatic and symbolic universe.

Video installation is not inhabited by the poetry of a unique and reticent form, but by the crowded prose of objects belonging to everyday experience.

Through displacement and condensation, this experience produces another displacement of the double dream, into the state of drowsiness, the sensation of a passage made, not through a leap, but through a continuity of movement.

In fact the work is constructed in the characters of the materials' recognizability and familiarity.

This recognition is the starting point for the vicissitudes of the public, which penetrates the path, gliding along the various forms without trauma. The video installation is characteristically without trauma, since it attempts to preserve the laic identity of contemporary art, pursuing life without fantasizing about a romantic existence elsewhere. Without trauma, the spectator enters the work, recognizing in its perimeter the traces of a universe codified through images and materials belonging to the urban passage and to the oneiric passage that follows. The difference lies in the fact that now the public can circulate in a space doubly animated by the activity of the subject and of the object purged of everyday passivity. Now there is no further need to dream of a sublimated, substitute elsewhere.

Video installation establishes a time of drowsiness, guaranteed specifically by the existence of a concrete space within which it is possible to wander, preserving the personal memory of everyday life and assuming another, more articulate one, through a mobile and iconographically airy experience.

(Published in the catalogue Il Novecento di Nam June Paik, Rome 1992, pp. 19–21.)

Translated from the Italian by Marguerite Shore

EDITH DECKER
BIG FISH EAT LITTLE FISH

My first personal encounter with Nam June Paik was in 1982 at the Whitney Museum in New York. It was on the day of the press preview of his extensive retrospective. I had begun my doctoral dissertation on his video works and had arrived at this event full of academic enthusiasm. On my way through the exhibition eventually I came across Paik, somewhere in the dark room of the

"Fish Flies on Sky" installation. He was lying on a mat on the floor and looked up at the monitors. Shuya Abe, his long-time chief engineer and friend, was with him. Because I wanted to strike up a conversation somehow I was foolish enough to ask what the fish meant to him: Paik and Abe smirked, and I understood something like big fish would eat little fish. I felt somebody was pulling my leg and discontinued inquiries of that nature from then on. For all his appreciation of scholarship, Paik was not willing to give interpretations of his own work, that much had become clear to me. On the other hand, he was open to factual questions about what, when and where, and he proved to be very cooperative. Concerning the fish, I quickly made up my mind at the time not to use them as a means of interpreting the content; at the time, iconographic examples from art history suggested themselves. But it was celar to me that for the interpretation of Paik's oeuvre it makes little sense to draw on traditional iconography. Paik belongs to the European and American avant-garde, which quite consciously and intentionally pits itself against traditions and has created new parameters. He is a Western artist with the bonus of being an exotic. His Asian background is relevant only to a degree for the understanding of his work, which is just as international as the avantgarde of the last few decades. Buddhist motifs such as "TV Buddha" do not originate from a personal conviction. They are pastiches from the Far Eastern treasure-trove of materials from which he avails himself as he does from Western culture.

I had worked out this understanding of Paik's works for myself and I wasn't alone with it, either. But there has been a noticeable change since the late eighties: Paik seems to be becoming more Asiatic, due to either commercial success or age. He has returned to his homeland Korea for the first time, and since then his Korean roots have strongly come to light, too. Korean overtones, as in the shamanism practised in collaboration with his close friend Joseph Beuys, now come through louder and clearer. Since Paik has tackled Korean culture in his works, the artist's Korean personality seems to have come to the fore. This is not to imply that he really has changed. It is more a phenomenon of the reception, the perception of a person who by a slight turn lets another facet gleam. Suddenly we recognize him for what he probably always has been, a Korean artist who for all the westernization has not lost the manners and values of Confucianism.

Returning to the outset, the fish episode was not so far-fetched after all. Today I am aware of the casualness with which he accepted and respected the basic laws of nature, and of the composure with which he recognized the good in evil and the evil in good.

Translated from the German by William A. Mickens

NAM JUNE PAIK
VENEDIG I – 1960,
JOHN CAGE IN VENEDIG

1960 fuhr ich nach Venedig, um der Cage-Cunnigham-Tudor-Caroline Brown Performance im alten Barocktheater beizuwohnen. Das Time Magazine hatte in seiner Ausgabe vom 10. Oktober 1960 über die Performance geschrieben:

Revolution von gestern

In den 23 Jahren der Geschichte des Internationalen Festivals zeitgenössischer Musik in Venedig wurde das Publikum mehr als einmal an den Rand der Gewalttätigkeit gebracht; mit seinen 48 Jahren hat der selbsternannte "nichtexpressionistische Komponist", der Mann des "prepared piano" wieder einmal sein Publikum an den Rand des Wahnsinns getrieben. In der letzten Woche haben der amerikanische Komponist John Cage und das Festival zeitgenössischer Musik ihre Kräfte in einem Konzert in Venedigs berühmten alten Teatro La Fenice vereint. Die Explosion war über den ganzen Canale Grande zu hören. Mad Mélange. Für seinen Auftritt in Venedig hatte Cage eine typische Mischung seiner musikalischen Mätzchen vorbereitet. Der Abend begann gemäßigt mit Runde 1, in der Cage und der Pianist David Tudor jeweils an einem Klavier saßen und abwechselnd in Intervallen von bis zu 10 auf die Tasten schlugen. Dann begann der Tänzer Merce Cunningham sich zu winden und symbolisch die Entwicklung vom Embryo zum erwachsenen Menschen anzudeuten. Als Cage in Runde 3 mit einem Stein auf seinen Klavierhocker einschlug, waren aus dem unruhigen Publikum die ersten Buhrufe zu hören, die lauter wurden, als Cage und Tudor in Runde 4 ein Klavierduett anstimmten, bei dem sie mit ihren Ellbogen die Tasten bedienten und das Innere des Instruments mit Messern und Blechstücken bearbeiteten. Nach Runde 6, in der Cage mit einem Eisenrohr auf das Klavier eingeschlagen und Flaschen auf den Boden geworfen hatte, erhob sich ein älterer Musikliebhaber von seinem Platz, schritt auf die Bühne, drosch mit seinem Spazierstock auf Cages Klavier ein und verkündete lautstark: "Jetzt bin ich auch ein Musiker." Schon bald flitzten Cage und Tudor zwischen drei Schallplattenspielern hin und her ließen abwechselnd Mozart, Blues und eine Rede von Papst Johannes XXIII, in der er um Frieden auf der Welt bittet, ertönen. Als die letzte Runde eingeläutet wurde, ging man im Publikum aufeinander los. "Verschwinden Sie hier", schrien die Traditionalisten, worauf ihnen ein entfesselter (un-Caged) Modernist zurief: "Gehen Sie doch woanders hin, wenn sie Melodien hören wollen. Lang lebe die Musik!" Cage brüllte das Publikum an, und das Publikum brüllte zurück. Ein namhafter Abweichler war Igor Strawinsky, der

die ganze Veranstaltung so langweilig fand, daß er schon nach der ersten Hälfte verschwand. Auf die Frage, ob der Tumult mit dem vergleichbar sei, was sich 1913 bei der Premiere seines "Sacre du Printemps" ereignet hatte, antwortete er stolz: "Es hat niemals einen größeren Skandal als den meinen gegeben." Geschicklichkeitsübung. In derselben Woche gab Strawinsky eine gemäßigte Demonstration seiner eigenen Kunst. Anlaß: die Welturaufführung seines siebenminütigen "Momentum Pro Gesualdo die Venosa Ad CD Annum" in Venedig, inspiriert von den Madrigalen des Don Carlo Gesualdo aus dem späten 16. Jahrhundert, der Strawinsky schon immer fasziniert hatte. (Gesualdo hat seine Frau und deren Liebhaber umgebracht und angeblich eines seiner eigenen Kinder erwürgt, bevor er seine Gemütsbewegungen in Lieder umsetzte.) 1956 machte es sich Strawinsky zur Aufgabe, drei Gesualdo-Madrigale für Orchester "umzuschreiben". Das Ergebnis war kaum mehr als eine Geschicklichkeitsübung in Strawinskyscher Orchestrierung, aber das Publikum bedachte den kränkelnden 78jährigen Komponisten mit wohlwollendem Applaus (er wurde in einer Sänfte auf die Bühne getragen).

Vielleicht war das Interessanteste des ganzen Festivals die Reaktion der jungen italienischen Komponisten, die sich über Cage amüsierten und Strawinsky ein wenig dekadent fanden, aber beiden mit Respekt begegneten.

(Time Magazine, 10. Oktober 1960, S. 59).

Es war ein großes Konzert und auch ein großer Skandal, wie Strawinsky bemerkt. Cage erschien in festlicher Kleidung (Frack mit Schwalbenschwanz), und während seiner Performance beschloß ich, diesen Schwalbenschwanz bei dem Konzert, das im kommenden Monat im Atelier von Mary Bauermeister in Köln stattfinden sollte, abzuschneiden. Stattdessen habe ich dann seine Krawatte abgeschnitten.

Nach der Aufführung gab es eine Party in Peggy Guggenheims Chateau, und ich brachte fast ihren Hund um.

Ich wurde ihr zuerst von Earle Brown vorgestellt und dann ein zweites Mal von John Cage. Peggy G. sagte, ein guter Freund müsse einem zweimal vorgestellt werden.

Dann sah ich zwei absolut identische Hunde auf dem Sofa liegen, die sich die ganze Zeit nicht bewegten. Weil ich langsam müde wurde, wollte ich mich auf einen dieser bewegungslosen, (zweifellos) ausgestopften Hunde setzen. Aber ich unterhielt mich noch mit einigen Gästen … und siehe da, einer der ausgestopften Hunde wachte plötzlich auf und lief davon …

Parallel zu dieser offiziellen Aufführung gab es ein Gegenfestival in einem kleinen Atelier der Kunstakademie in Venedig. Merce, Cage, Tudor, Bussoti und ein amerikanischer Ölmensch, der auch komponierte, waren die Hauptkomponisten und -performer. Es herrschte eine intime Atmosphäre, und ich hatte Gelegenheit, mit Cage in einem Vaporetto zu fahren. Das war am Tag.

Es war neblige Nacht … Heinz Klaus Metzger fuhr auch mit Cage im Vaporetto. Der Nebel war sehr dicht. Um einen Zusammenstoß zu vermeiden, ließ ein Boot sein Nebelhorn ertönen … und das nächste antwortete und das dritte stimmte ein, und vom anderen Ende des Kanals antwortete noch ein Vaporetto … und das alles vor der wundervollen Kulisse von Venedig … und neben ihm saß John Cage. Metzger sagte, es sei das beste Cage-Konzert gewesen, das er je erlebt habe. Vor diesem Happening (im wahrsten Sinne des Wortes) verkaufte George Brecht eine Fahrkarte als Eintrittskarte, um in den Bahnhof zu kommen.

NAM JUNE PAIK
VENEDIG II — 1966,
GONDOLA HAPPENING

1966 fuhren Charlotte Moorman und ich ohne Einladung zur Biennale nach Venedig und veranstalteten eine Art Gala-Happening. Auf dem Flugblatt stand nur

Gondola Happening
"Venedig ist die fortschrittlichste Stadt der Welt, denn hier hat man die Autos bereits abgeschafft."
John Cage, 1958

Viele hundert Leute warteten auf unsere Gondel, die wie immer eine Stunde zu spät kam. Endlich kamen wir an, und alle jubelten uns zu. Zuerst spielte Charlotte ein Stück von John Cage. Ein Film wurde über den Kanal hinweg auf die Wand eines Jahrhunderte alten Gebäudes projiziert. Wir hatten Glück und konnten den einzigen 16-mm-Projektor der Stadt ausleihen … und er ging nicht kaputt. Beim nächsten Stück (meine Saint Saëns-Variation), sprang Miss Moorman mutig in den Kanal, stieg wieder heraus und spielte das Stück, völlig durchnäßt von dem seit 10 Jahrhunderten verschmutzten Wasser. Nach der Vorstellung mußte sie zu einem Arzt gehen und sich eine Typhus-Spritze geben lassen. Wir hatten nur noch fünf Dollar; wir wurden aus unserer Herberge hinausgeworfen, weil Charlotte um zwei Uhr nachts Cello spielte … Zum Glück hatten wir einen Erster-Klasse-Eurail-Pass und konnten die Nacht im Erster-Klasse-Wartesaal des Bahnhofs verbringen.

In dieser ganzen Tragikomödie konnte ich nach 27 Jahren nur einen einzigen Zeugen finden, der die Performance gesehen hatte und bestätigen konnte, daß sie wirklich stattgefunden hat … sein Name ist Wim Beeren (Amsterdam).

NAM JUNE PAIK
VENEDIG III — 1975,
DIE STADT KÖLN
HAT MEINE IDEE GESTOHLEN

1975 gab es keine reguläre Biennale in Venedig wegen der Nachwehen der Studentenunruhen von 1968. Stattdessen hatten die Organisatoren der Biennale ein Dutzend Künstler eingeladen, einen Plan für die Entwicklung des Mulino-Baus auszuarbeiten, der viele Jahrzehnte lang auf der Insel Giudecca in tiefem Schlaf gelegen hatte. Ich schlug einen offenen, internationalen Freihafen und ein Studentenzentrum für den Austausch von Informationen vor. Dieser Vorschlag wurde gedruckt und als die offizielle Publikation der Biennale von Venedig überall verbreitet.
Man höre und staune!!!
Nur 10 Jahre später baute die Stadt Köln auf dem Gelände des Güterbahnhofs Gereon den Media-Park und eröffnete mit reichlichen finanziellen Mitteln eine Medienhochschule.
Hat die Stadt Köln meine Idee gestohlen, so wie es auch Bill Clinton später getan hat??

Idee für Giudecca
Der langsame Übergang unserer Gesellschaft vom Industriezeitalter zum postindustriellen Zeitalter korrespondiert mit dem langsamen Übergang unserer Lebensform von "Hardware" zu "Software" und ebenso mit dem schrittweisen Übergang unserer auf Energie basierenden Wirtschaft (Benzin, Öl) zu einer neuen Ökonomie, die auf Information (Ideen) basiert.
Der Wohlstand Venedigs im 12. bis 13. Jahrhundert war zu jener Zeit auf dem Austausch von Hardware gegründet. Diese Blütezeit kann jedoch durch den Austausch von Software auf der Insel Giudecca leicht wieder ins Leben gerufen werden. Die Videotechnologie ist dazu bestimmt, die führende Industrie im 21. Jahrhundert zu werden, weil hier das Verhältnis der gewonnenen Information/Unterhaltung zum Energieverbrauch sehr günstig ist.
Dennoch wird der internationale Austausch von Video-Software durch viele Probleme erschwert:
1) das komplizierte internationale Urheberrecht
2) Videosysteme (NTSC, PAL? SECAM etc.)
3) Sprachen/Übersetzungen
4) kulturell-gesellschaftlich-religiöse Bräuche, die Nacktheit etc. betreffen
5) das politische System und der Grad der Freiheit im Ausdruck etc.
Deshalb kann die Notwendigkeit eines internationalen Freihafens für Informationen, wo sich Käufer und Verkäufer und Studenten aus der ganzen Welt ungeachtet ihrer Herkunft treffen, diskutieren, sich in der Software aus aller Welt umsehen und einen Handel abschließen können, nicht überschätzt werden.
Die Insel Giudecca ist für diese Funktion geographisch wegen ihrer Nähe zur westlichen, sozialistischen und arabischen Welt gut geeignet.
Dieser Freihafen für Informationen entspricht auch ihrer kulturellen Tradition als Händlerin zwischen Ost und West, und er wird das wirtschaftliche Überleben der Giudecca-Insel für lange Zeit garantieren.
(Erschienen in: Magazzini del Sale alle Zattere, Venedig 1975, S. 86, 88)

Aus dem Amerikanischen von Birgit Herbst

FLORIAN MATZNER
EIN KURZER TRIP AUF DEM
ELECTRONIC SUPERHIGHWAY
MIT NAM JUNE PAIK

Florian Matzner: Heute nachmittag haben Sie mir gesagt, sie seien NICHT Andy Warhol. Deswegen machen wir diesen kurzen Trip auf dem Electronic Superhighway mit dem fast unbekannten Künstler Nam June Paik, der in den letzten Jahren von Kollegen und Kunstkritikern als "Vater der Videokunst" und "Kulturterrorist" gefeiert wird. Aufgrund Ihrer Teilnahme an der diesjährigen Biennale von Venedig muß dem ein neuer Titel hinzugefügt werden: "Ehren-Gast-Arbeiter" der Bundesrepublik Deutschland.
Nam June Paik: Die Sache ist die, daß die Entscheidung über meine Teilnahme an der Biennale im August 1991 publik gemacht wurde. Einer meiner Assistenten, Jochen Saueracker, erzählte mir, er habe im Radio gehört, ich sei der Vertreter für den deutschen Pavillon. Als ich mit Klaus Bußmann telefonierte, sagte ich ihm, daß es eine große Ehre für mich, den kleinen Koreaner, sei, das große Deutschland zu vertreten, aber ich sagte ihm auch, daß ich keinen deutschen Paß besitze. Wichtig ist auch, daß dies die erste Biennale nach der deutschen Wiedervereinigung ist, normalerweise hätte man einen Künstler aus dem ehemaligen Ostdeutschland und einen aus dem ehemaligen Westdeutschland ausgewählt. Ich meine, das wäre doch logisch gewesen, oder? Klaus Bußmann hat sich wohl gesagt: Wenn ich schon einen Künstler aus dem Osten nehmen muß, dann nehme ich lieber einen aus dem FERNEN Osten, aus dem sehr, sehr Fernen Osten. Und ich glaube, das Auswärtige Amt hatte sehr große Widerstände gegen seine Entscheidung, einen Koreaner als deutschen Künstler für

18

Venedig zu wählen. Daher wollte Klaus Bußmann seine Entscheidung SCHNELL der Presse bekanntgeben, sie zu einem fait accompli machen, so daß es für das Auswärtige Amt zu spät war, sich zu beschweren. Ich glaube, Klaus Bußmann hat eine unkonventionelle und mutige Entscheidung getroffen, was ich sehr begrüße.

FM: Klaus Bußmann hat nicht nur den Koreaner aus dem Fernen Osten ausgesucht, sondern auch einen Künstler aus dem FERNEN WESTEN, den deutschen Künstler Hans Haacke, der auch in den USA lebt!

NJP: Das ist eine Jungsche Koinzidenz. Das erste Photo von mir, das auf der Titelseite einer Zeitschrift erschienen ist, hat Hans Haacke 1960 in Schloß Morsbroich aufgenommen. Hans war damals erst 24 Jahre alt. Hans und seine Familie und Shigeko und ich lebten von 1971 bis 1972 in derselben Gegend; wir trafen uns immer im Supermarkt.

FM: Ferner Osten und Ferner Westen im deutschen Pavillon: diese Koalition aus Haacke und Paik ist von der Leitung der Biennale bereits zum Symbol der gesamten Biennale erklärt worden. Sie steht unter dem Motto: "Die vier Himmelsrichtungen der Kunst: Ost und West, Nord und Süd" oder "Der Künstler als moderner Nomade". Haacke und Paik haben den deutschen Pavillon selbst aufgeteilt: Haacke hat den mittleren Raum mit der Apsis und der repräsentativen Hauptfassade aus der Nazizeit genommen, und Paik stehen die vier Nebenräume sowie der Gartenbereich neben und hinter dem Pavillon zur Verfügung.

NJP: Das war sehr wichtig: ich hatte den Eindruck, Klaus Bußmann hätte mich lieber im Mittelraum gesehen, weil meine Arbeit bunter ist als die Hans Haackes. Aber ich dachte, Video braucht den Ton, und selbst wenn das nicht die ganze Zeit nötig ist, so kann der Ton doch für eine Videoinstallation von Vorteil sein. Aber das Problem ist, daß der Sound in den anderen Räumen zu hören ist. Ich dachte, es sei besser, lieber ein wenig Sound in drei oder vier Räumen zu haben als nur in dem einen Mittelraum. Deswegen habe ich mich freiwillig für die kleineren Räume entschieden. Ich sagte zu Hans Haacke: "Du nimmst den großen Raum, aber es kann sein, daß ich Deine Ruhe stören muß", und das war ein großes politisches Problem, denn jetzt hat Hans Haacke den großen Raum und ich habe keinen großen Sound, aber es ist in Ordnung – nächste Frage!

FM: Lassen Sie uns über Ihr Konzept sprechen, über das Hauptthema Ihres Biennale-Beitrags: es ist allgemein "Superhighway – From Venice to Ulan Bator" überschrieben. Es ist erstaunlich, daß 70 bis 80% der gezeigten Arbeiten absolut neu sind und speziell für den deutschen Pavillon gemacht wurden ...

NJP: Wenn Sie die Videoprojektion "Sistine Chapel before Restoration" mitzählen, die wir schon in der Holly Solomon Gallery für die Biennale geprobt haben, dann haben Sie recht: 80% ist neu, ja!

FM: Würden Sie kurz die verschiedenen Räume und den Gartenbereich erklären? Die zwei großen Räume werden von der Videoprojektion, der dreiseitigen Videowand "Electronic Superhighway" und von der Installation "Phasenverschiebung" beherrscht; und in den zwei kleineren Räumen ...?

NJP: OK, ich erzähle Ihnen jetzt die Geschichte der Verwandlung eines Konzepts: Marco Polo war von Bedeutung für die Beziehungen zwischen dem Westen und dem Fernen Osten und auch für die Amerikaner. Wenn Asiaten an Venedig denken, denken sie zuerst an Marco Polo ... Also dachte ich, zwei Räume könnten den Osten symbolisieren – die Mongolei, China, Korea und Japan – und die anderen beiden den Westen, der Rest, d.h. der Garten um den Pavillon und dahinter könnte die Wüste Gobi sein ... also beschloß ich, drei oder vier Banditen dort aufzustellen, die die Wüste Gobi eine Million Jahre lang beherrscht haben. Wenn wir also für draußen eine "Marco Polo" Statue genommen haben, eine "Tschingis Khan" Statue, eine "Attila" Statue – der König der Hunnen – dann ein Denkmal für den "Krimtataren", der Joseph Beuys das Leben rettete, wofür ihm die Deutschen niemals gedankt haben ... also brauchen wir für ein Denkmal für diesen Tataren ... und dann "Tangun", der erste koreanische König, denn wenn man koreanische Gräber öffnet, könnte es sein, daß man dort Skythen findet; Korea gibt es nur, weil dieser Mann und die skythischen Nomaden auch in Griechenland waren ... Skythen sind dieses alte nomadische Volk, das bei Herodot vorkommt ... und als man die Gräber in Südkorea öffnete, fand man viele Skythen, was bedeutet, daß diese Nomaden von Europa nach Asien gekommen sind, nach Korea ... und selbst heute kann man nicht von Südkorea nach Griechenland fahren, aber damals hat man es getan! Mein japanischer Freund, der Kunstkritiker Junji Ito hat mir erzählt, daß es auf frühen italienischen Bildern, z.B. von Cimabue und Giotto, Menschen mit schmalen chinesischen Augen gibt, denn damals wurde China idealisiert ... später dann, z.B. im Quattrocento, ähneln die Skulpturen und Bilder Italienern, weil zu dieser Zeit die Seidenstraße sehr wichtig war! ... Außerdem haben wir sogar ein "mongolisches Zelt" für 23 000 US-Dollar gekauft; es war schwerer, es außer Landes zu bringen als es zu bezahlen, weil die mongolische Botschaft in Korea dagegen protestiert hat. Der Vertreter der Botschaft sagte, das ist unser Kulturgut und sie können es nicht ohne unsere Erlaubnis ausführen! Dieser Mann war ein echter Kommunist; von dem Geld, das wir für dieses mongolische Zelt ausgegeben haben, kann man in Korea fünf Jahre, in der Mongolei sogar 50 Jahre leben! Wo wir gerade über die Beziehungen zwischen Italien und Asien sprechen, wußten Sie, daß die Spaghetti aus China kommen? Jedenfalls haben wir diese sieben Statuen für den Außenbereich gemacht; dazu gehören auch noch "Katharina die Große" und "Alexander der Große".

FM: Das bedeutet: "Marco Polo", "Tschingis Khan", "Attila", der "Krimtatare", der koreanische König "Tangun", "Katharina die Große" und "Alexander der

Große". Als ikonographisches System repräsentiert jede dieser Figuren einen anderen Transportweg, einen Verkehrs- oder Kommunikationsweg, aber die Titel lassen an Macht, Herrschaft, Entdeckung und Eroberung denken ...

NJP: Deshalb haben wir ZWEI Arten von Highways gemacht: der andere – der Electronic Superhighway – ist Teil von Mr. Clintons Wahlpolitik. Schon 1974 habe ich der Rockefeller Foundation ein bedeutendes offizielles Schriftstück übergeben, für das sie 14 000 US-Dollar bezahlt hat: ich habe eine Studie über den Zeitraum eines Jahres durchgeführt und den Vorschlag gemacht, die amerikanische Regierung solle elektronische Superhighways bauen, um ihre wirtschaftlichen, sozialen und politischen Probleme zu lösen. Von dieser Studie wurden 1976 3000 Kopien angefertigt, und dann kam Mr. Clinton und hat MEINE Ideen für seinen Wahlkampf 1992 gestohlen! ... Er hat eingesehen, daß Wirtschaftswachstum nur noch denkbar ist in Verbindung mit einem Umweltprogramm und einem reduzierten Energieverbrauch. Genau zu diesem Zeitpunkt hat der Club of Rome gesagt, jegliches Wirtschaftswachstum sei falsch, und der Club of Rome war die Vereinigung bedeutender Politiker. Daher habe ich den Electronic Superhighway als politische Maßnahme zur Bekämpfung der Arbeitslosigkeit vorgeschlagen, zur Gewährleistung eines wirtschaftlichen Wachstums ohne verschwenderischen Energieverbrauch. Das bedeutet, ich habe ein Wirtschaftswachstum nicht auf der Basis von Hardware, sondern von Software vorgeschlagen, denn für die Entwicklung von Software ist keine Energie erforderlich. Aus all diesen Gründen glaube ich an den Electronic Superhighway, und Mr. Clinton hat MEINE eigenen Worte gebraucht; ich dachte, es waren MEINEN eigenen Bericht aus dem Jahre 1974, als ich Clintons Rede aus dem Jahr 1992 las.

FM: Am Ende des 20. Jahrhunderts werden also Marco Polos historischer Highway von Venedig nach Asien vor 700 Jahren und der von Christoph Columbus vor 500 Jahren durch den Electronic Superhighway, eine weltweite Satelliten-Kommunikation ersetzt.

NJP: Sehen Sie, der Electronic Superhighway ist eine Breitband-Kommunikation, die Verdichtung von komplexer Information – wenn Sie wollen, können Sie sogar elektronischen Sex haben. Ich habe also eine große Arbeit aus 48 Projektionen oder 500 Fernsehgeräten in einem kleinen Raum gemacht, woraus mehr als nur eine Disco geworden ist; man kann auch ein intellektuelles Experiment machen mit der Frage, wieviel Information der Mensch aufnehmen kann. Und außerdem können wir den Leuten ein Maximum an Information für ein Minimum an Kosten geben; das ist eine Art reproduzierbarer Kunst: das ist mir sehr wichtig, denn sie steht in totalem Gegensatz zur Sammlermentalität.

FM: Lassen Sie uns noch ein wenig darüber sprechen, was Ihre Highways mit Venedig zu tun haben ...

NJP: 1958 antwortete John Cage im italienischen Fernsehen auf die Frage, welche Stadt in Italien ihm die liebste sei: "Venedig ist die fortschrittlichste Stadt der Welt, denn hier hat man die Autos schon abgeschafft." Eine Stadt ohne Autos ist die fortschrittlichste der Welt; Venedig existiert schon seit 1000 Jahren als Modell eines Lebens ohne Autos, aber sagen Sie das nicht Herrn Agnelli! Es gibt auch einen berühmten Satz von Joseph Beuys: "Es hat keine Wüste Gobi gegeben, die Wüste Gobi war GRÜN!" Das bedeutet, daß es in der Wüste Gobi eine Menge Kommunikation gegeben haben muß; das war Beuys' Chance, denn, wissen Sie, viele deutsche Soldaten, kluge und gebildete deutsche Soldaten hatten ein gutes Verhältnis zu den Krimtataren, aber nur Beuys hatte eine spirituelle Verbindung zu ihnen, denn er war der einzige, der etwas von ihrer ästhetischen Struktur verstand. Und weil für Beuys die Wüste Gobi grün war, möchte ich diesen Aspekt auf der Wiese betonen, auf der grünen Rückseite des Pavillons: die Wüste Gobi gibt es NICHT!

FM: Als Sie uns vor etwa einem halben Jahr den Titel "Electronic Superhighway: Bill Clinton stole my idea!" für ihren Biennale-Beitrag vorschlugen, haben wir ihnen, ehrlich gesagt, nicht geglaubt. Aber der Artikel in der Aprilausgabe des Time Magazine[1] und zwei Artikel, die gestern (am 17. Mai) in der International Herald Tribune[2] und im Spiegel[3] zu lesen waren, haben uns eines Besseren belehrt: der Electronic Superhighway ist nicht mehr die verrückte Fiktion oder das intellektuelle Utopia eines kleinen Koreaners, sondern Realität, denn er wird nicht nur in den USA, sondern auch in Europa gebaut. Ist Paik der Prophet einer internationalen elektronischen Kommunikation?

NJP: Nein, nein. John Cage und ich dachten: 95% der Welt müssen dumm sein, sonst hätte der arme Koreaner in Manhattan nie existieren können – und Cage dachte genauso. Also, sehen Sie: ich glaube nicht, daß ich schlau bin, aber ich glaube auch nicht, daß andere schlauer sind.

FM: Wenn man an die Anfänge des Highway denkt, die 700 Jahre zurückliegen ...

NJP: ... oder 7 Millionen Jahre ...

FM: ... dann nimmt das komplexe Geschehen auf der Erde am Ende des 20. Jahrhunderts durch die Möglichkeiten des Electronic Superhighway wieder die Intimität eines Dorfplatzes an.

NJP: Ja, sicher, das große Problem ist, daß beispielsweise Watteau NUR im 18. Jahrhundert gelebt hat, Voltaire die Geschichte nur ein klein wenig begreifen konnte, denn er konnte nicht reisen, er war nur in der Schweiz, in Frankreich und in Preußen. – Heute können wir nach Indien reisen, nach Pakistan, in den Iran, nach Ghana oder Tansania ... wir können gleichzeitig in der Zeit von Watteau, König Salomon oder im Reich Napoleons leben, wir können ZEHN Mal in der GLEICHEN Zeit leben, wir können gleichzeitig in New York und in Venedig leben und dann ins Flugzeug nach Kasachstan steigen ... so können wir dank der

Technologie nicht nur in der Zukunft, sondern auch in der Vergangenheit, in vielen verschiedenen Vergangenheiten leben ...

FM: ... und manchmal auch in der Gegenwart ...

NJP: ... manchmal, ja, natürlich. Wenn man die nackte ökonomische Wahrheit in Europa, Amerika und Japan will, voller Depression ... Der Grund für diese Depression in der überreifen Wirtschaft der USA, Europas und Japans ist, daß die Menschen schon alles gekauft haben. Sie haben alle Arten von Hardware von der Waschmaschine bis zum Videorecorder. Es gibt nichts Neues mehr zu kaufen! – Nur ein NEUER SOFT BOOM oder eine große Kriegskatastrophe kann dem Kapitalismus wieder auf die Beine helfen. Überhaupt, wer braucht noch einen Heimcomputer? Es gibt ein Problem. Wir Künstler müssen der Gesellschaft helfen, etwas Besseres zu ERFINDEN, etwas Gehaltvolleres als NINTENDO TV-Spiele. Daher wird das Vergnügen an der Vergangenheit in Venedig zu einer wichtigen Möglichkeit, eine neue Software zu erfinden und die Wirtschaft anzukurbeln. In den dreißiger Jahren war der Künstler der Feind des Kapitalismus, in den neunziger Jahren könnte der Künstler der RETTER des Kapitalismus sein (das ist für Hans Haacke). OK, zurück zu Gegenwart und Zukunft – einer der wichtigen Aspekte ist, daß wir die Geschichte wiedererleben können: man wird in der Zukunft sein und man wird in der Vergangenheit sein, nach Rom reisen und Filme über Tannhäuser sehen: wir müssen vor und zurück, wir müssen es irgendwie aufteilen, und wenn der Mensch nicht mit der Schaffung der Software-Kultur beginnt, wird es in den hochentwickelten Ländern wirklich zu einem Stillstand kommen: wir müssen uns mehr anstrengen, die Kunst interessant machen!

FM: Das ist es, was Sie "Information as art, art as information" nennen ...

NJP: Yessir!

FM: Lassen Sie mich Ihnen zwei letzte Fragen stellen ...

NJP: ... ja, das ist gut, dann kann ich schlafen gehen ...

FM: Im Zusammenhang mit "Art as Information" haben Sie den offiziellen TV-Spot für die Biennale gemacht, ein Werbespot in 21 Versionen, jede zwischen 15 und 20 Sekunden lang, mit dem Titel "High Tech Gondolas".

NJP: Das ist mein Geschenk an Achille Bonito Oliva, weil Achille und seine italienischen Freunde mich viele Male in den siebziger Jahren beschützt haben. Ich hatte einige rechtliche Probleme, denn dieser Spot ist fürs Fernsehen, d.h. wir mußten das rechtlich wieder mit jedem Rock'n Roll Star abklären. Wir haben weltweit die Rechte für drei Jahre gekauft und nach diesen drei Jahren müssen wir den Vertrag mit David Bowie, Peter Gabriel, Lou Reed und all den Jungs erneuern – ich weiß, daß ich gute Videoclips machen kann, aber rechtliche und finanzielle Probleme sind etwas anderes, also habe die Gelegenheit wahrgenommen. Zusammen mit Paul Garrin, ein großes Genie, und Mr. Guisti, der einiges Material über Italien für mich gesammelt hat, habe ich 21 Versionen gemacht, in denen ich versuchte, das alte und das moderne Venedig in den Mittelpunkt zu stellen. Sie, Herr Matzner, haben mir eine Menge Farbdias von Arbeiten der Biennale-Künstler geschickt. Mit Farbdias kann man gute, große Kunst machen, aber kein großes Fernsehen. Also habe ich sie einfach ignoriert und nur drei davon genommen (von Shigeko) und dann habe ich eine Hightech-Version für Venedig gemacht – wenn man EINEN Werbespot fürs Fernsehen macht, müssen zehn Leute zwei Monate daran arbeiten, aber Paul und ich haben 21 in NUR drei Tagen gemacht! Wir sind Supergenies, wir sind der Meta-Andy Warhol. Jetzt die letzte Frage!

FM: Wissen Sie, daß von einem pflichtbewußten Gastarbeiter erwartet wird, daß er sich mit 64 pensionieren läßt und in sein Heimatland zurückkehrt?

NJP: Nach dem deutschen Pensionsgesetz muß man 15 Jahre arbeiten, um Anspruch auf eine Pension zu haben; als ich anfing zu arbeiten – in einer Öffentlichen Anstalt – und von der Düsseldorfer Kunstakademie angestellt wurde, fragte mich Norbert Kricke ganz ernsthaft: "Wie alt sind Sie? Wenn Sie zu alt sind, können wir Sie nicht einstellen!" Ich war erst 48, also konnten sie mich einstellen. Aber ich konnte nicht oft in der Akademie sein, weil ich zu beschäftigt war, doch habe ich ein paar sehr gute Studenten: ein Drittel der Videos von erheblicher Qualität in Deutschland ist von MEINER Klasse, und nach meiner Pension werden wir eine große Ausstellung machen. Aber ich habe schon zu einem deutschen Sammler gesagt: "Sehen Sie, es ist für mich wirklich nicht in Ordnung, daß ich so selten in der Akademie bin, aber trotzdem so eine hohe Pension bekomme!", und er meinte: "Ihre Pension kommt nicht nur von der Kunstakademie, sondern von der gesamten deutschen Kunstwelt!" – Harald Szeemann war jedenfalls der erste, der gesagt hat: "Ich bin ein Geistiger Gastarbeiter." ... jetzt aber die letzte Frage, Sir ...

FM: 1990 haben Sie gesagt: "Jetzt, wo ich fast 60 bin, ist es Zeit, ein wenig Sterben zu üben. Im alten Korea sind Menschen meines Alters in Begleitung eines Geomanten in die Berge gegangen und haben einen geeigneten Ort für ein Grab gesucht." – Jetzt SIND Sie 60 und vor einigen Tagen haben Sie mir gesagt, wann Sie sterben werden ...

NJP: Ja, im Jahr 2010. Sehen Sie, ERST wenn ein Künstler stirbt, kommt er zu Geld ...

FM: ... das ist ein echtes Problem ...

NJP: ... wenn ich sterbe, wird Shigeko 50 % bekommen und vom Rest des Kuchens werde ich erstens 10 % meines Einkommens Amnesty International spenden, zweitens mein Grab am Himmel bauen, es ist eine wunderschöne Skulptur, und drittens sollte jeder Kabelkanal der Welt einen öffentlichen Kunstkanal haben (MTV ist eine Art Kunstkanal, aber ich mag die unpopuläre

Kunst); also werde ich von dem Geld für meine Kunstwerke überall auf der Welt Kabelkanäle kaufen – in Indien, in Monaco, im Kongo – so daß man jeden Abend um acht Uhr überall Videokunst sehen kann, und nicht nur meine Arbeiten. Das Problem der Kunstwelt ist, daß wir überall auf der Welt gute Künstler haben – aber fünf in Texas, zehn in Wyoming, 100 in San Francisco, 200 in New York ...

FM: ... zwei in Venedig ...

NJP: ... ja, 15 in Venedig, und sie alle sind starke, reiche, mächtige Leute, aber sie sollten sich ALLE abends zu einer Kabelfernsehen-Kommunikation zusammenfinden. Ich möchte, daß es freitags abends auf der ganzen Welt nur EINE sich austauschende Künstlergemeinschaft gibt. Es gibt aber noch zwei wichtige allgemeine Dinge: erstens, diese Biennale ist die erste nach dem Zusammenbruch des Kommunismus, und Fluxus war daran aktiv beteiligt, denn der Künstler Milan Knizak in Prag wurde 300 Mal verhaftet – er war so berühmt wie Havel – und im Radio sagte Präsident Nobotny: "Knizak ist ein Klassenfeind". Ich finde das unglaublich, denn Adenauer z.B., oder Strauß haben Beuys niemals erwähnt. Zweitens, Landsbergis aus Litauen war 1962 an Fluxus beteiligt, und er hat die offizielle Oppositionspartei in Litauen namens Sajudis gegründet; SAJUDIS heißt auf Litauisch FLUXUS; offiziell hat die Fluxus-Partei die kommunistische Regierung gestürzt, sie hat die ganze Sowjetunion zu Fall gebracht. Ich meine, in der Geschichte der Kunst hat KEINE Kunstpartei eine Regierung gestürzt. Können Sie sich vorstellen, daß dieser kleine litauische Fluxuskünstler gegen die gesamte Sowjetunion angetreten ist, und der Fluxus-Chef, George Maciunas, war ein KOMMUNIST! ... welch eine IRONIE ...

1 Time Magazine, April 12th 1993, Ph. Elmer Dewitt: "Electronic Superhighway", S. 50–55
2 International Herald Tribune, 17. Mai 1993, Steve Weinstein: "Building the Electronic Superhighway", S. 15
3 Der Spiegel, 17. Mai 1993, "Wir bauen die Datenautobahn", S. 272–284

Aus dem Amerikanischen von Birgit Herbst

ANJA OßWALD
"TO GRASP THE ETERNITY" REMARKS ON NAM JUNE PAIK'S VIDEOTAPES

"Actually I have no principles.
I go where the empty roads are."
(Nam June Paik in "Nam June Paik edited for television," 1975)

Discovering "empty roads" – this quotation sums up a fundamental characteristic of art production in the sixties very neatly. Innovative concepts are intended to contribute to the renewal of art by turning away from traditional forms. In the effort to abandon worn-out art paths, largely determined by painting and sculpture, a criticism of the state of art emerged that found its most commensurate expression in contemporary happenings and Fluxus actions. The avant-garde's demand for a connection between art and life was directed against formalist dictates of purity that had increasingly gained in significance in the wake of Abstract Expressionism. Painterly concepts like "hard edge," or "post-painterly abstraction" with their dogma of "art as art" formulated by Ad Reinhardt, were targets for criticism. Tying art in with everyday life was intended to break the concept of autonomy and make artistic expression part of a living dialogue again. Rejection of conventional techniques and content went hand in hand with general criticism of the art establishment. The action favoured by a younger generation of artists was an attempt to break away from both the hermetic isolation of the work of art and the traditional spaces associated with art.

Fluxus made its presence felt in the early Sixties in the heyday of both in the USA and Europe, and particularly in Germany. It is hard to come up with a conclusive definition of this heterogeneous and often contradictory movement of artists of the most different persuasions. Perhaps Joseph Beuys gave the simplest and most generally valid definition when he identified "Fluxus" – flow, or flux – as the „basic character" of the movement. Fluxus was to be understood as a programmatic defence of change against any kind of paralysis both in art and in a life solidified into a pattern of standardized dependencies. In this sense the predominantly musical Fluxus events were concrete actions directed "against the intentional, the consciously formal, and against the meaningfulness of art" (George Maciunas). These actions were intended to change, not only art, but ultimately life as well.

Paik, who had moved from Tokyo to Germany in 1956, soon attracted attention as the "enfant terrible" of the group. His musical actions and performances were inspired by the ideas of John Cage, whom he had met in Darmstadt in 1958, and were aimed at breaking up traditional musical conventions. In contrast with John Cage, Paik, who was a self-taught composer and pianist, went ahead in a consciously destructive mode. Knocking over a piano in "Hommage à John Cage" (1959) or smashing up a violin on the table, as in "One for Violin Solo" (1962), were acts of destruction at the same time aiming at a cathartic effect.

20

Attacking the incunabula of the bourgeois music business was intended to liberate music, cleanse it from the ballast of ideas, and enable it to be felt and experienced in its original dimension.

Unlike the dismantling of traditional forms of musical expression carried out in the Fluxus actions, the prepared television sets Paik created from 1963 were new artistic territory. This confrontation of one, or even *the,* consumer object of modern mass culture was appropriate to the avant-garde's demands for an expansion of art. In the by now legendary exhibition "Exposition of Music – Electronic Television in the Galerie Parnass, Wuppertal (1963), Paik exhibited his television works in public for the first time. Confrontation with these devices that were hitherto familiar just from their own everyday lives may have been shocking to an extent for the public. The television sets scattered across the floor showed telefixion programmes distorted by manipulation. Interferences, usually perceived only as tiresome interruptions of the programme, could be digested for their own sake, removed as they were from their usual frame of reference. The exhibition also offered visitors an opportunity for personal involvement: they could manipulate the technology and shape the sequences of images as they wished. By using various knobs or keyboards, or acoustic signals, they could influence the form of the television image – television, an object of consumption, became a creative instrument. In this installation, which Paik called "Participation TV," the artist deliberately refrained from artistic statements. The starting point for his thinking was not an artistic idea made over into a work of art, but the provision of a system of technical instruments intended to stimulate playful use. Thus devaluation of the artist as creator was juxtaposed with revaluation of the viewer as actor involved in the making of the work. The technical character of the "art objects" exhibited accommodated an effort to avoid the traditional myth of the artist, or the "fetishism of idea" (Paik). Thus the possible ways of manipulating the televisison sets were prescribed by the artist, but what they produced occurred within the apparatus. The subjective gesture, a target of violent criticism in contemporary avant-garde discussions, was abandoned; technology determined the mode of design. Distortions of picture and sound, abstract formations in the shape of dancing patterns or intertwining linear structures resulting from manipulative intervention were thus designs largely independent of artistic intentions and made available to aesthetic experience in the context of the exhibition.

The development of the portable video recorder (introduced on the American market by Sony in 1965) expanded the creative possibilities associated with the medium. Paik, who moved to New York in 1964, was one of the first artists to use this technical innovation. In contrast with his work presented in the Wuppertal exhibition, which was dependent on broadcast as screened on TV, it was now possible to record them with the so-called "Portapak" and make them accessible to artistic intervention. Examples of a strategy of this kind, which keeps to the broadcast television programme but keeps interferes with picture and sound partly at random, partly deliberately, are the "Mayor Lindsay" tape produced in 1965, showing a television appearance by the mayor of New York, and the "Early Study" dating from 1966. The latter tape is a record of an appearance in a chat show by Charlotte Moorman, who was involved in many of Paik's actions and performances.

Moreover, the introduction of the Portapak made it possible to film scenes oneself. Shortly after Paik had acquired the new recording and playback apparatus he produced "Electronic TV." The tape shows scenes from Pope Paul VI's visit to New York and was shown on the same evening in the "Café au Gogo." In his "Electronic Video Recorder" manifesto produced on this occasion, Paik evokes the future importance of video for the contemporary artistic scene. Video is understood here as a direct continuation of the happening and Fluxus tradition, as in this programmatic statement: "Someday artists will work with capacitors, resistors & semiconductors as they work today with brushes, violins and junk." The fact that innovative American broadcasting institutions offered artists the opportunity to work in their studios was important for the further development of Paik's ideas. Unlike Europe, where the media landscape of the day was still restricted to the state broadcasting institutions, the United States had a series of private channels even in the early Sixties, and because of the pressure of competition between them they were keen to open up new (artistic) approaches. Paik committed himself to cooperation of this kind at an early stage, as public broadcasting fitted in with avant-garde intentions to try out forms of artistic presentation outside traditional artistic areas. As alternative television, these productions placed themselves in a non-artistic context and presented themselves as part of modern entertainment culture. Similar to the contemporary happening or Fluxus actions, here too there was a dissolution of the boundary between the traditional space occupied by art and the quotidian: art entered the sitting room.

The dissoluton of dualistic categories of distinction, which had its counterpart in the inter-media activities of the Fluxus and happening movement, was not only reflected in Paik's choice of a medium that was rooted in everyday life removed from the art market and its distribution mechanisms; strategies of dissolution were also consistently pursued in the videotapes themselves. Thus Paik rejects work consisting only of his own – artistic – recordings in almost all his tapes. He does take the opportunity of using the video recorder or, when working with broadcasting studios, professional recording equipment, to produce his own material, but this is always complemented by recorded material from other contexts. Paik frequently draws on television itself as a "material depot," and also includes films or videos made by his artist friends. Excerpts from chat shows, news bulletins and above all commercial sequences are inserted into his own work in the manner of set pieces. The creative principle of collage that is a fundamentally characteristic feature of Paik's work thus leads to formal and contentual intersection of different spheres. In works like "Global Groove" (1973), "A Tribute to John Cage" (1973) and "My Mix" (1981), advertising, contemporary entertainment, avant-garde culture and political issues are arranged as individual sequences separated by cuts within the temporal sequence of the tape, and juxtaposed as items of equal value in principle. An exemplary combination of various spheres of representation, inserted in the very structure of the work, ultimately aiming at a levelling of the categorical givens of "high art" on the one hand and "mass culture" on the other, is to be found in the videotape "Waiting for Commercials" produced in 1972. It consists of contemporary commercials filmed from television and complemented by short insertions from a Music Performance by Charlotte Moorman. Commercials, are usually seen as unwelcome interruptions of the programme in the context of television, and here Paik is reversing the principle. Even the title refers to this reversal, which is directed against current modes of perception that the media help to determine to a significant extent. Thus the commercial spots shown are seen as less of a "disturbance" than the artistic offerings that regularly interrupt the colorful consumer worlds. Advertising itself is declared an aesthetic product. With advertising conspicuously inserted into an artistic or artificial context outside its actual system of reference, attention is drawn to its specifically artistic qualities.

A parallel to forms of representation of Pop Art can be drawn with this conscious recourse to mass cultural phenomena. But Paik's strategies of dissolution equally entail a criticism of the commercial media apparatus. The refutation of conventional forms of artistic expression on the one hand, and the subversion of traditional media communications structures achieved by Paik's "Participation TV" on the other, exist in a relationship of dialectical tension. For example, "Electronic Opera No. 1," produced by Boston station WGBH and broadcast as part of the programme "The Medium is the Medium," created by artists, contained stage directions addressing the viewer. Instructions like "close your eyes," "open your eyes" were intended to prevent merely passive reception of the broadcast material. The viewer was stimulated to withdraw from what was being presented on the screen to explore his own inner worlds of images. Of course, these instructions were to be understood mainly rhetorically. Viewers' attention was to be drawn to their own consumer behaviour, and at the same time the provocative gesture referred them to the manipulation emanating from the medium.

There is probably hardly a technology that has gained global acceptance within a very few decades as quickly and consistently as television. It is a mass medium in the true sense, with the striking quality of conveying messages that are consumed by a mass public. This can happen only if the messages are conveyed in standardized form using the lowest common denominator to reach the largest number of viewers. It is in the nature of the medium to deprive the consumer of the right of decision with pre-prepared pictorial, sound and meaning content – to fix him in the role of passive consumer on the basis of a one way broadcaster-receiver code. It is a "technology of free entry that does not know any practical or economic limitations, or any limitation specific to particular ideas" (Neil Postman) and that cannot give any consideration to individual thoughts, ideas and meanings that may change with time. Television does not live primarily on content and meaning, but on significance, the significance of the moving picture. This facticity of television (as that of every mass medium) has been confronted time and again with attempts to break up the standard distribution apparatus, to redirect the medium towards its "true" function as communication medium. "Breaking the sender-receiver code" and "activating the spectator" denote aims that have dominated the debate within media theory since Brecht. Against this background Paik's concepts developed in Fluxus circles can also be judged as alternatives of artistic origin to commercial use of the medium.

Paik developed a particular method of confronting the world of electronic images and their distributive structures with his videotapes, often created in cooperation with innovative American broadcasting companies, and emitted as "alternative television" within the normal range of broadcasting available. The "electronic Collages," as these works are called by a speaker in Paik's videotape "Suite 212," adapt the formal language of television. The tapes contain a sequence of set pieces, arranged through montage and collage, that correspond to everything that flickers across the screen every day in the form of news, feature films, entertainment and the inevitable advertising. But in contrast with television which suggests a continuity over and above breaks resulting from editing and montage, Paik's technique consciously breaks up continuity. The sequence of material originating from heterogeneous contexts is not open to a linear reading. This has consequences for the viewer, who is prevented from comprehending the representation as it unfolds gradually, but has to follow the sequences in jumps, analogous to their discontinuous presentation. In this way any meaning that may emerge does not derive from a logical continuity of episodes but rather the recipient viewer is required himself to become active and combine the sequences separated by cuts in order to give them any meaning at all. This meaning, which is always particular and personal, breaks up the traditional message character of the broadcast material. The "one way-communication" of

the commercial media apparatus, criticized by Paik becomes a real dialogue, a "two way communication." Paik's recycling process has an essential function in this context. As Paik does not understand video in its original meaning of "I see," but selects material that has already been looked at, commented upon, and has always already been interpreted, he is questioning visual communication processes. By this conscious inclusion of cultural codes he is playing with a specific attitude of expectation in the recipient in order to question it at the same time. For instance, an advertising sequence in a montage by Paik still refers to the original consumer article, but its fixed meaning is dissolved by its integration, through montage, into a new context. Thus for Paik montage always contains a demontage of the sign character inscribed in the material: as an allegorical process Paik's collage technique intends to liberate the picture and sound material from (apparently) unambiguous reference systems – the "revolt of the signs" (Baudrillard) is vividly demonstrated.

This principle also plays a particular part in Paik's own *oeuvre*. By re-using work that already exists, which is re-edited or becomes a fragmentary component of later video productions, any unambiguous reference quality is broken down, the artificially designed product is contrasted over and over with other set pieces and is integrated into a creative process that constantly offers new opportunities, for play and interpretation. The collage is shaped as a sequence of heterogenous realities that exist alongside one another with fundamentally equal values. By means of constant change and shifts in perspective, reality is understood and experienced, not as always already known and interpreted, but as constantly changing. The collage technique functions as a paradoxical principle, working with the medium against the medium. The illusive construction of categories through television which operates according to dualist principles and likes to fix meaning statically, is literally set in motion by Paik's electronic collages; reality regains its complexity. By admitting ambiguity, by not subjecting optical and acoustic phenomena to unambiguous, definable identification and thus "arresting" them, meanings collide with meanings and the familiar suddenly becomes questionable. Images regain their uncertainty or, as Paik says. "The absolute IS the relative, the relative IS the absolute."

This shifting between various levels of interpretation is complemented by a shifting between various planes of representation achieved by means of a synthesizer. The video synthesizer, developed by Paik with his engineer friend Shuya Abe in 1970, translates electronic impulses into optical signals that appear on the screen as abstract colors and shapes. In his manifesto "Versatile Color TV Synthesizer," Paik writes euphorically about the painterly possibilities of this device: "This will enable us to shape the TV screen canvas as precisely as Leonardo as freely as Picasso as colorfully as Renoir as profundly as Mondrian as violently as Pollock and as lyrically as Jasper Johns." The screen becomes a support – in Paik's words a "canvas" – for synthetically generated "paintly in motion", which intersects with the picture sequence collages. But the mimetic representations are not "destroyed" by this, as David Ross suggests, and this seems fundamental. Rather, the synthetic pictorial formations produce a fabric of images laid, as it were, over the video footage, and that does not fundamentally question the latter's representational quality: "realist" and "painterly" quality are juxtaposed on equal terms.

In this deconstructionist vein Paiks's work with and against television can be set in parallel with John Cage's ideas. Just as the conscious disorder of his compositions, derived from random processes like I Ging, was aimed at liberating music from traditional norms and conformity with laws, the staged disorder in Paik's collages rejects the categories governing commercial television. In each case solidified structures are to be broken down and long established modes of thought and perception are to yield to an unprejudiced view.

A direct juxtaposition of Cage's working method and Paik's treatment of video is to be found in the tape "A Tribute to John Cage," produced in 1973 on the occasion of the composer's sixtieth birthday by WNET, in New York. The tape gives an insight into Cage's work, showing excerpts from performances and the composer's well-known "Lectures." The world premiere of the composition "4'33," dating from 1953, is also presented. In his video work, Paik takes up John Cage's strategies for dissolving boundaries aimed at time and, in an oblique sense, at experience of the world. He does not restrict himself to the presentation of artist and work. Indeed the documentary is constantly interrupted by the insertion of other set pieces. But these only seem to be a contrast. In truth, the heterogeneous set pieces – advertising sequences, show interludes filmed from television and excerpts of the Woodstock film are consistent with Cage's ideas. The abolition of fixed norms and values, and insight into the equal value and equanimity in principle of all items and manifestations that make Cage's compositions and performances open to sensual perception, are accompanied by a formal design that, as a collage series of episodic scenes, does not recognize any qualitative distinctions and in this way structurally answers the composer's intentions.

The rhetorical function of Paik's collage method is clearly discernible here. The use of heterogeneous materials to start from is accompanied by a twisting of originally contrasting elements of content. Proceeding from individual sequences separated by cutting and montage, the eventual aim is to dissolve their boundaries. This takes place within the progressive sequence that in principle is able to abolish differences.

Paik's appropriation of the material is thus ultimately a process of dialectical reversal aimed at liberation from the entrenched allocation of meaning; Weltanschauung is again to be understood in its original sense of *Welt-Anschauung* – intuition of the world. The "Global Groove" tape, produced in the same year, is based on similar reflections. Its complexity and the diversity of material used suggest that it could be considered a model for Paik's subsequent video work. It was also produced at WNET and was first broadcast there on January 30th, 1974.

The credits contain a prophetic vision recited off-camera of a "video-landscape of tomorrow," in which the TV magazines would be "as fat as the telephone book", and what follows appropriately shows a varied mélange of the full range of international television: here, too, set pieces from an enormous variety of contexts are brought together. They include gogo and tap dance performances, a Navaho Indian woman drumming, John Cage telling anecdotes, excerpts from performances with Charlotte Moorman and a sequence from Paik's "Electronic Opera No. 1," Far Eastern dance rituals, a commercial break, scenes from a "Living Theatre" performance … all of which usually accompanied by music. There is no continuous sequence of action that would subordinate the sequence of episodes to an overall narrative context and make it easier to watch; the viewer is confronted with a kaleidoscope of rapidly changing picture and sound elements presented in a total of twenty-two sequences.

In this way montage becomes the origin of a gesture that certainly shows something, but does not narrate anything. The viewer counteracts this consciously staged "deficiency" by actively producing comment and interpretation himself. Paik channels the direction of interpretation by planting recognizable "remainders" within the fragments. The musical presentations from American entertainment culture were probably just as familiar to the viewer as the gogo and tap dancers or the montage of Coca-Cola commercials. Within the chronological sequence, the contrasting "alien" episodes like the Far Eastern dances or excerpts from performances produce meanings that can be characterized with pairs of concepts like old – new, tradition – modernism, east – west. Integration into a discontinuous compositional rhythm relativizes the complementary significations. Different cultures and traditions combine in "Global Groove" to form a global rhythm of realities created by the media.

If one considers the fact that the videotape was conceived as an artistic contribution to peace as the Vietnam war rose to its height, the sequence of heterogeneous units can be seen as a symbolic act to promote understanding between peoples. By using signs that refer as much to indigenous, familiar culture as to foreign lands and traditions, geographic and political boundaries are removed. Here, formal dissolution of boundaries follows dissolution of content: Paik's "Television Programme" refers to future media landscape that no longer knows any national limits and in which it will be possible "to switch to any TV station on the earth," as stated programmatically in the credits.

Thus "Global Groove" can be understood as an artistic staging of MacLuhan's utopia of the "Global Village," whose communicative function lies in imitiating a process of international understanding as much as in enabling viewerts to reflect on their own structures of consciousness and perception.

If "Global Groove" was concerned with combining and also relativizing spaces referring in their artistic realization to future media-technical developments (global networking), in "Guadalcanal Requiem" Paik adopts a similar strategy with respect to time. Resting the conventional linear experience of time, Paik makes a montage of documentary footage from the Second World War and sequences filmed by him in 1977 to combine into discontinuous sequence. The sequences filmed by Paik (performances by Moorman and Paik himself) and interviews with war veterans were shot on of Guadalcanal island, a former war theatre. The place's past and present are conflated in such a way that different times are brought together simultaneously. The digital clock built into the documentary footage refers on the one hand to a measurable, definable time, and on the other hand, confronted with contemporary shots, clarifies the relative quality of the experience of time. By alternating long and short sequences a discontinuous series of heterogeneous times emerges into whose rhythm the viewer is drawn. In contrast with a memory that documents the past only factually, the non-linear time structure provokes perception as creative memory in the Proustian sense. Thus the past is not lost in the darkness of history, but remains present and politically relevant precisely through the experience of time. Beyond the intended political implications the collage of space and time refers, to the structural conditions of electronic picture transmission. If in "Global Groove" the international network is presented as still a prophetic vision, the live video show "Good Morning Mr. Orwell," (staged on January 1st, 1984) is a programmatic spectacle of media possibilities. The show, which offered a varied mixture of entertainment by artists like Joseph Beuys and Ben Vautier, and pop musicians like Laurie Anderson, took place simultaneously in Paris and New York. Division of the screen by split-screen processes made it possible to experience events on both sides of the Atlantic at the same time. Music and dance, action and performances were brought together on the screen, and global networking could be experienced sensually by the viewer, qua music and dance. The "Video Common Market," demanded by Paik a model for international exchange and global understanding in the Seventies, was programmatically juxtaposed with the sinister Orwellian vision of "Big Brother."

In the final analysis, time and space are also the subject of the "Lake Placid" tape, produced in 1980 on the occasion of the Winter Olympics. Various kinds of

sport were shown, appropriately to the context, with the musical accompaniment of Mitch Ryder's "Devil with a Blue Dress on," and complemented by shots of aircraft circling in the sky. The speed of pirouetting ice skaters, skiers racing down hill and aircraft storming the skies all correlate with the rapid chain of sequences which, some highly speeded up, some showing shots backwards, provide a rhythmic structure for the tempo (understood as time and movement). Shots of Allen Ginsberg meditating are featured as only an apparent contrast to these sequences. In fact, the intoxication of speed and "slow" meditation time are mere complementaries of the one time as it flows, which, as already in "Guadalcanal Requiem," is the actual subject of the videotape.

The self-reflectivity of the medium, which can already be detected in making speed the prominent subject of "Lake Placid," is present even more strongly in "Butterfly", which dates from 1986. Here, the pictorial fragments are made into a collage frenzy of media realities in the two minutes that the tape lasts. They are electronically alienated to the point of still just being recognizable, and invite the viewer to a dance of highspeed sequences to the time of an aria from "Madame Butterfly."

It is beyond the scope of this essay to discuss all of Paik's tapes created since the early seventies and largely conceived for television. But if one examines the development of these videotapes it is striking that, apart from documentary videos like "Allan and Allen's Complaint" dating from 1982, for example, "Living with the Living Theatre" (1989), the montage methods consistently become more subtle as the years go by, and alienation of the starting material is conducted in a manner ever more refined. The fragmentation of the material down to hardly perceivable particles of reality, moving, or better flying across the screen in a frenzy of high velocity marks a sequence of realities happening ever more quickly and being accelerated in the truest sense by the electronic mass media, dissolving everything definable and leaving speed as the only valid constant. The question arises of whether the concomitant loss of interpretive variety on the part of the viewer does not ultimately reveal the "contentless message" of the medium in MacLuhan's sense. The increasing distancing of polyvalent reference systems draws the logical conclusion from MacLuhan's well-known dictum "the medium is the message." The "visual raw material" no longer aims at illustrating oppertunities inherent in the media in the sense of a "Global Village" but increasingly serves the concretion of abstract structural laws that govern it, viz., the connection of space and, time through speed and the relativization of meaning in collaged juxtapositions of heterogeneous realities. The medium presents itself in visual and acoustic "overkill," as David Ross once noted on the impact of Paik's videotapes: the medium is the message …

… and the message is "music," music made visible. This paradoxical thought makes the connection between Paik the video artist and Paik the musician. Apart from their confronting the modes of perception of television and its structural laws, Paik's video collages can also be understood as musical compositions. Paik organizes the "creative shape of structure" that MacLuhan detects in the "mosaic form" of television in accordance with guidelines that are to a certain extent musical. In contrast with other video artists like Bruce Nauman, Vito Acconci or Dan Graham he was originally a musician. The collage relates different units to one another structuring them through cutting and montage similar to a score. In this way fast and slow, accelerated and restrained, meditative and nervously active sequences make intervals, and their juxtaposition, the variation and thematic re-adoption of individual motifs creates a many-layered fabric of relationships. Thus, it is incidence that many of Paik's videotapes also have musical titles: "Global Groove," "Electronic Opera No. 1," "Guadalcanal Requiem," "Suite 212."

The synthesizer – called a "real-time video piano" by Paik – structures the musical movement beyond figurative references, beyond the musical movement presented in scenic episodes working from dance or musical performances. As visual notation the abstract color and formal structures correlate directly with the acoustic rhythm that accompanies the scenic episodes: the musical qualities of the moving picture supplement their painterly qualities. Musical time (the prescribed rhythm) and pictorial time (the movement of the synthetically created color formations) form a unity that can be experienced synaesthetically. The move beyond the boundaries of music initiated by Cage is consistently taken further as the exploration of the "non-musical sound fields" (Cage) is expanded by the optical dimension. The musical image emerges from the non-musical sound.

In the end, the question: "What is music?" is answered by Paik similarly to Cage when he says: „Music is a passage of time." Through the discontinuous rhythm prescribed by the collage structure, Paik "liberates" time from a linearity designed to be measurable. With their juxtaposition of different time forms, Paik's video collages present time to the ears and eyes as a relative parameter.

Situated on the borderline of television, music and "painting in motion," video serves as a meta medium for making time visible: a time that has been given rhythm, slowed down, accelerated, a time that aims at paravisual perception of the real world, understood as constant transformation and change. In the late Eighties, when Paik essentially parted from single-channel production and turned increasingly to the concept of large-format multi-monitor installations, this was ultimately only a logical consequence of the previous development. "The More the Better," a project conceived for the Seoul Olympics in 1988, used 1003 monitors and gave the programmatic impulse in this respect. No longer are

fragments of sound and pictures in this the only elements of the collage; rather, the collaged software is supplemented by the hardware of the monitors. Interconnected and fed by collaged software, they are a space-consuming and rhythmically organized all-over structure. The limitation governing single-tape production, confined, to one monitor only, is abolished. This also removes the possibility of distancing; the viewer is integrated into the pictorial flood of a monitor "wallpaper," as Paik calls these installations, that structures space rhythmically.

In the cataract of pictorial sequences, montaged, fragmented and synthetically alienated, that pours over the recipient, the disappearance of things from the images is discernible, that impression of disappearance being only further supported by the brief flashing into view of recognizable set pieces. Time remains: visible, reified in the rhythmic flood of images as flying time, illustrating the increasing relativization of perception in the speed frenzy of our "Fin de Siècle" (the title of a space consuming video installation created by Paik in 1989). The reversal is obvious: where there is too much, nothing can be seen any more, "Overkill" leads back into nothing, into the nirvana of the individual mind. In the context of current media discussion it is one of Paik's specific qualities that he sums up television as medium by probing the depths of its technical qualities and modes of perception, and brings about a paradoxical conclusion of reversal in an act of over-extension: the conditon of Information Overload returns to – or is thrown forward into – a condition of Zero Information. It is hardly amazing, therefore that Paik's early manipulated television sets produce a similar effect to that of the late video walls with their sometimes gigantic scale. "Minimal" – Paik's name for his early television works – and "Maximal" – the multi-monitor installations – are to be understood simply as the two sides of a coin. Thus, "Zen for TV," the title of a "chance composition" dating from 1963, could be adopted for his work of the Eighties. The Buddhist paradox seems applicable to both tendencies: "We can understand emptiness only through shape." The horizontal white stripe on the otherwise black screen that in "Zen for TV" emerged by chance because of a technical defect in the television set, gives shape to emptiness, as does the technically perfectioned flood of images.

"Top grasp the eternity": with this dramatic formulation dating from Paik's Fluxus days, the late work reaches back to the time when Paik exhibited his manipulated televisons for the first time in Wuppertal.

Translated from the German by Michael Robinson

GRACE GLUECK
EIN VIDEO-KÜNSTLER STELLT DIE VISION DES FERN-SEHENS VON ORWELLS "1984" IN FRAGE

In seinem prophetischen Roman "1984" hat George Orwell kein gutes Haar am Fernsehen gelassen. Für ihn war es der "Big Brother", ein Werkzeug des totalitären Staates. Aber heute, am ersten Tag dieses prophetischen Jahres, wird seine Ansicht von dem koreanischen Video-Künstler und Impresario Nam June Paik erheblich angezweifelt. "Good Morning, Mr. Orwell", ein Satelliten-Liveprogramm, das die öffentlichen Fernsehsender, einschließlich WNET/Channel 13, heute mittag um zwölf Uhr ausstrahlen werden, ist Paiks Plädoyer für das Fernsehen, in dem er keineswegs ein bedrohliches Instrument zur Gedankenkontrolle sieht, sondern ein Mittel zur internationalen Verständigung.

Wenn Paik sagt, er sei "unter den internationalen Künstlern der erste, der den Satelliten für eine globale Interaktion einsetzt", so bedarf dies einer kurzen Erklärung. Auch andere Video-Künstler, wie beispielsweise Dough Davis, haben Satellitenübertragungen durchgeführt, aber Paiks Unternehmen ist größer und komplexer. Während das kommerzielle Fernsehen verschiedene Teile der Erde zwecks Nachrichtenübermittlung miteinander verbunden hat, verwendet Paik Bilder, die speziell auf die Technologie des Satelliten selbst abgestimmt sind. So kann er interaktive Performances von verschiedenen Schauplätzen der Welt miteinander verbinden.

"Good Morning Mr. Orwell" ist im wesentlichen ein globales Varieté aus den Vereinigten Staaten, Frankreich und Deutschland, aber seine Darsteller werden den "avantgardistischen" Fans von Paiks Kunst wohl besser vertraut sein als dem normalen Fernsehzuschauer. Weil es in dem Programm nicht direkt um Orwells Philosophie geht, glaubt Paik, daß durch die Präsentation von bekannten und neuen Talenten aus Amerika und Europa die "positive Seite des Mediums gefeiert wird".

Zu denen, die live oder vom Band zu sehen und zu hören sind, gehören auch die Rocksänger Laurie Anderson und Peter Gabriel, die den von ihnen speziell für diese Sendung komponierten und aufgenommenen Titelsong schmettern werden. Auf einem geteilten Bildschirm werden der Choreograph Merce Cunningham und der Komponist John Cage in New York zu dem deutschen Beitrag – einem von Salvador Dalí (auf Band) rezitierten Gedicht – improvisieren. Der Künstler Joseph Beuys wird live vom Centre Pompidou in Paris aus Klavier spielen. Die Dichter Allen Ginsberg und Peter Orlovsky singen eine ihrer eigenen Kompositionen, und schließlich wird eine Gruppe von 80 französischen Saxo-

phonspielern und Sängern namens Urban Sax sowie die unbändige Charlotte
Moorman auftreten, eine Cellistin, die dafür bekannt ist, daß sie Paiks Komposi-
tionen fast nackt vorträgt (bei ihrem Satelliten-Debüt allerdings soll sie vollstän-
dig bekleidet sein). Für Lacher, so hofft man, sorgen Einlagen der Komiker
Mitchell Kriegman und Leslie Fuller, beide früher bei "Saturday Night Live". Der
Zuschauer wird außerdem Zeuge einer Fernseh-Welturaufführung: "Act III", ein
Film von Dean Winkler und John Sanborn mit Musik von Philip Glass, der neue
Maßstäbe im Bereich der elektronisch-grafischen Darstellung setzen soll. Paik,
der jetzt 51 Jahre alt ist, sieht mit seinen zerknautschten Kleidern und seinen
zerzausten Haaren noch immer aus wie der Wunderknabe, der in den sechziger
Jahren als Begründer der Video-Kunst die Aufmerksamkeit der Kunstwelt auf
sich lenkte. "Ich habe Orwells Buch nie gelesen – es ist langweilig", sagte er vor
kurzem in einem Interview bei WNET. "Aber er war der erste Prophet des
Medien-Zeitalters. Orwell hat das Fernsehen als ein negatives Medium darge-
stellt, das Diktatoren für eine einseitige Kommunikation benutzen können.
Natürlich hatte er zu 50 % Recht. Das Fernsehen ist noch immer ein repressives
Medium. Es beeinflußt uns in vieler Hinsicht."
(Erschienen in: The New York Times, 1. Januar 1984, S. 21)

Aus dem Amerikanischen von Birgit Herbst

24